Monumental

*Monumental: How a New Generation of Artists Is Shaping the Memorial Landscape*

Cat Dawson

THE MIT PRESS
Cambridge, Massachusetts • London, England

*For Kadian*

*Come, One and All, to Marvel and Contemplate*
The Monumental Misrememberings
*Of Colonial Exploits Yon.*
Kara Walker

*Introduction: Monuments and Memory*   1

1   *Materializing Absence*   39

2   *The Archive as Monument*   69

3   *Ambivalence and New Monuments*   125

4   *Monumental Time(s)*   169

   *Epilogue*   203

Acknowledgments   223

Notes   225

Bibliography   239

Index   251

# Introduction
## *Monuments and Memory*

F or two months in the summer of 2014, a former sugar refinery building on the Brooklyn waterfront housed an installation by Kara Walker titled *A Subtlety, or the Marvelous Sugar Baby, an Homage to the unpaid and overworked Artisans who have refined our Sweet tastes from the cane fields to the Kitchens of the New World on the Occasion of the demolition of the Domino Sugar Refining Plant*. The central figure, installed in the center of the cavernous building, was a seventy-five-foot-long, thirty-five-foot-high, crouching nude form fashioned from forty tons of sugar molded onto massive polystyrene blocks. Modeled on the Great Sphinx of Giza and named after edible and similarly unsubtle tableaux served at banquets for nobility in medieval England,[1] *A Subtlety* swapped the feline inflections of that ancient referent for a body intended to be read as that of a Black woman. Resting on elbows and knees, it had an indecipherable expression on its face; its head was bonneted; its breasts were bare; and its hands were balled into fists, the left in a *figa*, thumb inserted between index and middle finger in a sign of both fertility and defiance.[2] From where visitors entered, the

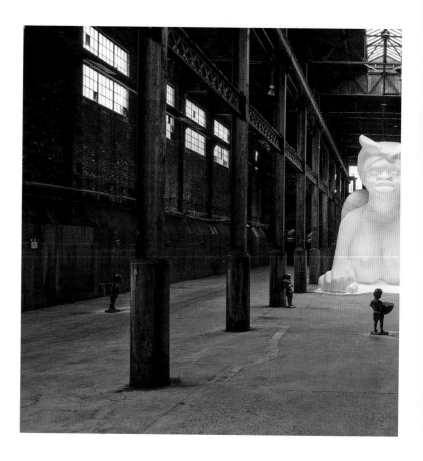

Figure 0.1   Kara Walker, *A Subtlety, or the Marvelous Sugar Baby, an Homage to the unpaid and overworked Artisans who have refined our Sweet tastes from the cane fields to the Kitchens of the New World on the Occasion of the demolition of the Domino Sugar Refining Plant*, 2014. Polystyrene foam, sugar. Approx. 35½ × 26 × 75½ ft (10.8 × 7.9 × 23 m). Installation view: Domino Sugar Refinery, a project of Creative Time, Brooklyn, NY, 2014. Photo: Jason Wyche. Artwork © Kara Walker, courtesy of Sikkema Jenkins & Co. and Sprüth Magers.

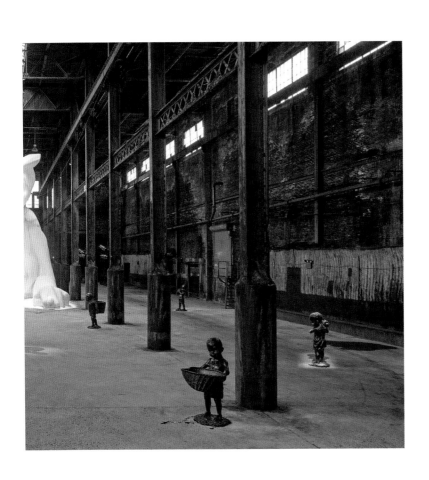

figure's hips were visible over its shoulders, and those who walked the length of the building to the back of the monumentally scaled sculpture found articulated labia framed by tucked feet. Scattered throughout the space around it were fifteen smaller sculptures made of sugar and resin that Walker called "Attendants," statues of children holding bunches of bananas or baskets of unprocessed cane. Referencing racist histories of minstrelsy, the caricature of Black children in the production and advertisement of candy, and the uncompensated labor of African Americans both within and beyond the sugar industry long after slavery had formally ended, the Attendants' expressionless visages echoed those of both the central form and the historical Sphinx.[3]

A Subtlety was a multivalent gesture toward histories of gendered racism in the United States and Europe made possible by Walker's citation and inversion of the conventions of formal composition, location, and titling. Whereas the Western art canon long understood itself as an inheritor of Greco-Roman classical traditions, Walker reached to the African classical tradition, decentering that narrative by centering the Sphinx. By elevating a Black feminized form to a status historically reserved in the West for white male figures, Walker underscored that ordering architectures have long devalued nonwhite and nonmale bodies and lives. The artist's use of sugar also referenced the history of Black bodies being consumed by the machinations of racial capitalism as both labor and confections; the sugar trade was a key driver of the Atlantic slave trade, and the factory that housed A Subtlety was responsible for refining over half of the world's cane into sugar at the end of the nineteenth century.[4] A hundred years later it had been emptied of its machinery, faced imminent demolition, and was occupied by an installation that not only laid bare the violent histories that attended it, but also pushed back against the idea of refinement as coterminous with whiteness by elevating Black subjectivity to monumental status.[5]

In addition to describing a set of histories rarely represented in monuments, however, A Subtlety interrogated the form and function of the medium itself. The term "monument" has been applied to a vast and incoherent range of projects,[6] but commonsense accounts often describe the category through a combination of material form and cultural function. Monuments tend to be substantially larger than the human body, hewn from heavy, often impermeable materials, and are placed in public to commemorate

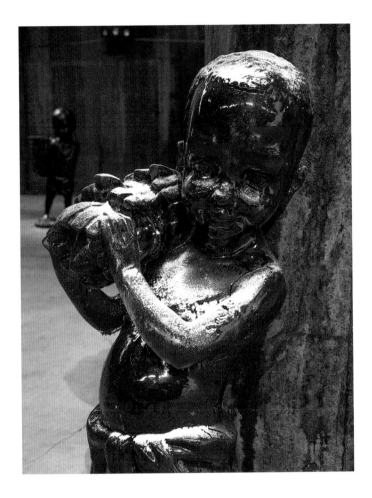

Figure 0.2   Kara Walker, *African Boy Attendant Curio with Molasses and Brown Sugar* (detail, bananas), from "The Marvelous Sugar Baby" Installation at the old Domino Sugar Factory Warehouse, 2014. Cast pigmented polyester resin with polyurethane coating with molasses and brown sugar. 59½ × 20 × 19 in (151.1 × 50.8 × 48.3 cm). Installation view: Domino Sugar Refinery, a project of Creative Time, Brooklyn, NY, 2014. Photo: Jason Wyche. Artwork © Kara Walker, courtesy of Sikkema Jenkins & Co. and Sprüth Magers.

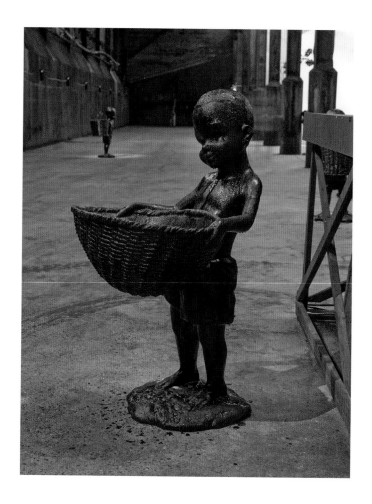

Figure 0.3   Kara Walker, *African Boy Attendant Curio with Molasses and Brown Sugar* (detail, front basket), from "The Marvelous Sugar Baby" Installation at the old Domino Sugar Factory Warehouse, 2014. Cast pigmented polyester resin with polyurethane coating with molasses and brown sugar. 59¾ × 33 × 36 in (151.8 × 83.8 × 91.4 cm). Installation view: Domino Sugar Refinery, a project of Creative Time, Brooklyn, NY, 2014. Photo: Jason Wyche. Artwork © Kara Walker, courtesy of Sikkema Jenkins & Co. and Sprüth Magers.

a significant event like the founding of a nation or the winning of a war. Given the significant resources required to bring them to fruition, monuments routinely represent the perspectives and subjects of dominant culture, and telegraph that culture's values using relatively permanent materials that project those values into a hypothetical eternity.

A *Subtlety* made use of enough traditionally monumental formal conventions to be recognizable as a monument: it was monumental in scale, styled after a historical monumental referent, and installed at great expense in a place of historical significance to its context. At the same time, other formal and narrative considerations challenged its easy assimilation into the category. It was designed to be temporary rather than permanent; it was made of materials both less (sugar) and more (polystyrene) ephemeral than those traditionally used for monuments; and the histories to which it gestured were grounded in minoritized rather than dominant experiences. This coincidence of traditionally monumental tropes and definitively unmonumental interventions enabled *A Subtlety* to challenge the long-standing associations between the monumental form and narratives of dominance and permanence and, in so doing, to invite questions about why many histories have not been monumentally told.

In drawing these formal and narrative conventions and interventions together, *A Subtlety* marked an inflection point in the role that monuments play in US culture. It was also among the first in what has since become a generation of monuments that has at once extended and undermined fundamental tenets and histories of the medium. As art historians and memory studies scholars have extensively documented, monuments have repeatedly been deployed in the service of political and ideological projects at moments of heightened cultural tension or national disunity in part because the form lends itself to the articulation of a national self-image of homogeneity and harmony.[7] In the United States, monuments have elaborated and sustained blatantly false narratives about the racial history of the nation, as in the case of the 2,000 or so monuments erected following the defeat of Reconstruction that furthered the Lost Cause narrative of the Confederacy, or the nearly 200 erected during and in the aftermath of the Civil Rights movement.[8] The monuments that have emerged in the twenty-first century, however, interrogate not just the formal constraints of the medium, but also the stories it can tell. Since 2014,

monuments that make the interrogation of monumentality itself central to their representational strategies have predominated over more normative representations of the form.

*Monumental* examines the historical conditions that have led to, and aesthetic terms that define, this new generation of monuments. In this book, I argue that the formal and narrative interventions that characterize recent monuments—which is to say, the shapes they take, the materials they use, the locations in which they are installed, and the stories told through their surfaces—are indebted not only to the monumental tradition to which they most obviously refer but also to representational strategies that grew out of later twentieth-century social justice efforts, including the Civil Rights movement and queer organizing during the AIDS crisis. Studying the emergence of strategies for this kind of monumentality along a fifty-year period from the end of the 1960s to the end of the first decade of the present-day monument boom, *Monumental* ultimately suggests that what enables this new generation of monuments to do the important cultural labor they do is also, in many cases, what makes them most traditionally monumental: they take on a metacritical—or metamonumental—role to describe the terms through which monuments come into being for the express purpose of demonstrating their utility to alternative, minoritized ends. This form of representation—that ruptures the idea of history as stasis in formal and narrative terms, wears its ideologies on its sleeve, and acknowledges that the very format in which one must often work is always already complicit in precisely that which one seeks to undermine—is precisely what characterizes the contemporary monumental era.

As both the title of this volume and a concept central to it, *monumental* refers to a diverse set of representational practices that conspire to produce an object that describes a specific relationship between cultural identification and that culture's relationship to past, present, and future. The formal and narrative interventions of this generation emerge from an interrogation of the bounds of the monumental form and push back against the monocultural fictions with which traditional monuments are freighted by exposing that the past is always subject to revision based on the needs of the present. This book suggests that there is both a formal case to be made for, and political imperative to, recognizing these forms not just as monumental but as monuments. To understand these objects as having the same claim to the term as more traditional

instances do challenges the kinds of exclusionary thinking that has long underwritten the relationships between monuments and domination. Another way in which the monuments studied in this book intervene into the historical conventions of the form is through a rather unmonumental relationship to time. Not only do these forms complicate normative understandings of time as linear and progressive; their lack of permanence also poses a challenge to traditional conventions of monumentality and, by association, to the architectures of domination that produce and are sustained by monuments.

Though a number of the monuments studied in this book are temporary, whether a particular monument represents the history and values of dominant or minoritized culture is more a matter of moment than of medium. This book refers to a ten-year period from 2014 until at least 2023 as a *monument boom*, a riff on the term "memory boom" in the field of memorial studies that describes a heightened period of memorial building in the closing decades of the twentieth century.[9] The monument boom that this book understands to have begun in 2014 consists of projects that answer to enough of the terms of traditional monuments to be recognized as such in their own right, whether they embody the conventional formal terms (solid, large, public) or adumbrate them through intervention (large but permeable, solid but temporary, widely available online but ticketed and private in person, and so on).

Within this new monument boom, *Monumental* focuses on a specific subset of projects that are densely illustrative of both the form and its potential for intervention. The contemporary examples selected for this study—by Kara Walker, Mark Bradford, Kehinde Wiley, and Lauren Halsey—take as a central narrative consideration what literary scholar Saidiya Hartman calls the "afterlife of slavery,"[10] the "skewed life chances, limited access to health and education, premature death, incarceration, and impoverishment" that have unfolded as a consequence of Atlantic slavery. That monuments examining the histories of Black life in the United States are some of the most potent examples to be found in this new monument boom is in part a consequence of the close historical relationship between monuments and the elaboration of white-dominant culture. But these forms also respond to calls in the late nineteenth and early twentieth centuries by African American activists and political leaders to build monuments as part of a larger project of giving material form to African American

pasts, presents, and futures. Throughout Reconstruction, notices went out in African American newspapers announcing efforts to raise funds to build monuments to, among others, the Reverend Christopher Rush, a key figure in the establishment of the African Methodist Episcopal Church, John Brown the abolitionist, and Abraham Lincoln, in both Washington, DC, and Springfield, Illinois.[11] This work of public commemoration was understood as crucial to the remaking of the United States into a country in which African Americans could equally partake of national values, and such work gained even more urgency as the Lost Cause narrative of the Confederacy gained ascendancy as the twentieth century dawned.[12]

Monuments in this book that center women or ground interventions in feminist-inspired praxis also respond to a long-standing elision of the role of African American women in narratives of turn-of-the-century memorial work. For example, at the same time that a bill was being circulated in Congress to fund the construction of "a monument in memory of the faithful colored mammies of the south" that was to be built by the United Daughters of the Confederacy,[13] the National Association of Colored Women (NACW) were raising funds to purchase Frederic Douglass's home, Cedar Hill, and turn it into a museum akin to that for George Washington's home, Mount Vernon. The historian Joan Marie Johnson describes the NACW's efforts around Cedar Hill in relationship to the contemporaneous effort in Congress as dueling efforts by Black and white women to "legitimize collective memorials" through monumental memorialization.[14] In the case of the 1876 Lincoln memorial in Washington—which came to be known as the Freedmen's Memorial to Lincoln—an African American woman named Charlotte Scott is often referenced as having given the first five dollars to what would become a $20,000 initiative as a way of implying the central role of African American women in bringing that monument to fruition.[15] But in other narratives of memorializing efforts during and after Reconstruction, as the historian Alexandria Russell has observed, scholarship that focuses on the elaboration of the Lost Cause narrative among whites, and on collective memory in African American culture, has routinely obscured Black women's stories and labor.[16] The representational conditions of this new monument boom, including but not limited to the elucidation of Black women's historical labor or recentering of Black women's subjectivity, have become possible only as a result of the emergence

of the cultural conditions that have given rise to contemporaneous movements like Black Lives Matter and calls to begin removing monuments to figures who upheld white supremacy.

While the narratives put forth by the monuments in this book primarily take up Atlantic history and the afterlives of slavery, the strategies used to tell those stories often also stem from queer experience and frameworks. This generation of monuments uses minoritized strategies alongside traditionally monumental ones to expose the ideological investments behind systems of valuation, and takes those machinations as their very subject. They also offer more than a single story, exchanging the monotonal, often monocultural narratives of traditional monoliths for those that explicate how the ongoing survival of a particular culture or nation-state is often conditioned on the ongoing process of defining and minoritizing certain categories of people. The formal traits of traditional monuments—their impermeability, centrality, and large-looming scale—have played an important role not only in demonstrating the impassable nature of the boundaries between the normative subject and the cultural other but also in challenging the idea that dominant narratives of the past will endure into eternity. The monuments studied in this book, by contrast, take what literary scholar Kevin Quashie calls a "dynamic" approach to temporality, "toggling between then (past), now (present), and what may come"[17] to interrogate the strategies with which traditional monuments enforce a vision for the future that is predetermined by the values of the past as espoused by those in power in the present. Using a broad range of materials, some dense and enduring and others not, these monuments—like the moments from which they spring, the histories toward which they gesture, and the subjects whose positionalities they query—disrupt the conventional relationship between the traditionally monumental form and the passage of time by proposing that the conditions of the future, just like narratives of the past, are far from settled.

Just as they perform the rather traditionally monumental conceptual labor of surfacing narratives of the past and their impacts on the present, this new generation of monuments also refuses to offer a reparative narrative for the future. *A Subtlety* offers no salve, no vision for a different world, no suggestion that this monument or any other can bring about an end to gendered racism.[18] From the minoritized perspectives from which these artists are working, any vision of a future has to hold space for what the literary

scholar Christina Sharpe calls the "past that is not yet past" to both "carry forward" the truths and traumas of the nightmare of Atlantic slavery and its afterlives, and describe what the theorist José Esteban Muñoz calls the "not yet here" of a different future, a way of using the past and the future to "combat the devastating logic of the world of the here and now."[19] These new monumental forms, in other words, make mending and tending the past and the future a central part of their work, demonstrating even within the small set taken up in this book a vast array of ways to disrupt the conventional relationship between monuments and time and envisage a new monumental future.

The monuments studied in *Monumental* are neither an exhaustive list of these new forms, nor an argument for the existence of something fundamental or specific to Blackness, queerness, or monuments. Rather, they illustrate a tendency in which a new generation of artists working in the monumental genre mobilizes representational strategies informed by the experience of minoritization to find ways of interrogating both the operations of power and some of its most recognizable aesthetic manifestations. Investigating, as this book seeks to, the sociohistorical conditions of the shifting aesthetics and utilities of monuments demands moving beyond dialectical thinking—between monuments and interventions, presence and absence, dominance and subjugation—to more diffuse or ephemeral ways of being, living, seeing, and resisting. It also requires an understanding that all monuments are subject to constraints that delimit even the most nuanced and complex examples of the form. It is the work of retraining the eye to see those constraints, and the possibilities that persist within or in spite of them, that this book takes up.

### A Prehistory of New Monuments

Monuments are fundamentally neutral surfaces that only gain meaning as a condition of the cultural significance with which they are freighted. Though historically associated with domination, monuments are yoked to such projects only by cultural habit. The extensive literature on monuments often reaches to the Latin root *moneō*—to remind, and to warn—thus situating the organizing principle of the category not in form but in function. Scholars have also repeatedly noted that the role of monuments in modernity

has often been to offer a coherent narrative around which individuals in a society who share a similar set of traits or values can coalesce. Historical monuments, therefore, "seldom showcase hard historical truths, but rather crystalize myth or political morality tales *staged* as the past," as the art historian Mechtild Widrich has observed.[20] Often, that past is told from a single perspective put forth as an authoritative and objective version of history told in a digestible way that positions that past as predicate for a similar future.[21] By accompanying the rise and continued dominance of groups with the means to build them, monuments also tend to index by elision the violent suppression of cultural others, who become defined by what cultural theorist Fred Moten calls "a vast range of brutal qualifications."[22] The ready availability of the monumental form to projects that benefit from such elisions, coupled with the conceptual implications of their material permanence, is what makes monuments such an appealing vehicle for ideological projects. Those same qualities are also, however, what makes conventional expressions of the form seem out of step with the prevailing cultural norms in the United States in the opening decades of the twenty-first century.[23]

The broad agreement on the cultural labor that traditional monuments perform starkly contrasts with the almost ludicrously heterogeneous range of forms that have been included in the category since ancient times. The Great Sphinx of Giza is carved from sandstone, longer than it is high, and figurative. Also figurative are statues of great men, but these are higher than they are long and are only counted as monuments when they are mounted on something to lift them off the ground. When that form is a simple plinth the object is often called a statue, but when ornamented (as in the case of Confederate Common Soldier monuments, discussed in chapter 1) or especially tall (such as the Washington Monument, discussed in chapter 2), or if the figure is astride a horse (in the equestrian tradition, discussed in chapter 3), the additional elements elevate the meaning of the form beyond the memorialization of a single figure and contribute to the recategorization of the object as a monument. Buildings can be monuments, too; some, like the Lincoln Memorial, also have monumentally scaled statues inside them, while others, like the home of Civil Rights activists Medgar and Merlie Evers, are national monuments, a designation that also includes areas of land of natural significance.

Since the late twentieth century, the variety of objects desig-
nated as belonging to the category of monuments has expanded
even further as numerous projects have sought to convey the cul-
tural significance of certain people or events. Objects ranging
from small obelisks and large buildings to temporary projects
and performance art have been called monuments; so too have
ephemeral projects that leave no visible trace, and which someone
passing by might not even know are there.[24] Another challenge to
understanding what the term denotes relates to the ways in which
these forms are named. One example is the routinized conflation
of objects that answer to the terms of the monument with those
more accurately described as memorials; though some memorials
are monuments, others are merely monumental. The category's
historical incoherence, coupled with postmodern and contempo-
rary interventions, has also spurred repeated efforts to revise the
meaning of the term itself, as in a 2021 effort by the prominent
organization Monument Lab, following an "audit" of the monu-
mental landscape in the United States, that defined monuments
as "statements of presence and power in public,"[25] a definition
so expansive as to invite an inquiry into whether the term even
remains useful. Put another way, the category has become so capa-
cious as to strain credulity in its ongoing utility. As such, one of the
projects of this book is to reconsider what purpose this category,
and the objects it purports to describe, serves in the unfolding
present. This book uses the distinction from the Latinate root,
where the memorial connects the present to the past as though
dragging it backward, while the monument describes a rela-
tionship between past and present that also engages with the
future[26]—even if, as in *A Subtlety*, its relationship to the future is
an ambivalent one.

   In addition to the expanding incoherence of objects orga-
nized under the term "monument," efforts to settle on a defini-
tion are also complicated by the fact that the category is reified in
part through the existence of challenges to it, as illustrated by the
steady drumbeat of topplings that punctuate the history of cul-
tures that have erected such structures. An early US example of this
is the legendary felling of an equestrian statue of King George III
in New York Harbor in 1776 that attended the establishment of the
United States as a nation-state. Depicted in a painting by Johannes
Adam Simon Oerteil (*Pulling Down the Statue of King George III, New
York City*, 1852–1853), ropes attached to a bronze equestrian statue

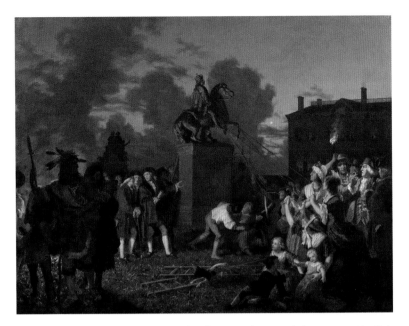

Figure 0.4  Johannes Adam Simon Oerteil, *Pulling Down the Statue of King George III*, *New York City*, 1852–1853. Oil on canvas. 32 × 41¼ in (81.3 × 104.8 cm). Gift of Samuel V. Hoffman. New-York Historical Society, 1925.6. Photo Credit: Glenn Castellano/New-York Historical Society.

on a stone plinth disappear into a mob on the right that is partially obscured by a group of torchlit onlookers. Opposite them on the left-hand side of the canvas, a group of politicians portrayed as white men are lit with the same theatrical and mysterious lighting as the onlooking crowd, while a few paces into the foreground, a small group meant to be read as a Native American family looks on apprehensively, their forms in conspicuous shadow. The tensions in the painting—between the monument and its impending fall, the land's Indigenous stewards and settler colonial rulers, the mob and the onlookers, all set in the visual and conceptual liminality of dusk—position toppling as a marker of change with an uncertain impact save for a reification of the power of the monument itself.

Nevertheless, toppling remains a culturally significant practice that operates alongside this monument boom, another tool that has played an important role in interrogating and reshaping the monumental landscape.[27] Yet despite the removal of markers to lives and histories that may no longer be part of the nation's dominant self-conception, the monumental landscape in the United States remains overwhelmingly white, male, and at best

ambivalent about racial equality and even emancipation. While a number of placenames and markers have been created to surface other lives and histories,[28] of the fifty historical figures most frequently represented by permanent monuments in the United States, half owned enslaved people, and all but 10 percent are white men.[29] At the same time, of the thousands of Confederate monuments and placenames throughout the United States, less than a quarter have been removed, even as calls to do so have grown louder and gained more political traction.[30] At the same time, there remain comparatively few traditional monuments to nonwhite and nonmale figures in US history, and even fewer to the Black and Indigenous individuals and cultures whose subjugation and extirpation attended the development of the United States into its current manifestation. US culture has only recently begun to seriously interrogate both the absence of critical histories from the monumental landscape and the mechanisms behind those absences. Recent changes in the US monumental landscape thus mark the beginning, rather than the end, of a shift in US cultural self-fashioning in public.

In the closing decades of the twentieth century, new forms began to emerge in Western culture that answered to some of the terms of the traditional monument while intervening in others. Scholars began to refer to traditional expressions of the form as "monuments," and to interventionist ones as "counter-" or "anti-monuments," a term translated from the German *Mahnmal* derived from the study of monumentally scaled projects in Germany toward the end of the twentieth century that sought to mark the Holocaust in ways that memorialized lives lost, while warning of the dangers of the monocultural and violent exclusions of fascism on which the Nazi regime turned. The novel monumental forms that answered to this term were described as "monuments, proposed or built, that differ from traditional commemorative works in at least one of the following five respects: subject, form, site, visitor experience and meaning";[31] were "representative but not conspicuously monumental";[32] and were meant "to admonish or warn people on the present,"[33] "jar viewers from complacency," and "challenge the very premise of the monument; to be ephemeral rather than permanent, to deconstruct rather than displace memory, to be antiredemptive."[34] In this book, the term *antimonument* refers specifically to German projects intended both to remind and to evidence a collective acknowledgment of the violent histories at

the center of their cultural self-understanding, and to telegraph a belief that learning about those histories is central to preventing their repetition.

An important and early example in the antimonumental tradition is Horst Hoheisel's 1985 *Aschrottbrunnen*, an inverted fountain in Kassel on the site of a historic fountain commissioned in 1909 by Jewish entrepreneur Sigmund Aschrott, then destroyed in 1939 by Nazi sympathizers. Hoheisel built a slightly less detailed reconstruction of the fountain that was installed, inverted, on the footprint of the original so that it descends below grade, while water, fed from channels in a street-level footprint, runs down what was previously up. *Aschrottbrunnen* gives the fountain life again, while performatively preventing the traditional affective experience of visiting or viewing a fountain, a formal decision that has the narrative effect of enunciating the impossibility of returning to a world before National Socialism or undoing the consequences of a genocide that manifests as exponentially compounding gaps exposed in its wake.

*Aschrottbrunnen* is premised in many ways on a clean dialectic between the traditional terms of the monumental and an inversion thereof, taking the elements of a historical form and making meaning by literally turning them upside down. Where the

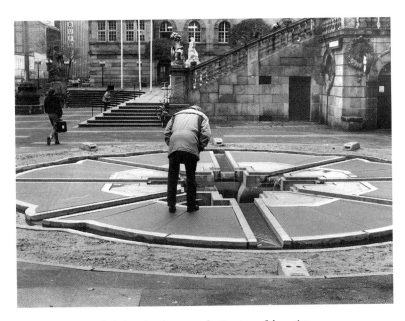

Figure 0.5  Horst Hoheisel, *Aschrottbrunnen*, 1985. Courtesy of the artist.

*Monuments and Memory*

historical fountain is no longer, Hoheisel revives it; where it stood up from the street, his goes down; where the original was visible, his no longer is; where water ran down the form, it now runs up it. In the decades since antimonuments such as *Aschrottbrunnen* emerged, these and other representational strategies that invert the key conventions of traditional monumentality were elaborated to take on a greater degree of variation and specificity. The *Denkmal für die Ermordeten Juden Europas* (Memorial to the Murdered Jews of Europe), designed by Peter Eisenman and completed in 2004, is an example of such an approach. Stretching over the entirety of a city block in the heart of Berlin, the *Denkmal für die Ermordeten Juden Europas* is comprised of a field of nearly 3,000 rectangular stelae, rendered in concrete of differing heights and laid out in a grid pattern. Located a block south of Brandenburger Tor, symbolic site of a series of victories throughout German history, the footprint of the *Denkmal für die Ermordeten Juden Europas* dips gradually below grade in undulating waves, a physical depression with moral and historical implications. As one wades into the field, the stelae loom ever larger and the noise of the city falls away, replaced by echoes of footsteps or voices. From street level or above, the *Denkmal* recalls a graveyard in its gray, gridded rows and undulating surface, but the similarity and density of the stelae refuse total assimilation into

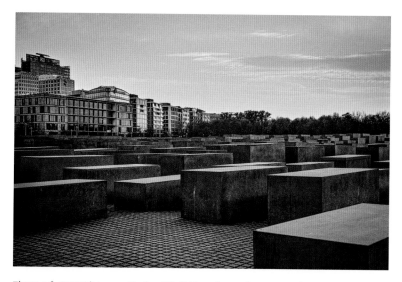

Figure 0.6   Peter Eisenman, *Denkmal für die Ermordeten Juden Europas*. Photo: Mark Priske. Copyright Stiftung Denkmal.

*Introduction*

that referent, recalling neat lines of bodies rather than the indentations of graves in a gesture to, among other things, the appalling conditions in which Jews were forced to live and die under National Socialism. In the field, if one is attuned to these histories, it is not simply the weight of loss, but also a material absence in the present, that produces the force and effect of this form.

The *Denkmal für die Ermordeten Juden Europas* was a nationally sanctioned project meant to demonstrate a collective belief that memory is not just the foremost bulwark against the repetition of violence, but also a way of sustaining narratives that are central to the self-image of that nation-state. In the United States there is no consensus that there is a defining violence or trauma in the nation's past and therefore no national monument that takes a comparably antimonumental approach to those in Germany. The closest the United States has come to such an understanding and its monumental representation is Maya Lin's 1982 Vietnam Veterans Memorial. For what is, in effect, a war memorial, Lin looked past the traditional forms used to commemorate a war—the obelisk, for example, or an equestrian statue mounted on a plinth—to a more sepulchral tradition, using large slabs of granite that recall gravestones to draw a line in the earth. Instead of giving differing treatment to lives lost based on rank, the names of the dead are ordered according to date of death, and in lieu of a more traditional monumental stone that is light in color and matte in finish Lin chose an almost black granite polished to a mirror finish to reflect the faces of visitors. The Vietnam Veterans Memorial engages the events to which it refers without the coherence or resolution of later monumental interventions in the United States (or earlier antimonumental gestures in Europe)[35] in part because it is, ultimately, a national monument in a nation without a narrative of collective guilt and redress at its core. Nevertheless, Lin's specific interventions into the conventions of national memory—so often crafted through the monumental memorialization of war— bespeak a profound ambivalence about the war itself. In opening onto a series of questions about the relationship between national identity, wars waged, and lives lost, and doing so for generations of visitors to come in a manner afforded by no other national monument, the Vietnam Veterans Memorial constitutes an early term in the monumental turn that would crystallize three decades later.

To fully grasp the genealogies that connect the precedents of traditional monuments and twentieth-century interventions like

the Vietnam Veterans Memorial and the German antimonumental tradition to more contemporary interventions, this book eschews the terminological distinctions that are often mobilized in the service of articulating a taxonomy for the genre. An *anti*monument is still a monument in the same way that toppling a monument is first and foremost a recognition of the power of the form. Rather than parsing where or whether a line should be drawn among media or periods or bodies, my interest lies in when and why these forms are made, where and under what circumstances such lines are drawn, and what the historical emergence of such distinctions can tell us about how we order the world. To this end, also included in this study are a number of other forms that are in conversation with the representational strategies of the monumental, but which do not answer to the terms of the monument. Including such forms—such as a series of photos by the artist Adrian Piper, discussed in chapter 1, and an African American quilting tradition in chapter 2—is integral to understanding the aesthetic origins of our contemporary monumental moment.

The inquiries into form, narrative, and their coincidence that are at the heart of this project also open onto other inquiries into what the erosion of the traditional relationship between monuments and projects of domination might expose or make possible. One regards what it means both to be minoritized and to have access to the means of monumental production. Another relates to the enduring appeal of the monumental form among the various ways to mark space or place in the contemporary, often urban, built environment. Yet another is why, in the current boom, the monumental form is perhaps most often taken up or deployed by artists using Black and queer strategies to interrogate the ways in which Black and Atlantic histories have been told or left untold. While this project opens onto, rather than answers, these questions, it understands their emergence to suggest that monumental projects require interpretative frameworks beyond those that have traditionally been used to examine them. In the next section, I give an example of what those analytics are, and how they are applied in the rest of the book.

### Black and Queer Strategies for New Monumental Forms

The monumental interventions explored in this book operate to a significant degree through representational strategies that derive

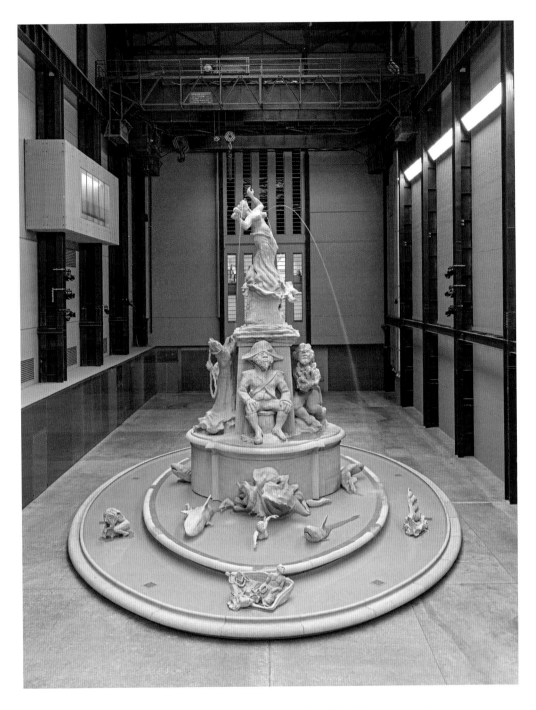

Figure 0.7 Kara Walker, *Fons Americanus*, 2019. Nontoxic acrylic and cement composite, recyclable cork, wood, and metal. Main: 73½ × 50 × 43 ft (22.4 × 15.2 × 13.2 m). Installation view: Hyundai Commission: Kara Walker—Fons Americanus, Tate Modern, London, UK, 2019. Photo: Tate (Matt Greenwood). Artwork © Kara Walker, courtesy of Sikkema Jenkins & Co. and Sprüth Magers.

from Black and queer ways of being, making, and seeing. One of the finest examples of this is Kara Walker's second monumental project.

Five years after *A Subtlety*, Walker unveiled her second monument: a forty-two-foot-high sculptural fountain titled *Fons Americanus*. Like *A Subtlety*, *Fons Americanus* was first installed in a cavernous space, a temporary installation venue called Turbine Hall in the Tate Modern in London, which is housed in a former power station. The fountain itself consists of a plinth rising up from the center of two concentric pools in which boats sail or sink while sharks chase desperate-looking swimmers. The plinth is ringed by four figures, three of them human caricatures, the fourth a tree with a noose hanging from one of its mottled branches. Atop the plinth, crowning the fountain, is a figure meant to be read as female, as evidenced by bare breasts and long hair. Head back and arms akimbo, water spouts forth from her nipples and a gash in her neck, arcing down into the pools below. On an adjacent wall, a massive gray banner announces the work's elaborate title and identifies the figure as the Daughter of Waters. As with the Attendants in *A Subtlety*, *Fons Americanus* also has a satellite piece, a five-foot-high sculptural shell that balances on its umbo, recalling a less upright version of the shell in Botticelli's famous *Birth of Venus* (1485–1486) and, as the curator Clara Kim has noted, illustrations of the Sable Venus.[36] In Walker's reworking, however, the shell cradles not a subject meant to be read as female, but a life-sized head of a short-haired figure with wide eyes, an open mouth, and tears gently rolling down its face.

Part of what makes *Fons Americanus* effective is how it adheres to monumental conventions. Walker modeled the work on a traditional monument—the *Victoria Memorial*, a sculptural fountain to Queen Victoria erected in 1911 outside Buckingham Palace[37]—and retains from that referent both a tripartite structure and the use of auxiliary figures placed some distance away to create a processional space. Also consistent across the two are the assignation of figure types: on the first level, pools of water allegorizing oceans or seas are accompanied by representations of figures on the water; on the second, three of the figures are cultural allegories, while the fourth is historical; and atop both forms, another allegorical figure refers to a concept that transcends earthly culture and gestures toward the transcendental. Though indoors in a museum, it was free to see, and though a temporary installation, it still exists, and is also widely available to viewing publics in digitized perpetuity online.

Figure 0.8   Kara Walker, *Fons Americanus*, 2019. Nontoxic acrylic and cement composite, recyclable cork, wood, and metal. Main: 73½ × 50 × 43 ft (22.4 × 15.2 × 13.2 m). Installation view: Hyundai Commission: Kara Walker—Fons Americanus, Tate Modern, London, UK, 2019. Photo: Tate (Matt Greenwood). Artwork © Kara Walker, courtesy of Sikkema Jenkins & Co. and Sprüth Magers.

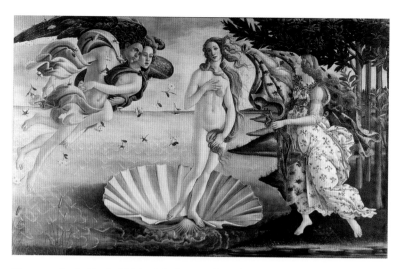

Figure 0.9   Sandro Botticelli, *The Birth of Venus*, 1484–1486.

*Fons Americanus* is also effective, however, because of the ways in which it departs from the monumental tradition. Rather than marble and gilded bronze, Walker used a jesmonite surface scaffolded by cork, metal, and wood, rendering her monument nontoxic, recyclable, and permanent as a condition of its materiality despite its eschewal of traditionally monumental materials. The water in the fountain is not the transparent and calm substance found in other fountains that stage oceans as neutral (if periodically unpredictable) surfaces to brave en route to distant lands. Instead, the waters are milky, gesturing toward amniotic fluid and breast milk and semen, and peopled with danger—a schooner has run aground, its survivors are beset by sharks—formal and narrative decisions made to telegraph natality and death in the very same breath. Above the waters, the allegorical figures around the plinth are given equal treatment, but unlike in the *Victoria Memorial* they are not all laudatory allegories. There is a queen, an enslaver, and a revolutionary modeled in part on Toussaint Louverture, who, as the figurehead of the Haitian Revolution, was of symbolic importance to abolitionist and civil rights struggles in the United States. The tree, which might be understood as the closest of the four to a historical figure, is not a person but a synecdoche for generations of people who either were lynched or were complacent in lynching. The figure of Venus atop the monument is not a winged victory taking flight into the heavens, akin to representations

of that figure found in the Western representational canon, but rather one who is giving life even as she herself is dying.[38] Whereas the leitmotif in the *Victoria Memorial* is robustly nautical, the leitmotif of *Fons Americanus* is the Western art historical canon, which has long obscured its indebtedness to non-European influences. *Fons Americanus* not only reinscribes those connections at several turns, but also does so in a structure whose finish is deliberately crude, as though the production of history is arrested and ossified in its incomplete retelling.

Each of the ways in which *Fons Americanus* departs from the monumental tradition enables the work to gesture toward the human costs of imperial hunger for expansion. They also facilitate the fountain's explication of how the cultural values that enable imperial projects are manifested in and upheld by a specific monument that is particularly central to a nation's physical and ideological core. But rather than simply seeking the obverse term—a soft monument rather than a hard one, something ephemeral rather than permanent—Walker selects interventions facilitated by representational strategies that derive from Black and queer ways of being, making, and looking to gesture to a set of practices and histories that contribute to but exceed those represented by its particular referent.

There are, importantly, different and distinct stories to be told about Black and queer histories, and their regular coincidence in lives, methods, and political solidarities, which have routinely been obscured by racism and homophobia. Those historical elisions and their repair alike have been investigated and explicated by scholars and activists who work at the intersection of the two, as in the example of a defining 1997 essay by Cathy J. Cohen which describes the possibilities and limits of queer politics. After recounting the systemic racism in a predominantly white gay activist organization,[39] Cohen observes that, while the simple fact of minoritization does not inherently preclude minoritized subjects from reproducing oppressive structures, the confluence of Black and queer, and their intersections with strategies derived from other forms of minoritization, affords a set of conditions under which it becomes possible to "work toward the destabilization and remaking of our identities."[40] In the works explored in this book, artists contribute to this project by interrogating the exclusion of Black and queer histories from the monumental landscape, using Black and queer representational strategies to destabilize the standing

conventions of the monumental form, and exploring whether and to what degree it is even possible effectuate a break from xenophobic pasts and presents, monumental or otherwise.

*Fons Americanus* explores the possibilities and limits of interventions derived from Black and queer strategies. Take, for example, Walker's deployment of caricature in the three allegorical figures who ring the central pylon. Not only is the ratio of historical to allegorical figures reversed from the historical referent—*Fons Americanus* has three historical figures to the *Victoria Memorial*'s one—but the group is also not consistent in the framing of the figures' ideological investments. While all are caricatured, the queen and an enslaver are made to look grotesque, while the figure meant to stand in for the revolutionary, though caricatured, is not made the worse for it, but is instead dignified and contemplative. Though a potent and formative element of the aesthetics of anti-Black racism, caricature is mobilized by Walker as a form of camp, which Bryan Stephens describes as "a queer-derived cultural practice that inflates identity to expose the constructed nature of gender" that is often deployed "to create immutable categories of racial distinction" to serve white-dominant ends.[41] A queer strategy with the capacity to undermine both gendered and racist tropes, camp allows Walker in *Fons Americanus* to lampoon not just the earnestness and moral clarity to which traditional monuments often pretend, but also the aesthetics of racist caricature routinely used to bolster claims to dominion made by the cultures that most often erect monuments. Walker's use of camp to undermine structural racism and its manifestations in visual culture includes the squat and nonrealist tree, which implicates individuals and institutions alike in lynching and other forms of racialized violence, while marking out the absence of those lives lost to that very particular violence and its legacies.

A queer and antiracist camp aesthetics also extends to the armature of the monument, which, instead of being hewn from materials that suggest impermeability and permanence, is a hollow shell. This formal decision has critical implications for the conventions of the traditional monument, exposing the relationship between material and conceptual weight to be a result of habituation rather than of inherence and, in so doing, disrupting the implications of ideological permanence with which that form is often freighted. Moreover, *Fons Americanus* was first made by Walker as a hand-built clay model that was later fabricated at

scale, with nothing refined out of its surface, and so the artist's fingerprints appear, magnified, on the surface of the work. The body of the artist, then, is present in the surface of the work not only by conceptual implication but also through an intimate and unique material signifier.[42] *Fons Americanus* thus literalizes Stephens's definition of camp: it is a project inflated to the scale of a traditional monument that lays bare the arbitrariness of the connection between scale and significance.

By underscoring the multiple formal routes through which a single conceptual effect can be charted, Walker intervenes in the traditionally monumental by challenging the idea that the monument is the exclusive purview of dominion, and offers just a few examples of how nonmonumental formal approaches can not only achieve monumentality, but also be freighted with relative multiplicity. Walker's strategy here rhymes with what Moten calls "consent not to be a single being," an acknowledgment of the multiplicity of Black subjectivity that turns in part on an allowance for opacity, which "simultaneously resists and reveals assimilation into the fatally political mechanism that requires and allows [one] to see [oneself]."[43] As a monument that realizes monumentality with the bare minimum of monumental conventions and a plethora of monumental subversions, *Fons Americanus* is an example both of how contemporary monuments reveal what is denied within traditional monuments, and of how that form can be deployed in the service of that which has been excluded from it by refusing to offer the clear, linear, monotonal stories that are so easily conveyed through historical expressions of the form. At the juncture of Black and queer strategies, these forms resist reabsorption by sustaining a tension that arises from refusing the condition of being either overdetermined or violently erased.

*Fons Americanus* also leverages Black and queer strategies to destabilize traditional monumentality in its approach to the past, and its relationship between past and future. By giving form to vignettes of the Black Atlantic that are hard to see or lost to history, Walker engages in speculative practices that facilitate the exposition of what Hartman calls Black "performance and quotidian practice" taken up to "establish the vision of *what might be*, even if unrealizable within the prevailing terms of order."[44] This act of restitution, which often turns on a minimum of archival material, stages a relationship to history that processes both the

white-dominant culture in which the Black subject is overdetermined by the variegated structures manufactured to support and perpetuate racism, and the recovery of subjecthood from archives that do not record Black life except as a trace of racial capital.

The location of queer histories in the archive also calls for a nonnormative approach. As I detail in chapter 2, minoritized strategies move off nonnormative ways of, among other practices, reading into the archive to find often coded evidence of lives lived under the conditions of racism, misogyny, homophobia. By reinscribing narratives only barely able to be glimpsed in archives while describing how the confluences of power, erasure, and representation have been mapped through monumental and art historical practices, Walker—and the other artists whose monuments are studied in this book—explicate the deep imbrication of minoritized histories and narratives of domination, even or perhaps especially when rendered utterly invisible, as is the case in traditional monuments. In the process of making those pasts visible, the monuments studied in this book also explore what the future might look like for a culture shaped by the values that form the monument. Envisaging a future that is tethered to a monumental present is a conventionally monumental practice, but such practices are not consistently present in Black, queer, and otherwise minoritized monumental projects. This can in part be attributed to the fact that, as cultural theorist Kara Keeling has observed, in conventional theorizations of history and time, "a queer/Black future looks like no future at all."[45] Contemporary monuments endeavor to call such a future into being through the rather conventional representational conceit of monument building. But rather than making the future contingent on the sustenance of the conditions of the present, these forms position the reinscription of violent and violently erased pasts as crucial to the fabrication of a different future, and mobilize material impasses as a strategy through which to exceed the regulatory logics of colonial and monocultural time under which they cannot exist.

The above is neither an exhaustive study of *Fons Americanus* nor a complete list of the kinds of representational strategies found in this text. Rather, it is a sample of some of the queer/Black strategies that will be found in this book that also demonstrate some of the ways in which this new generation of monuments refuse certain narratives of history as a predicate for the future, and expose

monuments and all they have stood for as both radically subjective and subject to rupture.

## Monumental

The scholarly investigation of monuments since modernity has primarily been the purview of art history and, in more recent decades, of memory studies, fields that leverage close reading and historical research and which have evolved a robust literature on monuments as both formal and cultural objects. *Monumental* contributes to this conversation by describing the tendencies of a subset of monuments that emerged during a ten-year period from 2014 to 2023 and which make an interrogation of the terms of monumentality and the elucidation of minoritized experience their central focus. These recent monuments are often spoken about in relation to the Black Lives Matter movement—begun by Alicia Garza, Patrisse Cullors, and Opal Tometi in July 2013, a year before *A Subtlety* was installed—and to the reemergence of long-standing calls to remove Confederate monuments, the most recent manifestation of which is generally traced to an effort begun in South Africa in 2015 to remove a statue to prolific colonist Cecil Rhodes, just nine months after *A Subtlety* was deinstalled. These distinct but related phenomena have collectively reinvigorated discussions both within and beyond the academy about both the form and the function of monuments in the United States, but they are coincident with rather than causal to works including and akin to those studied here. Rather than effectuating a break with the monumental tradition, this book suggests that these forms are resolutely within it, evidencing a shift in rather than break from the *longue durée* of the monumental form.

In addition to describing the formal and narrative terms that constitute this new generation, *Monumental* also demonstrates that the representational innovations that distinguish these monuments from what has come before stem not only from their attention to minoritized histories previously almost entirely absent from the monumental landscape—though this alone is novel—but also from their deployment of strategies derived from those minoritized experiences. Moving approximately chronologically from the early 1970s when many of the representational strategies used in these new monuments began to take hold, *Monumental*

focuses on key moments in the elaboration of those strategies into the present.

Across four chapters, *Monumental* recovers specific representational traditions previously not considered in the conversation about monuments to tell a story about where this new generation comes from. The objects and traditions that this book understands to be vital to the current monument boom include the quilts of Gee's Bend and the Freedom Quilting Bee, which grew out of a centuries-old African American quilting tradition and emerged to great publicity and acclaim in the late sixties, yet are never considered as a precedent for the AIDS quilt. This book also understands the early photography of Adrian Piper, widely understood as one of the most important artists of the late twentieth century and early twenty-first, as a bridge from traditional monuments to interventionist ones. In both cases, these practices have often been excluded from the study of monuments because they themselves do not take that form, severed from monumental history because of disciplinary habits of sorting fine art by medium, separating high art from craft, and other mechanisms for ordering objects and bodies into categories to serve often hierarchical ends. *Monumental* restores these objects to their historical context to elucidate their discursive entanglements with more familiar and famously monumental forms including Confederate monuments, the Washington Monument, and two separate memorials to Queen Victoria, to reveal a complex network of interdependencies that have led to this moment.

Given the centrality of nonmonumental strategies to these recent monumental forms, this book begins not with monuments at all, but with an examination of the origins of representational strategies from both within and beyond the monumental tradition that laid the groundwork for these recent monumental shifts. In the first chapter, I examine a series of objects across which echoes a key representational throughline related to race, representation, and the monumental body. At the beginning of the twentieth century, one of the most frequently made monuments was the Common Soldier, a simple form made to represent the Civil War soldier that also naturalized whiteness, masculinity, and militarism as the conditions of the common or universal subject. These were often installed on courthouse lawns, which were at the time a preferred location for white mobs to lynch African Americans. Common Soldier monuments still stand, haunted in perpetuity by the specter

of lynching, the visual culture of which also persists in circum-scribing representations of the Black body. A powerful rejoinder to this regime can be found in *Food for the Spirit*, a 1971 photo series by Adrian Piper of herself in varying states of undress. I argue that, in materializing a ghostly echo of the visual culture of lynch-ing, *Food for the Spirit* not only privatizes the public gesture of the purportedly common display of the individual subject's body—something not common at all but indeed reserved in the mon-umental tradition for white male subjects—but also refuses the objectification and subjugation that routinely attends the display of Black women's bodies. By operationalizing the contingent and ambivalent ways in which the categories of race and gender come to gain social meaning and structure subjectivity and perception, *Food for the Spirit* lays a representational foundation for this new generation of monuments to intervene in the historical conven-tions of the monumental form.

*Food for the Spirit* is a particularly rich example of the kinds of representational strategies that emerged on the heels of the social upheavals of the 1960s and early 1970s. Whether directly or indi-rectly, many artists at the time were engaged in civil rights, femi-nist, labor, and antiwar organizing. At the same time, many were also reacting to the failure of those protest-based movements to realize their full promise, and turned to art that used the body as a medium to communicate with newly politically engaged audi-ences. When the AIDS crisis hit a decade later, artists would again inflect their aesthetics with activist practices, leveraging the quo-tidian materials of lives lost to AIDS as the basis for a monument to those lives and that loss. Chapter 2 studies the coincidence of those strategies with the NAMES Project AIDS Memorial Quilt, a monument begun in 1987 as that crisis was still unfolding. The AIDS Quilt was an important early challenge to the long-standing association between war dead, national identity, and monuments. To memorialize a minoritized population, it drew for its aesthetic and material interventions on a quilting tradition developed by African American women dating back to the early nineteenth century, and mobilized queer and feminist traditions of a decen-tered structure and self-selecting membership to scaffold both its terms of inclusion and its layout. These multivalent genealogies contribute to the Quilt's novel status as a monument that is also an archive: participatory, materially heterogeneous, insistently flat, and nearly infinitely expansive.

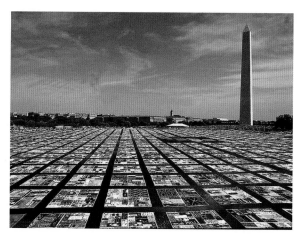

Figure 0.10  AIDS Memorial Quilt on display at the National Mall in Washington, DC, 1996.

The last chapters closely study a group of vanguard monuments to trace the elaboration of a set of representational strategies that have become hallmarks of the genre since the emergence of *A Subtlety*, including ephemeral materials, contingent publicness, references to the African classical tradition, and impermanence. In chapter 3, I study these strategies as a precedent for two monuments revealed within days of each other in 2019: Walker's second monument *Fons Americanus*, and Kehinde Wiley's equestrian monument *Rumors of War*. While both explore themes related to Black life and death in the Atlantic world, a close side-by-side reading reveals distinct representational strategies: while Walker's partakes of both Black and queer strategies, Wiley's emphasizes the Black to the exclusion of the queer, its singular focus on describing the terms of Black life through death leaving no room for ambivalence.

Where chapter 3 focuses on an examination of the differential application of Black and queer strategies in recent monuments, chapter 4 compares two divergent applications of Black and queer representational strategies as a mediation on the role of monuments themselves: Mark Bradford's *Tomorrow Is Another Day* (2017), a ruination of the American Pavilion in Venice, and Lauren Halsey's *the eastside of south central los angeles hieroglyph prototype architecture (I)* (2023), installed at the Metropolitan Museum of Art's Roof Garden. Though both works are monumental buildings surrounded by monumental space, Bradford and Halsey deploy similar strategies

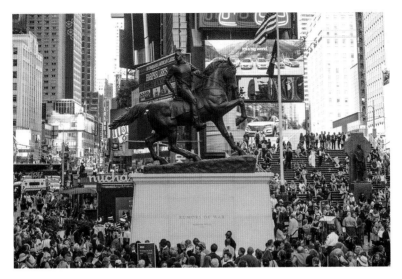

Figure 0.11   Kehinde Wiley, *Rumors of War*, 2019. Bronze on a limestone base. 328¾ × 306⁵⁄₁₆ × 189⅜ in. Presented by Times Square Arts in partnership with the Virginia Museum of Fine Art and Sean Kelly, New York. © Kehinde Wiley.

Figure 0.12   Mark Bradford, *Tomorrow Is Another Day*, 2017, installation view. Detail: *Barren*. Gravel. Dimensions variable. La Biennale di Venezia, US Pavilion, Venice, Italy, 2017. © Mark Bradford. Courtesy of the artist and Hauser & Wirth. Photo: Joshua White.

Figure 0.13   Special exhibition, *The Roof Garden Commission: Lauren Halsey*, Metropolitan Museum of Art, Lila Acheson Wallace Wing, Iris and B. Gerald Cantor Roof Garden, Gallery 926, April 18–October 22, 2023. View: north looking south. © The Metropolitan Museum of Art. Image source: Art Resource, NY.

to obverse ends. Bradford deconstructs, while Halsey builds anew; Bradford destabilizes a monumental past, while Halsey explores its reinstatement; and Bradford takes on an understanding of collectivity as based in shared national identity, while Halsey takes on a collective identification based on shared racial, linguistic, and geographic experience. Between these two formally similar works, the mechanics of contemporary monumental strategies, in both their interventions and limitations, become apparent.

These last two works demonstrate that this most recent manifestation of the form is highly circumscribed by the investments of the present. They also evidence that we are not truly in a moment in which it is possible to move beyond the monumental, a topic I examine in the epilogue by returning to a series of works that describe the limits of the genre, all that comprises it, and all it points to. Implicit in this project is an examination of why monuments, however temporary or ephemeral, continue to be built even as monuments from previous eras that represent ideas no longer in keeping with the values of the the present are taken down in a demonstration that most monuments do not withstand the test of time. As the philosopher Paul B. Preciado has suggested, "the first law of democratic gravity" is that "all statues fall down sooner or

later,"[46] but this set of objects indicates an ongoing need to continue building them. One reason the form persists in its utility, this book suggests, is that real efforts to redress the historical and present violences to which they point lag even further behind the process of aesthetically moving beyond the monumental form, if that is indeed what is happening in this current monument boom. What is clear, however, is that these monuments catalog the impossibility of repairing the past in the present, a monumentally scaled performance of what Hartman calls the "inadequacy of the redressive action."[47] In the interim, these monumental forms play a role in inching toward a different future; the adumbration of the traditional form is a pathway to articulating certain histories with an authority, publicness, and cultural circulation as yet unarticulated in other forms. These interventionist monuments are a first step toward a new relationship between collective identification and public representational strategies. They play into the politics of the present, offering a way of understanding the now as a generative, hopeful, or otherwise affectively satisfying moment, while trafficking in multiplicity, undecidability, and ambivalence to describe the limits of repair. These forms demonstrate, in the final analysis, that the project of building a future in which the subject is at once comprehensible and safe in their irreducibility is never so simple as a single monument.

1    *Materializing Absence*

In the summer of 1971, Adrian Piper made fourteen nearly identical black and white self-portraits in her New York City loft.[1] In each photograph in the series, titled *Food for the Spirit*, Piper stands alone in front of a mirror in a dimly lit space holding a Brownie automatic camera just below her sternum with both hands.[2] Her face inscrutable, Piper looks directly ahead, but the graininess of the photographs makes it impossible to discern whether she returns her own gaze in the mirror or is looking into the lens of the camera. There are only two significant variations across the series. In some images Piper is fully clothed, while in others she wears only underwear or is fully nude. And in some images the loft is illuminated enough that Piper is fully visible, while in others the low light makes it seem like the artist is dissolving into her otherwise murky surrounds, threatening to disappear before our very eyes.

The photographs of *Food for the Spirit* were originally presented in a ring binder in which the silver gelatin prints were interspersed between forty-four annotated pages of a copy of

Immanuel Kant's *Critique of Pure Reason*, which Piper was studying in relative isolation when she made the images.[3] As both a series of photographs and an intensely private work, *Food for the Spirit* is resolutely unmonumental by many of the standards laid out in the introduction of this book. But in both its representational strategies and the narratives with which it is freighted, it constitutes an important intermediary term in the aesthetic genealogy leading from the historical monumental tradition in the United States to the interventions studied in the subsequent chapters. The series is also densely illustrative of how the tendencies of the moment from which it emerged would be elaborated by subsequent generations of artists to undermine key promises of the traditionally monumental form.

This chapter explores the relationship between *Food for the Spirit*, the historical monumental tradition, and the interventions into that tradition that would transpire decades later. The first part of the chapter examines one specific type of frequently occurring historical form—the Common Soldier monument, sometimes referred to as "citizen soldiers" or "silent sentinels"—that offers a transparent example of the ideological work that monuments do. Traditionally comprised of a bronze statue mounted on a plinth or column, Common Soldier monuments proliferated across the United States in the decades following the Civil War. When the style emerged in the 1860s, as the art historian Kirk Savage notes, it was intended "to be universal in its reference, a generic representative of the rank and file." There are two different expressions of the Common Soldier, one Union, one Confederate, indicated by the way the figures are attired, "particularized in certain crucial respects"—namely, that the figure was intended to be read as white to naturalize whiteness as the common and universal trait of the citizen soldier.[4] In the South, from the 1890s on, the style was also part of cultural to efforts to recuperate the memory and values of the Confederacy after the defeat of Reconstruction, and to make the slaveholding and white nationalist values of the Confederacy seem as if they were universally held values of the citizenry, a particularly visible facet of the effort to extend white dominance over the realm in spite of the Emancipation Proclamation. Few elements of this tendency articulate those aims more transparently than the routine placement of Confederate Common Soldiers on courthouse lawns, which, during the same period, were favored locations for lynching.

A similar rhetorical claim to the one that undergirds the premise of the Common Soldier monument was present in the art world when Piper entered it. For the better part of the midcentury, the dominant form of art criticism was formalist modernism, in which objectivity was a precondition to the ability to pass judgment on art. The very concept of objectivity—which turns on an understanding that certain subjects are inherently able to pass impartial judgment, while others are not—was an inheritance of the work of Immanuel Kant, whose *Critique of Pure Reason*, or first *Critique*, Piper found to be the most "profound" book she had ever read.[5] *Food for the Spirit* is an early example of representational redress to the kinds of logics specifically designed to be impervious to the specificity of subjectivity, among them modernism, philosophy, and monuments—all of which were understood by white Western culture at the midcentury as their exclusive purview.

In the second part of the chapter, I show how Piper, in both *Food for the Spirit* and her philosophical writings, pushes back against the specious claims to universality for which the Common Soldier stands by challenging interpretations of Kant's work that are invested in objectivity and the exclusionary inheritances staked upon it. Though the body in *Food for the Spirit* is Piper's, I argue that that body in this series exceeds Piper's own subjectivity to stand in for the ways in which bodies legible as nonwhite and nonmale are routinely at once overdetermined and underrepresented on their own terms. As such, the subject in *Food for the Spirit* stands in for another kind of common subject, one extinguished in lynching but whose specter attends each courthouse Confederate Common Solder monument. In presenting a body that refuses to be white, lynched, invisible, or even consistently material, *Food for the Spirit* can be read as both a general statement of persistent and resilient Black subjectivity in spite of ongoing and violent efforts to extinguish Black life in the United States, and a specific reclamation and proclamation of Black women's subjectivity.

*Food for the Spirit* gestures toward the monumental—a genre from which the subject figured in it has been excluded—by playing into its obverse formal and narrative position: private not public, specific not general, legible as Black and female rather than white and male, and framed in an oscillatingly murky black and white. The paired representational strategies of subjective specificity and semantic mobility make it possible to understand *Food for the Spirit* as a rejoinder to the traditionally monumental and thus a

precursor to later interventions. The photographs privatize a series of otherwise very public, white-dominant and dominated visual languages, and thus constitute both a citation and a refusal of the terms of objectification and obliteration through terror, mutilation, and death for which the Common Soldier monument stands in. As such, this series offers a road map for later interventions by crafting not just a narrative rejoinder to the past, but also an alternative vision of it that materializes certain contingent legibilities that have historically been marginalized or violently erased. Piper's body, the resolution of the photographs, their initial placement in a binder, and their much-delayed release—Piper would not show this work for sixteen years—offer a path to redress through rupture that refuses the traditional terms of public display, and give undeniable form to the structural mechanisms of exclusion.

## Uncommon Bodies

The monumental landscape in the United States is a variegated space with a vast array of different forms freighted with a variety of narratives, many of which have resulted from efforts to bring communities together around an event or idea. A significant proportion of those ideas are consistent with white nationalist values; for example, of the nearly 6,000 Civil War monuments in the United States, over 2,000 are to the Confederacy.[6] Since the 1890s, the most prolific disseminator of such forms has been the Richmond-based United Daughters of the Confederacy (UDC), an organization established not in the immediate aftermath of the Civil War but thirty years later, following the defeat of Reconstruction, that "monumental effort to create a biracial democracy out of the wreckage of the rebellion," as the historian Henry Louis Gates Jr. describes it.[7] Reconstruction was marred by campaigns of terror and extrajudicial violence that reinscribed white domination beyond its juridical limits, and by inaction by individual white citizens to stand up for the rights and safety of Black citizens. Following the defeat of Reconstruction, cases like *Plessy v. Ferguson* (1896), which sanctioned segregation, and *Williams v. Mississippi* (1898) and *Giles v. Harris* (1903), which upheld laws that made it harder for African American citizens to exercise the franchise, were joined by state-level efforts to reinstitutionalize white dominance. These blows to the spirit and letter of Reconstruction went hand in hand

with the reinstallation of white supremacist legislatures and made clear the depth of entrenchment of the ideologies that had motivated the Confederacy.

The UDC's 1895 founding charter states that the organization's objective is to "collect and preserve the material for a truthful history of the war between the Confederate States and the United States of America."[8] What the UDC considers a "truthful narrative" is a fundamentally revisionist one known today as the Lost Cause, a combination of partial truths and outright lies that emerged after the end of the Civil War to celebrate the members, soldiers, and fact of the Confederacy in spite of its defeat. After Reconstruction, the Lost Cause became even more important to those who remained invested in Confederate ideologies. According to historian Adam Domby, the Lost Cause was "a crucial rhetorical tool" in Southern Democrats' turn-of-the-century efforts to "justify segregation, disenfranchisement, and racial discrimination"—in other words, to lay the groundwork and garner political support for the implementation and proliferation of white nationalist policies, including but not limited to the Jim Crow system.[9]

Monuments played a crucial role in shoring up the Lost Cause, lending that discourse credibility through the familiar tropes with which traditional expressions of the form are freighted. Perhaps the most important monumental quality in the Confederate context is the long-standing assumption that monuments, as a condition of being public, are also the product of the will of the general public or a majority of people. The reality, however, is more complicated. Monuments often come into being through what historians Harriet F. Senie and Sally Webster call a "complex matrix where personal ambitions as well as larger political and economic agendas often merge"[10] rather than through grassroots efforts, the result of the determined investments of a powerful few. Once a monument is up, however, its publicness and permanence lend the weight of the suggested collective will to its narrative.

Though fundamentally rooted in "fraud and fabrication,"[11] Confederate monuments lent monumental credibility to the Lost Cause. Though the coupling of the Lost Cause narrative with the cultural credibility of the monumental form elided to some degree the white supremacism that underwrote both, those investments were palpably in evidence when Confederate monuments were unveiled. Domby has shown that the "racial language" of white supremacy, which "explicitly celebrated the overturning of

Reconstruction," was found not only in speeches at the dedication of Confederate monuments, but also in other, contemporaneous events in the South, from addresses at university commencements to rallies for the Ku Klux Klan,[12] a group whose membership overlapped substantially with that of both local and state governments and the UDC.[13] That these were "victory monuments" celebrating the defeat of Reconstruction was also not a secret[14] and, as the historian Karen Cox has shown, the term "white supremacy" was explicitly used by those erecting these monuments both to celebrate the forms and to describe the ties that bound groups who came together to celebrate their installation.[15]

The emergence and proliferation of Confederate monuments as a condition of the defeat of Reconstruction has garnered more public attention as Confederate symbols across the United States have begun to come down.[16] Most of that attention has been paid to the largest or most municipally central monuments, or to the use of Confederate names and likenesses on college and university campuses. But a significant proportion of the Confederate monumental landscape is comprised of Common Soldier monuments, which have garnered less attention perhaps because, in standing for an everyman rather than a specific leader, they are less conspicuous. The conventional Common Soldier monument is modeled on a figure meant to be legible as phenotypically white and male, attired in standard-issue military uniform, holding a gun but not engaged in battle, rendered in bronze or stone, and usually mounted on a column or plinth. Some Common Soldier monuments are arrayed at their base with a pantheon of other figures, whether mythological or historical, but the representational core of the form is its suggestion that the figure atop it is a synecdoche for all who fought and died.

Though the genre "spoke eloquently, every day of every year, for the heroism of the ordinary white man defending the nation," according to Kirk Savage, the irreconcilably divergent values for which different deployments of the Common Soldier stood baked incoherence into the genre from its very inception.[17] Beginning shortly after the end of the Civil War, the Common Soldier monument was so popular in both the North and the South that the companies who produced them routinely sold statues from the same mold to both sides. The result of the commercial success of these forms on both sides of the divide resulted in an ideologically muddled political landscape,[18] thus contributing to the relative

discretion of Confederate deployments of the Common Soldier form and producing a condition of representational slippage that lends a patina of ideological continuity across battle lines.

Monuments are not explicitly mentioned in the UDC's founding charter, but they are the most visible product of the organization's labor. Beginning in 1891 the UDC funded and coordinated the installation of over 400 Confederate monuments not only in the South but in other areas of the country as well.[19] One of the first Common Soldiers was erected in Grayson County, Texas, following an eight-year-long effort. Dedicated to "our Confederate dead," it is comprised of several different monumental styles, including a tiered plinth topped by an obelisk, both of which are rusticated, with a single star carved into each side halfway up the obelisk and a small Common Soldier statue resting on top. Confederate monuments whose installation was lobbied and paid for by the UDC, like the one in Grayson County, proliferated in the public spaces of cities and towns throughout the South during the opening decades of the twentieth century.[20] Nearly half were installed on courthouse lawns,[21] underscoring not only that the common citizen whom the justice system served was a white male—even in the North—but also the ideological similitude between the kind of justice served within the courthouse and that served just outside its walls in the form of the racist vigilantism of lynchings.[22] Confederate Common Soldier monuments on courthouse lawns are thus a symbol not just of racist ideology, but of a belief that a very specific and especially horrific form of racialized violence in the United States constitutes the same kind of justice as is laid out in the letter of the law.

Though lynching was a long-standing practice of often racialized terror in the United States, it was solidified as a specifically anti-Black form of violent terror during Reconstruction and, by the time of that effort's defeat, was in brazenly widespread use. As the literary scholar Jacqueline Goldsby argues, by the end of the nineteenth century "there was nothing *extra*legal about the mob murders of African Americans," which Goldsby argues is the result of a series of Supreme Court rulings between 1873 and 1896 coupled with a failure to pursue lynching at the federal level or "criminalize lynching as murder . . . nullif[ied] African Americans' rights of citizenship and, with them, the affirmative duty to protect black people from unjust harm."[23] Lynch law derived substantial power from the public nature of the spectacle of terror

that both forms and is reproduced by that act. The legal scholar Sherrilyn Ifill has noted that even when carried out in less central spaces or in front of white mobs, victims of lynchings were routinely "dragged back to the black section of town to terrorize the black community."[24] Ifill also notes that lynching in the twentieth century was "most often an explicitly public act," carried out in broad daylight and regularly attended by hundreds or even thousands of onlookers.[25] Where lynching that took place under the cover of darkness or in an otherwise liminal space was of a piece with what Saidiya Hartman calls "spectacular violence," where the body of the victim both is and stands in for a spectacle of what is not visible, the public nature of twentieth-century lynchings resolutely positioned the practice as a form of "ordinary terror and habitual violence that structured everyday life and inhabited the most mundane and quotidian practices."[26] Lynching became so familiar as to be naturalized into the system of values of those who perpetuate and benefit from white dominance, an irrepressible potentiality that stalked all who understood themselves as subject to that violence—a bifurcation very much like the stereotypes that would structure Walker's *A Subtlety* a century later.

Lynching is about more than killing. Staging violence as an ineradicable condition of Black life in the United States, lynching was an important part of an ideological project of elaborating a narrative of white racial solidarity and security through a multipartite reign of terror against Black bodies. Lynching, according to the ethicist Ersula J. Ore, "functioned as a counterargument to the inclusion of blacks within the nation and at the same time as a violent performance of white citizenship and white nation making."[27] Put another way, never only the terrible act itself, lynching also offered a discursive strategy that reinforced white national identity, where the juridically termed and even, according to Goldsby, provisionally juridical practice of lynch law was crucial to rhetorically positioning whiteness as a predicate to citizenship, and Black bodies as a threat to the body of the nation-state.

The circulation of lynching photographs extended the reach of lynching beyond the space and time of its occurrence and, as Ore argues, "expanded the pro-lynching public beyond the immediacy of the lynching scene through its invitation to disidentify with the black victim and to identify with white onlookers."[28] One venue for the circulation of lynching imagery in the early twentieth century was the news media, which regularly published photographs or

illustrations alongside announcements of events. Lynching pho-
tographs were also coveted and traded among white individuals;
some were turned into postcards and sent through the mail, a prac-
tice that persisted in spite of a 1908 prohibition against sending
such images through the US mail that went largely unenforced.[29]
But such images circulated far less prolifically, Goldsby observes,
than "minstrel-themed chromolithographs and postcards" that
were "published in lots by the hundreds of thousands" and were
part of the machinery of normalizing and expanding racist carica-
ture.[30] Lynching imagery was moved more surreptitiously, and its
provisional and irregular presence in the public sphere, Goldsby
argues, mimicked and sustained a broader discourse around the
"terrorist tendencies that animate lynching," and underwrote less
ostentatiously anti-Black rhetoric, too.[31]

Though each individual act of lynching is temporally and geo-
graphically bounded, its effects extend well beyond those who
witness or are victimized by it in the form of generational trauma
and absences that reverberate in the present. These impacts are
exacerbated by the myriad image cultures that developed along-
side the elaboration of systemic racism. In the genre of lynching
photography, when an individual's genitalia had been mutilated
or removed by their murderers, the victim's midsection was often
partially covered by a sheet before being photographed to obscure
sexualized violence and other acts of torture that left evidence on
the body.[32] Such images sanctioned one kind of violence while
eliding the presence of another and, as Ore argues, "helped per-
petuate the image of the stately and respectable white citizenry"
defined against dehumanized Black bodies to "reinforce the
very discourse of white civility that legitimated lynching" in the
first place.[33]

That lynching was deeply imbricated with national identity
by the early twentieth century is also evidenced by its regular
staging on courthouse lawns. Though courthouses were often
adjacent to the jails from which African American citizens were
routinely dragged before being murdered, the significance of the
courthouse lawn goes beyond mere convenience. To display the
often-mutilated body of a lynching victim outside a courthouse,
Ifill notes, "sometimes for hours or days, was the means by which
whites let blacks and other whites know that white supremacy
would be protected in that jurisdiction at all costs."[34] The ideolog-
ical significance of the location is underscored by the fact that the

accused were also routinely brought to the courthouse lawn after being requisitioned from elsewhere in a community.[35]

By the early twentieth century, many courthouse lawns on which a person or people were lynched often already had Confederate Common Soldier monuments on them, their construction motivated by the same ideologies that presented lynching as imperative to an exclusively white *sensus communis*. Caddo Parish, Louisiana, is a case study in the temporal coincidence of, and ideological continuity between, Common Soldier monuments and lynching. In 1914, Ed Hamilton, an African American man who had been imprisoned, was dragged from his cell and lynched outside the courthouse. A contemporaneous piece in the *New York Times* noted that a mob of a thousand "men and boys" had spent what it described as "hours" to break through the walls of the jail to reach Mr. Hamilton, and his murderers left a knife sticking out of his hanged body, both signals of the impunity with which lynch law was administered.[36]

By the time of Mr. Hamilton's murder, the courthouse lawn on which he was lynched had been home to a Confederate monument for nine years. The Caddo Parish Common Soldier monument consists of a common soldier statue atop a column mounted on a plinth flanked at each corner by the busts of Confederate generals. A statue of Clio, Greek goddess of history, stands at the center of the base of the monument. But rather than having her back to the monument so she is facing the viewer as they approach the courthouse, Clio is represented facing the monument and reading from a book whose pages bear the inscription "Erected by the United Daughters of the Confederacy, 1905 / Love's tribute to our gallant men." The Caddo Parish Common Soldier monument, then, stages the UDC and its Lost Cause ideology as the authoritative source of history and, by association, the laws of the Confederate rather than the United States as those under which justice is carried out in the building in front of which the monument stands.

In Caddo Parish as elsewhere, lynching was an all-too-common occurrence, but one with a finite temporality. Though more innocuous in both iconography and name, Common Soldier monuments constitute a more permanent manifestation of the same system of values that made lynching possible. Given the close historical relationship between Common Soldier monuments and lynching, these forms are attended in perpetuity by the specter of the lynched Black body. They stand in not only for a vision

of the United States as a nation elaborated through the terms of whiteness—one also meant to extend, through the formal terms of the monument, from the nation's past well into its future—but also for the violent, public, and ongoing subjugation and murder of Black citizens as a necessary condition of that dominance. Common Soldier monuments are, in other words, a public warning of the ever-present possibility of violence that stalks Black life into the present.

In addition to being attended by the specter of lynching, and by association an extension of the para- or extrajudicial practice of lynch law, Common Soldier monuments also mark out the impossibility of justice for Black citizens in jurisdictions in which they stand outside courthouses. Caddo Parish once again offers a useful case study because it has long remained a bastion of Lost Cause rhetoric, bolstered in part by narratives of the war that suggest the territory of the Parish was never touched by Union soldiers.[37] The belief in the rhetoric of the Lost Cause in Caddo Parish has material consequences that play out as racial disparities in that court's application of the law. In 1955, nearly half a century after the installation of its Common Soldier monument, Caddo Parish began flying the Confederate rather than American flag outside its courthouse at a moment in which that flag was proliferating as the symbol of a midcentury brand of white supremacy whose ascendency tracked that of the emergent Civil Rights movement.[38] As legal scholars Cecelia Trenticosta and William C. Collins have argued, the presence of the Confederate flag over a courthouse suggests to all who must pass underneath it to enter that they are subject to the laws of the Confederate rather than United States, and therefore in a jurisdiction in which racial equality under the law simply does not exist.[39] A similar logic can be understood to attend courthouses on whose lawns Common Soldier monuments stand, many of which both antedate the installation of the Confederate flag and persist long after that flag has been removed.

Efforts by citizens' groups or municipalities to remove Confederate symbols such as flags or monuments have regularly incited heated public advocacy in favor of the retention of these symbols as transparent representations of an accurate past. That these arguments are repeatedly resurrected when removal efforts commence is a testament not only to the effectiveness of the Lost Cause narrative but also to the public signifying regimes that emerged

to stand in for it. In Caddo Parish, challenging the presence of the Confederate flag was, by Trenticosta and Collins's account, so "paralyzing" to the community as a whole that, as recently as 2011 when their article was published no discourse on the subject was possible (though the Confederate flag finally ceased to fly there that same year).[40] Ifill describes a similar instance in Talbot, Maryland, related to a 2004 proposal for a monument of Frederick Douglass, who grew up in Talbot and later returned for reconciliatory conversations with the man who enslaved him. Soon after, that town's courthouse lawn would become home to a Confederate Common Soldier monument, erected in 1913. A smaller and less central Vietnam War memorial was also installed on the grounds decades later. The backlash to the Douglass monument came, predictably, from white groups, who characterized the courthouse lawn as a "sacred" and "hallowed" space to honor only those who have died for their country in war.[41] This line of argumentation is characteristic of the discourse that unfolds around efforts to take down monuments that were built on a lie; not only does it partake of the falsehoods of the Lost Cause, but it also lashes a racialized prohibition to the notion of the sacred.

Given the imbrication of white-dominant culture and Confederate monuments, the act of creating, renaming, or removing them is not just symbolic. It also has material implications, and so removal becomes possible only through enormous political effort, or public expenditure, or both. Well over a century after their organization began erecting Confederate monuments throughout the United States, and amid public and political challenges to the persistence of those structures, the UDC in the twenty-first century has routinely sued both public and private entities over removal efforts. For example, in 2018 when Vanderbilt University sought to change the name of Confederate Memorial Hall to Memorial Hall, the UDC—which had paid $50,000 for the naming rights to the building in 1935—successfully sued the University for over a million dollars.[42]

The UDC's litigious approach to institutions that engage in renaming or removal projects is staked on contractual terms laid out long ago, rather than on the Lost Cause narrative that motivated the UDC's various historical efforts to mark public space with signifiers of that narrative for the express purpose of making that narrative seem both objective and universal. But the success of their suits nevertheless bolsters the Lost Cause narrative, which

remains, perniciously, alive and well today. In subsequent chapters of this book, I demonstrate how the projects in this new monument boom intervene in the Lost Cause narrative and other discursive strategies long furthered through monuments to elide a more accurate and nuanced narrative of US history, especially as regards African American stories and experiences. These recent projects derive key elements of their representational strategies from those elaborated earlier by Piper, who entered the New York art scene at a moment of substantial change that centered on similar questions about objectivity and subjectivity as those raised by new monuments today. In the next section, I engage in a close reading of Piper's groundbreaking *Food for the Spirit* in relationship to conditions within the art world at the time when Piper made it, to argue that the work evacuates the very prospect of objectivity and, by association, all claims that hinge upon it.

## Food for the Spirit

*Food for the Spirit* was made at a moment of critical flux in the US art world. As has been extensively explicated in the field of art history,[43] for a substantial portion of the midcentury the predominating form of representation was painterly abstraction, interest in which had been underwritten by the elevation of the notion of critical objectivity. The defining voice of the period was Clement Greenberg, who, in a 1939 essay, espoused the virtues of abstraction as a capitalist innovation developed in part as a response to Soviet realism and figurative propaganda.[44] The ability to make and appreciate what Greenberg called the "superior culture" of abstraction was predicated on social "conditioning" more or less exclusively available to those of a particular socioeconomic status that, in 1939, denoted a particular race and gender as well. This critical style, which has come to be known as formalist modernism, would persist in defining the terms of valuation and explication of art for decades to come.

Both within and beyond his seminal 1939 essay, Greenberg routinely packaged arguments with an evident politics in the language of objectivity, a rhetorical move that authorized his voice as uniquely predisposed to that faculty. As has been observed by scholars of art history and modernist aesthetics alike, Greenberg also routinely invoked Kant, especially when elaborating

frameworks of objectivity in critical analysis.[45] Objectivity is a central feature of Kant's work, appearing in the *Critique of the Power of Judgment*, or third *Critique*, as the concept of disinterestedness. Kant argued that an individual's ability to reason enabled him to interact with the world around him and secure the well-being of the polis. The power to reason, in turn, scaffolded the ability to pass judgment, which could only be exercised by a disinterested viewer who could separate himself from what he reflexively found pleasurable as a result of his social conditioning.

A central feature of Kant's writing is the contextual specificity of objectivity, but Greenberg repeatedly invoked Kant while making a broader argument that there was a political imperative for separating art from life, painting from sculpture, and the various academic disciplines from one another.[46] However formalist in origins, this fear of mixing looked different during the height of the Cold War—when it easily mapped onto Red Scare fears of Soviet contamination and Lavender Scare fears of queer spies— than it did a decade later amid the Civil Rights movement and other, more germinal struggles for justice. Against the social backdrop of a range of upheavals rooted in the politics of identity that were becoming an increasingly visible feature of the New York art world, any claim that one group of people could lay sole claim to the ability to objectively determine what constituted good art seemed increasingly suspect.

By 1971 Greenberg himself was no longer the influential figure he had long been.[47] Already a visible touchpoint for social justice movements, New York City was experiencing changes to its cultural and commercial layout that furthered demographic shifts that were felt in the art world. These changes supported an efflorescence of new ways of making art and new venues in which to view it. The art world, long concentrated downtown, had expanded dramatically following World War II; in 1955 there were 123 galleries, but by 1965 that number had doubled. Along with new venues to show art came an expanded field for both art and criticism.[48] Though formalist modern interpretations of art were still in wide circulation, they were being inflected with and challenged by other critical approaches that had long coexisted with (if less frequently contravened) them.[49] The art historian Darby English argues that a branch of late modernist criticism—among which he includes the later work of Greenberg—had emerged by 1971 to "declare color painting to be *about* being with the other"

and "announced the end of a modernist project dedicated to using this art to deny the centrality of contingency to contemporary life."[50] The painterly abstraction taken up by this late modernist project was just one among an ever-widening breadth of representational strategies that proliferated as artists sought ways to connect with newly politically engaged audiences in a city with rapidly shifting demographics.

One emergent strategy was body art, which often took the form of durational performances in which artists made their bodies their medium and, in doing so, made the perceived similarities or differences between the subject position of the artist and that of the viewer central to the meaning of the work of art. On the heels of nearly two decades of civil rights struggles for African Americans, and amid emergent gay, feminist, labor, and antiwar movements in the late 1960s and early 1970s, a number of artists turned to the body in pursuit of ways of making art that reflected some of the changes that the protest-based movements had failed to realize, such as the reduction of hostilities to difference.[51] The strategies of social address that emerged apace of and in body art allowed artists working in that medium to inflect their practice with inquiries into the conditions and consequences of subjectivity and difference, which in turn enabled them to connect with newly politically engaged and rapidly diversifying audiences. By marking out degrees of difference between viewer, object, and artist, body art set up a new spectatorial situation that made the viewer always already distinct from the artist, exposing that the terms through which a work of art is made are never identical to those through which it is interpreted. The art historian Amelia Jones argues that body art functioned as a rejoinder to foundational tenets of formalist modernism by "instantiat[ing] the dislocation of the Cartesian subject," the very same type of subject who in Greenberg's accounts possessed the power of objectivity.[52] By taking as its very subject the space between production and interpretation, body art abrogated the claims of objectivity that lay at the center of formalist modernism.

*Food for the Spirit* was neither Piper's first foray into body art nor her first exploration of how her body signifies in public.[53] It even resembles a work Piper had made the previous year, *Concrete Infinity Documentation Piece* (1970), which consists of a series of fifty-eight notebook-sized pages containing a handwritten record of Piper's activities on a given day.[54] Appended to thirty-six of the

pages are small, square photographs of Piper standing in front of a mirror, sometimes clothed and sometimes not, presumably also from that day. In its seriality, use of self-portraiture, indexing of those images to prose, and subsequent production, *Food for the Spirit* pushes strategies in *Concrete Infinity Documentation Piece* further by substituting the detailed accounting of her own daily movements for torn-out pages of Kant's writings marked up in her own hand. This change marks a maturation away from a hyperlocalization of focus on the self—a classic trope in body art of the moment manifested here by the artist examining herself simultaneously as visual object and textual subject—and toward a more broad set of questions that are posed not just by Piper as a discrete subject but also by Piper as a synecdoche for the ways in which the body she inhabits is always already circumscribed through gendered and racialized terms. *Food for the Spirit*, then, offers a heuristic through which to explicate the relationship between the philosophical underpinnings of Western spectation and the ways in which some subjectivities are hypervisible while others are invisible within white-dominant ordering logics.

That the work of Kant has been central to Piper's development as both a philosopher and an artist has been regularly noted in the scholarship on both Piper's work in general and *Food for the Spirit* in particular.[55] So too have assertions that Piper's artistic practice is engaged in a set of representational strategies that both expose and intervene in the mechanisms of gendered racism.[56] Among the various explications of her work, however, Piper's own annotations persist in offering the most illuminating account of the ways in which her encounter with Kant scaffolded her subsequent interventions into objectivity. In the torn-out pages of the first *Critique* that accompany her original staging of *Food for the Spirit*, Piper heavily underlines the following passage on the subjectivity of perception: "[Objects] belong only to appearance, which always has two sides, the one by which the object is viewed in and by itself . . . , the other by which the form of the intuition of this object is taken into account." What seems to have caught Piper's attention was Kant's suggestion that there is neither such a thing as universalized objectivity nor a coherent object or subject. For Kant, the extent to which any concept or belief can be totalizing is always delimited by the conventions that arise within groups formed around shared traits or experiences. Even these conventions can never be totalizing because it is impossible to perceive

that object's "reality as representation" save for through "the sub-
ject to which the object appears." Put another way, the material
in the first *Critique* that Piper seems most interested in relates to
an argument that each subject or object has two truths to it—
one that is interior to it and one that is perceived by that which
is outside of it—a duality that renders any totalizing knowledge
of something fundamentally impossible. This argument is a foil
to formalist modern objectivity in the work of the very thinker on
whose scholarship that concept had been repeatedly staked.

*Food for the Spirit* suggests a radical disjuncture between the
Kantian ideas that underwrote formalist modernism and claims
to subjectivity and agency by nonwhite and nonmale subjects. In
a 1981 essay in the avant-garde art magazine *High Performance*, Piper
describes how *Food for the Spirit* came about as a result of a summer
dedicated to reading Kant's *Critique of Pure Reason* while fasting,
practicing yoga, and living in relative isolation—the life, in other
words, of an ascetic.[57] Piper describes how eventually she "could
think of nothing else and became obsessed with Kant's thought"
and would periodically "go to my mirror and peer at myself to
make sure I was still there."[58] The photos became a mechanism to
"anchor" herself "every time the fear of losing [herself] overtook"
her. Piper's essay on *Food for the Spirit* can be read as an early exam-
ple of what the critic Hilton Als has characterized as Piper's explo-
ration of "the ways in which we internalize the roles assigned to
us,"[59] and as an important act of resistance against the dissociative
pressures of a text to which one is purportedly invisible.

In foregrounding the ways in which roles are both assigned
and internalized, *Food for the Spirit* provides an opportunity for a
viewer to enter into a spectatorial situation in which any claims
one might make to objectivity or disinterestedness are always
already undermined by the subject within the frame. Exposing
these investments undermines the totalizing assumptions that
undergird ordering systems of race and gender, which presume
comprehensive knowledge of a subject or group of subjects based
on observable traits. But exposure alone does not explain the rep-
resentational interventions at work in *Food for the Spirit*; Piper's
mobilization of fundamental unknowability as a strategy for refus-
ing such ordering regimes goes further by presenting a subject laid
both rhetorically and literally bare, yet utterly unavailable to objec-
tification or knowability. This strategy is different from merely
marking out the space of difference between where the artist ends

and the spectator begins because it stages conceptual and intellectual unknowability as a locus of agency under conditions in which, or for subjects for whom, such a thing is scarcely available. *Food for the Spirit* thus constitutes a pictorial representation of what Antillean literary scholar and critical theorist Édouard Glissant calls opacity, or a way of restaging unknowability as the root of a "right to difference."[60] For Glissant, Western subjecthood is premised on understanding and transparency, concepts that are traceable to the Cartesian subject, for whom subjecthood is premised on the ability to "understand and thus accept" the other. A similar assumption of transparency also underwrites formalist modernism; to presume that one can pass objective judgment is to claim at once that one can understand anything. To focus instead on opacity as fundamental to the process of relationality means not just to allow for the possibility of difference but indeed to "give up this old obsession with discovering what lies at the bottom of natures." Understanding the subject to be the product of a complex network of identification and signification, opacity provides a framework through which to relate through, not just in spite of, what Glissant calls "subsistence with an irreducible singularity." Opacity, in other words, allows for the presence of difference while refusing to be reduced to that difference, to order or be ordered according to hierarchies staked on that difference.

Read as an exercise in opacity, *Food for the Spirit* works against structural racism and challenges ordering regimes that turn on observable traits by demonstrating that the characteristics mobilized as evidence for marginalization or discrimination are always premised on specious claims to knowability.[61] *Food for the Spirit* can thus be understood not only to expose the limits of disinterested spectation, but also to do so through terms that are facilitated by a subject who would have been understood, in the Western philosophical canon undergirding that principle, to be preontologically excluded from the domains of activities of making art and passing judgment. The spectatorial condition set up within *Food for the Spirit* is also crucial to the work's intervention in the concept of objectivity. Because it is nearly impossible to tell whether Piper is returning her own gaze in the mirror or looking into the camera, the spectator is placed in a liminal position in which the observer either has their gaze resolutely returned or is being ignored by the self-contained subject of the work. In either case, the viewer can only occupy a space always already occupied by Piper in 1971.

*Food for the Spirit* also contravenes a long-standing tradition in Western art of placing the viewer in a position of spectatorial power relative to the bodies of subjects intended to be read as nonwhite and nonmale. In most representations of women and people of nonwhite descent in Western art, the viewer is the observer and explicitly not the observed, and minoritized subjects are almost without exception objects of the gaze rather than subjects with the status routinely afforded masculine-coded bodies of Anglo-European descent.[62] Staging a body provisionally legible as that of a Black woman—as suggested by skin tone, hair, and secondary sexual characteristics either suggested in images of Piper clothed or revealed in those of the artist partially or totally nude—as the primary spectator creates a closed spectatorial/representational loop that precedes the position of all other viewers, whose experiences are even further mediated by both the reflection of the mirror and the refraction of the camera; to look at *Food for the Spirit* is to look into a mirror, and find another person in another time. All viewers are thus precluded from taking up a position of domination because no viewer can inhabit the specific spatiotemporal location inhabited by Piper when the shutter clicked. *Food for the Spirit* thus suggests that object, maker, and spectator can overlap and intersect while remaining irreducible to one single element of their being, and that a whole history can gather and refract through an object such that the object is at once about, and in excess of, its subject.

As an assertion of the fundamental subjectivity of perception, *Food for the Spirit* suggests the possibility of evacuating of the claims to objectivity that undergird not just formalist modernism but traditional monuments as well. A comparative study of *Food for the Spirit* and the Common Soldier monument is instructive in obverse relationships to objectivity. Deploying a generic—which is it say, white and male-gendered—form and titling, the Common Soldier monument makes a broad claim about the universality of its content. Confederate instantiations of the form interpellate viewers in even more insidiously racialized terms, presenting in these commonly occurring monuments a vision of a nation in which what is common is not an implicit commitment to maintaining white dominance, but an explicit commitment to attaining white nationalism by whatever violent means are available. While its Northern manifestations would seem to perform the rather traditionally monumental cultural labor that makes its vision of the

common coextensive with whiteness, the minimally distinguishable formal differences blur the iconographic and ideological lines between them and their Confederate counterparts in a way that also gestures toward the minimal efforts on the part of white citizens to stem the tides of anti-Black violence or intervene in the white-dominant status quo.

*Food for the Spirit* works the valences of the Common Soldier's claims to commonality and objectivity in reverse, representing a specific body whose public display is overdetermined through the conditions of gendered racism while at the same time privatizing that otherwise public gesture to refuse the terms of public representation. In lieu of a white, masculine-coded figure meant to stand in for some universalized whole, the figure who returns the viewer's gaze in *Food for the Spirit* is marked out through difference from that viewer, even when the viewing subject is Piper herself after the fact. Where the Common Soldier is articulated through terms in which white masculinity is the universal common, *Food for the Spirit* proposes the often-overdetermined cultural obverse as just as common and universal, whether clothed or nude, thus destabilizing the primacy of place of the white masculine subject. This destabilization only becomes possible, however, as a condition of Piper's withdrawal of the work from the public realm, a severing that deracinates the materiality of her body from the disciplining grids of gendered racism. Where the Common Soldier holds a gun—a machine designed to kill—Piper holds a camera, a machine that processes the terms of representation that has played its own role in elaborating hierarchies based on observable traits. The intervention of *Food for the Spirit* into objectivity—and, by implication, into the signifying regimes that underwrite both the Common Soldier monument and formalist modernism—may ultimately be most apparent in Piper's interspersal of these images into the torn-out pages of a foundational text of modernism, a decision that positions the series as at once an inheritance of and intervention into that otherwise white- and male-dominated tradition.

The series is also a particularly dense example of the key sociopolitical themes that body art and its attendant representational strategies make possible. As has been extensively documented, one of the most urgent questions for artists in the 1960s and 1970s was how to work in a way that engaged in or contributed to the urgent social and political struggles of the time.[63] Though it comes about through similar conditions to those of contemporaneous works of

performance art—a time-based event featuring a nude form that persists as the photographic traces left by it—*Food for the Spirit* differs from the conventions of the genre in important ways. While numerous contemporaneous works of performance art were also recorded, and persist, as a series of photographs, the conditions from which *Food for the Spirit* emerged—Piper has called it a "private loft performance"[64]—do not resolve the question of whether Piper intended it to be understood as a work of performance art in the same way other artists working contemporaneously may have. The photographs that comprise *Food for the Spirit* may therefore be more akin to a precipitate of a private event with a conditional or ambivalent relationship to display than a permanent record meant to stand in for a temporary event both publicly and indefinitely.

Another significant departure of *Food for the Spirit* from contemporaneous works of body art is the actual body in the photographs. Most of the individuals working in a manner that answers to the terms of body art at the time positioned the nude body as spectacle, whether by enunciating bodily processes—as in Carolee Schneemann's *Interior Scroll*, in which the artist slowly pulled a narrow scroll of paper from her vagina and read aloud from it as she went—or rendering themselves abject, as in Vito Acconci's *Conversions*, in which the artist put his nude body through a sequence of steps such as burning his hair off in a futile attempt to rid himself of the signifiers of masculinity. *Food for the Spirit*, by contrast, works rather spectacularly against the spectacularization of the body. Piper presents herself in the same, straightforward way across the series, a contravention of both the gendered, racist tropes all too frequently associated with the representation of bodies that are legible as those of Black women and those of the self-spectacularizing terms that characterize much of the body art of the moment. Rather than speaking through white-dominant representational conventions in circulation in the practices of white artists seeking to deracinate the body from the social and cultural expectations superimposed onto and through it by dominant cultural norms, *Food for the Spirit* instantiates a straightforward representation that is neither spectacular nor invisible—a representational privilege from which Black women have historically been routinely precluded. This effect is further underscored by variations of light and clothing across the series, which suggest that conditions may change, but Piper remains present, on her own terms, unavailable whether clothed or nude, visible

or disappearing, to the spectatorial regimes through which the white-dominant institutions of philosophy, criticism, and the gaze have long related to bodies like hers.

In addition to departing from the traditional conventions of body art as a condition of the raced and gendered terms of the work, *Food for the Spirit* also stands apart from the representational conventions in the work of Black women contemporaries of Piper's whose practices explored the relationship between race, gender, and power. Few if any Black women who were making and showing art at the time engaged in nude or even seminude self-representation; the artist and scholar Lorraine O'Grady, Piper's contemporary, identified *Food for the Spirit* as "a catalytic moment for the subjective black nude" that became "a paradigm for a willingness to look, to get past embarrassment and retrieve the mutilated body."[65]

The "catalytic" nature of *Food for the Spirit* is partly a function of the politics in the art world at this moment. Though the first racially integrated art show at a major US museum went up the same year that Piper made *Food for the Spirit—The De Lux Show* at the Menil Collection in Houston[66]—1971 was also replete with demonstrations of just how little progress had been made in a major push for equitable representation of Black artists that had unfolded in the preceding two years. In January 1969, the same month that the Art Worker's Coalition presented the Museum of Modern Art's director Bates Lowry with a list of 13 demands, the Metropolitan Museum of Art mounted *Harlem on My Mind: Cultural Capital of Black America, 1900–1960*. As Hilton Als recently observed, *Harlem on My Mind* "treated Harlem as a social narrative, told through newspaper clippings, timelines, and numerous photographs by James Van Der Zee,"[67] but did not contain a single painting or sculpture by any of the many artists living and working in Harlem, including Faith Ringgold and Jacob Lawrence whose work was already in the Met's permanent collection. In response, a group of artists and cultural workers founded the Black Emergency Cultural Coalition (BECC) to advocate for changes to the ways in and degree to which Black artists were included and represented, and for the hiring of Black curators both within and beyond the Met. The BECC's efforts ultimately led to a show at the Whitney Museum of American Art in 1971 called *Contemporary Black Artists in America*, but fifteen of the seventy-five artists pulled out as the show opened on the grounds that it failed to meet key criteria enumerated by the group: the

13 DEMANDS

submitted to Mr. Bates Lowry, Director of the Museum of Modern Art,
by a group of artists and critics
on January 28, 1969.

1. The Museum should hold a public hearing during February on the
topic "The Museum's Relationship to Artists and to Society",
which should conform to the recognized rules of procedure for
public hearings.
2. A section of the Museum, under the direction of black artists,
should be devoted to showing the accomplishments of black artists.
3. The Museum's activities should be extended into the Black, Spanish
and other communities. It should also encourage exhibits with
which these groups can identify.
4. A committee of artists with curatorial responsibilities should be
set up annually to arrange exhibits.
5. The Museum should be open on two evenings until midnight and
admission should be free at all times.
6. Artists should be paid a rental fee for the exhibition of their
works.
7. The Museum should recognize an artist's right to refuse showing
a work owned by the Museum in any exhibition other than one of
the Museum's permanent collection.
8. The Museum should declare its position on copyright legislation
and the proposed arts proceeds act. It should also take active
steps to inform artists of their legal rights.
9. A registry of artists should be instituted at the Museum. Artists
who wish to be registered should supply the Museum with documen-
tation of their work, in the form of photographs, news clippings,
etc., and this material should be added to the existing artists'
files.
10. The Museum should exhibit experimental works requiring unique
environmental conditions at locations outside the Museum.
11. A section of the Museum should be permanently devoted to showing
the works of artists without galleries.
12. The Museum should include among its staff persons qualified to
handle the installation and maintenance of technological works.
13. The Museum should appoint a responsible person to handle any
grievances arising from its dealings with artists.

Figure 1.1   Art Workers' Coalition, "13 Demands Submitted to Mr. Bates Lowry, Director of
the Museum of Modern Art, by a Group of Artists and Critics on January 28, 1969." Printed
ink on paper. 11 × 8½ in (27.9 × 21.6 cm). Archives Pamphlet Files: Art Workers' Coalition,
Museum of Modern Art Archives, New York. Courtesy of the Museum of Modern Art/
Licensed by SCALA/Art Resource, NYC.

Whitney had not worked closely with specialists in Black art, and the show had opened not in the fall, the "most prestigious period" of the year, but rather in the spring.[68]

The BECC is just one example of how the social and political changes of the moment were deeply imbricated with practices of many artists, and of the many organizing efforts by Black artists to create spaces for themselves, and to address Black audiences, that did not rely on the often exclusionary systems of the white-dominant art world.[69] As in broader social justice structures, organizing in the art world also cut along gendered and racialized lines that made it especially difficult for Black women to find space for themselves on account of experiences of racism from white, feminist-identified artists and misogyny in most other places.[70] It was in the context of an art world arguably not ready for the kinds of representation in which *Food for the Spirit* engaged that Piper would not mention the work to a general public for a decade, and not show it for another six years after that.[71] Regardless of its subsequent display and widespread circulation, *Food for the Spirit* may therefore be understood as an insistently private work that suggests an understanding of the public as an arena in which the dehumanization of bodies that are legible as Black and female is dangerously naturalized.

*Food for the Spirit* is also one of the earliest works of art that Piper explicitly indexes to her study of philosophy.[72] Though she had already earned a degree from the School of Visual Art in 1969 and was maintaining a robust artistic practice, Piper went on to earn a BA from City University of New York in 1974 and a PhD from Harvard in 1981, and to teach and earn tenure at several prestigious universities including Georgetown, where she was the first African American woman to be tenured in the field of philosophy.[73] Piper's essay "Xenophobia and Kantian Rationalism," from 1992, offers possible insight into some of the themes that are surfaced in *Food for the Spirit*. Piper begins by observing that twentieth-century interpretations of Kant—which would have included those contemporaneous to formalist modernism—favored later work by Kant while giving a comparably "wide berth" to the first *Critique*.[74] Piper attributes this to a "postwar behaviorist sensibility, for which the best conceptual analysis of interior mental life was no analysis at all,"[75] a nod to a broader, postwar scholarly trend repeated in later texts on the interpretation of Kant.[76] But Piper identifies in the first *Critique* a counterargument to claims

routinely attributed to later interpretations of Kant; a focus, Piper argues, that elided an "inchoate but suggestive"[77] argument in the first *Critique* that at least conditions, if not wholly contrasts with, assertions in his later writings. In the opening passages of the essay, Piper states that "we identify others as persons on the basis of our own self-identification as persons,"[78] while dealing with otherness through xenophobia, an aversion that Piper defines as a "fear, not of strangers generally, but rather of a certain kind of stranger, namely those who do not conform to one's preconceptions about how persons ought to look or behave," that manifests as "racism, sexism, homophobia, anti-Semitism, etc."[79] Piper argues that interpretations of Kant that neglect the first *Critique* could readily understand Kant to be arguing that humans do not have agency to act on their own faculties of reason,[80] conditions under which, Piper notes, "xenophobia is a hard-wired, incorrigible reaction to a threat to the rational integrity of the self."[81] But Piper found in the first *Critique* a different understanding of rationality, one fundamentally embedded in Kant's conception of "personhood," which was, in turn, the basis for judgment.[82] According to Kant in the first *Critique*, Piper argues, human behavior is the result of "conditioning and therefore susceptible to empirical modification."[83] Xenophobia, then, becomes "corrigible in light of empirical data that may be realistically expected to compel the revision of those concepts."[84] When shown their own biases, in other words, humans have the power to do something about them.

Kant's third *Critique* had long been wielded as a cudgel by Greenberg and others in the art historical tradition to insulate the opinion of a tiny minority of artists, critics, media, and genres from interventions into their dominance. Because of this history, finding within foundational texts of modernism, penned by that very same author, a possibility—however germinal—that there were multiple interpretative possibilities that diverged from or even openly contradicted dominant and exclusionary frameworks would not have been an abstract concept in an art world still partially in thrall to formalist modernism. The stakes are also not an abstract philosophical concept in Piper's essay, but rather an urgent inquiry with real material implications that Piper says are "of particular concern for African Americans" because "as unwelcome intruders in white America we are the objects of xenophobia on a daily basis."[85] *Food for the Spirit* suggests that a reading of Kant in which such principles could be found had been under

active construction for Piper for two decades before she laid it out in "Xenophobia and Kantian Rationalism," making *Food for the Spirit* a crucial germinal node in Piper's nascent career as a philosopher. The work of art born of Piper the artist's first intensive engagement with the first *Critique* is not the full articulation that Piper the seasoned philosopher articulates, but it has the inchoate scaffolding thereof. *Food for the Spirit* thus lays the groundwork for proposing that all subjects contain within themselves the potential to do something about gendered racism because the structures on which racism are built are all smoke and mirrors. "Xenophobia and Kantian Rationalism" builds this out into a broader argument that suggests that redressing xenophobic responses to difference is everyone's responsibility.

—

*Food for the Spirit* is a resolutely human series of photographs of a body almost always already subsumed by systems of signification over which that body has no control, asserting its a presence before and beyond those systems. In deploying fine art photography, the iterative conditions of conceptual art, and her own body, Piper disrupts the conventions of each in ways that thematize race and gender while simultaneously demonstrating their exclusion and absence from consideration within the frame. As Piper's state of undress alters, as her form oscillates in and out of visibility, and as the viewer's eye moves between images of Piper and the text of the first *Critique*, *Food for the Spirit* adumbrates the workings-through of how bodies are raced and gendered, and how conventions—conditioned here on subjectivity and dually thematized through clothing and visibility—become not just scripted for specific subject positions, but expected of them by others.

In creating a work that describes the distance between all viewers and the presumptive viewer, *Food for the Spirit* anticipates some of the ways in which contemporary artists intervening in the monumental tradition have injected the complexities of history and subjectivity as a form of expository intervention into white-dominant formal and narrative traditions. Piper's straightforward self-presentation in *Food for the Spirit* powerfully undermines assertions of the possibility of critical objectivity not only because it asserts the persistence of an individual not afforded subjecthood under that framework but also because it destabilizes any claim to

totalizing knowability. The viewer may see Piper nude, but cannot claim to know her or her experience, a refutation of the spectacular body that situates the work as a precursor to the contemporary monument boom. In bringing to the fore a body marked out as minoritized in raced and gendered terms, *Food for the Spirit* marks the beginning of an arc along which the politics of the body would become increasingly central to avant-garde aesthetics. This arc would eventually find its apotheosis in *A Subtlety* and the forms that come after it, manifesting as explications of the histories and consequences of Atlantic slavery—albeit with monumental and other aesthetic twists—and enunciating the gap between the simple fact of subjectivity and the social or epistemological origins of their categorization and ordering.

The same admixture of conventions that enables *Food for the Spirit* to constitute an inverted echo of the Common Soldier Monument also facilitates a range of monumental interventions forty years later. Walker's *A Subtlety* conjures a specific set of signifiers at the juncture of embodied experience and stereotypes, demonstrating some of the impacts of the white dominance that underwrites US culture on individual and collective lives while at the same time making those signifiers literally loom so large as to be absurd and vulnerable to disruption. Piper's disruptive representational strategy is a germinal node in the emergence of artists whose work engages in what the art historian Huey Copeland has argued a photo series can offer: a way of "framing American history as a racialized theater of deadly repetition."[86] Though Copeland's remark is about the work of Carrie Mae Weems, a slight variation might be applied to *Food for the Spirit* to understand it as a staging of the theatricality of the politics of race and gender, framed through a subject not only located at arguably the most dangerous nexus thereof, but also rarely afforded the privilege of visibility, never mind mundanity. It is a world in which this is no longer the case that recent monuments, drawing on strategies I have suggested can be traced to *Food for the Spirit*, propose.

The next chapter studies the NAMES Project AIDS Memorial Quilt as an intermediary term in the arc from *Food for the Spirit* to this new generation. As I will show, the AIDS Quilt draws on a genealogy and produces a set of representational strategies that are distinct from those of *Food for the Spirit*. Combined with those of the traditionally monumental, however, these two strategies provide a tripartite basis for more recent monumental interventions.

2    *The Archive as Monument*

The NAMES Project AIDS Memorial Quilt was established in 1987 to memorialize those who have died from complications from AIDS. Consisting today of nearly 50,000 panels, weighing over fifty tons, and so large that it cannot practicably be displayed in its entirety in any one place save for online where it is digitized and searchable in its entirety, the AIDS Quilt is a monumentally scaled effort to memorialize an ongoing loss.

There is no adjudicating body for whether someone meets the criteria for inclusion in the AIDS Quilt. The NAMES Project asks for no proof that the person being memorialized was HIV-positive or died from AIDS-related causes, only that contributions be submitted with a note of remembrance, and adhere to the very few standardizing conventions that govern the project. The basic structure is the three-by-six-foot panel, dimensions that are slightly larger than a flag, and slightly smaller than a grave. An incredible diversity of materials and aesthetics are represented within the AIDS Quilt. Panels can contain anything its maker wishes, and so the AIDS Quilt includes hard hats, tulle skirts, glitter, BDSM accoutrements,

IN THE UNITED STATES DISTRICT COURT
FOR THE WESTERN DISTRICT OF TEXAS
AUSTIN DIVISION

CLAUDE DAVID MILLER

Individually and on behalf
of all others similarly situated.

    Plaintiff

V.

MARLIN W. JOHNSTON,
Commissioner of the Texas
Department of Human Services;
J. LIVINGSTON KOSBERG. sued
in his official capacity as
Chairman of the Board; VICKI
GARZA and ROB MOSBACHER.
as Board Members of the Texas
Department of Human Services.
sued in their official capacity

    Defendants

*Thanks David*

## COMPLAINT

### I. Preliminary Statement

1. Plaintiff brings this action individually and on behalf of a class of Medicaid recipients who are unable to obtain the drug Retrovir (AZT) under the Texas Medicaid Program. Plaintiff seeks declaratory and injunctive relief to ensure that he and the class he seeks to represent will be able to obtain this drug in an effective manner.

Plaintiff claims that defendants refusal to place this drug on the Texas Vendor Drug Formulary or otherwise provide effective Medicaid coverage for the drug violates federal regulations 42 C.F.R. §§ 440. 230(b) and 440.240(b) and 42 U.S.C. § 1983 and is thus invalid under the Supremacy Clause of the United States Constitution.

### II. Jurisdiction

2. Jurisdiction is conferred upon this court by 28 U.S.C. §§ 1331, 1343(3) and (4) relating to actions brought under 42 U.S.C. § 1983.
3. Plaintiffs cause of action arises under 42 U.S.C. § 1983 and Article II of the United States Constitution.

### III. Plaintiff

4. Plaintiff. Claude David Miller is a Texas Medicaid recipient who resides in Austin, Travis County, Texas.

Figure 2.1 AIDS Memorial Quilt, Panel 0788: Claude David Miller. Courtesy of National AIDS Memorial.

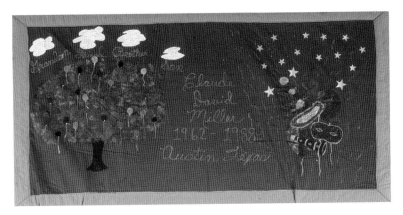

Figure 2.2 AIDS Memorial Quilt, Panel 1175: Claude David Miller. Courtesy of National AIDS Memorial.

and a vast array of other objects and signifiers of identification and belonging that comprise the lives memorialized therein. There is no limit to how many panels can be made for an individual, and so a single person may be remembered in dramatically different ways by different people, as in the example of the two panels for David Miller. One, made by his doctor, contains the partial text of a lawsuit Miller filed on behalf of himself "and the class he seeks to represent" to be able to access the early antiretroviral drug AZT via Medicaid. The panel, a simple white sheet with black, hand-written lettering, has a single pictorial element aside from the text: an upside-down pink triangle with the words "Thanks, David" written across it. The other, made later by his family, is pink with a blue border and features illustrations including a tree, balloons, and an inscription that says simply "Brother, Friend, Son."[1] Public figures have also been memorialized, resulting in multiple tributes from fans, as in the case of the thirty-one distinct panels made for Queen front man Freddie Mercury. A panel need not represent only a single person, as in the example of one early panel made for nine students and a professor at the University of Chicago,[2] or the four panels made to fit together and look like a sun that memorialize thirty-one members of the Sisters of Perpetual Indulgence, a performance and activist group whose members memorialized in the panel are designated "Nuns of the Above." Many panels also describe the complex networks of minoritization that contributed to the rampant spread of HIV through already disenfranchised or persecuted communities, as in a panel made by Maron Banzhaf for

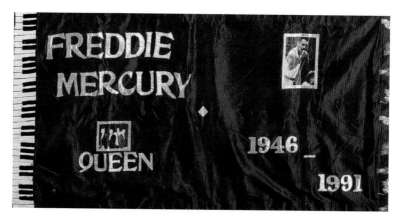

Figure 2.3  AIDS Memorial Quilt, Block 2742: Freddie Mercury. Courtesy of National AIDS Memorial.

Kuwasi Balagoon, a member of the Black Panthers and Black Liberation Army who died in prison. Balagoon's is a two-toned panel of green and red with a black panther superimposed in the center and the words "REVOLUTIONARY • WARRIOR • POET • SORCEROR • LOVER • FRIEND" written across the bottom. Once submitted, panels are incorporated into the AIDS Quilt in twelve-by-twelve-foot blocks in the order they are received, and each block is bordered by a white fabric backing that both frames the panels and conveys a tacit request that viewers look but do not touch.

From the beginning of the AIDS crisis, understandings of HIV/AIDS were skewed by structural racism, homophobia, and a broad and entrenched disregard for intravenous drug users and the unhoused that also elided a longer history of HIV/AIDS. Though its presence has since been traced at least to the 1940s, HIV/AIDS was not recognized by medical science until 1981, and was first reported in a July 3, 1981, *New York Times* article titled "Rare Cancer Seen in 41 Homosexuals."[3] The uptick in infections quickly spiraled into the crisis that it became in part because of what political scientist Cathy J. Cohen called a "cumulative marginalization" of minoritized communities that created the conditions for the crisis to unfold in the first place, and which made it proportionately harder to staunch.[4] The initial face of the epidemic was white, gay, and cis-male in part because, as historian Dan Royles notes, "'out' gay communities . . . were white or were seen as such," which "reinforced the idea that AIDS was a disease of white gay men, even as doctors began to see cases of the disease among hemophiliacs

Figure 2.4  AIDS Memorial Quilt, Block 0753: University of Chicago Students Remember. Courtesy of National AIDS Memorial.

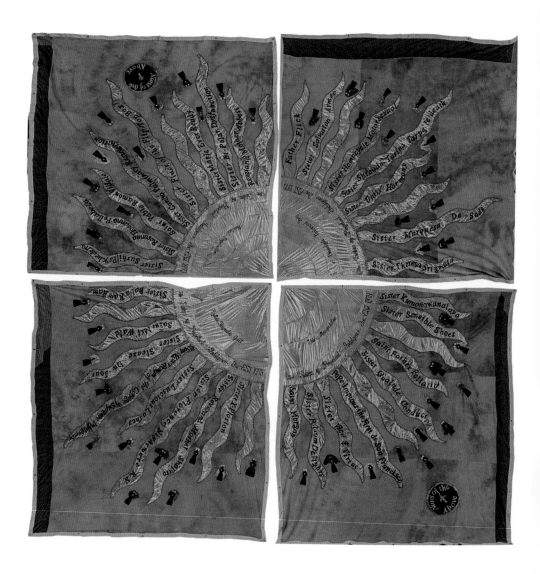

Figure 2.5  AIDS Memorial Quilt, Panels 4663–4666: Sisters of Perpetual Indulgence, Inc. Est. 1979. Courtesy of National AIDS Memorial.

Figure 2.6  AIDS Memorial Quilt, Panel 0873: Kuwasi Balagoon. Courtesy of National AIDS Memorial.

and injection drug users, as well as their heterosexual partners and children."[5] Many early epidemiological inquiries also diagnostically centered on Kaposi sarcoma—a cancer that presents in dark lesions on the skin and often is one of the first visible signs of infection—before testing was available, further concentrating the focus on white bodies.[6] The stigma that homosexuality was a biological disease, the structural racism that presumed exclusively heterosexual sex in the Haitian population, the systemic exclusion of IV drug users and the unhoused from society and from medical studies, and a blatant unwillingness to understand that these populations overlapped and exchanged fluids both with one another and with individuals in groups other than these would contribute to a structural inability to effectively understand and curtail the spread of HIV/AIDS for years to come.[7]

HIV/AIDS hit the gay community at a complicated moment for queer subjects in the United States. The gay liberation movements of the 1950s and 1960s, which culminated in the Stonewall Riots of June 1969, had enabled certain, especially white and urban gay populations to lead more out lives. Contemporary pride parades have their origins in that moment; the first ones took place in New York, Chicago, San Francisco, and Los Angeles in 1970, as celebrations of the first anniversary of the Stonewall Riots. Apace of progress for queer acceptance, however, was a conservative backlash that made central to its claims a variety of long-standing homophobic stereotypes reanimated to galvanize a public just getting used to seeing queer lives lived out in the open. As was noted

contemporaneously and has been documented extensively by people including Paula Treichler and Susan Sontag, the AIDS crisis became a powerful vehicle for the remobilization of homophobia, which amplified the sense of isolation felt by those already living with and dying from a disease that remained inadequately understood, and substantially feared.[8] One of the most visible of these anti-gay efforts was aimed at overturning a 1977 law in Dade County, Florida, prohibiting discrimination on the basis of sexuality, led by the singer-turned-activist Anita Bryant who also made the damaging and false linkage of homosexuality to pedophilia central to her very public campaign. That HIV/AIDS hit just a few years later gave incredible fuel to the resurgent homophobic fire. HIV infections and the deaths that lagged a few years behind continued to rise over the course of the 1980s and neither trend would begin to reverse in the United States until the 1990s, long after the introduction of antiretrovirals.[9] AIDS became associated with long-standing stigmas about homophobia, including that of homosexuality as itself a kind of contagion.

HIV does not make the same distinctions between bodies on the basis of race, gender, sexuality, or disability through which culture is structured, but the epidemiological characteristics that made HIV/AIDS particularly deadly for certain demographics aligned potently with sexual and racial biases that were primed to flare in the early 1980s. Personal and public health fears in both the medical community and communities first impacted by AIDS were compounded by new and exponentially stronger life being breathed into the long-standing armatures that structured efforts within at-risk minoritized communities as well. For example, Cohen has observed that "to discuss AIDS in black communities is to discuss a multiplicity of identities, definitions of membership, locations of power, and strategies for the political, social, and economic survival of the community, because all these factors interact with a disease that divides and threatens ever-growing segments of these populations."[10] The early nomenclature—4H (homosexuals, heroin addicts, hemophiliacs, and Haitians), gay cancer, or GRID (gay-related immunodeficiency syndrome)—evidenced and solidified the othering both of queers from any assimilationist gains that may have been made before the crisis and of those non-queer impacted communities from narratives about HIV/AIDS. Communication across identitarian lines among marginalized populations—precisely what would have been called for to

stem the spread of disease—was antithetical to operative cultural structures, deepening the rifts that stymied information sharing among those groups who were most at risk.

From the beginning, people with AIDS and those who cared for them received little if any public social or scientific support, a circumstance both caused by and fueling social stigmas already in circulation. The US government and scientific communities waffled between total disengagement and fascist actions, from ignoring the spread to imprisoning over 150 Haitian refugees at the now infamous military detention camp Guantanamo Bay on the grounds that several among the group, who had fled Haiti after a military coup overthrew the Aristide government, were HIV-positive. In October 1987, the same month the AIDS Quilt would be unfurled on the National Mall for the first time, Senator Jesse Helms put forth the first of several amendments that turned homophobia into government policy, one of which barred anyone who tested positive for HIV from traveling or immigrating to the United States. Another prohibited the use of Centers for Disease Control funding to create HIV prevention materials that "encouraged"—by which it really meant merely mentioned—homosexual activity or IV drug use.

Antagonistic and apathetic social and political conditions, then, compounded the painful social and medical realities people living with HIV/AIDS had to endure. Those who were sick enough to be hospitalized were often met with fear from, and poor if any treatment by, medical practitioners as they endured long, painful deaths, while those who were not lived amid a profound stigma that frequently kept them in near-total isolation, and a fear of the progression of the disease. Divisions also arose within the gay community between the infected and uninfected that exacerbated these conditions. The mandatory depopulation of queer social spaces also had a chilling effect on queer sociality that further hampered the circulation of information, such as that which resulted from a 1984 directive by San Francisco director of health Mervyn Silverman to close bathhouses, which had been crucial spaces for sociality and the exchange of safe-sex information when little was circulating elsewhere.[11] The most visible responses came from within affected communities, in the form of groups like the Gay Men's Health Crisis (GMHC), which was established in 1982 to collect and eventually distribute information on AIDS and its prevention, and to do patient advocacy for people

with AIDS by getting them onto social security and Medicaid or Medicare. Another important intervention was the San Francisco model of care, described in a 1988 medical journal—also articulated by Mervyn Silverman—as "a coordinated, integrated system of inpatient hospital care, outpatient care, and community-based care"[12] that sought to mitigate the impacts of stigma, isolation, and the vast array of other complexities that arose around supporting an overwhelmingly young and queer population while at the same time (and uncommonly for medical care at the time) treating people with HIV/AIDS humanely. While these are just two of the organizing efforts that came from within populations affected by HIV/AIDS, they are as notable for the tasks they undertook as for the ways in which their scope of impact paled in comparison to the kind of response that could have been mustered by the federal government.

The first panel of the AIDS Quilt was made by the activist Cleve Jones and consists of a portrait of Marvin Feldman holding a cat and rendered in lavenders and black. Below the portrait Feldman's name is printed in black block letters on a white background, a separate segment that, though it does not look like a gravestone, nevertheless can be read like one. Feldman's was one of the names of 40 friends and lovers initially compiled by the group that would become the NAMES Project. The very creation of a list of known dead was a revolutionary act, one of many efforts of those living with, at risk for, or in community with people with HIV/AIDS and their allies to destigmatize the disease and demand not only ethical and compassionate care but also treatment and testing.

The AIDS Quilt would expand rapidly through contributions from communities across the country that established quilting bees—opportunities to gather socially around the shared practice of quilting—to make panels together. Quilting bees also provided a set of communitarian spaces that, at least to a small degree, could stand in for those that had been erased in the opening years of the epidemic. The very first flyer advertising the AIDS Quilt, from 1987, announces a June 10 meeting at the Women's Building in San Francisco, and mentions the Quilt's impending display on the National Mall in October of that year. It does not reference a particular identity group, instead inviting "anyone" to participate in a project memorializing the "thousands of people who have died of AIDS." When it was first displayed in Washington, DC, in October 1987, the nearly 2,000 panels that constituted the Quilt

Figure 2.7   Gay Men's Health Crisis poster, "Great Sex Is Healthy Sex," 1984. Courtesy of Manuscripts and Archives Division, the New York Public Library and Gay Men's Health Crisis (GMHC).

at that time covered the Ellipse, the forty-two-acre park between the White House and the Washington Monument. Nine years later, its 40,000 panels covered the full 300 acres of the National Mall.

The AIDS Quilt is the product of a moment in which a crisis was not only in process, but seemed to be exponentially, uncontrollably expanding, and so it constitutes a literal stitching together of lives lost in relative isolation. This chapter argues that the AIDS Quilt also, however, constitutes an intervention into the monumental tradition facilitated in large part by Black and queer representational strategies. The AIDS Quilt restages the infinite expansion that made its project of memorialization necessary in the first place as an architecture for its own infinite elaboration across space and time, such that its spread describes and intervenes in the false dichotomies of a separation between the *us* of the protected and the *them* of the susceptible that made HIV/AIDS so prolific. The rapid expansion of the NAMES Project was facilitated by a radically decentralized structure that presents a queer rejoinder to the traditional process whereby a monument is only able to come about through the work of a small, often homogeneous group of already powerful individuals. The AIDS Quilt puts the decision about inclusion into the hands of those who wish to self-identify, and makes the materiality of its own archive—the stuff of the lives and subcultures for which it stands—central to the monument itself. Moreover, though the AIDS Quilt emerged from the small, predominantly white, cis-male gay community— one that remains overrepresented within the AIDS Quilt relative to the demographics of HIV/AIDS itself but is by no means the only demographic therein—the key formal interventions it makes into the monumental form are, as this chapter will show, an inheritance of an African American quilting tradition, and of a queer archival approach. Such a tremendous diversity of lives and materials is represented in it that the AIDS Quilt is coherent only in terms of a logic of lives lost to a global pandemic that is still unfolding over four decades later.

In many respects, the AIDS Quilt answers to the terms of monumentality. It is born of a recognition within a particular community of the need for a material representation of a significant historical event on a grand scale, and it accomplishes this by conveying the gravity of a massive loss of life through a form that is greater than life-sized and impossible to grasp in its totality. It is also meant to call up in onlookers a sense of collectivized

Figure 2.8  AIDS Memorial Quilt, Block 0001: Marvin Feldman. Courtesy of National AIDS Memorial.

Foujita
1928

LISA HEFT 1987

# MARVIN FELDMAN

# The NAMES PROJECT

## A NATIONAL AIDS MEMORIAL

## PUBLIC MEETING
## 8:00 pm, Wed, June 10

Anyone interested in volunteering
time or talent to helping the NAMES
Project create a national AIDS quilt
to express our loss is urged to attend.
Everyone is welcome.

### The Women's Building
### 3543 18th, between Valencia & Guerrero

On October 11, 1987 The NAMES Project will
display a quilt memorializing thousands of
people who have died of AIDS. Covering large portions of the Capitol Mall,
the quilt is part of the National March on Washington.

For more information, call Mike Smith
Cleve Jones

Figure 2.9   First flyer advertising the AIDS Quilt, June 10, 1987. Courtesy of National AIDS Memorial.

self-recognition that may happen internally, but which takes place in public. The publics that encountered the AIDS Quilt did so on the National Mall, which is situated at a cultural crossroads, bounded by cultural and political institutions and anchored by the Washington Monument, an obelisk built to a figure whose conquests were of significance to the elaboration of the nation-state whose military he led. Though the vanquished of that war was an imperial other, the ability to wage it hinged on the establishment of a footprint on land belonging to an Indigenous other whose histories and attempted extirpation are often incorrectly told in, or wholly absent from, narratives of the founding of the nation. The Mall, in other words, both contains and is bounded by monuments and is monumentalized space, and it projects a unified national identity in part by eliding a range of violences and racial or cultural others that are far more original to the land on which the nation-state was established than its founding figures.

The AIDS Quilt resists key formal tropes of the monumental tradition, and does so in a way that makes space for, even turns on, minoritized communities. The ways in which it does this come into particularly sharp relief against the backdrop of the National Mall. It is horizontal in its orientation rather than vertical, and lays out each death not only according to the unique internal logic of each panel, but also along the same, ever-expanding plane, affording equal import to each life memorialized within without rendering them equivalent. It is materially heterogeneous; each panel is comprised of fabrics, objects, images, and words that are chosen by the panel's maker, and those decisions contribute to a multivalent, at times conflicting set of narratives about the experience of living with and dying from AIDS. In contradistinction to the way that traditional national monuments come about—via rare commissions that often follow a lag time and which have a long lead time[13]—the AIDS Quilt came into being before the event to which it referred had even reached its apex. Furthermore, it was begun not by a static group of individuals who had survived an event to create something in memoriam, but by a heterogeneous group of individuals with a wide range of investments, including some of the very same people who would eventually be memorialized therein.

The monumental interventions of the AIDS Quilt extend to the ways in which names are both selected for it and represented in it. In traditional monuments, material homogeneity is used to telegraph a uniform narrative of the triumph of one culture over

another in which myriad individual deaths are collapsed into a single allegory of death, rebirth, or both. When individual deaths are named, they are often listed according to rank, or other ordering logics of militarization or war. The AIDS Quilt, by contrast, is born of an architecture that all but ensures heterogeneity. Rather than listing names in an order governed by a particular set of conventions—such as alphabetically, by military rank, or, as Maya Lin does in the Vietnam Veterans Memorial,[14] by date of death—the Quilt puts the temporality of memorialization into the hands of its contributors. Further, its structural openness both within each panel and in its governing architecture facilitates—though neither enforces nor guarantees—the expression of individualized experiences of a shared condition, proffering a collectivized sense of the event without enforcing a single experience as a purported universal. The AIDS Quilt thus invites a multiplicity of meaning-making and interpretation that references traditional monumentality, but does this as a condition of its refusal of key traditional conventions of the monumental genre.

The formal interventions in the AIDS Quilt are both facilitated and amplified by narrative ones. It memorializes a loss at scale that was national in the ways in which it touched lives nationwide, and that continue to be palpably evident in multiple ways, including the greatly reduced numbers of the generation of gay men who survived to witness the proliferation of the virus into a global pandemic. But the first period of acute loss and governmental inaction is not broadly understood, either historically or in the present, as a national loss because of the social stigma around both the lives and deaths of those memorialized. With the exception of hemophiliacs, the groups most impacted by, and therefore associated with, HIV/AIDS were both loathed and feared in the dominant cultural imaginary because they lived in ways that enabled them to contract a virus largely believed to be a result of "lifestyles" considered undesirable within dominant culture, and because they died as a result of a virus widely misunderstood, and so occupied a range of subject positions antithetical to the discursive position occupied by those memorialized in most traditional monuments. The installation of the AIDS Quilt on the Mall allowed the NAMES Project to assert the centrality of these losses to the reality of the nation, and to point to their routinized exclusion from the national self-image.

The AIDS Quilt is also remarkable for being not just a monument, but also an archive that is self-selecting. Where traditional

monuments often draw on an archive to create a coherent narrative from the contents of history, or create an archive from the material of their choosing, the AIDS Quilt both draws from and contains within it a collection of heterogeneous material precipitates of a historical event and range of lives associated with and impacted by it. Each panel indexes a life or shared connection among multiple individuals, and the project is collective and ongoing, two structural qualities that set it apart from more traditional war monuments, in which a list of proposed names to be included is traditionally vetted to ensure both veracity (that the deceased did indeed die in conditions understood to be related to that war) and validity (that a veteran honored was not dishonorably discharged). By putting those decisions in the hands of panel makers, the AIDS Quilt decenters the authorizing conditions of the terms of representation away from both monumental and archival traditions of having a single authorizing source. Rather than offering a single narrative for an event that is recoverable into the national narrative, as is the case with war memorials, the AIDS Quilt contains panels to a breadth of subjects across diversely intersectional subjectivities as they are traditionally conceived and so also performs both the conditions of, and barriers to, participation and representation in monuments that purport to speak to a monocultural or universal ideal.

The mechanisms that have enforced the conditions of queer experience as something that both can and needs to be hidden, lied about, exorcised, or otherwise separated out from normative life inform queer forms of signification and representation. The heterogeneity of the AIDS Quilt reflects the ways in which queerness has historically and routinely pushed against homogenizing projects. Imperatives toward the obfuscation of queer subjectivity and experience functioned in the United States until the AIDS crisis as an exercise of what Michel Foucault calls biopower, or the development and deployment of "numerous and diverse techniques for achieving the subjugations of bodies and the control of populations" that have "acted as factors of segregation and social hierarchization, . . . guaranteeing relations of domination and effects of hegemony."[15] As a mode of social regulation, biopower is not exclusively tied to the regulation of queerness, but it aligns certain sexual practices with ideas of deviance, mental or physical illness, and other behaviors that reify dominant cultural norms through the regulation and exclusion of certain bodies or lives.

But the operations that created and emerged from the conditions of the AIDS crisis took things further. Because the AIDS crisis hit at the precise moment of a resurgence in social and political campaigns that sought to further institutionalize the marginalization of queer and trans people, campaigns to stigmatize people with AIDS and to prevent government action to stem the tides of the epidemic are an instantiation of what Achille Mbembe calls necropolitical power, or the administration of life and death as a manifestation of neoliberal social control in which life, as Mbembe says, is "merely death's medium."[16] By building a monument that is not just based on but which quite literally surfaces the archive that authorizes it, the AIDS Quilt lays bare the mechanisms of necropolitical control by resisting the separation of life from death, and of proximity to infection from distance from it. In doing so, as this chapter shows, the AIDS Quilt offers a novel approach to the monumental form that anticipates the strategies of monuments today by at once explicating the dominant narrative and suggesting an alternative that represents a more accurate view of the past and present.

### Quilting as Kinning

Among the most important features of the AIDS Quilt's is its insistent horizontality, which intervenes into monumental conventions born of a long tradition in Western culture of physical elevation as a metaphor for spiritual elevation. The coupling of physical and allegorical elevation is perhaps made most explicit in columnar monuments, which tend to be topped by a statue that elevates a figure's likeness high off the ground—an unsubtle metaphor for proximity to the divine that both is conditioned on and enunciates a separateness from the terms through which the human tends to be thought.[17] The AIDS Quilt violates the monumental regime of verticality, something unavoidably apparent to those who visited it on the Mall, blanketing the nation's most prominent monumental space at the foot of perhaps the most significant of the nation's monuments.

The contrast between the insistent horizontality of the AIDS Quilt and the sharp verticality of the Washington Monument, however, produces a less than purely binary situation in part because of the complex conditions out of which the Washington

Monument was raised. As Kirk Savage has observed, though the Washington Monument was intended as a symbol of "peace and amity," those terms were "purchased only with the acceptance of white supremacy and its violent social order" following the defeat of Reconstruction, a moment of "systematic retreat from" the government's "postwar commitment to civil rights" for the formerly enslaved.[18] Within two decades of the Washington Monument's completion the Mall itself underwent a dramatic reenvisioning. Its new designers pivoted away from Frederick Law Olmsted's initial 1882 vision for an "urban forest"[19] and opted instead for a blank space based on an earlier vision articulated by Pierre Charles L'Enfant facilitated by a set of clearcutting "acts of conquest and destruction."[20] Built into the origins of the Washington Monument and the space that surrounds it, then, is a fraught dualism that makes its thesis as a monument far less clear that one might expect; as readily as it can be read as performing a clarion vision of the nation's founding, it can be understood as an embodiment of the tensions that arise from the ongoing project of revising history and national identity.

The National Mall on which the AIDS Quilt was unfurled was designed around principles of clear lines of sight across and ambulation through a space both ringed and anchored by structures that monumentalize the nation-state. But these obscure or wholly elide a bevy of unresolvable contradictions in both the space and the nation-state that are in evidence in the two-toned stone of the Washington Monument and are laid even more bare by the AIDS Quilt. During its final 1996 installation on the Mall, the Quilt was nearly twenty times as long as the Washington Monument is from base to tip, and the scale of the loss to which it gestured already substantially exceeded even the most incautious estimates about the loss of life resulting from the Revolutionary War. The memorialization of war dead in an object with the scale and centrality of the Washington Monument traditionally positions the loss of those lives as central to the continued survival of the body politic: lives lost in war are rhetorically positioned as assimilable or even vital to national identity, martyrs valiantly fighting for a righteous national cause. Lives lost to AIDS were narrativized in a significantly divergent way, and individuals and communities were alienated, isolated, aggressed against, and left to die.

Though the AIDS crisis does not meet all of the criteria for the traditional definition of a war, which is the most common

motivation for monumental memorialization in US culture, con-temporaneous firsthand and historical accounts of those years certainly sound like they come from one: a rapid-onset, large-scale loss of life that skewed young and male. For those who lived through or in close proximity to those deaths, loss that had already come to pass was joined by a sense of the inevitability of losing one's own life or the life of yet another beloved. That sense inter-mingled with a range of other affective and material certainties and uncertainties that stemmed from being subject to a set of conditions over which one has no control. The AIDS crisis also answers to the wartime condition of the differential valuation of lives lost, which the theorist Judith Butler describes as a division between subjects whose lives are valued—and thus counted as "grievable" in death—and those not counted as lives at all, and are thus ungrievable.[21] It is not only that a life ended by AIDS was ungrievable, or the consequence of a dominant culture's devalu-ation of the various valences of otherness that exist beyond the racial, sexual, behavioral, or medical bounds of dominant culture. It was also the case in the 1980s that the fear of contamination—which stemmed from and permeated medical contexts, but also extended to cultural ones—made the stakes of grief and grievance especially high. Such a vocal and substantial proportion of doc-tors refused to treat the afflicted that in 1987 the American Medical Association deemed it necessary to declare that medical practi-tioners had an ethical obligation to treat people with HIV/AIDS.[22] That this pronouncement should be understood not as an isolated event but rather as a heuristic for the tenor of the moment is also apparent in the extensive scholarly work on the sociology and his-tory of violence against people with AIDS.[23]

The AIDS Quilt was begun at a moment when to grieve a death from AIDS was to make oneself part of an extended network of that contaminant, its presence an indicator that this disease, far from being cordoned off, already touched a growing number of lives that did not accede to the stereotypes that accompanied its emergence. In keeping with this history but in contradistinction to the upward gaze associated with the more traditionally mon-umental, the spectator looks down on those represented in the AIDS Quilt in a literalization of the ways that not only people with AIDS but others perceived to be at risk were often treated. While this characterization may seem to connote a denigration that lit-eralizes the dominant cultural relationship to those deaths, the

*Chapter 2*

embodied experience of viewing the panels is more akin to that of walking among graves, situating the spectatorial condition of viewing the AIDS Quilt as neither veneration nor denigration, but instead as intimately personal. This spectatorial relation shares with the conditions of losses in war the practice of graveside grieving that is not indexed to an intimate familial loss, or even to the presence of a body. War tourists visit military cemeteries or battlegrounds not only because of a personal connection to a particular individual who fought or was lost there, but also—perhaps more frequently—out of a sense of connection to the national narratives represented by a place and its sepulchral markers.[24] It may be the same instinct that has led humans throughout history to sequester ungrievable lives into physically liminal spaces in death that also gives rise to monuments, which have to them a different kind of physical apartness with markedly distinct resonances. As with monuments—at which we look up—there are directional locutions attendant to the marginalization of others as outsiders upon whom a "we" looks down. Tourists came to the AIDS Quilt, too, many with little connection to the lives memorialized; as the activist and art historian Jonathan David Katz recalls, visitors were moved to tears with enough regularity that volunteers laid out tissue boxes in the aisles between the blocks.[25]

The Quilt emerged at a key moment in which the national understanding of HIV/AIDS was shifting, if glacially, toward a greater realization that those affected might be part of a national "us," whoever might be interpellated by that deictic. Today we understand HIV as a global pandemic in which it is possible to live a full and healthy life under the right pharmacological conditions—an undetectable viral load is untransmissible, and a cure is within medical grasp—but the attitudes that facilitated our contemporary relationship to HIV/AIDS have come to pass only decades later and in spite of extensive and willful institutional refusals to spend time and money on HIV/AIDS in the opening decade of the epidemic. That HIV was likely sexually transmitted had been established early on within the gay community and among those impossibly rare health care providers who cared for people with AIDS without allowing fear and bias to provide a permission structure through which to ignore medical ethics. In 1987, the FDA authorized AZT for human trials, and the Centers for Disease Control launched the first AIDS-related public service announcements. That same year the US federal government

issued a ban on HIV-positive individuals entering the country that would not be lifted until 2010. The year the AIDS Quilt was started, in other words, HIV/AIDS was still seen as the most insidious kind of infection: difficult to prevent, impossible to cure, and overwhelmingly fatal as a result of an almost decade-long institutional refusal to look into it. By monumentally representing the consequences of this condition flat against the surface of the earth, the AIDS Quilt repositions these lives and deaths as an intimate part of the national self-image, both literally and conceptually reorienting how a national and collective loss might be monumentally rendered. By laying it out in one of the most hallowed of national spaces, the NAMES Project positioned the AIDS Quilt as a single body lying in state in a funerary manner usually reserved for figures of great national import, affording grievability to the lives that comprised the AIDS Quilt, and to those living who might understand themselves to be a part of the class it seeks to represent.

As important as location to the AIDS Quilt's ability to function as both a monument and an intervention into that tradition is the quilting tradition to which it refers. Quilting is generally understood as a craft that arises out of labor performed by women in pursuit of the creation of an object with a primarily utilitarian purpose. In the United States, quilts are often material precipitates of kinship networks, made to endure and be passed along generations not only of heterofamilial relation but also of other forms of kinning that arise through nonhetero reproductive forms of relating. The practice of quilting in groups—often called quilting bees—both stems from and contributes to the elaboration and strengthening of such networks. Until the emergence of Black and feminist art movements, quilting and other fiber-based arts were largely excluded from consideration as fine art, relegated to a lower cultural status as craft.

Quilting practices in the later twentieth-century United States were bifurcated along racialized lines, and histories of the AIDS Quilt have routinely emphasized a white-dominant tradition of quilting as its precedent.[26] This is in part because, by the time the AIDS crisis hit, that tradition was in wide circulation as a function of the central role quilting played in the expansion of network television. One of the first successes of a 1969 effort at PBS to develop television programming that would be good for all time zones was an instructional show by

Boston-based British designer Erica Wilson that focused on fiber arts, including quilts that emphasized symmetry, repetition, and pictorial themes that evoked a didactic Americana. *Erica* was popular throughout the 1970s and played a significant role in the adoption of both quilting and network TV across the United States.[27]

The connection between *Erica* and a particular vision of national identity is made explicit in the 1979 book *Erica Wilson's Quilts of America*. The book situates quilting in the United States as a European inheritance, and stages quilting as an important conveyor of the traditionally white-dominant mythos of American culture, foregrounding quilts that could be mapped through narratives that celebrate the ingenuity of "America's colonists" and laud "settlers of America's West" as intrepid elaborators of a national aesthetic tradition.[28] Wilson asserts that what sets US quilting apart from European practices is the use of the "patchwork" method, in which heterogeneous scraps were "overlapped without any formal design to save on thread and fabric."[29] Aside from the uncited attribution of this practice to an ancient Chinese tradition, there are few references to nonwhite populations, with one exception in the United States, a pattern style designated, also uncited, as a "Seminole Indian"-style quilt.[30] *Erica Wilson's Quilts of America* included numerous quilts already held in the Smithsonian's collection at the time of publication, which suggests that this particular type of quilting and the narratives with which it was freighted already overlapped by the end of the seventies with a national self-image.

The patchwork method described by Wilson is a rare departure from the highly regimented pictorial and geometric designs that comprise the overwhelming majority of quilts featured in the book. But patchwork quilts would have been relatively well known in major coastal cultural hubs by the time *Erica* was distributed as a consequence of another, US-based quilting tradition. This other tradition had emerged in Wilcox County, Alabama, an area located in the Black Belt, so named for the nutrient-dense soil but semantically redolent of the richness and multivalence of Black history and culture in the region. The quilting tradition in Wilcox County can be traced at least to the early nineteenth century, when a white slaveholder whose last name was Gee had purchased a large plot of land in what has since come to be known as Gee's Bend and, in 1816, moved there with the people he had enslaved to establish

a cotton plantation. Upon his death, the land was inherited by a different white slaveholder by the name of Pettway, who, upon assuming control of the land, marched the hundred or so people he had enslaved in Halifax County, North Carolina, on foot to Alabama—a journey of around 750 miles.[31]

As in much of the rest of the rural South, when slavery was abolished the lived experience of African Americans in the area did not change substantially. Though the community in Gee's Bend transitioned to being tenant farmers or sharecroppers, their earning power and voting rights remained highly circumscribed. While many African Americans in the South participated in the Great Migration, most of the residents of Gee's Bend remained in place, according to the art historian John Beardsley. The land they had farmed for generations was isolated, a condition enforced substantially by the then-unbridged Alabama River that surrounded it on three sides. Over the subsequent century, the residents of Gee's Bend—around a hundred in the mid-nineteenth century[32]—suffered and survived cycles of destitution that resulted from the actions of the several white landowners through whose hands the land passed. For example, when one of the white people who had owned the land for a number of years died in 1932, his estate foreclosed on over sixty of the families who had farmed the land for generations, and seized what Beardsley characterized as "every kind of negotiable property: livestock, farm implements, hand tools, even stored corn, sweet potatoes, and peanuts"—in other words, all their food stores, and all their means of production to replenish them.[33] The community survived through a combination of perseverance and happenstance; by all accounts on the verge of starvation, they made it through that winter foraging, hunting, and fishing, and on flour and meal rations sent from the Red Cross by boat.[34] Events like those of the winter of 1932–1933 were interspersed with interventions by experimental programs run by federal and state agencies that approached Wilcox County in general and Gee's Bend in particular as a test case for aid initiatives, but did not provide ongoing support.

The history of Gee's Bend also contains an example of African American community efforts of placemaking mentioned in the introduction to this book. In the early 1960s, residents of Gee's Bend traveled to Selma, Alabama, to hear Dr. Martin Luther King Jr. speak, and subsequently invited him to their rural community, where he spoke in February 1965 at the Pleasant Grove Baptist

Church.[35] Dr. King's visit was of profound significance to the community; Ethel Mae Pettway recalls that Dr. King "helped us stand straight. . . . I guess we was just meant to be poor. . . . Don't reckon Dr. King or anyone else could change that. But we're not ashamed anymore. That's what he did . . . and we believed him, and we still do."[36] Three years later the town, which had grown to around a thousand people in an area of just over 300 acres, petitioned to change the name of their region, long named for the men who a century before had enslaved their ancestors and forced them onto the land they now owned, to the Town of King, a testament to the power of the practice of naming and renaming.[37] Though they were not pursuing a monument, their effort certainly meets the definition of monumentality in terms of the interpellative effects the name change was intended to have on the community. Their petition was ultimately denied, underscoring that Mrs. Pettway, her family, and neighbors were indeed not meant, more or less than anyone else, to be poor, but were instead the survivors of structural racism.

Dr. King spoke at Pleasant Grove a month before the events of March 7, 1965, that would come to be known as Bloody Sunday, when a march for civil rights from Selma to Montgomery was met with extraordinary police violence on the Edmund Pettis Bridge. Among myriad other effects of that march and the ensuing violence, Gee's Bend legend is that it inspired a white Episcopal priest named Francis X. Walter, who was originally from the area but living elsewhere, to move home and organize for civil rights. As has been often recounted, Walter was driving through Possum Bend, another rural and predominately Black community to the southwest of Gee's Bend, when he stopped to look at a clothesline with unusual quilts outside a home. Noticing someone inside the nearby house, he headed over, but the person he saw, Ora McDaniel, on seeing a white man approaching her house ran into the woods,[38] a highly logical response given the times and conditions. Walter would later return with someone McDaniel knew, and soon began buying quilts from McDaniel and other local quilt makers. His original intent was to sell them to fund the Civil Rights movement, but he eventually augmented that plan to respond to the needs of those who had made them, eventually resulting in the Freedom Quilting Bee, a collective established to promote the quilts and turn them into an economic engine for the women of the area and the people they supported.[39]

The style of the quilts of Gee's Bend and the surrounding area is a mixture of inheritances of African quilting traditions and those learned as a condition of enslavement. African American quilters in the antebellum period combined both traditions, but these quilts garnered national attention because of the historical moment in which they began to circulate in a larger context, because their aesthetics resonated with the formal conditions of abstract and minimal art, two movements that had predominated in the decades immediately before the quilts of Gee's Bend began to circulate beyond their local communities. For example, in a 1970 quilt by Lucy T. Pettway, brightly colored strips are laid out in a rectangular pattern around a central square that both echoes the shape of the form of the quilt and also has an optical effect afforded by the precision of the junctures within the pictorial field, a style known as "housetop" that looks similar to the work of Josef Albers or Frank Stella. Similarly, the all-over color of other quilts, such as Lorraine Pettway's *Strip Quilt* (1974), would have been legible through the terms of abstraction, while also giving tell to their own materiality in a way that resonated with contemporaneous interests in assemblage and minimalism. *My Way*, made by Rachel Carey George in the 1970s, can also be seen through the terms of abstraction of the moment while retaining an insistence on its own style, an effect that stems from the quilt's development at a remove from the dominant aesthetic terms in New York. In each of these examples the quilter draws from long-standing material and pictorial traditions, including the process of piecing—using leftover or scrap fabric—as the formal constraint that determines the overall pictorial effect. These quilts, then, resonate with the formal terms of fine art evolved in New York in the decades preceding the art world's introduction to them, but cannot be mapped through or reduced to them.

By 1970, the quilts of Gee's Bend and the Freedom Quilting Bee had circulated widely through the United States. In 1968, they began working with a marketer in New York, secured a $20,000 order from Bloomingdales, and appeared in *Vogue* three times between May 1968 and June 1969.[40] The Freedom Quilting Bee quilters were also given patterns devised to cater to these new markets, which they integrated into their existing formal vocabularies, as in the example of Nettie Young's *Milky Way* (1971), a variation on the H-style quilt with what Lucy T. Pettway called a "snowball quilt" that recalls the aesthetics of the Bauhaus. By 1970,

Figure 2.10   Lucy T. Pettway, *Housetop*, 1970. Copyright 2024 Estate of Lucy T. Pettway/Artists Rights Society (ARS), New York.

Figure 2.11   Lorraine Pettway, *Medallion Work Clothes Quilt*, 1974. Copyright 2024 Lorraine Pettway/Artists Rights Society (ARS), New York.

Figure 2.12   Rachel Carey George, *My Way*, ca. 1970s. Copyright 2024 Estate of Rachel Carey George/Artists Rights Society (ARS), New York.

Figure 2.13   Nettie Young, *H* (*Milky Way*), 1971. Copyright 2024 Estate of Nettie Young/ Artists Rights Society (ARS), New York.

Gee's Bend and the Freedom Quilting Bee would have been part of the discursive and aesthetic milieu of major cities including New York and San Francisco. *Erica Wilson's Quilts of America*, published a decade after the Gee's Bend quilts came onto the national aesthetic stage, may have learned from their precedent; the book situated mid-nineteenth-century quilts in the white-dominant tradition through more contemporary aesthetic terms, claiming that these much earlier quilts had to them "very modern Op art effects."[41]

Perhaps because of the long-standing craft and multivalent nature of quilting traditions, there are few if any formal constraints that define a quilt, and conventions often vary significantly among communities. Beyond providing comfort and warmth—a charge that might be fulfilled by any number of non-quilt objects—what defines a quilt also differs among communities of quilters with only vague regional specificity. What one tradition might understand to be a hard and fast rule—of piecing elements together every three inches, for example, as in certain communities in the US Northwest that took their cues from *Erica*—fundamentally contravenes the more free-form aesthetics of other communities, which might be determined by the kind of scraps available, or by familial tradition, as in Gee's Bend. It is entirely possible that the only parameters on which a majority of practitioners might agree is that a quilt have three layers (backing, batting, and the top layer, which are quilted together), and that whatever rules the quilter follows provide an armature for a design that is indexed exclusively to that object; that each quilt, in other words, is unique.

Between the introduction of the quilts of Gee's Bend and the popularity of *Erica*, quilting was a part of the cultural discourse in major cities by the time the AIDS crisis hit. The mythology around the AIDS Quilt often situates it as an inheritance of a white-dominant tradition, likely the result of statements by one of the founders, Cleve Jones, that he was inspired by quilts his grandmother made.[42] But the NAMES Project's ultimate selection of the medium of quilting, combined with a material and aesthetic subversion of the conventional rules of quilting for the purpose of carrying on languages and connections across time, separation, and death, resonates far more with African American quilting traditions. It is an aesthetics related to this tradition that facilitates the AIDS Quilt's participation in a multivalent set of communitarian discourses that, under many other circumstances, are separated out into discrete identitarian projects.

The AIDS Quilt contributes to the elaboration of the tradition begun in Wilcox County by offering its own pieced system. Like many Gee's Bend quilters who make quilts from whatever clothing scraps were available or provided by customers, the AIDS Quilt is constituted from heterogeneous elements submitted by community members. Whether drawn from a person's effects, found by happenstance, or purpose-bought for the occasion, the component parts that make up the AIDS Quilt mix the formal and material terms of quilting with objects not traditionally associated with that tradition.[43] Though this material intervention occurs on the level of the individual panel, it is also in evidence in the monument and its intervention as a whole. Where the bronze, marble, and granite of traditional monuments are both drawn from and contribute to the formal conventions of the monument, the AIDS Quilt contains a vast heterogeneity of elements that may accede to the conventions of quilting—such as softness, pliability, and the provision of warmth or comfort—but just as often disrupt them. This admixture of tradition and its rupture is inflected by more broadly legible subcultural signifying regimes that produce an interpictorial (or, more precisely, interpanel) dialogue: objects that might appear in a single panel—teddy bears, bowling shirts, or even the fact of a person's multiple memorialization—come into conversation with other instances of the same object, such as in the panels for David Miller, memorialized differently by those from distinct spheres of his life. Such repetitions constitute an intermediary layer of signification that occurs among panels. If one begins to look for them, there are multiple panels with jock straps, vests, and other accoutrements identifying the person as a member of leather or BDSM communities; cowboy boots to indicate participation in a two-step group; and multiple panels featuring the same Gay Men's Chorus T-shirt. The matter of a single life taken up into this endlessly complex project of memorialization contributes to a material heterogeneity that reflects an expansive array of entangled narratives of individual and distinct lives ended in similar ways, a polyvocality arising from countless smaller signals of subcultural identification impacted by the crisis that echoes across the superstructure of the AIDS Quilt as a whole.

As a collective project made in a range of ways and places, the AIDS Quilt reconstituted some of the community lost or cut off earlier in the epidemic. Quilting bees were a powerful rejoinder

Figure 2.14  AIDS Memorial Quilt, Block 3278: Fort Worth TX Cowtown Leatherman: Mother Michial Robinson, Gary Taylor aka Raina Lea, Carl Thorp, Allen Mosley, Mitch Hunley, Mink, Ray Hubbard, and Rick Knight. Courtesy of National AIDS Memorial.

to the profound isolation that had marked the early years of the epidemic, offering one of only a few opportunities for those both living and supporting those with AIDS to come together and perform an act of care not directly related to the maintenance of their own or another's body in a way that would last beyond their own lifetimes. As communities with significant loss were often the best-educated on how the infection spread, what drug trials were available, and how to care for or make comfortable or support people with AIDS, quilting bees also became an important site through which that information could be shared.[44]

The practice of quilting as a site of information sharing is also an inheritance of African American traditions in the United States. According to the scholar of folklore and English Gladys-Marie Fry, quilts were a vital part of the Underground Railroad.[45] As historian

Jacqueline L. Tobin and art historian Raymond G. Dobard have demonstrated, patchwork quilts provided "metaphors and signs" to signal to those escaping to the North when to go, what route to take, and how to stay safe on the way. Dobard and Tobin have suggested that people learned the code through sample quilts that had all of the signs in a single object.[46] A single quilt with a single pattern corresponding to a single message might have been all that was needed at a particular location, laid out on a fence and unnoticed by white enslavers because it would be assumed the quilt was being aired out. As Fred Moten has observed, the experience of moving beyond the condition of being fugitive is an act of agency, but one that may not necessarily have an endpoint: "the whole point about escape is that it's an activity. It's not an achievement . . . you don't ever get 'escaped.'"[47] The subcultural codes that may have their closet historical correlate in the quilts of the Underground Railroad evidence this ongoing agentive fugitivity, leveraging information asymmetry in broad daylight. A similar opacity would be used over a century later in the AIDS Quilt, in which the kinds of in-community codes long invisible to those beyond the gay community were on full display, but the meaning of any of the systems of signification would have only been provisionally available to any individual viewer regardless of whether they identified as queer.[48] Uncovering the presence of such practices is foundational to the repositioning the enslaved subject as actively engaged in the process of becoming free, and vital to understanding the AIDS Quilt as an active practice of resistance.

### Sepulchral Relations

In the AIDS Quilt, lives came together through signifying systems in ways that were either infrequent or impossible in life during the crisis. This was especially true early in what is now an AIDS pandemic but was then still an epidemic, as fear fed rifts between the infected and uninfected. This in turn led to years characterized by an ineluctable sense of isolation mixed with and heightening other sensations of loss and grief that continued to stalk sociality in affected communities long after. In addition to being marginalized on account of being who they were, people with AIDS faced the additional stigma of being a carrier for an infection that was

not widely understood, which in turn gave way to the spread of disinformation that kicked what was just *de rigueur* marginalization, previously tempered by building or being in community with others like oneself, into high gear. To be infected was to face, often while terminally ill and cut off from social networks and human touch, a refusal of service from broad swaths of a medical establishment unwilling to treat people with AIDS, and to have little reason to hope that medical and other providers' ability or even willingness to provide curative or palliative care would change in time.

Mourning was also profoundly impacted, regulated by the state through additional, extramilitary machinations in the name of national serosecurity. Next of kin who were notified and to whom bodies were released (when they were released at all) were often the biological family. Though standard operating procedure, this was devastating in the queer community because this often meant that mourning rituals were placed in the hands of biofamily rather than—and often to the exclusion of—partners and other queerly kinned relations. The drumbeat of losses that were already complicated by tensions over who had the right to mourn or bury an individual were further heightened by the fact that this loss took place at scale but was not recoverable to the narrative of a national tragedy, where mass death is framed discursively as an exceptional event that momentarily interrupts and not, as was the case during the AIDS crisis, an ongoing condition in which the experience of mourning is coextensive with the comprehension of an ever-widening scope. The unwieldy expansiveness of that loss—and its corollary in the theoretically infinite possible expansion of the AIDS Quilt—stands in dramatic contradistinction to the highly regulated, architected, and choreographed spaces like the National Mall.

The AIDS Quilt provided a way of mourning those lost to AIDS with a corollary body—one associated, as quilts are, with comfort, an affective condition that is often out of reach when experiencing grief. But the kind of comfort provided by the AIDS Quilt does not stem from the same haptic conditions of weight and warmth from which traditional quilts derive their comfort, in part because the materials that comprise the AIDS Quilt are not uniformly insulating or soft. Though backed by fabric, the heterogeneity of the materials and forms within or affixed to the panels, coupled with their collection into larger, bordered panels meant

to be looked at and not touched, contravenes the traditional conventions of quilts in a way that rhymes with the way in which the AIDS Quilt contravenes the orientation of traditional monuments. The comfort the AIDS Quilt offers, then, exceeds the physical limits of the object, and might be better understood as a "comfort object" or "transitional object," terms developed by the psychoanalyst D. W. Winnicott to refer to something tangible into which an individual cathects, or invests, attention and psychic energy to ease the trauma of a significant transition.[49] In Winnicott's writings on early childhood development, transitional objects are crucial to a child's ability to transition among the various stages of development, an object such as a stuffed animal providing a sense of stability as their perception of the world changes, and a way of moving emotionally through events that otherwise feel untenable.

Echoing Winnicott's theories of childhood development, the activist and art historian Douglas Crimp described the AIDS Quilt as an object that solicits hypercathexis, or a significant emotional investment. For Crimp, panels aid the living in detaching emotionally from the deceased through a process of psychically investing "hopes and memories" associated with that person in the "mementos associated with the lost object."[50] Both Winnicott's and Crimp's frameworks underscore the importance of a material object for the individual's ability to process loss. They also both understand processes of care to take place on haptic as well as visual levels. This compound process is crucial to the way that the AIDS Quilt both functions like and differs from more traditional conceptions of the transitional object. The maker is afforded that affective admixture, but most people who engage with the AIDS Quilt do so through sight, rather than touch. In this context comfort or solace often sought in mourning comes, in contradistinction to traditional quilts, from the projected valences rendered symbolically through cathexis. Extending Crimp's formulation to include not only the spectatorial relation of viewing the AIDS Quilt—which, on the Mall, was a profoundly public act—but also the sociality of quilting bees, this process of psychic investment may have led, per Katz's testimony, so many viewers to tears regardless of proximity to the AIDS Quilt or the plague because of the way that many in the West are accustomed to reading quilts, personal effects, and a range of other objects as transitional.

The affective valences of comfort and care are also associated with practices of tending, a kind of labor traditionally associated with the labor of women that is also often largely invisible to normative frameworks for the valuation of labor under capitalism. In a way, the AIDS Quilt meets the conditions of a routinized exception to those rules in which a crisis offers a permission structure for those not gendered male to perform roles usually designated as such, as is often the case in times of war. As noted by Cohen, Sarah Schulman, and Jih-Fei Cheng, among others, cis women during the AIDS crisis were crucial to supporting the communities around them, performing acts of care alongside those who were themselves at risk of getting or already themselves sick, when no one else would tend to those who were dying.[51] To tend to the AIDS Quilt can thus be understood as a labor of care for both an individual body and a collective one that can also take place long after those lives have ended. Many who stepped in to perform these acts of care but who were not in a high-risk group for contracting HIV contributed to the establishment of these and other practices passed down through queer kinship networks that extend into this moment. For example, getting tested for HIV every time one goes in for a blood panel, even when at incalculably low risk for contracting the virus, is an act of solidarity with those who fought for the research to develop such tests, survived because of them, or died before they came to market.

Contributors to the AIDS Quilt both past and present also partake of experiences that are at once collectivized through the experience of working in constraints of panel size, and highly individuated in how a single person might relate to the object. The simultaneity of individual and collective systems of signification also evidences a very social history attendant to both the AIDS Quilt and the conditions of its emergence. These perhaps little-noticed but powerfully resonant systems of signification—to which viewers will never be privy in totality—are particulate traces of communities that often, sometimes only, become visible as a condition of the disappearance of the communities that birthed them. Distinct from the history of quilting but very much in keeping with that of monumentality, the AIDS Quilt also comes into being as a condition of a mass near-extinction event. The residual systems that signify discursively on scales large and small, visible and not, inflect the space between the particularization of the individual and the otherwise totalizing uniformity

that results from standard conjunctions of narrative and form, describing a condition of multiplicity and in-betweenness that undermines any hard and fast distinction between one group and another.

## Of Mourning and Militancy

As this book has repeatedly asserted, the articulation and reification of distinctions are central rhetorical features of traditional monuments. They are also two of the most important ways in which the AIDS Quilt intervenes in that tradition, manifesting in the heterogeneity of materials and aesthetics, and in the perennially blurred and mobile meanings it makes available. The radical openness of its structure also contravenes the material valences of traditional monuments, like endurance and impenetrability, that tend to align with the idealized terms of normative white heteromasculinity in the United States. By contrast, the AIDS Quilt is open to infinite expansion, and inclusion in it is is premised on an infection with profoundly minoritized associations. Its heterogeneity also contrasts sharply with traditional monuments, both because such a diverse range of lives and experiences are included in it, and in the use of soft, stretchy, other otherwise non-solid-seeming materials. This decentering of multiple normatively monumental tropes points not only, however, to a usurpation of a masculinized materiality by a feminized material and process but also to the abrogation of more fundamental binary constructions attendant to the monumental form, thus demonstrating that material conventions that may seem natural are instead naturalized.

The NAMES Project was founded the same year as the AIDS Coalition to Unleash Power (ACT UP), an initiative begun by the playwright Larry Kramer in response to years of government inaction and cultural silence that played a key role in bringing about a shift in perception both within and beyond the medical community. Using activist tactics both established and novel, such as die-ins and political funerals, ACT UP advocated loudly and publicly for institutional action in urban centers, eventually catalyzing the allocation of funding for research and treatment, including the authorization of AZT, the first available antiretroviral, for human trials. In comparison to this hypervisible, hypervocal organization

primarily oriented around urban centers, quilting bees were more discrete and diffuse.

As evidenced by contemporaneous accounts of the tensions within AIDS activist communities, some perceived the AIDS Quilt as striking a plangent tone that suggested surrender to the plague and, by association, to the institutional forces that created the conditions for it to decimate communities. Kramer called mourning rituals "ghoulish";[52] Eve Kosofsky Sedgwick recalls being "angry at the Quilt" for its "nostalgic ideology and no politics";[53] and Sarah Schulman relays the existence of a belief that the AIDS Quilt "was being used mostly . . . to give the right wing cover for their inaction on AIDS."[54] But as noted by Sedgwick and Crimp, both of whom were also on the front lines of AIDS activism, the AIDS Quilt cannot be reduced solely to mourning. It speaks not with one single tone, but rather through a veritable cacophony of voices from many individuated panels and, simultaneously, from the signifying systems that emerge across multiple panels in which, for example, the same jock strap or leather flag or bowling shirt recurs. These objects, or depictions of them, call or reach across other panels, making the AIDS Quilt endlessly collective in a way that undermines any purported universality or singularity. This multiplicity also gestures to the fact that to die "of AIDS" is not one thing; the range of AIDS-related opportunistic infections like Kaposi sarcoma (a common early indicator) or pneumonia (a frequent final cause of death) that co-occur with or precede AIDS deaths makes it a blurry, dispersed, and irreducible target.

The AIDS Quilt's complex tonality is evoked by Sedgwick in an account of seeing panels on display in 1988: "the square I had no way of dealing with was the one appliquéd with SILENCE = DEATH and ACT UP T-shirts: not because of them, but because of the unplaceable, unassuageable voice of its lettering, which said starkly: 'HE HATED THIS QUILT.'"[55] In Sedgwick's telling, the deceased's politics are ventriloquized by friends leveraging a medium the subject purportedly hated to memorialize him anyway, his allegiance to a politics different from those the AIDS Quilt was accused of trafficking in articulated through the inclusion of an ACT UP T-shirt. At the same time, this panel is part of a subculture of panels that include ACT UP T-shirts; whether those same politics were shared by others who were memorialized with ACT UP T-shirts cannot be known from the panel, leaving the politics of both the panel and the person it memorializes ambiguous.

Figure 2.15  AIDS Memorial Quilt, Block 1268: Terry Sutton. Courtesy of National AIDS Memorial.

Sedgwick cites this panel in a talk she gave titled "White Glasses." Like the AIDS Quilt and its component parts, her talk can be read as a love letter to a dying intimate, but also opens onto devices to think structurally about raced and gendered asymmetries of living, illness, and death. Sedgwick opens with an account of meeting a beloved, Michael Lynch, noting that the talk is not, as she thought it might be when she began writing it, an obituary for him. As she records Lynch's battle with AIDS, which ebbs and flows apace of her own with breast cancer and the loss of other friends, Sedgwick grapples with the tension between mourning and militancy within the queer community during the crisis, the AIDS Quilt standing in for mourning, and ACT UP for militancy. Sedgwick points to the narrative conflict all but implicit in the muddied waters of belonging among these ostensibly differently politicked organizations: "Churned out of this mill of identities crossed by desires crossed by identifications is, it seems—it certainly seemed in October 1987—a fractured and *therefore* militant body of queer rebellion."[56] For Sedgwick, as for Crimp, and also for traditional monuments, mourning and militancy are not diametric opposites, but rather two sides of the same representational coin, each impossible without the other.

Sedgwick slightly misremembers the panel that so powerfully evoked this tension for her, made by Gert McMullin, an AIDS Quilt cofounder and long-term caregiver for the Quilt, with Leslie Ewing in honor of Terry Sutton.[57] It does include the text Sedgwick repeats, along with a drawing of an ACT UP shirt and a small

"SILENCE = DEATH" medallion, but in smaller lettering below "HE HATED THIS QUILT" are the words "AND SO DO WE!" Reread in full, the panel even further complicates any easy repatriation of the narrative to the already murky binary Crimp characterized as "mourning and militancy" by demonstrating the slipperiness of aversion and affection, anguish and anger, in the realm of such heightened affective charge and such profoundly circumscribed power.

In identifying within the multiple voices contained by the AIDS Quilt a polyvocality that is also often fractious or conflicting, Sedgwick performs an ambivalence in the AIDS Quilt that also stems from and echoes the experience of living through and in that time, each of which is anchored in a multivalent loss that reverberates through the text. When Sedgwick delivered "White Glasses" as a talk on May 9, 1991, she closed by addressing Lynch directly: "Hi Michael! I know I probably got almost everything wrong but I hope you didn't just hate this. See you in a couple of weeks." Smaller, italicized text added for publication reads, "Michael Lynch died of AIDS on 9 July 1991"—two months to the day later.

Both individually and together, the two endings of "White Glasses" constitute what Sedgwick calls the "obituary relation," a form of speech that "rupture[s] conventional relations of person and address" such that "anyone, living or dead, may occupy the position of the speaker, the spoken to, the spoken about."[58] Reliant in no small part on deictics—linguistic shifters that gesture to multiple people at once, such as the word "you," which can address any reader—the obituary relation is perhaps best exemplified by the epitaph, a form of memorial writing often found on a gravestone but that was also used in the AIDS Quilt, where a person might be described in the third person ("she was . . ."), in the second person ("you were . . ."), or in the first person ("here I lay . . ."). The obituary relation makes any reader into someone with a personal relationship with the deceased, even interpellated as the deceased. In the AIDS Quilt, the obituary relation manifests in phrases Sedgwick recalls encountering: "Love You! Kelly." "Frederic Abrahams. 'Such Drama.'" "Roy Cohn. Bully. Coward. Victim." Though written by those mourning for the dead, deictics interpellate any viewer who takes the time to read them such that, as Sedgwick puts it, "we hardly know whether to be interpellated as survivors, bereft; as witnesses or even judges; or as the very dead."[59]

Though Sedgwick's obituary relation is not strictly textual, the unrestricted possibility of slipping into the position of the deceased has the perhaps unintended consequence of making it vulnerable to a range of foreclosures that threaten to erase distinctions between differences, such as that which arises from the specificity of subjective experience.[60] Though powerful in part because it is agnostic to the subjective differences among living and dead and the experiential differences among those who understand themselves to be at risk for infection and those who do not, the obituary relation contains a degree of agnosticism about the specificities of, for example, race, gender, or sexuality among the speaker and the interpellated. The AIDS Quilt, by contrast, with its uneven demographics and multilayered signifying systems, sets up a different kind of signification that is at once more broad in attending not only to the reader of a specific panel but also to visitors to the AIDS Quilt as a larger object (whether in person or to its digitized archive), and capable of greater attention to the differences among subjects—particularly important given that many of the "I"s are living, and many of the "you"s are dead.

The spectatorial relation set up by the AIDS Quilt is therefore more akin to what might be called a sepulchral relation that gestures not to the distinction between the living and the dead but rather to the tonal gloom and materiality of a tomb, where death is all around but not so easily separated from life. To look to the sepulcher—a tomb or monumental space meant to house a body in repose but that is, crucially, also a space for the living and which implies or allows for ritual[61]—rather than the obituary as a correlate for the AIDS Quilt is to take into account a material or conceptual space for the deceased, even when the body of the deceased is there. Sometimes such a space is created in advance of the body's coming, and though that space does not change as a condition of either its specificity or presence, how the visitor or viewer relates to that space may vary not only as a condition of whether the body is there or not, but also of the viewer's own subjective experience. A sepulchral relation makes it possible to foreground distinctions among different subject positions, material precipitates of the living and the dead like both the AIDS Quilt and the objects contained within or attached to it, funereal or mourning practices, the ways in which we each individually relate differently both to objects and to death and dying and the subversion of the conventions of those and other normative rituals.

These different ways of relating to objects might also include differences in how one comes to an object; whether and to what degree one brings prior knowledge or openness to an experience; how one touches or imagines touching something or someone; and the ways in which differing conditions of encounter impact perception. These multiple and constantly shifting terms unfold and change in real time and contribute to the terms of viewing the AIDS Quilt that, like the object itself, are at once highly individuated, broadly universalized, always in flux, and bridged in those conditions by a range of extra- or subtextual trends.

The sepulchral relation presupposes that there is an imperative for accounting for both subjective and collective experiences of the affective experiences of loss and death in view of the historical specificity of the moment, the terms of each panel's making, and the ongoing conditions of the HIV/AIDS crisis as the pandemic that it has become. It enables us to think through the ways that loss itself can persist in the subject in different ways. For some, they might be haptic or spatiotemporally located for some, while for others they might manifest as an a- or transtemporal haunting that is rarely the dominating thought but which is always present. The sepulchral relation renders the subject unstable not only through the linguistics of a deictic but also—and perhaps more profoundly—by the interpellative effect through which a piece of one's consciousness never quite leaves a moment in the past.

That viewers adopt fragments of experiences as a condition of spectation is given form in one of the most recognizable works of AIDS-era art. Felix Gonzalez-Torres's 1991 *"Untitled" (Portrait of Ross in L.A.)* consists of a large volume of hard candy in brightly colored, metallic wrappers spilled into a corner. When installed, the work weighs 175 pounds, which correlates to the weight of the artist's partner Ross Laycock before Laycock began losing weight as a result of the toll that AIDS was taking on his body. Signage accompanying the work encourages visitors to participate in it by taking a piece of candy; viewers who acquiesce to this request participate in an act of communion, taking in another's body and being bound to it in reverence and submission, but in lieu of the body of Christ denoted by a wafer is a brightly wrapped piece of candy standing in for the queer and HIV-positive body. Those who participate become complicit in a metaphorical extinguishing of a life. Each piece of candy works in the body the way the deictic works on a page; to take one is to ingest by association an infection

of both putatively but not truly contagious homosexuality, and highly infectious HIV, turning the participating spectator into a carrier of a wide range of behaviors and presumptions yoked through dominant narratives to HIV/AIDS regardless of whether they are aware of the multilayered meaning of the work.

*"Untitled" (Portrait of Ross in L.A.)* is among a number of works made primarily by artists with close ties to the AIDS crisis that do not overtly deal with HIV/AIDS but which cannot be understood without accounting for it. Such projects answer to the terms of what Katz calls the "poetic postmodern," a representational strategy born of the dissimulative practices leveraged by gay American artists at the midcentury and built on by artists during the AIDS crisis that appeared to conform to the representational conventions of the moment, but that also mobilized semantic slippages that made possible a range of interpretations that changed based on the subject location of the viewer.[62] Katz argues that Gonzalez-Torres's viral works in candy at once complicate and erase binary distinctions between self and other, queer and het, infected and protected, and, in so doing, challenge normative ontological formations that give rise to such categorizations in the first place.[63] By subversively incorporating the viewer who, knowingly or not, becomes complicit in the realization of the work of art, *"Untitled" (Portrait of Ross in L.A.)* turns even those with a politics hostile to homosexuality into vectors for the spread of this queerly crisp aesthetic.

The AIDS Quilt has to it little of the coding, dissimulation, and "cool, postminimalist" aesthetic that Katz describes as central to the poetic postmodern.[64] But the sepulchral relation shares with the poetic postmodern a slipperiness between the roles of maker and memorialized, and between different kinds of viewers privy to different signifying systems within, that manifests in the AIDS Quilt in both textual and orientational ways, turning all viewers—regardless of serostatus, relationship to the plague, or relationship to queerness—into graveside grievers, the intimates of those with or at risk for HIV/AIDS, or both simultaneously. This queer and viral spectatorial condition works across a fine ontological crack, an ill-defined line that draws attention to the separation between two things even as it shows how close they are to one another, not just between the living and the dead, but between those intimately affected by AIDS, and those without a way of grasping that loss.[65]

As with Sedgwick's obituary relation, deictics are crucial to the sepulchral relation. Deictics were used extensively by authors

during the AIDS crisis in part because, as the theorist Lauren Berlant observes, the shifter "makes the people impacted by AIDS *kinds of people* who are not identical . . . to any biopolitical norm."[66] An extension of Berlant's statement might also apply to the AIDS Quilt, whose deictics make all viewers identical to a necropolitical norm, collapsing the difference not only between those who are affected and those who are not—a distinction whose maintenance is critical to the ongoing project of upholding and sustaining dominant culture—but between those whose lives hang in the balance and those whose do not. In this multiple materiality that aggregates to a polyvocal cacophony of voices, we are not all made equivalent, but we are all equivalently at risk.

### Archival Shadows

In one of the most widely circulated images related to the AIDS Quilt, a young man holds up a panel he made for himself that reads, "My name is Duane Kearns Puryear. I was born on December 20, 1964. I was diagnosed with AIDS on September 7, 1987 at 4:45 pm. I was 22 years old. Sometimes, it makes me very sad. I made this panel myself. If you are reading it, I am dead . . ." Puryear made his panel in 1988, completing it on the Ellipse, just south of the White House, when the AIDS Quilt was displayed there,[67] and when Puryear died in 1991, his panel was incorporated into the Quilt. Seeing the panel in his hands is different from seeing it incorporated into the AIDS Quilt: in his hands it opens onto the possibility of death, while in the Quilt it gestures back toward the previous condition of life, interwoven on both material and significatory levels with others' lives and deaths. That it is possible to take in both versions of the panel at once is an instantiation of the sepulchral relation through which it becomes possible to experience life and death in simultaneity.

The photograph of Puryear with his panel describes a relationship between lives lived and lost and incorporated into the AIDS Quilt that maps onto a rather traditional trajectory from the archive to the monument. In some conventional expressions of the form, the monument is drawn from an archive, a body of information that determines what or whose stories are included in the monument, but also whose are not, to create a narrative coherent enough to be representable in the reductivist terms of the

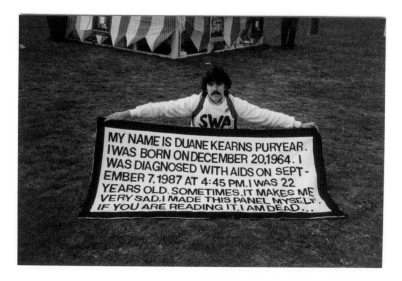

Figure 2.16  Duane Kearns Puryear with his AIDS Quilt panel, 1988.

conventionally monumental. It is here, at the juncture of archive and monument, that the convention often authorizes a particular narrative ahead of others, such that the final product reflects the moment of its inception at least as much as its ostensible subject matter. This holds as true for the Washington Monument in its abstract representation of the birth of a nation as it does for the Vietnam Veterans Memorial in its indexing of each life officially determined to have been lost in that war.

The traditional archive as both material fact and conceptual underpinning for the monument has deep ties to imperial and colonial projects.[68] As the theorist Jacques Derrida has observed, the archive "names at once the *commencement* and the *commandment*," the "*there* where things *commence*, . . . *there* where authority, social order are exercised."[69] This ordering system both articulated by Derrida in language and performatively enforced through italicization—a literal bending of the letters to bespeak the force and effect of the authority about which he writes—is also one that, like monuments, routinely implies violence.[70] Though often envisaged as a passive container, the traditional archive is both subject to, and an extension of, the ordering systems of the project that motivates its creation and determines what is worth keeping. What is worth keeping, in turn, is often mapped through a necropolitical norm such that, as the curator Okwui Enwezor describes

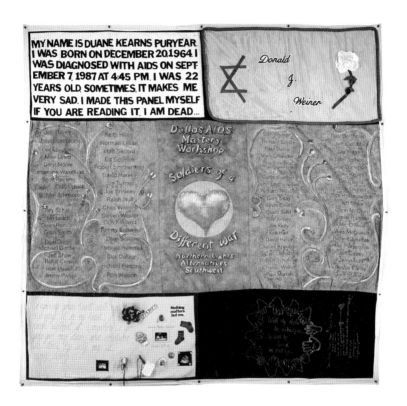

Figure 2.17   AIDS Memorial Quilt, Block 2052: Duane Kearns Puryear; Donald J. Weiner; Benjamine Wakefield, Bobby Johnson, Carl Oldham, Charles Kneupper, Charles Walker, Chris Walters, Conn McClure, Curtis Kuethler, Dale Dammon, Dallas Aids Mastery Workshop: David Harvey, David Heller, David Swid, Dean Hamilton, Dean Salley, Deryle Moore, Dick Dufour, Don Kirkland, Don Warner, Doug Byrd, Dow Dixon, "Eagle" Cliff Powell, Ed Schmidt, Gary Schalles, Gary Seay, Glen Smith, Jay Hays, Jeff Casey, Jeff Collatt, Jeff Shaw, Jerry Auld, Jim Kelly, Jim Leach, Jim Turner, Jimmy Parker, John Hampton, John James, John Keyes, John Leatherwood, Keith Huey, Ken Stanley, Kevin Smith, Kirk Hart, Lee Laughlin, Mark Chandler, Mark Glayzer, Mic O'Neal, Michael Gardana, Mike Lewis, Mike Portersnak, Norman Lillian, Paul Burns, Paul Murrah, Ralph Nulf, Ray Araujo, Ray Bertholet, Rich Mason, Richard Boyd, Richard Parsons, Richard Rhodes, Rick Hollingsworth, Robert Jose Frak, Robert Schulman, Robert Smitherman, Ron Watson, Roy Edwards, Royce Earley, Rufus Cruse, Scott Robens, Steve Ralston, Steven Rummel, Tommy Eubanks, Wes McQueen, Aarron Phillip Nelson; Bryan Angel, Bryan's House. Courtesy of National AIDS Memorial.

it, the archive functions as an "active discursive and regulatory system" enlisted in monumental projects "as a form of commemoration . . . in no apparent order or hierarchical arrangement" in which the "democracy of death" becomes the emphasis.[71] Traditional archives are, in other words, widely available to processes of safeguarding authorized narratives in part because they restage lives included therein as "democratized in death." As such, much like traditional monuments, archives run the risk of eliding a range of subjectivities and stories that fall outside of their authorizing terms.

Yet, as feminist studies scholar Anjali Arondekar says, "the archive still promises."[72] The ready availability of archives to projects of defining and ill-defining value and belonging also makes them available for intervention by scholars looking for traces of minoritized lives that should not, according to the logics of racial and sexual capital, have wound up there. Saidiya Hartman calls the archive "a death sentence, a tomb, a display of the violated body, an inventory of property, a medical treatise on gonorrhea, a few lines about a whore's life, an asterisk in the grand narrative of history,"[73] noting that those traces of violence are also the events through which Black Atlantic histories and those of Black life in the United States come to be told. To read history into those traces when there is little more than that is a practice Hartman calls critical fabulation, a way of writing histories of lives intentionally or violently excised from the records that is facilitated by a speculative archival practice through which one endeavors to "exceed or negotiate the constitutive limits of the archive," taking the moments that mark death and writing them to breathe life.[74] This is not a reparative practice, Hartman notes, but is instead coextensive with, enabled by, and never wholly recoverable into, the traditional archive. Rather, critical fabulation makes possible a "recuperative hermeneutics" which emerges as an "agnostically co-constitutive" process that describes simultaneously the possibility and constraint of the archive.[75] These possibilities also extend beyond conventional (which is to say national, imperial, or otherwise normatively institutional) archives in the form of community archives and archiving practices that use, for example, collecting and access practices that invite self-identification from contributors and otherwise endeavor to center participatory practice and utility to the communities about and for whom these archives exist.[76]

The AIDS Quilt's ongoing expansion and capacity to signify in multiple ways is in part a function of its condition not of having an archive as traditional monuments do, but of rather of being one. It is both a monument to a massive loss created with the intention of drawing attention to that loss and preventing something similar in the future, and a collection of objects that describes the contours of the origins and effects of that loss. Strategies of or akin to recuperative hermeneutics and critical fabulation are at work in the AIDS Quilt; viewers can glimpse in panels the material or language of a life, whether they understand the codes or references or not, and be interpellated into the process of narrativizing a life by reading stories into or through traces and fragments that persist as a remainder of a life or lives that do not. These processes take place in the same aleatory way that reading within an archive does, where the collected materials gain new meaning as a condition of being brought into relation with other traces. To read the AIDS Quilt, then, is to partake of Black and queer archival studies and archiving practices that have developed to account for the absence of materials that result from devaluation or wholesale erasure of certain lives or histories. Unlike the experience of reading the narrative put forth by the traditionally monumental form—fundamentally a process of being told a single story—the AIDS Quilt instead surfaces a narrative complexity and multivalence made possible by the ways that objects and language gain meaning socially. In not only harboring within it traces of lives that take on new meaning as a condition of being incorporated into it, but also containing signifiers whose meaning is coded and subcultural—in being partly produced, in other words, by logics of codes used in but not explained by it—the AIDS Quilt renders its narrative permanently open and subject to those who choose to read meaning into and through it.[77]

Because it is an ever-expanding and unceasing endeavor, the signifying systems inscribed into or that emerge from the AIDS Quilt also expand kaleidoscopically and exponentially. The project is both composed from ever more specific parts and never truly contained within itself, a product of the signifying systems at work within it that preexist and extend beyond it to new meanings as codes and cultures evolve. This is also how the AIDS Quilt allegorizes illness in its very architecture. Derrida suggests that the archival impulse is motivated by a feverish search for an origin story; in the AIDS Quilt, that fever becomes real, the condition

of illness and death and destruction on which the logic of the Quilt is scaffolded.[78] Also like a feverish illness, the AIDS Quilt, to borrow Sedgwick's characterization, "wrings" many viewers out.[79] The spectatorial condition of being wrung out is not just experienced by those with the kinds of close relationships to the plague and its scale and depth of loss, however; most viewers were likely not prepared to be wrung out by the AIDS Quilt, not least those who may have come to it accidentally, who might have had a clarion sense of their impermeability to HIV and all that follows from it, making the ensuing experience all the more poignant. It also makes the affective valences of the AIDS Quilt powerfully unlike either the vague stirrings of an inarticulable quality that a national "we" is supposed to feel in the presence of a monument—a connection to history that is at once individual and collective and often at least somewhat nationalistic—or the mournful stoicism one is supposed to at least perform at a graveyard.

No "we" is trained for what to do with the AIDS Quilt, which derives some of its affective power from retooling the relationship between the monument and the archive on which it is based. It is filled out by archival material with a complex set of relationalities not only within each frame but also in the other systems woven through it that reach beyond the borders of each panel, connecting and elucidating the mutuality of leathermen and Black Panthers and Levi's employees and people in ACT UP who hated the AIDS Quilt with those in ACT UP who loved and worked on it and others who were ambivalent or agnostic. By surfacing the archival into and through the monument, the temporal distinction that otherwise persists between the two is collapsed, creating a single—and singular—memorial monument that relies on, but is distinct from, the archive from which it is drawn. This element of temporal and material collapse is critically important to the distinction between the AIDS Quilt and more traditional monuments' relationships to archives, and is a reflection of the Quilt's emergence not after the crisis it was to mark concluded but, crucially, as it seemed to be getting even worse.

The AIDS Quilt as a monument thus becomes an anticoagulant, a memorial armature for an event in whose midst we remain. Though the earliest deaths it represents are temporally more distant each day, the plague and its effects are very much ongoing. The World Health Organization estimates that 650,000

people died from HIV-related illnesses in 2021—forty years after the first cases hit the national news wires—whether from long-term health consequences or due to social and economic conditions that preclude them from accessing the medical and psychological support necessary to live with HIV.[80] Today, people continue to die from AIDS, and make panels, and so the Quilt continues to grow.

—

Querying what makes a life grievable, Butler argues that the "normative production of ontology" entails a question of how we apprehend a life, which in turn spurs an ethical question of where to draw the line between self and other; to define, in other words, an *us* against a *them*.[81] Often, it is the ontologically normative *us* doing the defining and so the *them* never quite comes into focus without the contamination of stereotype. The AIDS Quilt—and the objects in the genealogy it instantiates—forms a road map for how to bring those precarious subject positions, and their attendant and erased histories, into more sharp monumental relief. The Quilt thus constitutes not only an intervention into historical silencing in the form of a strategy for writing marginalized histories into the conversation around national identity. It also opens onto avenues through which marginalized subjects might come to see themselves as agents in a project of resisting the conditions of the present and orchestrating strategies to imagine what a different future might look like.

Such strategies, however, are not inherent to the AIDS Quilt in particular, or interventions into the monumental more broadly; they may lend themselves to—but do not guarantee—dissonance and multiplicity. It is in the facilitation of that multiplicity, however, that the AIDS Quilt as a monumental intervention does its most crucial work: it offers scaffolding through which interpellation, individual identification, and the sepulchral relation can converge in ways that are at once communitarian and individual, public and private, surface and sub, and which allow for collectivity without erasing difference. This kind of monumentalizing labor seeks not to topple that to which it refers, but rather to function as a shadow for it, giving form to what is not represented or representable. If the AIDS crisis was, at its core, an exercise of necropolitical control, the AIDS Quilt restores the symbolism of life and death that Mbembe describes as a core function of that

control.[82] In forming a shadow of the Washington Monument that is also a specter of those lives lost to AIDS that creates and reifies an ongoing and ever-expanding set of relationalities among the dead and the living, the AIDS Quilt redoubles its redress of necropolitical control by working the seam of a different kind of collapse, one that makes all subjects subject to its signifying regimes.

Another expression of the archival impulse in the AIDS Quilt manifests as photographs taken at the grounds of the Mall that show an expansive Quilt reaching horizontally and seemingly without end beyond the edges of the photographic frame, as though it might stretch on forever. The Quilt is large enough today that, were it to be laid out on the Mall, it would exceed the parameters of that highly regulated public space and reach into the surrounding neighborhoods, an encroachment that allegorizes both an infinitude of infection and the persistent sense of distance from the ongoing AIDS crisis that many living in the white-dominant heteronormative West may feel—something that may not have changed substantively in the decades between the historical crisis and the present.

In addition to offering a nontraditional relationship to the past facilitated through the sepulchral relation that collapses past into present, the AIDS Quilt is also ambivalently monumental in its relationship to the future. The future it proposes is just like that of the present, in which the crisis continues to rage someplace largely out of sight from the National Mall and all that is allegorized by it—an effect afforded, paradoxically, by its rather unmonumental open structure. This dystopian vision exposes the specious nature and social origins of ways of ordering the world that separate an *us* from a *them*. In the AIDS Quilt's monumental vision of the future, HIV/AIDS ends up impacting or even infecting us all, spreading like the Quilt itself over purportedly impenetrable forms of government buildings and national memorials alike, through the national museums, and out into the surrounding neighborhoods. As a cure for HIV is on the horizon, its distribution is likely to follow the same patterns as the original epidemic and to be made available to privileged populations first, for cheap or for free, and only decades hence to those of the global racial majority and in non-Western nations who mostly live and die out of Western sight and minds.

The AIDS Quilt casts its own shadow, one of the fundamental unrepresentability of loss, particularly but not exclusively at

scale. Those who were there—whether physically visiting the Quilt or in community at the time and who have survived—still live in the shadow of that loss and carry with them the trauma of having lived through nearly two decades of a seemingly endless drumbeat of loss. The echoes of those years reverberate across a lifetime of medically maintained living, survivors' guilt, mourning, and the absence of friends and lovers and family. Meanwhile, those who were not there but who love or have loved survivors, or who have lived long enough (which is not very long at all) to have come of age without contemporary antiretrovirals or the widely used preventative PrEP (only approved by the FDA for prophylaxis in 2012) also largely live in the shadow of that great shape. The temporal relation between the opening decades of the AIDS crisis and now—which echoes the conventional delay between the archival impulse and the sanctioning of monumental memorialization—also gestures back toward the AIDS Quilt as a synecdoche for and monument to a crisis that is still unfolding, which is one of the Quilt's most novel departures from the normatively monumental. Ultimately, the AIDS Quilt casts its own shadow, one that extends out from the base of the traditionally monumental and toward a set of conventions that not only allow for but indeed encourage the use of the form of the monument for the representation of a heterogeneity of subject positions and ways of living that refuse to answer to a biopolitical norm or bow to a necropolitical one. In giving monumental form to a group and event, and in making the materiality of difference into its very surface, the AIDS Quilt demonstrates powerfully that monuments can represent the persistence of multiple and minoritized subjects and histories, and are also available for nuanced or complex ways of thinking about the future.

3  *Ambivalence and New Monuments*

W hen *A Subtlety* opened in 2014, it marked a turning point in the monumental tradition, describing a distance from much of what had come monumentally before in both form and narrative and drawing together the tropes of the recognizably monumental, such as scale and location, with stories rarely if ever told in that form. In the case of *A Subtlety*, those stories were a history of Atlantic slavery and its afterlives, and the visual manifestations of stereotypes that emerged in that era and which persist in sustaining conditions of raced and gendered minoritization in its wake.

*A Subtlety* draws on a set of monumental interventions similar to those in the AIDS Quilt in several ways. It uses the monumental form, but does so for the purpose of representing a minoritized rather than dominant history; it gives monumental scale and form to a loss that not only results from the structural devaluation of a particular kind of person but is also still unfolding; and it is made with materials that not only are at odds with those traditionally used for monuments, but also intervene into their claims

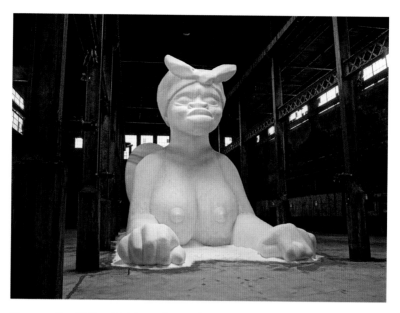

Figure 3.1   Kara Walker, *A Subtlety, or the Marvelous Sugar Baby, an Homage to the unpaid and overworked Artisans who have refined our Sweet tastes from the cane fields to the Kitchens of the New World on the Occasion of the demolition of the Domino Sugar Refining Plant*, 2014. Installation view: Domino Sugar Refinery, a project of Creative Time, Brooklyn, NY, 2014. Photo: Jason Wyche. Artwork © Kara Walker, courtesy of Sikkema Jenkins & Co. and Sprüth Magers.

of permanence and universality in ways that are specific both to the minoritized communities whose history they represent and to the mechanisms through which they have been minoritized. The most striking continuity across these forms, however, is an ambivalent relationship to time. The possibility of a break with the past is present in the AIDS Quilt: though its infinite expandability evidences a material continuity, it proposes the possibility of a future in which no one is safe from infection, and all are rendered equivalent through susceptibility. The maintenance of present conditions, in other words, ensures that everyone will eventually be impacted by AIDS. In *A Subtlety*, a possible break with the past is suggested through a range of ambivalences: it is made out of an ephemeral substance (sugar) but scaffolded on one of the most permanent materials (polystyrene); it was temporary and installed in a building meant to be destroyed, but the hand of the figure and shell of the building remain; and it materializes at scale the tropes of gendered racism, making them undeniable, yet is powerless to truly intervene in them. *A Subtlety* presents a

vision of history told through the terms of the present and, in monumentally representing them, suggests that tomorrow may be no different from today. At the same time, because it is recognizable as a monument but departs in form and narrative from the conventions of the monumental, it opens onto the possibility that what is today need not be how things are tomorrow. Both the AIDS Quilt and *A Subtlety*, then, present a vision of the past bounded by and processed through the terms of the present, and stage the relationship between the histories they represent and the futures that they, as monuments, are supposed to narrativize as anything but certain.

*A Subtlety*'s departure from the AIDS Quilt, however, is about more than the largely distinct histories referenced in the two projects. Rather than representing myriad discrete lives as a way of personalizing a loss that dominant culture was only just beginning to pay attention to, as is the case in the AIDS Quilt, Walker tends to the mechanisms that make it possible play down or look past blatant and systematic acts of violence that have nothing to do with the individual minoritized subject at all. *A Subtlety* can be understood as a maturation of the project of the monumental intervention by moving from humanizing the individual who is minoritized to elucidating the machinations of the structures that minoritize.

This chapter examines two projects, both presented in 2019, that learn from the important precedents that the AIDS Quilt and *A Subtlety* set: *Fons Americanus*, a second monument by Walker, and *Rumors of War*, by Kehinde Wiley. Like *A Subtlety*, these forms take as their points of departure specific traditional monuments, and contribute at monumental scale to a project of describing the lacunae that persist in Black and Atlantic histories. As important to their interventions as their aesthetic referents, however, is their relationship to time. Traditional monuments stage history as something that is fixed, static, and located in a past whose narrative has been thoroughly integrated into dominant aspirations for the future. These monuments, by contrast, propose that history is an arena filled with ideological contestation; that the past is very much part of the present; and that failure to accurately describe or address events in the past is often a barrier to realizing a different future. In giving form to this relationship to history, these new monuments resist the narrative conditions of traditional monuments by showing that it is a privilege to consider

the past as settled, and to wish for a future as a continuation of what has come before.

Rather than presenting the relationship among past, present, and future as linear and progressive, as traditional monuments do, works like those studied in this chapter also suggest that periodization is not only not possible for all subjects but also often reinforces the conditions of minoritization by making it seem like certain acts of violence took place exclusively in the past when, in reality, those violences are still ongoing, if perhaps in slightly altered form. In this chapter, I argue that writing long-elided histories into the monumental landscape, and doing so in a way that surfaces more nuanced and complex experiences of temporality, enables this generation of monuments to demonstrate that history can be readjudicated—even, in many cases, that it demands reconsideration—precisely because of the continuities between past and present. Importantly, however, there are limits to the rhetorical possibilities of these monuments; as Saidiya Hartman observes, "the breach can never be fully repaired or compensated" given that "the efforts to set things right would entail a revolution of the social order, an entirely new set of arrangements."[1] This chapter understands those limits as, perhaps paradoxically, productive. Proceeding from an understanding that the work of repair is a categorical impossibility, these monuments describe that breach, working within the constraints of what is possible to build upward from traces that mark what is missing and thus describe—though they do not themselves take—a step toward a new set of sociopolitical conditions that are no longer beholden to those of the past—or, at least, are less so.[2]

Both monuments studied in this chapter propose a vision of history as at once singular and universal, intervening in the monumental tradition in ways that are not only formally distinct, but which also offer divergent visions of the relationship between the past and the future. At the same time, they have very different relationships to permanence that track what seem to be the two artists' distinct perspectives on the form of the monument. Hewing as close as possible not just to that form but to a very specific monument, Wiley offers in *Rumors of War* a rigorously formal interrogation of one of the most conventionally imperial expressions of the monumental form. Carefully describing the formal characteristics of the monument, Wiley suggests not only that the contours of the form are available to any narrative—and therefore not

the exclusive purview of dominion—but also that the form can be made powerfully resistant to the most insidious projects to which it has been applied. Walker, by contrast, gestures toward a wholesale evacuation of the category, critiquing the possibility of any rapprochement to the monumental that is not parodic, and suggesting that the monument itself may be little more than a parody, whatever form it might take.

As this chapter demonstrates, *Rumors of War* and *Fons Americanus* learn different lessons from *A Subtlety*. But they share with it, and with one another, an aesthetics of social address that is central to their representational strategies. Social address—a visual language drawn from contemporaneous social and political themes—can be traced to the work that came out of the social upheavals of the late 1960s and early 1970s, including *Food for the Spirit*, which made the body of the artist into the work itself. The connection between these recent monuments and Piper's early practice is not incidental; indeed, encountering Piper's work seems to have been formative for Walker's ability to develop the signature style for which she is now known. As a graduate student, Walker was referred by a professor to Piper's work, and an essay written shortly thereafter suggests that, as a result, Walker began, as Hilton Als describes it, "pushing herself toward identity politics, and beginning to question her own existence between two worlds, as a relatively privileged black woman."[3] Piper was also a relatively privileged Black woman who, as an art student in the late 1960s, underwent a similar experience when "life—and race—intruded on her universalist approach" according to the cultural critic Thomas Chatterton Williams.[4] In her essay on Piper, Walker refers directly to Piper's *Calling Cards* (1986), wallet-sized pieces of cardstock printed with text and designed to be handed out in situations in which someone with whom Piper comes into contact behaves in a way that Piper understands to be facilitated by imbalances in gendered or racialized power. One begins, "Dear Friend. I am black. I am sure you did not realize this when you made/laughed at/agreed with that racist remark"; another, "Dear Friend, I am not here to pick anyone up, or to be picked up. I am here alone because I want to be here, ALONE." *Calling Cards* strongly suggests that Piper was aware that the different ways in which she was perceived according to race or gender impacted the behavior of others, and were inextricable from her own understanding of her subjectivity. It is this awareness, as Williams and others have suggested, that led Piper

toward ever more socially engaged forms of representation as her career progressed.[5]

The shift that Als argues takes place for Walker as a result of the artist's encounter with Piper's work also echoes a shift within Piper's practice toward a more material expression of themes related to the social construction or function of subjectivity that seems to take place in the fifteen years between *Food for the Spirit* and *Calling Cards*. Walker's progression toward ever more direct address of the themes in which she is interested constitutes an evolution that Walker also carries forward in her progression from silhouetting to *A Subtlety*, a shift that might be understood as a public, intergenerational return of Piper's earlier gesture of privatization in *Food for the Spirit*. *A Subtlety* can thus be understood as a specter of all that *Food for the Spirit* refuses, a collection of the significations that overdetermine bodies that are legible as Black and female and which underwrite persistent systematic efforts to dislocate Black women from subjectivity or prevent such associations from taking root in the first place. Walker gives scale and volume to formal and narrative precedents set by Piper to demonstrate that the specters that seem to always already predetermine the condition or experience of one's legibility as a Black woman—something Piper was not consistently, as *Calling Cards* demonstrates—have nothing to do with questions of ontology and everything to do with the operations of gendered racism.

*A Subtlety* does not gesture generally toward stereotypes, but rather to a very specific set of them, and to one of the more grotesque uses to which the monumental tradition has lent itself. In an early twentieth-century effort to institutionalize the Mammy stereotype by a group of nine white prominent male educators and businessmen in Athens, Georgia, who called themselves the Black Mammy Memorial Association, and sought to create a "Black Mammy Memorial Institute" that would train young African American citizens in domestic skills and the trades, linking that training explicitly to the organization's mission of white-dominant cultural values.[6] While the institute was intended as "a living monument" in itself, the group also wanted a formal monument, and lobbied for congressional approval for an accompanying monument on the National Mall.[7] The text of the 1922 authorizing bill, sponsored on the floor of the Senate by John Sharpe Williams of Mississippi, directed that a monument be executed by the Jefferson Davis Chapter of the United Daughters of the Confederacy

(UDC), a group that, as discussed in chapter 1, would already have been known as successful proliferators of monuments to white supremacy. The bill also stated that "the United States shall be put to no expense in or by the erection of said monument," just one among myriad instances in which historical monuments have been sponsored by a select few yet are central to and inextricable from nationalist as well as national projects.[8] Though never realized, the very existence of this proposal in the congressional record is a testament to the gendered racism deeply intertwined with US national identity. So too is the reality that contemporaneous efforts by African American women to elaborate their own monumental projects are rarely discussed when the Mammy Monument is brought up.

A Subtlety is not an attempt at a reparative imagining of what a monument to Black women could have looked like. Walker's first monument traced, in specific and historically precise ways, a set of genealogies that produce and sustain stereotypes. Certain facets of A Subtlety—particularly in its representation of a body intended to be read as that of a Black woman—interpellate some viewers as self-same by giving form to certain tropes of gendered racism with which members of the audience might identify. Even for those who may understand themselves to be represented substantially by the form and history represented, the experience of the work—as evidenced by myriad and disparate reactions to A Subtlety—does not map cleanly onto identitarian frameworks. No viewer, regardless of their subjective proximity to the purported terms of the work, is ever self-identical to it, so all viewers share the experience of being marked out as different from it, just not all in the same way. A Subtlety, then, evidences that even the monumental, just like the subjects for whom such forms purport to stand, always partakes of a degree of opacity, always exists in excess of the signification with which it is imbued, and yet is inevitably overdetermined by the terms of its form. This is also true for Confederate monuments, where the opacity works in obverse, a warning and a threat that what is common or universal is not open to all.

Walker emphasized the heterogeneity of spectatorial experience of A Subtlety in An Audience (2014), a documentary film that consists of footage taken of visitors during the monument's installation and which captures an incredibly broad array of reactions to the work. The vast array of behavior that results is, in many ways, precisely the situation Walker intended to set up. In an interview

67TH CONGRESS,
4TH SESSION.

# S. 4119.

IN THE SENATE OF THE UNITED STATES.

DECEMBER 8, 1922.

Mr. WILLIAMS introduced the following bill; which was read twice and referred to the Committee on the Library.

# A BILL

Authorizing the erection in the city of Washington of a monument in memory of the faithful colored mammies of the South.

1      Be it enacted by the Senate and House of Representa-

2   tives of the United States of America in Congress assembled,

3   That the Chief of Engineers, United States Army, be, and he

4   is hereby authorized and directed to select a suitable site

5   and to grant permission to the Jefferson Davis Chapter No.

6   1650, United Daughters of the Confederacy, for the erection

7   as a gift to the people of the United States on public grounds

8   of the United States in the city of Washington, District of

9   Columbia, other than those of the Capitol, the Library of

10   Congress, Potomac Park, and the White House, a monu-

11   ment in memory of the faithful colored mammies of the

Figure 3.2 US Congress, Senate, Committee of the Library, "Authorizing the erection in the city of Washington of a monument in memory of the faithful colored mammies of the South" (Bill S. 4119), 67th Cong., 4th Session, 1922, pp. 2–3. National Archives Identifier 4685889; Record Group 66; General Files, 1910–1954; National Archives Building, Washington, DC. Courtesy of the Library of Congress.

3

South: *Provided*, That the site chosen and the design of the

memorial shall be approved by the Joint Library Committee

of Congress, with the advice of the Commission of Fine

Arts; that the monument shall be erected under the super-

vision of the Chief of Engineers; and that the United States

shall be put to no expense in or by the erection of the said

monument.

67TH CONGRESS, } S. 4119.
4TH SESSION. }

A BILL

Authorizing the erection in the city of Wash-
ington of a monument in memory of the
faithful colored mammies of the South.

By Mr. WILLIAMS.

DECEMBER 8, 1922.—Read twice and referred to the
Committee on the Library.

three months after the work was deinstalled, Walker said, "I put a giant 10-foot vagina in the world and people respond to giant 10-foot vaginas in the way that they do. . . . Human behavior is so mucky and violent and messed-up and inappropriate. . . . I've got a lot of video footage of that [behavior]. I was spying."⁹ The footage from Walker's self-proclaimed spying underscores that Walker is not invested solely in a project of repair, but rather in provocation for the sake of demonstrating the limits of or barriers to repair in the face of the often-violent complexities of both contemporaneity and the human.

A key trope of the monumental is a claim to the universal applicability of the history and lessons that it proposes. But the only universal that *A Subtlety* sets up is the impossibility of anything approaching universality. *A Subtlety* is not only the histories and afterlives it represents, or the reinscription of a set of pasts in the present. It is also a description of the myriad elisions required to craft the kinds of coherent and monotonal narratives of the past on which dominant cultures so often rely to create and sustain hierarchies. *A Subtlety* testifies, in other words, that the myths and realities of such projects are always at work, as poisonous when they circulate invisibly as when they do so visibly. In what follows, I study two different approaches to elucidating the monumental forms and narratives on which dominant cultures have long relied.

### Rumors of War

On September 27, 2019, a twenty-seven-foot-high monument made from a limestone plinth topped by a bronze statue of a figure in a hoodie, jeans, and Nike Air Force 1s and seated astride a horse was installed in Times Square. The flat chest, defined jaw line, facial features, and hair—locks gathered into a topknot—are intended to make the statue legible as a Black man in the prime of life, his torso torqued not in the manner of the baroque tradition but rather with a square-shouldered solidity as he looks eternally over his shoulder. His right hand grasps the back of the saddle while his left holds the reins to his horse, which is collected, equestrian parlance for primed to move at the most subtle command from its rider. Carved into the plinth, the attribution—"RUMORS OF WAR / KEHINDE WILEY / 2019"—links the work to a verse from the book of Matthew—"you will hear of wars, and rumors of

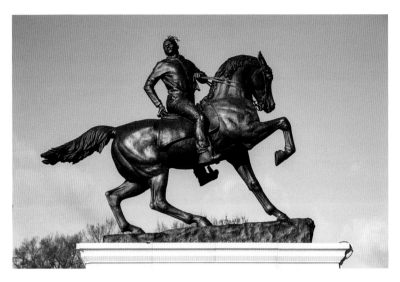

Figure 3.3 Kehinde Wiley, *Rumors of War*, 2019. Bronze on a limestone base. 328¾ × 306⁵⁄₁₆ × 189⅜ in. © Kehinde Wiley. Presented by Times Square Arts in partnership with the Virginia Museum of Fine Art and Sean Kelly, New York.

wars"—a multivalent gesture toward the self-perpetuating nature of violence, the oft-collapsed distinction between threats real and false, and the dangerous imbrication of fallibility and bellicosity that seems so utterly and unavoidably human. Against the ever-churning commercial chaos of Times Square, *Rumors of War* exuded persistence and endurance, a moment of elegance in a place otherwise not known for those qualities.

After two months, however, the monument was relocated to its permanent home on the grounds of the Virginia Museum of Fine Art (VMFA) in Richmond, where it stands today. Wiley could have installed his monument perpendicular to the museum in the style of most equestrian statues related to buildings, which would have oriented it toward Arthur Ashe Boulevard and, by association, in the direction of its referent, an equestrian statue elsewhere in the city of Richmond of the Confederate general J. E. B. Stuart. But the VMFA shares a property line with the headquarters of the UDC, and Wiley instead chose to install *Rumors of War* along the property line between the two buildings parallel to the VMFA's facade so that it points directly—and potentially eternally—at the UDC building.[10] As was noted on the occasion of its unveiling,[11] *Rumors of War* is part of a monumental genealogy that stretches halfway around the world and across nearly three centuries; the

Stuart monument was designed by Frederick Moynihan with such faith to its referent that a description of one can, to a significant degree, apply to both. This proximity also, however, enunciates the formal differences between them, and the contours of white-dominant equestrian tradition that Wiley's intervention maps. In lieu of a named white general in military dress who led an army to uphold the values of a dominant culture, Wiley instead composed the face of his subject from the visages of multiple people to create an anonymous Black everyman who could be any man.[12] Wiley's universal or common subject is clothed in the fashionable stylings of athletic clothes and work wear, a uniform suggesting sartorial savvy rather than racist cause. Wiley's steed is not wild but calm beneath him and, uncommonly for statues in the equestrian tradition, the rider bears no arms, whereas Moynihan's horse looks panicked, and his rider holds a sword. Formally and historically situated at the juncture of imperial domination and the monumental form and physically positioned to face the UDC building, *Rumors of War* suggests that it is not the monuments themselves but the underlying systems that are the problem.

Moynihan's is just one among an extensive catalog of Confederate monuments that stood in Richmond until an ordinance was passed in 2020 to begin removing them.[13] Many of these were erected during the early twentieth-century Confederate monument boom that followed several decades of post-Civil War efforts by Unionists and African American political leaders to put public monuments to the task of restaging enslavement as a practice opposed to, rather than part of, the national identity. But this effort to "mold history to its rightful pattern"[14] through monument building is also what made the form appeal to the UDC in its own more prolific campaign.

By the time Moynihan was commissioned to make the monument to Stuart, there was no shortage of equestrian monuments to which a sculptor could look for a referent in the United States.[15] But Moynihan, who was English, looked instead to India, which remained in the early twentieth century subject to a range of forms of imperial domination and extraction that had been ongoing for nearly two centuries. Moynihan's choice of referent was a monument to the British general James Outram made in Britain by John Henry Foley and then shipped to India where it was erected in 1861, the same year the Civil War broke out in the United States. Outram is remembered for his leadership in a number of especially

violent suppressions of revolutionary efforts by local populations in response to British imperial expansion across several different colonial holdings, but he is perhaps most known for his leadership in an 1857 conflict in India referred to in British accounts as the Sepoy Mutiny or Rebellion but referred to in India as, among other names, the First War of Independence. This semantic distinction arises not just from the different sides of the conflict but also from differing political projects; at the time, as Francophone studies scholar Nicola Frith notes, "Britain was beginning to come to terms with the idea that its colonial rule over India was under serious threat from Indian insurgents."[16] The nomenclatural decisions taken by what Frith calls the Anglocentric press in India, which would have been operating under the indiscreetly named Censorship of the Press Act of 1799 that subjected all periodicals to government scrutiny, reflected British political priorities that were playing out across all facets of British rule in India.[17] At a time when that rule was actively being challenged, calling it a mutiny or rebellion worked to "delegitimize [the uprising's] impetus by reducing it to [a] self-serving agenda that categorically denied any populist base and, hence, any revolutionary potential."[18] Foley's statue of Outram is an example of the crucial role of the monumental form in upholding such narratives; as the art historian Fintan Cullen has observed, the monument was supposed to represent "a European style of art . . . a European artist, . . . and the imposition of a very public celebration of a British victor in the heart of an Indian city." But, as was so often the case in the British empire, reality was more complicated than the narrative let on; Foley was himself an Irish immigrant, and the statue was made of Indian steel.[19]

The more muddled of its constitutive parts notwithstanding, the classically equestrian statue to Outram was part of a larger project to elaborate what amounts to an earlier and British Lost Cause project by representing Outram astride his horse, looking around for surprise attacks when it was well known by then that such attacks could very much be expected. Foley's monument to Outram also contributes to a more broadly applied British cultural hegemony imposed throughout the Raj as both a means and an end to extractive colonialism. Before the arrival of the British, India was, as diplomat and public intellectual Shashi Tharoor characterizes it, "the glittering jewel of the medieval world," with productivity at the start of the eighteenth century that accounted for

LIEUT. GEN. SIR JAMES OUTRAM. G.C.B. &c &c.

ENGRAVED BY W ROFFE FROM THE GROUP BY J. H. FOLEY, R.A.

Figure 3.4   William Roth, *Portrait of Lieutenant General Sir James Outram, G.C.B.*, ca. 1875.

nearly a quarter of the global economy.[20] After coming into being as a function of the commercial concerns of the British, the British East India Company's fiduciary control was quickly and systematically enhanced by military control over the subcontinent that methodically escalated to a multivalent depredation that stripped it of most of its means to generate and retain capital, reducing its contribution to the global economy to only 3 percent by the time the British left two centuries later.[21]

The Victorians erected monuments like Foley's to Outram both at home and in colonial holdings abroad—including but not limited to India—both to celebrate their imperial accomplishments and, as the Victorianist Cornelia D. J. Pearsall argues, with "the architectonic ambition of thematizing and indeed producing imperial subjects within the 'single frame' of each elaborated structure." Imperial forms, Pearsall continues, had the effect of not only "summarizing the Queen's imperial subjects . . . [but] forming them" with "the institutionalization of whiteness not only as its organizational grounds but as its goal."[22] Though Pearsall's referent is a poem, her argument explicates the role of monuments as well. Both the statue of Outram and the gardens to Queen Victoria in which it long stood memorialized the successes of the Raj in forming India as controlled through the extractive colonial efforts that played a central role in both developing and feeding an insatiable hunger for capital. The Outram monument not only commemorates the military exploits of an individual known and celebrated in his time for the violence of his tactics, but also stages those events as integral to the well-being of both the British and Indian peoples, in a context in which the very idea of nation is predicated on the sustenance of a framework in which whiteness not only reigns, but is the very condition that constitutes the human.[23]

Monuments to figures who led armies assembled or deployed in the service of defending the racialized values of a nation—whether in the extractive colonial context of the Raj or the settler colonial context of the United States—interpellate all subjects as a subject of empire, while simultaneously making clear that some subjects are more subjected under that system than others. Like Moynihan's monument to Stuart, Foley's monument to Outram was erected in a period during which the Victorian empire understood itself to stretch, both spatially and temporally, into eternity, and was installed to remind passersby in Kolkata that they were also subject to that regime into eternity. Though the government

for which it stood no longer operates there—and though an inter-
ventionist monument, to Indian nationalist Subhas Chandra
Bose, was erected 8 kilometers away in 1964—the afterlives of the
Raj remain palpably in evidence there. Three-quarters of a century
after the official end of that system, the monument to Outram still
stands. More than a relic of colonial domination, it is a shibboleth
for a national identity born of and architected through white-
dominant ideology and those willing to secure it at any price.

Both the Foley and Moynihan monuments are part of the
equestrian monumental tradition, which has often been used to
similar ends, staging narratives of masculine militarism rendered
in impermeable materials to make the cultural projects with which
they are freighted seem both existentially imperative and eternal.
There is also an iconography to the hooves—one or two off the
ground suggests the rider died in battle, while four on the ground
indicate an extramilitary demise—that implicitly situates the
death of each rider in the mythology of the national narrative, ele-
vating the specificity of the individual to a synecdoche not just for
a single battle, but for a whole nation whose values are scaffolded
onto the violent domination of populations defined as other.

Though scholars have repeatedly explained the resonance
between these two monuments by pointing to the presence
of a robust set of coincidences between Foley and Moynihan—
Moynihan apprenticed under Foley, and Foley made a monument
to Stonewall Jackson in Richmond that was unveiled in 1875—the
formal and narrative relationship between the two monuments
cannot wholly be explained by the overlaps between these two
men. Rather, the relationship between these monuments is a
statement of a transnational racial solidarity. Because traditional
monuments are often erected in the service of a national narra-
tive or nationalist project, they are less frequently thought across
national borders than they are within them, where monuments
tend to emerge at moments in which, as the art historian Mechtild
Widrich has observed, "neither community nor individual action
seem equal to the task of representing a political relation to the
past." As synecdoches for a nation, monuments pull focus from
continuities across national borders that might appear to be spe-
cious comparisons in light of different political, historical, or tem-
poral grounds. But this contradiction, as the philosopher Hannah
Ardent observed, "can and has been bridged by tribal national-
ism and outright racism."[24] In other words, white racial solidarity

Figure 3.5 Frederick Moynihan's monument to Confederate general James Ewell Brown Stuart, at the monument's unveiling, May 30, 1907. Courtesy of the Valentine.

knows no national bounds. Moynihan's choice of a referent over 8,000 miles away constitutes an attempt to bespeak an ideological affinity that exceeds—even precedes—the formal, and which was also on full display at the monument's unveiling: strapped to the right-hand side of the plinth, the same direction that the statue of Stuart faced, was an almost six-foot-tall Confederate flag. Though not, in all likelihood, the artist's doing, Moynihan could hardly have been ignorant of the ideological motivations of the monument he was commissioned to build. The aesthetic allegiance between these two artists and forms thus signifies a transnational commitment to white dominance whose formal terms were drawn from British attitudes in India and brought to bear on US culture.

Wiley's careful attention to precisely replicating the tradition into which he intervenes demonstrates both how and to what degree the monumental form and its exclusions are inscribed through racialization. This extends to—or perhaps begins with—Wiley's choice of material for the statue portion of the monument, which shares with its referents the condition of being cast in bronze, which is dark in color. Bronze was a fraught choice in the creation of monuments in the South even before the Civil War,

as can be seen in the discussion of a proposal for a bronze monument to George Washington that passed through the Virginia state legislature, and spurred debate over the racialized implications of using a dark-toned metal for a figurative statue to Washington. Fears that he would look Black were allayed only by reassurances that "pure bronze can never become black,"[25] a tonal splitting of hairs that both stems from and reflects the arbitrary nature of sorting bodies on the basis of perceived traits including but not limited to race. Wiley's sculpture, notably, is intended to be read as Black not because of the color of the metal, but instead because of a concatenation of other signifiers that suggest racial identity.

Another crucial way that Wiley intervenes in the Foley-Moynihan genealogy is in his remaking of the military uniform. Figures represented in military monuments are traditionally depicted in military regalia and are also often extensively decorated because they tend to be made to individuals of high rank. But Wiley's subject wears civilian clothing available to the average consumer—Air Force 1s, jeans with a ripped knee, and hooded sweatshirt—that constitutes its own uniform pioneered in the later twentieth century in predominantly Black and urban communities that are often engaged in the work of strategizing survival within a system bent on their destruction. By elevating a civilian to the position of someone who died in a war but would not usually get such rarified representation, Wiley introduces into the equestrian genealogy in particular and monumental tradition in general an ambivalence by giving pride of place to precisely the kind of subject who had been historically excluded from it.

Among the elements that comprise the outfit, the hoodie occupies a special status as an emblem not just of a particular style but of the ways in which the afterlives of enslavement persist in inflecting Black life and death. This inheritance is captured by the recurrence of hoodies in work like David Hammons's *In the Hood* (1993), a single, green cotton hood cut off from the rest of the garment at the neck and hung in the gallery on a single nail, or John Edmonds's 2018 *Untitled (Hood)* series, a series of portraits of subjects wearing hoods with their backs turned to the camera, the shot closely cropped so that all that is visible is the hood and its background. Though they make meaning in distinct ways, both works bring the hood together with the implied presence of a subject who is absent or has his back turned, which has the effect of "highlight[ing] the precarity of the Black subject," according to

the curator Ashley James. That these works are made a quarter of a century apart gestures toward the ongoing nature of some of the most unselfconscious extensions of structural racism and systematized violence faced by Black subjects in the United States. In *Rumors of War*, the hood and the other sartorial decisions with which it is associated become a site that Fred Moten describes as "the locus and method of a massive interplay of policing and exploitation, repression and desire . . . that produces the objects of its prosecution and persecution in the violent enforcement of lethal state legality's response to the resistances and flights that prompt it,"[26] signified through a complex network of representation that extends beyond and contributes to the persistent overdetermination of the Black body in contemporary culture.

In *Rumors of War*, the subject stands in for generations of Black men murdered at the hands of the myriad extensions of a deeply rooted kind of violence that Wiley stages as a war at once like and unlike any other through a monument also at once like and unlike any other. After dying in battle, many subjects have been lost to history because of a range of systemic exclusions and erasures that foreclosed on their stories being entered in the annals of history, with individual lives being counted among the dead of a long-standing warlike condition not recognized as such. As I demonstrated in the previous chapter on the AIDS Quilt, certain deaths may happen at scale but are not considered casualties of war, nor are they conventionally counted as grounds for national mourning because of the way the subjects who are dying are rhetorically positioned. Wiley's monument restages a series of such deaths as grievable through a set of honorific representational conventions from which Black bodies have routinely been excluded, and by literally and figuratively underwriting them with biblical titling to underscore that the multivalent violences that give rise to the tradition into which Wiley intervenes are so ingrained as to seem as if they cannot be changed. To be faced in potential perpetuity with the sense that there is nothing to be done is its own kind of violence, but by monumentally representing a subject who can stand in for myriad others devalued under the kinds of systems for which Stuart and Outram served as figureheads, Wiley restages the definition not just of the monument but indeed of the national body as a site for contestation.

Whereas the close formal mapping of *Rumors of War* onto its referent affords the work precision in its narrative intervention,

that proximity also constrains the work by making it subject to a similar constellation of problematics to which the traditionally monumental is also subject. *Rumors of War* transparently represents the conditions of the present, and positions the present as a continuation of a long-standing past; but though it critiques those conditions, it also binds the future to them. Its retention of the same materials and scale as its referents enables it to adumbrate oppressive narrative terms, but also ossifies the narrative in the same way that traditional monuments become bound, freezing the meaning in the moment in which the monument is built and all but guaranteeing it will become outdated. What makes *Rumors of War* such a powerful narrative intervention, in other words, is also what makes it so traditionally monumental. Rather than using non-traditionally monumental materials to suggest the dismantling of those systems, Wiley mobilizes the same physical and conceptual heft that undergirds traditional monuments to make clear the degree to which the future is highly circumscribed by the conditions of the present, the horse in forward motion while the entirely unarmed subject of this military-style monument looks to the past as the cause of all that comes after.

Rather than functioning as a wish for the future as do its referents, *Rumors of War* constitutes a wish for its own obsolescence, an acknowledgment that the tendency toward ossification that plagues traditional monuments also enables his monument to stand for a not too distant future in which the current conditions could no longer hold sway. Crucial to its status as a wish is a rather traditional monumental relationship to the future, in which the past is staged as determinative of a time to come that extends indefinitely into the future. This lack of ambivalence might be explained in part through the monumentally traditional materiality of the work. Yet if, as is understood in this book, there is no inherent meaning to the monument that precedes the narrative or ideological utility to which it is assigned, then there is also no inherent meaning to its materiality. What separates *Rumors of War* from other major interventions of this new generation, then, is not Wiley's choice of materials, but rather a lack of engagement with ambivalent representational strategies. This is remarkable given that Wiley built his career on creating paintings that turn on an aesthetics drawn from queer sociality, into which ambivalence in the form of behavioral and sartorial codes figures substantially. Wiley's signature reworking of canonical paintings replaced the

white historical figures with Black contemporary subjects dressed in contemporary clothing and set within monochromatic backgrounds and floral motifs, a careful anachronistic recombination with profoundly queer payoffs in works that luxuriate in Black male bodies, skin, hair, and clothing.

One of the best examples of the queer strategies that inform Wiley's painting practice is *Femme piquée par un serpent* (2008), an intervention into an 1847 reclining statue of the same name by Auguste Clésinger in which Wiley reworks in painting a nude sculpture rendered in cool white marble and intended to be read as white and female with a male body in a fitted cap, hoodie, sagged pants, and gold and white sneakers, laid out on a white cloth in the same torqued position as its referent, all in the rich

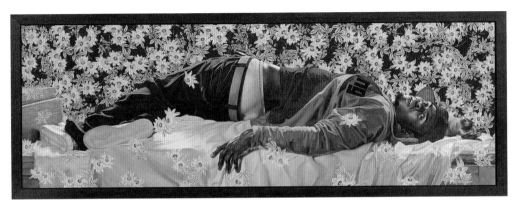

Figure 3.6   Kehinde Wiley, *Femme piquée par un serpent*, 2008. Oil on canvas, 102 × 300 in. © Kehinde Wiley. Courtesy of the Dean Collection.

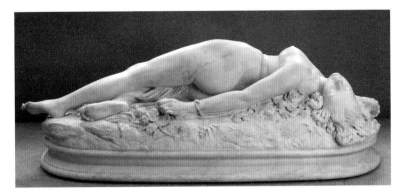

Figure 3.7   Auguste Clésinger, *Femme piquée par un serpent*, 1847. Courtesy of Creative Commons Attribution-Sharealike 4.0 International license.

chromatics of oil paint. The figure is intended to be read as masculine but is positioned in a way traditionally associated with representations of bodies meant to be read as feminine and sexually available, as evidenced by Clésinger's sculpture, with long hair, bare breasts, and a twisting form that decenters the subjectivity of the subject, and makes it possible to take in the nude form without being observed by it. Wiley's remixing of these gendered conventions also opens onto a suggestion of sexuality that seems present but is not available for or legible to all viewers. The queer as a strategy in the work, then, includes an unconventional mix of asymmetrical sexual availability, but extends beyond gender and desire to the very structure of the pictorial surface: Wiley also blankets the figure in flowers—another trope infrequently placed in pictorial space with masculine bodies—but whereas the flowers are part of the background at the top of the painting, they are part of the foreground in the lower half of the painting, a spatial conceit that complicates but does not flatten the pictorial space and suggests, perhaps even more than the anachronism of placing contemporary bodies into historical forms, the highly subjective nature of meaning.

*Femme piquée par un serpent* is just one example of a robust tendency in Wiley's painterly practice in which an intervention is made not only through the inscription or reinscription of Blackness but also through queer attention to the various elements within the work. Wiley's style also points to the long history of systemic racism bridging the then and there of binary racialized logic, and the ways in which subjectivity also exists in excess of those constrains and revels in the here and now of Black queer life. Yet at the monumental scale—which Wiley ventures into for the first time in *Rumors of War*—Wiley's queer painterly strategies are nowhere in evidence. This can be attributed to a degree to the presence of a different process for making this work. The subject is not a single person Wiley knows or loves, but rather a composite of multiple subjects, collapsing the implications of individuality in the service of a more universalized address. The careful adumbration of the referents also precludes any queer slippage or multiplicity; both the subject and the clothing appear designed to the specifications of the occasion rather than to an individuated intervention into a historical referent. The absence of queerness further results from Wiley's centering of the violent conditions of Black life during and in the wake of the Atlantic slave trade, aggregated

through a single body as a synecdoche for both individual and cultural conditions of life and death. *Rumors of War* can thus be understood as a powerful intervention into the tradition to which it refers that stages the racialization of bodies as not just the most potent among the various ordering systems, but indeed the totalizing term ahead of all others. The work does not read as queer because queerness is understood as subsumed by or tangential to the representational labor demanded by this monument—which is to stand as firm evidence against, and in full view of, the material and ideological underpinnings and efforts of the UDC and other groups that do the poisonous work of perpetuating white-dominant and white nationalist ideologies.[27] Read in this way, then, the mounted figure not only looks back over his shoulder into eternity; he also calls upon those behind him to join him.

### Fons Americanus

Autumn of 2019 was a significant moment for new monuments. Within days of *Rumors of War*'s unveiling, Walker's second monumentally scaled work—the forty-three-foot-high fountain *Fons Americanus* described in this book's introduction—opened in Turbine Hall at the Tate Modern in London. Like Wiley in his equestrian monument, Walker moved off a particular historical referent in the same city: the *Victoria Memorial* (1911), a monumental fountain commissioned from Thomas Brock in honor of Queen Victoria situated in the middle of a roundabout just outside the gates of Buckingham Palace. Its central feature is a plinth with a single figure on each of its four sides—an imperious statue of a seated Queen Victoria and three allegorical figures for Truth, Justice, and Motherhood—topped with a gilded statue of the winged Victory bolstered by figures meant to represent the virtues of Constancy and Courage.[28] The central monumental sculpture is surrounded by monumental space marked out by concentric terraces bounded at four points by bronze lions representing Peace, Progress, Agriculture, and Manufacture, each an allegory for a facet of the mythology of the Victorian period and its imperial expansion. Two crescent-shaped pools arc along the northeastern and southwestern peripheries of the monumental complex, bifurcated by a processional axis that stretches from Buckingham Palace on its southwest side to the Mall, a monument in its own right to

Figure 3.8 Kara Walker, *Fons Americanus*, 2019. Nontoxic acrylic and cement composite, recyclable cork, wood, and metal. Main: 73½ × 50 × 43 ft (22.4 × 15.2 × 13.2 m). Installation view: Hyundai Commission: Kara Walker—Fons Americanus, Tate Modern, London, UK, 2019. Photo: Tate (Matt Greenwood). Artwork © Kara Walker, courtesy of Sikkema Jenkins & Co. and Sprüth Magers.

major military victories at the turn of the nineteenth century that runs northeast to Trafalgar Square. The modest pools and multiple fountains in the *Victoria Memorial* are accompanied by a heavy sculptural leitmotif of water: boats sail forth from the base of the monument in four directions while bas-reliefs along the base in both marble and bronze feature mythic nautical scenes, and there are shells everywhere, carved into corners and scalloping behind the Queen's head.

Imperial expansion is neither uniquely British nor specific to the nineteenth century, but in the nineteenth century Britain was an alpha predator, hungering for and fueling the expansion of an ever more globalized market. British concerns extracted raw materials from colonial holdings and developed existing industrial methods for the production or refinement of goods like steel and fiber into high-yield processes. At the same time, they choked off competition by imposing so-called global standards that positioned the British way of doing things as the correct way and all others—such as those in their colonial holdings that posed the

Figure 3.9    Unveiling of the Queen Victoria Memorial, London. Rotary Photo, 1911.
Courtesy of the Yale Center for British Art.

threat of competition—as unfit.[29] To speak of these and other
forms of global trade in the nineteenth century is also in many
ways to speak of what becomes possible on and in water. In var-
ious Western conventional wisdoms, water is variously a neutral
surface, the stuff of life, the danger and promise of the unknown,
and a cleansing baptismal force. In the *Victoria Memorial*, water as
not just fact but also allegory, even a character unto itself, is a crit-
ical component of the nineteenth-century British convention of
what the art historian Anna Arabindan-Kesson calls "speculative
visions," or "a way of seeing the natural world through the lens of
profit."[30] The narrativization of expansion as an organic process
was central to the Victorians' rhetorical framing of their imperial
proliferation; as Pearsall notes, this often showed up in metaphors
of flora and fauna spreading across the globe through naturally
occurring processes, for example, as seeds carried to new lands
by natural forces beyond their control.[31] Power operates this way,
too, most effective when seemingly absent, working so covertly or
diffusely that it seems natural or even invisible.

The *Victoria Memorial* describes with precision the relationship
between monuments and the ideologies they so powerfully serve.
It is unselfconsciously monotonal and crafted around allegories
related to progress and growth. By scaffolding those values on
nautical themes, the monument reflects the profound degree to

which imperial progress relied on narratives of fortunate expansion across a globe that was rhetorically positioned as there for the Victorians to discover. Far from being a neutral actor in that process, water is inseparable from the complexities that structured access to the globe, its incorporation as leitmotif in the *Victoria Memorial* giving the lie to imperial expansion as anything but carefully and intentionally architected. In both material and thematic terms, water contributes to narrativizing the home country in contradistinction to an *out* or *over there* of the machinations of empire, an example of what Paul Gilroy calls the "binary perspective on modernist consciousness"[32] where the supposedly civilized realm of the heart of empire is counterposed to the primitivized spaces of otherness that become incorporated into the national body as imperial holdings, against which the national self is racially, geographically, and economically defined. Though the imperial capital is traditionally understood as an arena in which imperialism does not occur, the trappings of empire are very much present, perhaps most visibly in the minoritization of all racialized others within the boundaries of the homeland. In the *Victoria Memorial*, the idea of the imperial seat as a place from which empire comes is not only telegraphed through the fact of a monument, but the distance and difference between the imperial heart and the over-there of primitivized holdings is also staged as vital to the perpetuation of that empire through the monument's placement between the seats of power, its naval successes against its racially and geographically nearer rivals represented at the other end of the Mall in Admiralty Arch and Trafalgar Square. Both conceptually and monumentally, then, the fact and fabrication of British power are visually articulated in the *Victoria Memorial* through an expressly water-based understanding of progress.

Though Walker retains the thematization of water in *Fons Americanus*, the artist restages it from leitmotif to a more complex surface against which a vast array of violences have been carried out. Where the hub-and-spoke design of the urban space that houses the *Victoria Memorial* enables visitors to approach from any angle, the long, rectangular shape of Turbine Hall and its position within the larger building of the Tate Modern meant that most viewers approached *Fons Americanus* from a single direction. The four lions of the *Victoria Memorial* are gone, replaced by a single sculptural shell with a small, crying, upward-tilted face barely visible at its base. This secondary, smaller sculpture that meets the viewer in

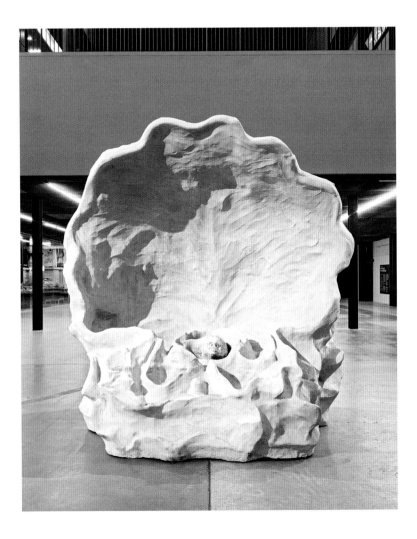

Figure 3.10  Kara Walker, *Fons Americanus*, 2019 (*Shell Grotto*). Nontoxic acrylic and cement composite, recyclable cork, wood, and metal. Main: 73½ × 50 × 43 ft (22.4 × 15.2 × 13.2 m). Installation view: Hyundai Commission: Kara Walker—Fons Americanus, Tate Modern, London, UK, 2019 Photo: Tate (Matt Greenwood). Artwork © Kara Walker, courtesy of Sikkema Jenkins & Co. and Sprüth Magers.

advance of their arrival to the main monumental event harkens back to the attendants scattered throughout the space surrounding *A Subtlety*. Walker also carries an uncommonly elaborate titling forward from that earlier monument, taken even further here and rendered in white text on a gray background. The titling prose situates the work not just in Atlantic history but also in specific traditions within it that create the conditions for and extend beyond enslavement. Describing *Fons Americanus* as a depiction of "the Citizens / of the / OLD WORLD / (Our Captors, Saviours, and Intimate Family)" Walker uses fonts, spacing, sizing, and selective capitalization to evoke the voice of a carnival barker, compelling visitors to "Marvel and Contemplate / *The Monumental Misrememberings /* Of Colonial Exploits Yon."[33] The aesthetics of the title—an object unto itself—references both memorial epitaphs carved into stone and the printing format of the broadside, a form of communication popularized in the nineteenth century that often spectacularized otherness in the service of shoring up dominant culture's hold on power, but redeployed in Walker's hands in the service of explicating how power and otherness are not natural conditions but naturalized categories.[34]

While the full title functions as a heuristic for the work, it neither circumscribes nor fully explains the monument, which suggests that the monument is described in part by, but is distinct from, the title text. Among the myriad pictorial elements mentioned in the title text is the figure atop the fountain referred to therein as the Daughter of the Waters but called Venus elsewhere.[35] The figure of Venus frequently recurs in Western cultural production, a Roman goddess born of the water who represents key tropes associated with femininity including beauty and sexuality. Among myriad other examples, those tropes are thematized in Botticelli's famous painting of a body idealized through historically specific white-dominant terms. The figure of Venus has also, however, been repeatedly mobilized in visual cultural materials to support the elaboration of racialized ordering systems that map otherness through Black women's bodies. One of these is the convention of the Sable Venus, a Black Venus that circulated in print culture in the later eighteenth and early to mid-nineteenth centuries. The name *Venus* recurs throughout archives and narratives of the Atlantic world in reference to women of African descent who become visible within those contexts, as Saidiya Hartman says, at "the convergence of terror of and pleasure in the libidinal economy

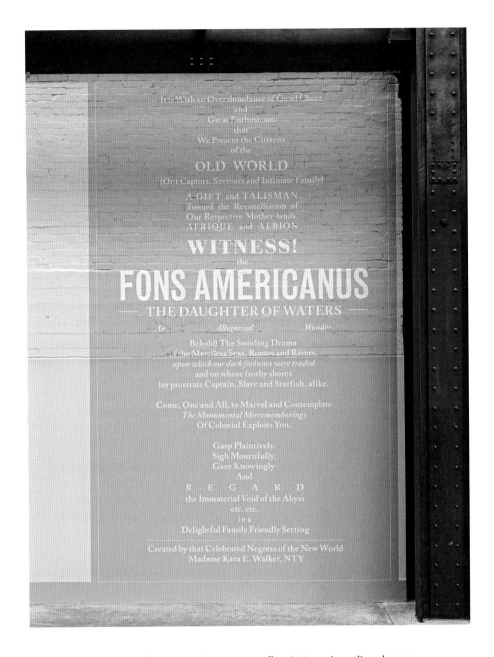

It is With an Overabundance of Good Cheer
and
Great Enthusiasm
that
We Present the Citizens
of the

OLD WORLD

(Our Captors, Saviours and Intimate Family)

A GIFT and TALISMAN
Toward the Reconciliation of
Our Respective Mother-lands,
AFRIQUE and ALBION

WITNESS!
the

FONS AMERICANUS
— THE DAUGHTER OF WATERS —

*An          Allegorical          Wonder*

Behold! The Sworling Drama
of the Merciless Seas, Routes and Rivers
*upon which our dark fortunes were traded*
and on whose frothy shores
lay prostrate Captain, Slave and Starfish, alike.

Come, One and All, to Marvel and Contemplate
*The Monumental Misrememberings*
Of Colonial Exploits Yon.

Gasp Plaintively,
Sigh Mournfully,
Gaze Knowingly
And
R E G A R D
the Immaterial Void of the Abyss
etc. etc.
in a
Delightful Family Friendly Setting

Created by that Celebrated Negress of the New World
Madame Kara E. Walker, NTY

Figure 3.11   Kara Walker, *Fons Americanus*, 2019 (wall text). Nontoxic acrylic and cement composite, recyclable cork, wood, and metal. Main: 73½ × 50 × 43 ft (22.4 × 15.2 × 13.2 m). Installation view: Hyundai Commission: Kara Walker—Fons Americanus, Tate Modern, London, UK, 2019. Photo: Tate (Matt Greenwood). Artwork © Kara Walker, courtesy of Sikkema Jenkins & Co. and Sprüth Magers.

of slavery."[36] Both the figure and the name *Venus*, then, describe the juncture of the possibility and prohibition of Black women's subjectivity in white-dominant cultural contexts both within and beyond the terms of sexuality.

By elevating a body meant to be legible as a woman of African descent to a privileged position, both as a goddess historically exclusively indexed to a white vision of what is beautiful and through the process of monumentalization, Walker goes beyond the pictorial language of replacement—which risks inverting binary distinctions—to one of reinscription. Walker also introduces into an otherwise largely Eurocentric representational history a West African mythological tradition, evoked in Walker's use of the phrase "daughter of the waters," which may also suggest the Yoruba figure Yemoja, an orisha of the Ogun River in modern-day Nigeria who became the goddess of the waters at the inception of the Atlantic slave trade, responsible for those who perished in or were kidnapped across the Black Atlantic.[37] In addition to watching over those with whom she is charged, Yemoja is also associated with a set of practices of restitution. Kimberly Juanita Brown argues that Yemoja "engenders both the life-giving and nurturing aspects of a deity and the capacity for anger and retaliation" and "strikes the delicate balance between this world and the next, marking a hybrid territory for herself in the diasporic universe."[38] It thus becomes possible to read the figure atop *Fons Americanus* as one of slippery origins who is as available to the Roman tradition as to the Yoruba tradition, a duality that fundamentally challenges the exclusivity and monotonality associated with the monumental form. Yemoja's mobility of meaning from the river to the ocean, and her narrative location at the juncture of this world and the next, also situates her between the temporally bounded conditions of life, the eternality of death, and a vast array of other binaries made possible by or allegorized through water.

By crowning *Fons Americanus* with a form who stands between here and eternity, Walker produces a temporal dislocation that challenges the traditional terms of the monumental form. The work connects past, present, and future in a way that marks a prohibition against a more traditional or linear relationship to progressive time central to the way it makes meaning. In drawing Yoruba and European traditions together, Walker writes a new chapter for Yemoja's mythology in which a Venus of African descent is transported, whether by ship or by shell, across the Black

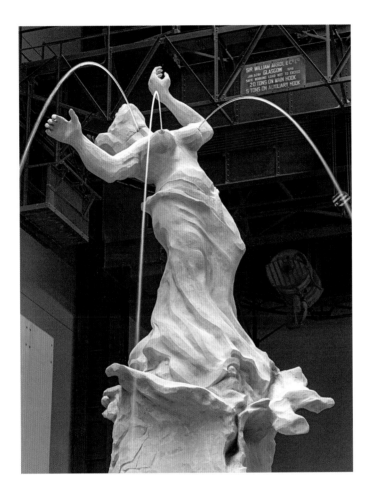

Figure 3.12   Kara Walker, *Fons Americanus*, 2019 (detail). Installation view: Hyundai Commission: Kara Walker—Fons Americanus, Tate Modern, London, UK, 2019. Photo: Tate (Matt Greenwood). Artwork © Kara Walker, courtesy of Sikkema Jenkins & Co. and Sprüth Magers.

Atlantic to the city in which many of the machinations that drove the Atlantic slave trade were honed and deployed. The waters in the pools surrounding the central sculptural element are opaque, allegorizing life-giving liquids like amniotic fluid and semen and breast milk to tell a set of connected stories that give form to the narrative parallels elided as a result of the differential valuation of bodies across and through the signifying systems of national or imperial projects. These and other entanglements are amplified in moments across the fountain that have multiple meanings, as in the water that spouts forth from Venus's neck that does double duty as blood. The Daughter of Waters thus constitutes an ambivalent reinscription that resists a reparative narrative, addressing the myriad lives lost as a consequence of the Middle Passage while also signaling a persistence beyond that history that acknowledges, even cultivates, a multifaceted subjecthood that accounts for, but is not limited by, the myriad structural ways in which Black women's subjectivity is called into question in the service of raced and gendered systems of power. The Venus atop *Fons Americanus* thus stands in for the inheritances of death-dealing ideologies, both in their contemporary manifestations in various forms of structural violence and in the persistence of subjects who, as the poet and activist Audre Lorde put it, "were never meant to survive."[39] Walker's citation of the mother of all orishas also constitutes what Brown calls an "imprint of a diasporic return," a "layered construction of all that the image cannot contain, and that which flows out from the body"[40]—as well as that which persists beyond it to return to face key progenitors of the structures that have tried to extinguish her. This imprint contains the art historical references to Botticelli's Venus; read as though transported from her shell to the top of the monument to reveal a crying face in her place, Venus and all that she represents to white culture—valences of femininity and fertility and the divine right to build and spread empire, no matter the cost—are shown to have been standing on Black lives all along.

Also not mentioned in the title text are the four allegorical figures that ring the central plinth, recast by Walker as pillars of the Atlantic slave trade. The only figure Walker retains from the Victoria Memorial is a queen, who Walker calls Queen Vicky.[41] In lieu of the regal representation in the original Walker gives her a caricatured, laughing, twisted visage framed by a textured head scarf, and shows her holding open her skirts to reveal a crouched,

childlike figure Walker calls Melancholy who is neither coming nor going, suspended by the ongoing and incomplete project of historical revelation and its fraught intersections with its telling. This moment in the monument speaks to "imperialist nostalgia," which Renato Rosaldo describes as a postcolonial admixture of mourning for a time before colonial means while idealizing its ends.[42] A figure Walker calls the Captain is seated, looking resolute, reportedly an amalgamation of revolutionary leaders of resistance movements including Haitian revolutionary leader François-Dominique Toussaint Louverture and Jamaican political leader Marcus Garvey.[43] Another figure, intended to be read as male as indicated by military garb and short hair, is crouched looking upward, hands pressed together as though in prayer, with a pleading look on his face as though begging for mercy, or forgiveness, or both.[44] The fourth figure is not a subject at all but a stunted, gnarled tree, all trunk and no leaves, with a noose dangling from one of its abbreviated branches. The teardrop shape of the noose is echoed in a knot in the trunk, an aesthetic echo whose vulvar form suggests a generational condition of loss and trauma. After the 1991 beating of Rodney King, the poet and literary scholar Elizabeth Alexander wrote that "Black bodies in pain for public consumption have been an American national spectacle for centuries."[45] Rather than participating in a long-standing tradition of figuring a lynched subject, Walker uses the noose to articulate not only that history but also a refusal of that figuration, describing instead the impossibility of truly grasping the totality of violence and consequences of lynching with or without its pictorial representation.

Rather than describing the absence of lives lost in white-dominant terms, then, *Fons Americanus* gives form to the moments and processes of loss brought about and rendered invisible by the machinations of racial capital through what Jacquelin Goldsby calls "reading history *out* of literary text."[46] The figures in the water are read not just out of history but also into art history. A segment Walker calls *The Physical Impossibility of Blackness in the Mind of Someone White* includes a body meant to signify as Black and swimming, anachronistically, with a snorkel. The title is a reference to *The Physical Impossibility of Death in the Mind of Someone Living*, a work by white British artist Damien Hirst that consists of a tiger shark preserved in formalin in a glass display case in a gesture of the unknowable but supposedly universal nature of death. Walker, by contrast, illustrates a moment of Black life in the act of knowing

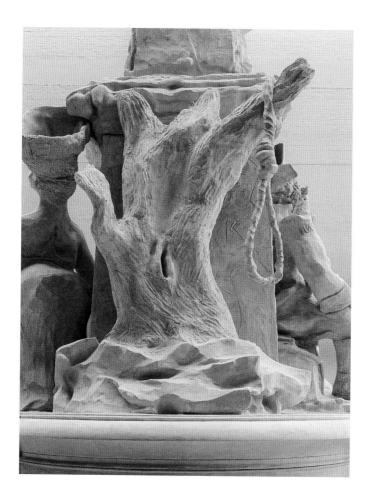

Figure 3.13  Kara Walker, *Fons Americanus* (detail), 2019. Installation view: Hyundai Commission: Kara Walker—Fons Americanus, Tate Modern, London, UK, 2019. Photo: Tate (Matt Greenwood). Artwork © Kara Walker, courtesy of Sikkema Jenkins & Co. and Sprüth Magers.

but refusing death, a single figure standing in for countless lives lost in the Middle Passage. But Walker gives that figure the ability to swim and a way to breathe—two things not consistently available to Black subjects in the contemporary United States—thereby undermining the universality proposed in Hirst's work by pointing to racialized differences that circumscribe experiences in both life and death.[47] Walker's citation of Hirst also resists reinscription, positioning the loss of Black lives and lacunae in Black histories as fundamental and irreparable facets of what Hartman calls "the inevitable loss or breach that stands at the origin and engenders the black 'New World' subject."[48] For Hartman, as seems to be the case also for Walker, the project of overcoming history that is so central to the traditionally monumental is always already foreclosed upon because the site of history can never be fully known and is therefore unavailable for repair.

Walker's speculative vision of the past as told through *Fons Americanus* also describes the core challenge of reparative projects that are staked on mutual understanding across difference. If traditional monuments aim to make histories or subject positions comprehensible and digestible into eternity, *Fons Americanus* works with an eye toward the impossibility of ever fully knowing the details of the histories to which it refers. But this opacity also offers political potential. For Édouard Glissant, the subject is always opaque not only to the other but also to itself, a reflexivity that offers grounds for solidarity that does not turn on comprehension: "To feel in solidarity with him or to build with him or to like what he does, it is not necessary for me to grasp him . . . nor to 'make' him in my image."[49] To understand the subject as opaque is to understand it to be always already in excess of its overdetermination. *Fons Americanus* does not put forth a graspable otherness, or one that can be easily assimilated into subject categories, instead—and like *Food for the Spirit*—marking difference out at every turn. This comes through in the anachronistic and transtemporal art historical references, which some but not all will get, while Walker's assigning to herself the honorific NTY— for *not titled yet*, a riff on the Order of the British Empire—is an imperial inside joke. The coincidence of these elements with the speculative and historical suggests that the present is a heterogeneous moment already contingent on opacities that cannot be repaired to some utopian togetherness across distinctions, however they have been inscribed. Rather than tracking neoliberal

ideals of diversity, the multiple opacities in *Fons Americanus* reflect an understanding of subjectivity as slippery and multiple and irreconcilable to static identitarian categories. In this way, Walker's work harkens back to the exploration that seems to be taking place in *Food for the Spirit* of how precisely to go about the work of representation while honoring the fundamental irreducibility of subjectivity, even when that subject is in an elemental—in the case of *Food for the Spirit*, naked and alone—state. In *Fons Americanus* Walker not only describes and disrupts the relationship between form and narrative found in traditional monuments, but also learns from Piper's precedent to show that the stakes of monumentality in Western culture have always stemmed from the fundamental unknowability of both the other and the self, and from the constant labor that goes into the delicate work of reifying a fragile set of specious distinctions.

Walker's introduction of caricature into the monumental genre is a key way in which her monuments disrupt the traditional conventions of the form. As has been extensively documented by scholars including Micky McElya and Patricia A. Turner, stereotypes perform an important role in naturalizing hierarchies by creating typologies that offer a permission structure for, in this case, a broad range of raced and gendered subjugations.[50] For example, a caricatured depiction such as the Mammy figure, according to McElya, "blurs the lines between myth and memory, guilt and justice, stereotype and individuality, commodity and humanity."[51] Visual cultural caricatures exaggerate commonly occurring physiological features and index them to the fabrication of categories that are preontological and, therefore, immutable. Often deeply imbricated with scientific racism, which they at once stem from and contribute to in a xenophobic ouroboros, racial caricature naturalizes these differences within the white-dominant zeitgeist.

In addition to making a select few into archetypes of otherness based on phenotypic or observable traits, however, caricature also has the capacity to denaturalize the conventions of representation. As with decisions made elsewhere in the monument Walker does not simply invert the terms of caricature to take aim at, for example, white rather than Black subjects. Instead she applies an aesthetics of caricature to everyone, a queer destabilization of the traditional applications of that aesthetic. While all the figures represented on the monument are rough-hewn but not cartoonish, the figures that flank the plinth have a more clearly caricaturing

tone. Facial expressions alone convey dignity in the figure of Louverture, seated in a regal but not ostentatious position with his chin up. That same aesthetics is applied to different narrative ends in Queen Vicky, meant to be the figurehead of empire but rendered in ways that call upon anti-Black racist caricaturing aesthetics to complicate the representational politics of the work. The Kneeling Man looks plaintively up to an almost performative degree, hands clasped, the lace of his cuffs and collar standing straight out in an accentuated gesture of the absurdity of the European heraldic tradition and its motivations and inheritances. In giving this same caricaturing treatment to all four figures on the same level of the monument, Walker undermines the use of aesthetic differences to create ordering systems while demonstrating the ease with which the mechanisms used to subjugate one group can easily be mobilized to do the same to another—an assertion that also suggests the insufficient nature of simply replacing one set of permanent monuments with another. *Fons Americanus* thus constitutes a mobilization of a representational strategy often deployed in the service of xenophobic projects used instead to describe the machinations of xenophobia.

Walker's use of the queer, campy representational strategy of caricature extends beyond the figures themselves to the monument as a whole. The rich availability of the composite narrative parts of *Fons Americanus* to multiple meanings—including the work's ability to adumbrate dominant narratives while reinscribing the more accurate and violent truths often masked by such narratives—opens onto the possibility that neither conventional nor interventionist narratives of the past need be the only or final story. This is also suggested in the finish of the work: where the *Victoria Memorial* is in cleanly carved marble with bronze and gilded accents, Walker sculpted her monument in a small scale out of plasticine, the models then scaled up without alteration to create larger-than-human-scaled forms. The final product is hollow and made of recycled and biodegradable materials, affording the monument a temporary materiality that points up the ambivalent status of the intercession, at once a monument and monumental rebuttal who engages in caricature through the formal camp of taking something small and making it so absurdly big that it is inescapable. *Fons Americanus*, then, is not only a send-up of the *Victoria Memorial*, but of the category of the monument more broadly. It becomes big even though it began small, is hollow but

permanent, and the final signifying layer of its surface is not the invisible hand of a white man but the visible and magnified fingerprints of a Black woman. These formal conditions facilitate a richly textured explication of a monument to Britain's most famous queen and an extensive excavation of the violent consequences of her reign, made by a subject whose subjectivity was not recognized or respected within that system. Where the original uncritically lauds the Victorian imperial project, *Fons Americanus* shows its terrible consequences for the enslaved, caricatures its armatures, and seeks restitution through the explication of the mythologies that account for these losses throughout the Atlantic world. By laying bare the intentional nature of conquest, its very human cost, and the sinister implications of staging the Black Atlantic as innocuous and mysterious, Walker lampoons imperialism itself through the monumental gesture of the persistence of Black life despite truly monumental efforts against it.

—

*Fons Americanus* and *Rumors of War* are not the only monuments of this new generation to describe the terms of exclusion implicit in many traditional monuments, and monumental explorations of those exclusions are hardly the first thoughtful explorations thereof. Among other scholars who have taken up these themes for decades, Sylvia Wynter has explicated the process through which knowledge formation in Western culture has often reified racial categories that make whiteness synonymous with humanity, while all racial others are positioned as less than or nonhuman, a rhetorical ordering that lays the ethical groundwork to treat nonwhite subjects in a way that is inhumane.[52] These new monuments contribute to the ongoing project of elucidating the terms through which such ordering systems are produced by giving monumental form not to the key terms of those ideologies—which is the role that many traditional monuments play—but to key subjects and histories that such ideological projects go to substantial length to keep minoritized, silenced, or only provisionally visible.

Wiley and Walker hew close to the conventional monumental form through a range of formal decisions that keep their interventions in close conversation with their referents. Both artists avoid marble, the highest order of sculptural material, perhaps in response to its centrality to the naturalization of the white body

to conventions of beauty.[53] Their monuments also share an ambivalent publicness, not ticketed but also not placed in the kind of central urban spaces in which more traditional monuments are located. *Fons Americanus* was installed on the grounds of the Tate, while *Rumors of War* stands on the unceded lands of the Powhatan Chiefdom and Monacan Nation first nationalized, then privatized, through the machinations of settler colonialism. In other words, both monuments participate in the ritual of privatization even as they interrogate and challenge a vast array of binary distinctions and acknowledge that normative distinctions between categories like public and private are specious or fraught. These projects will also circulate in perpetuity online for the foreseeable future, their status there conferring its own kind of publicness into eternity while simultaneously opening onto other questions about the difference, if there is a one, between the phenomenology of the traditionally ascendant monuments and the more contingent visibilities of looking at something in two dimensions on a screen.

Importantly, *Fons Americanus* and *Rumors of War* do not promise a better tomorrow, which brings them closer to a traditional monument than other narrative and formal decisions made by the artists. Instead, they describe a vision of the past framed through the values of the present and propose those as the terms that will also define the future. But rather than lauding those conditions they problematize them, framing the present not as a time of triumph over the past but as coterminous with it, two periods joined in the ongoing condition of a national loss whose tides could, but have yet to, be stemmed. At the same time, these monuments demonstrate the complicity of the monumental form in projects that support and perpetuate those systems, and propose instead that what is happening in the present need not extend to eternity. *Fons Americanus* and *Rumors of War*, in other words, describe a new monumentality in which the cultural labor that monuments perform is not only the monumental representation of narratives previously excluded from the monumental landscape, but also the explication of mechanisms both formal and ideological through which such exclusions have come to pass.

Of these two monuments, however, *Fons Americanus* proposes a particularly important intervention in its interrogation of the relationship between the monumental form and material and conceptual impermanence. For her first monument Walker used a combination of ephemeral and functionally unbiodegradable

materials, making it at once impermanent and hyperpermanent—a material tension that was echoed in the temporary nature of a work that, like the building in which it was installed, was planned to be demolished. The coincidence of the imminent destruction of the work and building, together with the narratives with which *A Subtlety* was freighted, proposed an ambivalent relationship to the future in which a single turbine of racial capital and material expression of its gendered racist inheritances might be destroyed. In *Fons Americanus*, Walker mobilizes ambivalence more forcefully, using nontoxic but sturdy materials fashioned into a hollow shell for a temporary installation with no guarantee either of destruction or of persistence to more robustly interrogate the ways in which permanence itself is a construct subject to a multiplicity of contingencies.

*Fons Americanus* also articulates an approach to the future that is palpably different from what Wiley proposes in *Rumors of War*, a difference that is both made possible by and evident in the artists' divergent approaches to key tropes of the monumental tradition. Where Wiley largely retains the materials, finish, and style of figurative representation in traditional monuments, intervening only in the type of subject figured, Walker departs from all three. While Wiley's retention of permanent materials and their conceptual implications is crucial to his ability to propose the finitude of the present condition, Walker's choice of ambivalently permanent materials and hollow form is similarly central to her ability to call the relationship between present and future into question. *Fons Americanus* also still exists, challenging the idea that something that looks unfinished, is made of temporary materials, and is a temporary installation need also be temporary, and proposing instead that temporariness as a concept contains within it the possibility of a different future that cannot yet come to pass. The ability of the work to signify as a monument despite its non-monumental materiality forcefully challenges formal distinctions between the monumental and non-, belies claims to ideological permanence underwritten by solid and impermeable materials, and proposes that the monumental form can stand at the juncture of a single present and single future while simultaneously opening onto a vast array of potentialities that are like or unlike the present to varying degrees.

Despite their divergent propositions about materiality, *Fons Americanus* and *Rumors of War* both suggest that temporal rupture

of one kind or another is now a central feature of the monumental form, and that material permanence need not denote cultural permanence. This deracination can be extrapolated to other cultural implications of the traditionally monumental; in intervening in them, this generation of monuments demonstrates that these formal associations, like the cultural logics they support, are vulnerable to rupture. By decentering, destabilizing, and rendering impermanent public and material expressions of empire and its consequences, the monuments by Walker and Wiley adumbrate that the universal is not only an impossibility, but also a falsehood sustained and fed by a set of violent pasts become systematized in the present, such that even as the temporal gap between the nightmare of slavery and our present moment grows, Black life in the United States is still circumscribed by the conditions of what Christina Sharpe calls living "in the wake" of slavery, or "the contemporary conditions of life as it is lived near death, as deathliness."[54] These monuments are not, in the final analysis, new, but rather evidence that we remain beholden to the same kind of thinking that the form has been used to perpetuate in the past. The only difference is that these recent monuments wear their ideologies on their sleeve, exposing rather than eliding that the past is a venue of ideological contestation. By demonstrating that multiplicity is inherent to narratives of history, and doing so through formal conceits that deracinate material permanence from conceptual permanence, this generation of monuments invites an interrogation of the relationship between what is and what must or could be.

4   *Monumental Time(s)*

Since the unveiling of Kara Walker's *A Subtlety*, a significant proportion of new monuments have used appropriation as a central representational strategy. In numerous works including those studied in the previous chapter, either a specific historical monument has been used as a referent, or a broadly recognizable monumental trope such as a plinth with some kind of statue on top of it has been mobilized to reimagine who or what can be represented in the genre. In these and other ways, recent monuments have described the terms through which traditional monuments make their meaning, while applying the traditional conventions of the form to different narrative ends. The AIDS Quilt borrows from an African American quilting tradition for its structure, and from a vast array of subcultures for its surface; Kara Walker draws on both the monumental and art historical traditions while appropriating racist caricature to subvert the traditional deployments of all three; and Kehinde Wiley also looks to both the monumental and art historical traditions, but blends those with his own longstanding representational methodology, which itself borrows in

substantive ways from the practice of earlier painters ranging from the French epic tradition to the American Barkley Hendricks.

As important to these new monuments as appropriation, however, is their intervention into the conventional relationship between monuments and time. In traditional expressions of the form, the vision of the past on offer is fabricated not in pursuit of historical accuracy, but according to the politics of the present in which the monument is made. The resulting narratives are progressive and linear, where what is represented is selected according to the political exigencies of the present. The temporality that results is what Elizabeth Freeman calls chrononormative time, in which "naked flesh is bound into socially meaningful embodiment through temporal regulation."[1] Chrononormative time is regulatory time, meted out in increments whose measurement is co-constitutive with processes of categorizing what is otherwise naturally occurring to hierarchical ends, producing one sense of time that is standard and a multiplicity of temporalities that are not. Time itself is conscripted as a tool of hegemony, that "absent totality," as Ernesto Laclau and Chantal Mouffe describe it, that emerges in the guise of agency of social movements but which more fundamentally serves as a tool to order and regulate bodies.[2] The violence of chrononormativity is not simply the determination of the normative and not but the validation of one temporal experience and an infinitude of other times that are captured and held captive by it. Traditional monuments, then, have a chrononormative relationship to history, collapsing the past into a single narrative that is not historical at all, but rather crafted in the interest of reifying hierarchies according to the operative political or ideological winds of the moment, and of positioning those narratives as the predicate for the future.

The monumental form is readily available to ideological projects that reduce the complexity of the past to what is of value in the present in part because it does not lend itself to a nuanced narrative. But recent monuments pose a challenge to the chrononormative time of traditional monumentality by challenging the idea that only one history can be authorized, giving fuller form to historical elisions and violences, and exposing that the progression from past to present has been contingent on social and temporal regulation. Both *Rumors of War* and *Fons Americanus* betray as false the myth of time as neutral actor; *Rumors of War* at once

demonstrates the durability of the past in shaping the future while asserting that what now is rarely persists forever, while *Fons Americanus* both demonstrates and resists the regulatory conventions of time by breathing new life into histories of violence intended to be lost through the whitewashing of the narratives of those in power. The monuments studied in the previous chapter also challenge the linear causality of time in their assertion that there cannot be a future until those more complex, often violent histories and their impacts in the present are acknowledged.

This chapter studies two further monumental challenges to chrononormative time. Rather than staging the future as a categorical impossibility, as the monuments in the previous chapter do, these suggest that the possibility of a future turns in part on a collapse in the distinction between past and future. The first part of this chapter studies *Tomorrow Is Another Day*, a multimedia installation by Mark Bradford mounted in the American Pavilion at the Venice Biennale in 2017. Across the exterior and five rooms, Bradford mobilizes deconstruction in both material and rhetorical terms, working against the chrononormative temporality of traditional monuments to propose that the future becomes possible only through the destruction of monuments and the claims they lay to concepts like objectivity and truth. Bradford's work envisages a relationship to the future despite the material dehiscence of the work, proposing that dehiscence as crucial to reaching the future. *Tomorrow Is Another Day* also proposes a relationship to time that might best be described through what José Esteban Muñoz calls "the future in the present,"[3] a queer temporal collapse in which the possibility of the future already exists in the present in germinal nodes that are barely perceptible under conventional regulatory regimes. Drawing extensively on Black, queer, and feminist histories, Bradford's project gives form to the concept of the future in the present by performing the necessity of the destruction of the monumental—of both the form and the linear and progressive vision of time it contains—as a predicate to redressing the conditions of domination that authorize a single vision of history to the exclusion of all others. The queer temporality of *Tomorrow Is Another Day*, this chapter suggests, not only opens onto the possibility of a different future, but also intervenes in chrononormative regulatory architectures that reserve and preserve the future as the exclusive purview of a select few.

The second part of the chapter examines Lauren Halsey's *the eastside of south central los angeles hieroglyph prototype architecture (I)*, the 2023 Rooftop Commission at the Metropolitan Museum of Art. Halsey took as a referent the Temple of Dendur, joining an African classical past with an African American present to propose, in stark contrast to Bradford, that the renewed efforts to build monuments are crucial to the project of both imagining and bringing about a future that is distinct from the past. *the eastside of south central* also constitutes a queerly temporal collapse, but one where a different future comes about through a return to history and a reclaiming of what has been lost or devalued as a condition of living in a present in which, as Kara Keeling puts it, "a queer/Black future looks like no future at all."[4] *the eastside of south central* mobilizes a queer relationship to time that resists the efforts toward totalizing knowability of regulatory mechanisms—among them, chrononormativity—and makes possible, in its status both as a prototype and as an object that is at once ancient and contemporary, what Keeling calls a "Black diasporic temporal accumulation" that surfaces a minoritized vision of the past in the present to make queer/Black futures possible.[5] Halsey, in other words, proposes a classically monumental relationship to time, the obverse of the one put forth by Bradford. In *the eastside of south central*, the past is an arena full of potential, waiting to be uncovered, and to get to a queer/Black future, that past has to be found or fabulated[6] to form the future.

The projects in this chapter also cast off the monumental in a way that, much as *Food for the Spirit* did in 1971, dictates nothing to the viewer, but rather engages in a process of retraining the eye by posing questions about how what one is looking at differs from what—or perhaps how—one may be used to seeing. Central to both projects and their divergently queer relationships to time are the artists' interventions into the monumental tropes of solidity and finish: both take a critical stance to the polish, perfection, and permanence telegraphed in traditional monuments. By creating monuments that appear formally, even performatively in process, Halsey and Bradford create speculative monuments, forms that make their meaning beyond or in spite of traditional claims to veracity and time, and in so doing, offer a vision of the monumental that moves beyond traditional or chrononormative temporality to call into being and inhabit what Muñoz calls the "not yet here" of a different future.

In 2017, the US representative to the Venice Biennale was the painter Mark Bradford, one of only a handful of nonwhite or queer artists selected for the role to date. The American Pavilion in which the US commission is installed was built in 1930 in the Palladian style, a form developed by sixteenth-century Venetian architect Andrea Palladio to foster civic and academic learning. Palladian buildings are characterized by a lateral symmetry, often anchored by a large central room and capped by a rounded dome, and are not often monumental in their scale, but the narratives with which they are freighted are often monumental in their significance to the well-being of the polis, something that made them appealing to later architectural projects with academic and civic purposes. Perhaps the most famous application of the Palladian in the United States is in Thomas Jefferson's Monticello, designed by and built by enslaved laborers, where the most notable departure from the traditional expression of the form is in the introduction of octagonal rather than rounded elements in the dome and the central room below.

Despite this more recent American version of the Palladian form, the design for the American Pavilion reached back to the traditionally Palladian style, in which a round room topped by a rounded dome is flanked on either side by a picture gallery along a lateral processional axis, and appended to the front of both side rooms is another picture gallery. The end rooms on either side draw the eye to the centralized front entrance, imagined as the grand beginning of a prestigious commission, making the overall shape of the building a bracket.

Visitors to Bradford's installation *Tomorrow Is Another Day*, however, arrived to find a building that looked shuttered or abandoned. The doors to the building's central entrance were closed, and the familiar gravel that lines the pathways of the Giardini that houses the Biennale was piled up against the facade. Facing passersby on the outer wall of the left-hand picture gallery was a monumentally scaled slate tablet into which a poem written by Bradford, titled "Hephaestus," was etched like an epitaph. The title of the poem refers to the Roman god cast out from Olympus for a physical trait over which he had no control, who later returns to become the blacksmith to the gods, revered for his productivity and for his craftsmanship but relegated to a lower status than the

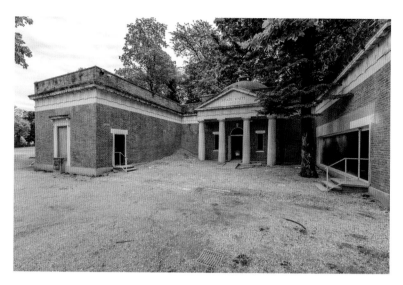

Figure 4.1   Mark Bradford, *Tomorrow Is Another Day*, 2017, installation view. Detail: *Barren*. La Biennale di Venezia, US Pavilion, Venice, Italy, 2017. © Mark Bradford. Courtesy the artist and Hauser & Wirth. Photo: Joshua White.

one into which he was born. Bradford's version of the narrative opens with a skepticism toward official narratives: "I mean nobody likes to admit it— / Somebody threw me out of my house / They told me / they told me it was my mama. / But let me tell you somethin' / the hands dragging me to the cliff / (and I kept my eyes wide open) / were not the hands of my mother." The poem goes on to describe the subject awakening to discover that he has a broken foot and embarking on a perilous journey in which he tries, but ultimately fails, to evade kidnappers.

In ways that anticipate Walker's later use of epitaph-like prose to frame *Fons Americanus*, Bradford's "Hephaestus" describes but does not wholly account for the pictorial elements of *Tomorrow Is Another Day*. The tablet into which "Hephaestus" is carved is just around the corner from the discreet side entrance to the installation, the first room of which contains a reddish-black sculptural work titled *Spoiled Foot*, which stands in for the corporeal beginning of the tale of Hephaestus. Suspended from the ceiling and sagging almost to the floor, *Spoiled Foot* evokes rotting flesh and seems to strain under its own capacity for containment, like a boil that needs lancing to prevent it from exploding, or an infection from spreading. To move into the next gallery, visitors have to

Figure 4.2   Mark Bradford, *Tomorrow Is Another Day*, 2017, installation view. Detail: "Hephaestus." Cement board, in two pieces. Each piece: 83¾ × 48¼ × ⅝ in (212.7 × 122.5 × 1.5 cm). La Biennale di Venezia, US Pavilion, Venice, Italy, 2017. © Mark Bradford. Courtesy the artist and Hauser & Wirth. Photo: Joshua White.

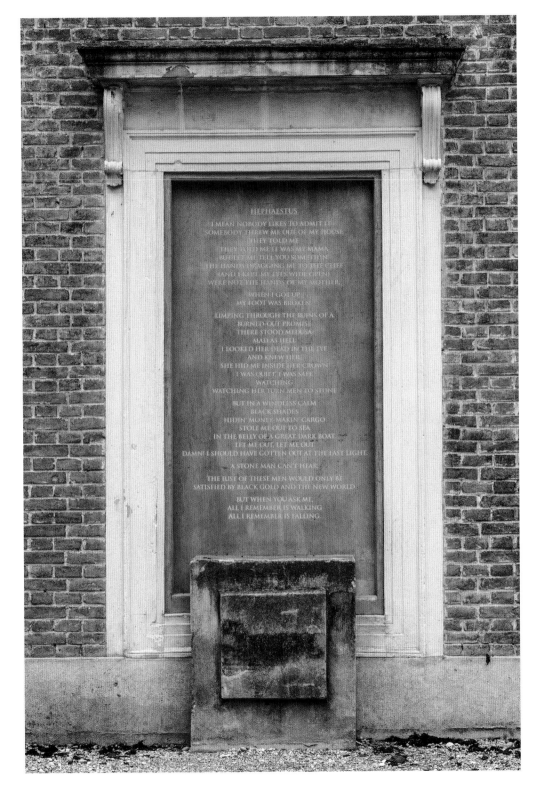

HEPHAESTUS

I MEAN NOBODY LIKES TO ADMIT IT
SOMEBODY THREW ME OUT OF MY HOUSE
THEY TOLD ME
THEY TOLD ME IT WAS MY MAMA
BUT LET ME TELL YOU SOMETHIN'
THE HANDS DRAGGING ME TO THE CLIFF
(AND I KEPT MY EYES WIDE OPEN)
WERE NOT THE HANDS OF MY MOTHER.

WHEN I GOT UP
MY FOOT WAS BROKEN

LIMPING THROUGH THE RUINS OF A
BURNED-OUT PROMISE
THERE STOOD MEDUSA
MAD AS HELL
I LOOKED HER DEAD IN THE EYE
AND KNEW HER.
SHE HID ME INSIDE HER CROWN
I WAS QUIET, I WAS SAFE
WATCHING
WATCHING HER TURN MEN TO STONE

BUT IN A WINDLESS CALM
BLACK SHADES
HIDIN' MONEY-MAKIN' CARGO
STOLE ME OUT TO SEA
IN THE BELLY OF A GREAT DARK BOAT
LET ME OUT, LET ME OUT
DAMN! I SHOULD HAVE GOTTEN OUT AT THE LAST LIGHT.

A STONE MAN CAN'T HEAR

THE LUST OF THESE MEN WOULD ONLY BE
SATISFIED BY BLACK GOLD AND THE NEW WORLD

BUT WHEN YOU ASK ME,
ALL I REMEMBER IS WALKING
ALL I REMEMBER IS FALLING.

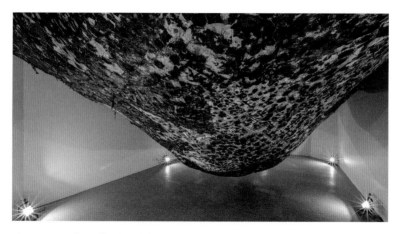

Figure 4.3 Mark Bradford, *Spoiled Foot*, 2016. Mixed media on canvas, lumber, luan sheeting, and drywall. Dimensions variable. © Mark Bradford. Courtesy the artist and Hauser & Wirth. Photo: Joshua White.

keep to the edges of the room, most compelled to duck to avoid touching the sculpture.

The second room contains the series *The Odyssey*, three large-scale, black-and-purple-toned paintings (*Leucosia, Raidne,* and *Thelxepia*) made with perm end papers, small pieces of tissue used to absorb and evenly distribute hair treatments and ubiquitous in beauty shops. Their striation in Bradford's paintings recalls strips of film, which freeze instants linked together to form the illusion of continuity where none truly exists. In keeping with the narratives from which the title for the series is drawn, the paintings of *The Odyssey* are epic in scale: larger than the human body, they consumed the better part of the field of vision for most who took them in. The abstracted and irregular gridding of the pictorial field combined with the massive scale of the works gestures ineluctably toward minimalism, but with a material armature drawn from the maintenance practices of certain valences of femininity that rupture the traditionally masculine associations of painterly and minimalist traditions.

The resonances of feminized hair practices are also present in *Medusa*, a sculpture installed in the center of the room comprised of a hulking mass of black paper that has been bleached and twisted into ropelike cords that recall dreadlocks. The mythological origins of both Medusa and Hephaestus demonize the feminine and maternal and emphasize the triumph of a specifically

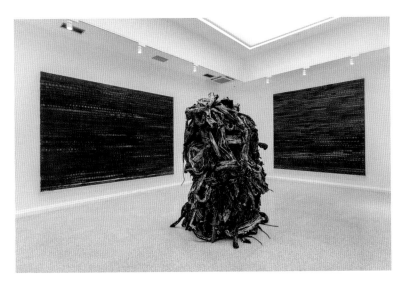

Figure 4.4  Mark Bradford, *Tomorrow Is Another Day*, installation view. La Biennale di Venezia, US Pavilion, Venice, Italy, 2017. © Mark Bradford. Courtesy the artist and Hauser & Wirth. Photo: Joshua White.

masculine strength and productivity that comes after. But Bradford follows a long tradition that intermingles with the feminist in repositioning what in the original mythological context is a deficit as a source of power and safety: the narrator finds safety under Medusa's "crown" and watches her "turn men to stone" to keep him safe for a time.[7] *Medusa* can thus be understood as a restaging of the mythological Hephaestus as a journey across which the power to disrupt the operations of domination are the remit of Black women and located in Black feminist praxis.

The subsequent space in the flow of *Tomorrow Is Another Day* is the rotunda at the heart of the building. In the European and American architectural canon, rotundas are associated with the apparatus of the political state, the arched dome that swoops up to an oculus at the top meant as a synecdoche for both nation-state and God, its presence conveying a connection between the individual subject and a force so great as to be unknowable in its totality. Inside this dome-capped rotunda Bradford installed *Oracle*, a material continuation of *Medusa* in which long, ropey strands that evoke the mythological snakes of hair take on new and larger life, coiling into the dome and up to the edge of the oculus. They also wend their way along and into cracks in the walls of the room below, where paint and plaster chips are scattered on the floor as

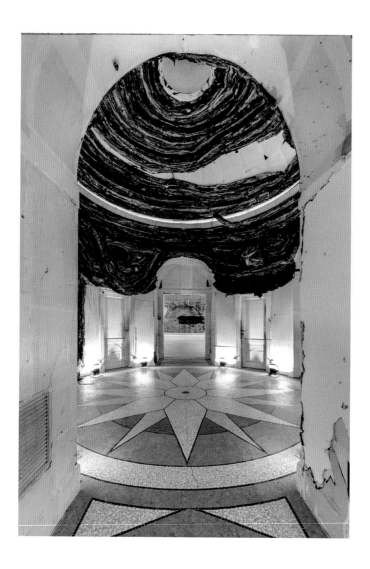

Figure 4.5  Mark Bradford, *Oracle*, 2017. Mixed media. Dimensions variable. © Mark Bradford. Courtesy the artist and Hauser & Wirth. Photo: Joshua White.

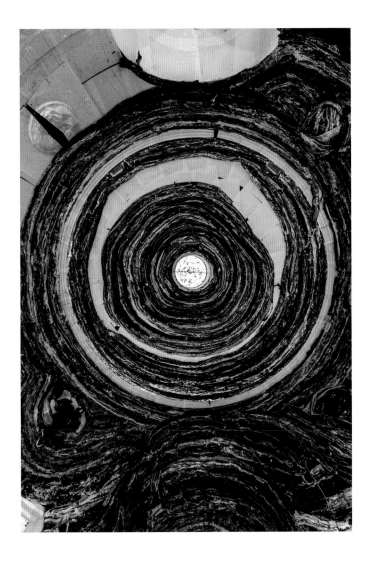

Figure 4.6   Mark Bradford, *Oracle* (detail), 2017. Mixed media. Dimensions variable. © Mark Bradford. Courtesy the artist and Hauser & Wirth. Photo: Joshua White.

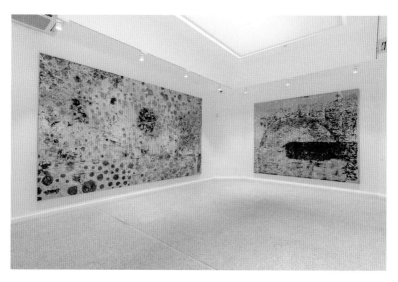

Figure 4.7   Mark Bradford, *Tomorrow Is Another Day*, installation view. La Biennale di Venezia, US Pavilion, Venice, Italy, 2017. © Mark Bradford. Courtesy the artist and Hauser & Wirth. Photo: Joshua White.

if the building is disintegrating before our very eyes under an out-of-time siege from an oracular Medusa who brings about ruin as the condition of (or perhaps precondition to) her truth.[8]

The subsequent room—the fourth in the installation—contains another series of three large, abstract canvases: *Go Tell It on the Mountain*, *105194*, and *Tomorrow Is Another Day*. In contradistinction to the dark minimalism of *The Odyssey* series, these are comprised of layers of brightly colored paper overlayed with paint that has been sanded, burned, and cross-hatched to reveal layers of material beneath. From across the gallery, these largely nonfigurative surfaces suggest cell cultures but on closer inspection evoke decaying flesh, with pieces of knotty fibrils emerging out of the rough-hewn pictorial surface and black, fungal-looking areas visible in a layer far below. The fleshy decay of these painterly bodies might seem out of sync with what could be understood as this moment in the poem, in which a wind picks up and turns everything around again, leaving the narrator exposed, then recaptured, and coming to terms with the possible permanence of that condition. But it both resonates deeply with the decay of the building and becomes legible through its historical context: a gay man born in 1961, Bradford came of age in Los Angeles during the AIDS crisis, one of the countless young people coming into the power and

Figure 4.8  Mark Bradford, *Niagara* (still), 2005. Video. 3:17 minutes, color, no sound. ©
Mark Bradford. Courtesy the artist and Hauser & Wirth. Photo: Joshua White.

potentiality of their queerness just as the plague blew through and
dislodged whatever contingent sense of safety their discovery and
exploration of their sexuality had afforded. The canvases in this
room, then, can be read as gesturing toward Kaposi sarcoma, sick
cells, and other epidemiological themes of threat associated with
the AIDS crisis and its aftermath.

The final of the five galleries—installed in the architectural
mirrored space of *Spoiled Foot*—contains the video *Niagara* (2005),
projected onto a screen in the middle of the room. Titled after the
1953 film by the same name featuring Marilyn Monroe that con-
tains a long shot in which Monroe's character walks away from the
camera into an urban horizon to articulate a very particular kind of
idealized white femininity, Bradford's short, three-minute version,
rendered from even shorter footage slowed down to emphasize the
movement in the frame, consists of a single, tight shot in which a
figure slowly walks away from the camera down an urban sidewalk
lined with older cars, with large weedy grasses sprouting from the
edges of the concrete and litter dotting the street. The figure is
legible as Black and masculine, as evidenced by dark skin, short
hair, and relatively straight physique, and wears a ribbed tank
top, yellow athletic shorts, crisply white athletic socks, and black

sneakers. It is difficult to discern the subject's age; though adult-sized based on his scale relative to the cars nearby, his biomechanics hint at youth, as though he has recently come into his height. As he walks, the ever-so-slightly unsteady camera—and therefore the eye of the viewer—are trained on the shorts, whose length and materiality allow them to swish slightly with each step. Though the subject is simply walking, his body seems unconstrained; his arms swing freely, and there is a slight bounce at the toes accentuated by the slowed tempo of the video. This effect is emphasized by the fact that he only becomes fully visible partway through the film, once he is far enough away from the camera's frame to, perhaps paradoxically, be captured by it.

In *Niagara* Bradford brings together a range of formal elements that cite monumental or art historical conventions to destabilize them, and does so in ways that gesture toward valences of Blackness and queerness that are strengthened in the larger context of *Tomorrow Is Another Day* through the repeated return to materials and mechanisms associated with the feminine. Each of these interventions is underwritten by the complex relationship to time in *Niagara*. In its use of slow footage, the film both thematizes and disrupts racialized and racist cultural expectations or stereotypes around Black masculinity, a category whose overdetermination is also destabilized in the film by what seems to be a contingent youth in the subject's biomechanics. The trope of slowing portends danger or death as often as it does a heroic culmination, but here it dislocates spectatorial expectations around the filmic passage of time, mobilizing the terms of a famous scene emblematic of white femininity at a particular historical moment to get at something related to Black queer masculinity, while also suggesting that the overdetermination of certain bodies has not changed much with time. At the same time that the slowing of the film gestures toward ways in which Black lives are circumscribed, it also holds this body and its signification in stasis in ways that, coupled with the looped footage, open to narrative alternatives. This is echoed materially in the cars lining the street, several of which seem old by the standards of 2005, thus situating this film not concretely in the present, but rather in multiple recent pasts.

*Tomorrow Is Another Day* ends in a very different place than the one in which it began, a journey mapped at least in part through the narrative Bradford offers in "Hephaestus." The poem and the building both begin with a bad foot, and undergo a series of

changes that end in a more ambivalent place; at the end of the poem the narrator is stolen "out to sea / in the belly of a great dark boat"; "all I remember is walking / all I remember is falling." In *Niagara*, the walking and falling in the poem, which are sequential—first walking, then falling—are collapsed into a campy walking-falling that looks like a skip or sashay. Especially as the subsequent term in the sequence to the previous room that gestures at the AIDS crisis, the focus on the subject's hips, which in slow motion have a sway to them that might not be visible or even extant at conventional speed, is imminently, eminently queer, bolstering—or perhaps stripping away to expose—the complex networks through which subjectivity comes into being, and the ways in which it is repeatedly confirmed and contested both from within and beyond the self. Zadie Smith observes that camp is at work in *Niagara* in its most root sense, the kind that "begins in excess" and performs a "flagrant and delicious survival *in the face of* and *despite the fact*" that one was never meant to survive.[9] *Tomorrow Is Another Day* can thus be understood to describe a relationship between constraint and freedom. But rather than mapping a linear arc with a clear start and end, that arc describes the deconstruction of the relationship between beginning and end as a condition of the deconstruction of the building. This is perhaps most in evidence in the juxtaposition of *Niagara* with *Spoiled Foot*, where the conventional dyad of opening and closing the exhibition that would have this project begin in rot and end in resistance is complicated by the filmic cut, where the subject moves away from constraint but never actually escapes, stuck in perpetuity in a narrative loop of getting away but never having gotten away. Fred Moten calls this being "sentenced to the gift of constant escape,"[10] where escape is not a binary condition but rather an ongoing and effortful process that may never fully resolve. Moten uses a similar definition elsewhere to describe or define freedom,[11] a concept that also characterizes both the temporality and the narrative arc of *Tomorrow Is Another Day*.

In describing the subjective constraints and contingencies of freedom, *Tomorrow Is Another Day* also describes a range of opacities that intervene into the universalist claims of the traditionally monumental. A monumental intervention into a monumental building, *Tomorrow Is Another Day* smuggles something at once rote and insidious—the trenchant pasts and presents of anti-Black racism—into other ways of thinking about being that adduce those

raced histories while simultaneously touching other violent otherings and the promises that persist in spite of them. The rot in the first and fourth rooms, in concert with the general dehiscence of the building, suggests a Black feminist resolve visited on the kinds of structures both real and allegorical that make events such as the kidnapping of the figure in Bradford's poem possible, and which enable other structural violences that follow on. Rot is thus repositioned as something productive, a time-based process of decay with organic implications that suggest there is something bad at the core of the structure that will emerge naturally in time; Bradford simply helps this process along by excavating a form in a way that performs the inextricability of the United States as both an idea and a nation-state from the histories and afterlives of enslavement that persist at its core. Medusa's snakes become dreadlocks also restage the European mythological narrative in an African diasporic context, redeploying a figure often demonized in white-dominant culture as guardian or protector of the persecuted while threatening to compromise the structural integrity of the building in its role as allegory for a coherent and uniform national body. This intervention is all the more powerful because of its dual origins in ancient culture (to which Western culture has long looked to anchor itself historically) and in more recent histories Black life in the United States, which continues to unfold in spite of elaborate attempts to extinguish it.[12] These are joined together with attempts to extinguish queer life, making the journey across through the middle three rooms one along which conditions of constraint are co-constitutive with those of persistence. In this formulation the rotunda offers a brief moment of respite in which to gather strength as one moves from living in the wake of slavery to being surrounded by the threat of the AIDS crisis and its own long tail. The failure to effectuate a rupture between the complex temporalities of minoritization and violence and the present ends up infecting everyone, rotting the national pavilion—and, by association, the nation—from the inside out.

On the heels of this multivalent rot, *Niagara* shows us a body both skipping and not, the difference between those two conditions circumscribed by a host of formal and, by association, social constraints. Smith notes that "there's no way of knowing if the world is open for [Bradford's] neighbor's performance or filled with daily threat and fear."[13] Both are likely simultaneously true. The ambivalence of this way of being in the world—the coincidence of

openness and threat, the knife's edge of limb-loose walking and sashaying—is compounded with filmic tropes of slowed tempo and the looped cut that invites careful attendance to each movement, as though close looking will reveal something that can settle that movement once and for all. Instead, the film ends in a partial revelation of a body—the figure becomes visible from head to toe as he walks away from the camera, but never turns around to face us—that can be read as camp and swishy but only under very specific conditions that at once manifest those implications and call them into question. An ambivalent ending is also anticipated by the poem, in which the subject's ultimate fate is left unresolved; while the narrative gestures toward his ultimate absorption into the machinations of racial capital, it also leaves the door open to the possibility of escape, however faint.

The queer ambivalence of the film also reverberates through the larger installation in its deployment of a narrative arc and temporal progression that rhymes with Black and queer ways of coming of age. Queer childhoods are often mapped onto reparative narratives—recall the "It Gets Better" campaign, begun in 2010 to support queer youth—where childhood is a space of danger and adulthood one of comparative safety. But the threat of inhabiting certain subjectivities never truly falls away with time. This unresolved arc is palpable in *Tomorrow Is Another Day*. If the swish at a reduced tempo could also be read as a swish at full speed, then the subject could be read as experimenting with mature ways of moving through the world while simultaneously remaining in possession of the deniability of more youthful and childlike movements that enable—but by no means guarantee—safe experimentation. As it is, however, the spoiled foot is just the beginning of an odyssey that brings this boy through trial to something that gestures toward but utterly refuses the triumphal or triumphant.

If *Tomorrow Is Another Day* gestures toward a queer potentiality of adolescence, however, it also surfaces the racialized conditions of childhood in a culture built through the violent regulation of bodies legible as Black and masculine that are rigorously circumscribed from early childhood. Nonwhite children are held to more adult standards for behavior, and afforded fewer protections, than their white counterparts, a racist asymmetry that has its US origins in the late eighteenth and early nineteenth century. As Robin Bernstein has shown, by the mid-nineteenth century childhood "was understood not as innocent, but as innocence itself," while

both childhood and innocence were coterminous with "a spectacle of phenotypical and chromatic whiteness."[14] This association plays out in the higher frequency of contact between Black children and the carceral system that, as the legal scholar Michelle Alexander argues, "operates as a tightly networked systems of laws, policies, customs, and institutions that operate collectively to ensure the subordinate status of a group largely defined by race,"[15] and often replaces systems that guard childhood for white or white-passing children.

In drawing Black and queer themes together along an axis of overlapping violences and preclusions premised on conditions largely beyond an individual's control, *Tomorrow Is Another Day* instantiates a temporal collapse in which the looped film is echoed in the procession through the building: the visitor exits through a door that is the mirror image of the one through which they entered the building, thereby closing the loop of the exhibition. This is what Muñoz calls a "stepping out of the linearity of straight time,"[16] where the conditions of arrested progress also open onto a new set of possibilities. The monumental building is suspended in the ongoing condition of being ruptured from the inside out by a range of minoritized structures that propose minoritization not as a set of terms through which the subject becomes subjected, but rather as a site through which a new monumental hermeneutics can emerge. Imperfectly (though not imprecisely) indexed to the poem that announces its beginning, *Tomorrow Is Another Day* also evades totalizing comprehension, giving the work porous material boundaries that open onto similar semantic ones that enable it to mean multiply and complexly, while simultaneously working through the historical factors that contribute to the conditions of Blackness and queerness in the United States in the present. *Tomorrow Is Another Day* is like *Food for the Spirit* in this way; it is not an act of protest, but rather an ideation of what comes after protest fails to effect change. Neither reparative nor recoverable into such a narrative, Bradford's installation gestures toward disruption and destruction as the only viable alternative to repair in a context in which extant structures of identity-based domination both literal and figurative still stand.

The modality of constant escape in *Tomorrow Is Another Day* begins with a membrane that pushes all viewers toward physical avoidance—even if one is not so tall that ducking is absolutely necessary—and works toward a future in which a certain degree

of that pressure can be released. Read from start to finish, the installation opens with a skepticism of dominant narratives, journeys through a range of experiences in which the subject is both marginalized through and rescued by the conditions of minoritization, and leaves with the hint of a skip or swish that suggests but does no confer a different or more hopeful future. The myth of Hephaestus is available to readings assimilable to ontological understandings of disability and, by association in the context of this piece, race and sexuality. But Bradford instead makes use of representational and methodological queerness to appropriate that myth beyond easy binaries of trial and triumph, monument and rupture, choosing to stage resistance as an ongoing process of becoming that understands the future, as Muñoz says, as "a kernel of political possibility within a stultifying heterosexual"— and white-dominant—"present."[17] *Niagara*, then, is not only its cut, but also its swishy potentiality, a slowing of chrononormative time that interpellates the viewer who is on the lookout for that swish and invites them to leave (or go through the exhibition again) more attuned to alternative possibilities in the world beyond the exhibition.

Bradford's installation is, like other new monuments discussed in this project, transparent in its politics from the very beginning, as suggested in a section of the poem that reads, "The lust of these men would only be / satisfied by black gold and the new world." These lines gesture toward the necessity of ruin, of stripping away the architectures both literal and figurative that ease the way for the satisfaction of that insatiability. Traditional monuments scaffold that hunger by suggesting that it has been sated before and can be again. Bradford, by contrast, demonstrates that such narratives, which pretend to linearity, are instead mostly closed loops whose inescapability is a boon to those in power and a form of subjection to those who are not. The only way out, as *Tomorrow Is Another Day* proposes, is through the ruination of all monuments.

Crucially, Bradford's project does not suggest that a new monumentality must be premised on the physical condition of rupture, which would render it synonymous with Walker's use of the materiality of impermanence. Instead, he uses material rupture to suggest a more conceptual break between the present and a truly distinct future, and the elaboration of such a project through very specifically minoritized terms. *Tomorrow Is Another Day* has its own spacetime that begins with "Hephaestus" and ends with *Niagara* and

Figure 4.9 Special exhibition, *The Roof Garden Commission: Lauren Halsey*, Metropolitan Museum of Art, Lila Acheson Wallace Wing, Iris and B. Gerald Cantor Roof Garden, Gallery 926, April 18, 2023–October 22, 2023. Image copyright © The Metropolitan Museum of Art. Image source: Art Resource, NY.

in which forward motion through the installation—and, therefore, through time—only becomes possible as a condition of the ways that women and Black and queer people have developed to survive. In elaborating a project that lays this tension bare, Bradford creates a space in which what has been need not persist in being what is or will be, and suggests that the only way toward a different future is through fissures in the facade of the past as they manifest or are created in the present. In Bradford's hands, the future is not yet here, but it is visible through those cracks; to get to them, to borrow from the same biblical passage to which Wiley turns, all stones must be thrown down.

### the eastside of south central los angeles hieroglyph prototype architecture (I)

*the eastside of south central los angeles hieroglyph prototype architecture (I)*, by Lauren Halsey, is a twenty-two-foot-high temple consisting of a hollow cube with massive cutouts—two at opposing corners, and one facing the sky—and flanked by four columns and four sphinxes, all made from glass-fiber-reinforced concrete. Inscribed

onto its surface like hieroglyphs is a broad range of visual signifiers drawn from of a collection of ephemera Halsey has collected, including drawings, tags, signs, cutouts, and vernacular objects whose spatiotemporal locations reach from ancient Egypt through African American culture in the United States to the Black and Latine cultures of South Central Los Angeles today.[18] Transcribed from that archive onto *the eastside of south central* is a catalogue of the visual culture of Halsey's surrounds: images of heads with short hair and patterns shaved into them, pyramids, ankhs, space-age bodies, and an array of slogans ranging from the political ("unite gangs / unite the poor / stop gentrification") to the colloquial ("waz up?"), and a multiplicity of other forms that are possible to describe but utterly illegible to those not familiar with Halsey's personal iconography, such as verbal vernaculars that might be shared widely or among a select few friends, tagging vocabularies of South Central, and the commercial aesthetics of Southern California. This world-building, indexed to and filtered through a single life, extends to the faces of the sphinxes and column capitals, whose faces are those of Halsey's own personal pantheon of chosen kin, biological and not.

Halsey created *the eastside of south central* for the Metropolitan Museum of Art's annual Roof Garden commission, where it was installed from April to October of 2023, using the Temple of Dendur, an Egyptian temple housed in a purpose-built space in the Met, as a referent. The Temple of Dendur has a single front and a unidirectional processional axis that proceeds from an auxiliary structure in front of it, through a courtyard between the structures, and through the entrance of the temple itself, which has a solid ceiling and no alternative way in or out.

The Temple of Dendur is a study in the slippery and mobile nature of meaning, and the ways in which the meanings of objects are fluid from their inception. Built during the Roman period, it was sited on the bank of the Nile at the river's first cataract, a point on a line that divided Egyptian culture to the north and Nubian culture to the south. The iconography of the temple includes representations of the goddess Isis, celebrated in part for her extensive magical powers; the enigmatic figures Pedesi and Pihor, siblings deified locally after drowning in the Nile; and then-emperor Augustus Caesar. The pictorial and linguistic references to these and the other figures, whether plant, animal, god, or some confluence of the three, are carved in relief into the walls

Figure 4.10 The Temple of Dendur. Given to the United States by Egypt in 1965 and awarded to the Metropolitan Museum of Art in 1967. Courtesy of the Metropolitan Museum of Art.

and, prior to a series of floods, would have been brightly painted.[19] Though these and other iconographic regimes within the temple gesture primarily toward localized Egyptian pantheons, the representation of Augustus Caesar is an indication of the politics of the moment: portrayed in a Pharaonic headdress, the Roman emperor is rhetorically positioned in a way that blends two cultures to give pictorial form to the emperor's role as the leader of the recently annexed area. The Temple of Dendur, as Robert Schork has argued, thus answers to the terms of propaganda, where the restaging of the Roman emperor in pharaonic clothing is meant to insinuate a faraway leader into signifying regimes that range from the transcontinental to the hyperlocal.[20] In addition to being characteristic of the aesthetic, material, and conceptual entanglements of Roman, Egyptian, and Nubian cultures in that time and place, the Temple of Dendur is also, as Erin Peters has argued, "a colonial object made so largely through the constructs of modern Western structures of thought." Since its transposition from the banks of the Nile to the edge of Central Park, it has come to both stand in for and serve narratives of international cooperation that themselves serve both US and Egyptian nationalist ends.[21]

Figure 4.11  Special exhibition, *The Roof Garden Commission: Lauren Halsey*. Detail: the oculus. Metropolitan Museum of Art, Lila Acheson Wallace Wing, Iris and B. Gerald Cantor Roof Garden, Gallery 926, April 18–October 22, 2023. Image copyright © The Metropolitan Museum of Art. Image source: Art Resource, NY.

*the eastside of south central* gestures toward its referent in multiple ways. As with other monuments in this book, the elements that Halsey retains from the Temple of Dendur are as important as the ways in which she intervenes in it, which come about first and foremost through the representational language of processional space. The two structures are approximately the same height, hewn from light-colored materials, covered with diverse iconographic vocabularies, and have auxiliary structures that create monumental space. Where the Temple of Dendur has one entrance and a single processional axis, *the eastside of south central* arguably has two, suggested by the two sets of sphinxes and columns that would, in another structure, flank the front entrance, but which here offset the bidirectional processional axis to produce not just a duality but a destabilized one. There is an enormous, square cutout in the roof of *the eastside of south central* that is similar to an oculus—a focal point for the sky and all of those ideals with which the above is freighted—but Halsey's is both square and more expansive than traditional expressions of the form. *the eastside of south central* is also slightly taller and wider than its referent, and has an open structure that affords a sense of being even greater than the monument to which it refers. The Temple of Dendur would have had wooden doors and been brightly painted, but *the eastside of south central* has no suggestion of enclosure or, for that matter, of color. This latter point is especially notable given that this is not Halsey's first monumentally scaled piece, and her similar earlier structure, *The Crenshaw District Hieroglyph Project (Prototype Architecture)* (2018), though formally similar in many ways, featured columns with colorful portraits on them, making *the eastside of south central* a significant departure from Halsey's often technicolor practice.

With color eschewed and imagery rendered only in carved reserve, *the eastside of south central* draws not on the original context of the Temple of Dendur but instead on its modern and contemporary manifestation, an act of partial severance from the Egyptian conditions of its emergence that facilitates its appropriation to more contemporary African American ends.[22] As in *The Crenshaw District*, Halsey titles *the eastside of south central* to include the phrase "prototype architecture," a decision that marks the object as distinct from a finished product. Designating the work as a prototype also distinguishes it from the monumental tradition; the word "prototype" lends itself to the idea of a scaled-down version of something else, but such an object need not be smaller.

Prototypes, however, often have less finish and detail than the final product—in some cases a function of the constraints of smaller scale, and in others, one of materials, where the most precious ones are reserved for the finished product. In calling this a prototype, Halsey points to the possibility that this object may have scale, but does not have material permanence, suggesting that the work is not finished because what it is meant to monumentalize has not yet come to pass. Here, it is the quality of permanence, rather than that of scale, that constitutes the properly monumental. *the eastside of south central*, then, is a prototype not for another building to be built based on the successes and failures of this project, but rather because it describes the not-yet-here of Black diasporic temporal accumulation, where what is possible is marked out as such but not yet materialized. Operating in this temporally interstitial space, Halsey's monument describes the relationship between past and present that must remain semantically and materially open to facilitate the eventual emergence of the kinds of future structures that are not possible today but whose envisaging is central to their realization.

The ability of *the eastside of south central* to call into being a future that is not yet here derives substantially from the inclusion of Halsey's personal iconography and its intermingling with the augmented form of the Egyptian temple. While some of the signifiers Halsey has collected are iconic well beyond Los Angeles—pharaonic heads, the Watts towers, and spaceships—others have meanings that can only be explicated by the artist or can only be guessed at beyond their hyperlocal context, such as the faces represented in the column capitals and sphinxes, whose presence bounds the work to Halsey's own social and familial pantheon. Not all of these signifiers are proper to either an African past or an African American present; rather, they are in conversation with Afrofuturist discourse, which Keeling describes as "cultural forms and logics through which creative entanglements of Black existence, technology, space, and time might be accessed and analyzed."[23] Foundational to Afrofuturism are transtemporal entanglements that bear striking similarity to the monumental: they reach to the forms of a very specific past to describe a vision of the future, and frame that connection in terms of the sociopolitical desires of the person or people who are crafting that narrative in the present.

The visual culture of Afrofuturism was crucial to certain segments of African American culture in the 1960s and 1970s. During

that period of substantial upheaval, as Paul Gilroy has shown, the ancient "was not counterposed to views of 'modern' reality but rather presented in a way that emphasized its continuity with contemporary technological and scientific developments."[24] Among other places, Afrofuturist aesthetics show up in the album covers for the band Parliament-Funkadelic, or P-Funk, whose influences, as the curator Abraham Thomas has noted, can be seen in Halsey's dense layering of signifiers.[25] The aesthetics of and related to funk music—a genre that also appears in Adrian's Piper's work in the 1970s[26]—drew on iconography from the African classical tradition to create, enunciate, and elucidate a relationship between the modern and ancient despite knowledge gaps created by the subsumption, domination, and erasure of African cultures and their descendants in white-dominant modernity. Put another way, African references in this earlier moment—the same period in which *Food for the Spirit* was made—were mobilized to describe a continuity between past and present as a way of reinscribing that past in the present and staging that coincidence as a new locus from which to think about a different, Black future. Half a century later, Halsey updates this tradition by recombining funk semantics with a contemporary urban archive of signs and symbols refracted through her own aesthetic, social, and political experience of, and perspective on, the world to build a monument to a future that cannot yet come into focus, but is very much on the verge of being.

As just one example of the visual funk aesthetic, P-Funk album covers emphasize the future, bundling the present and the past into it, as in the example of the cover for *Mothership Connection*, which features a subject in a silver outfit popping out of a door in a flying saucer as it hurtles through space. In this particular example, the suturing of temporalities is surfaced through spectacular flourishes like the yellow outline around the spaceship, which suggests electrified and exciting possibilities to come. That same yellow line, however, also constitutes a suture that enunciates the heterogeneity of constituent parts rather than their assimilation into one coherent, uniform image. Halsey, by contrast, emphasizes assimilation, gathering components from disparate places, then filtering them through a single subject to give aesthetic cohesion to the narratively heterogeneous pictorial field. What this amounts to, however, is not a flattening of all symbols into one set of conditions—an overarching aesthetic that usurps the individual

semantics of each of its component signifying parts—but rather a surface tension across the work that suffuses the present with a temporal collapse of past and future.

There is radical potentiality in creating a surface where these three major temporalities converge. Keeling suggests that joining an African classical tradition together with a contemporary African American zeitgeist produces a queer temporal collapse that can rupture the regulatory space-time of chrononormativity and make a queer/Black future possible. *the eastside of south central* goes a step further, with signifiers both ancient and contemporary working in tandem on the same representational plane through phrases like "PRIDE IN OUR NEIGHBORHOOD" that constitute both a statement and a wish. That wish instantiates a co-temporal basis for a future monumentality that is already being not just imagined but prototyped. That *the eastside of south central* represents a future under construction is underscored by the degree to which the monument refuses the high finish of the traditionally monumental. Though the aesthetics of the work are clean to a high degree of finish within each component piece, they are imperfectly joined together, with uneven seams and visible chips. But rather than standing in for the wear and tear over centuries visible on the surface of the Temple of Dendur, the imperfections in *the eastside of south central*, evident only when viewed up close to the work, are quiet reminders of a labor still left to do, arresting this work in the not-yet-here of a queer/Black future.

Though *the eastside of south central* is formally recognizable first and foremost as a monument, it does its most potent work of temporal collapse not in its condition of monumentality or intervention into the monumental form, but rather through the signifying systems on its surface. The surface of Halsey's work is an accumulation, a term Keeling also deploys to describe the conditions of both colonial and neoliberal practices (accumulation of capital, bodies, and agency through violent ends), wherein "the piled up or sedimented past remains as a constitutive, yet often imperceptible, component of the present."[27] For Halsey, that past is on full display both in the structure of the temple and on the surface of the work, where fragments collected into the artist's archive monumentalize items not usually lent monumental credibility. Staged in the form of an ancient monumental prototype for a future not yet here, *the eastside of south central* proposes not only that "any struggle over or for the future must also attend to futures past,"[28] as Keeling

suggests, but also that, according to this present and in a fundamentally monumental manner, the past will become the future.

In creating an archive, drawing on that archive to elaborate the surface of the work in ways that have multiple and overlapping systems of meanings, and scaffolding it with an architecture indebted to African origins narratively transported to the United States, Halsey also draws on set of mechanisms similar to those that underwrite the AIDS Quilt. The sole authorizer of an archive not only used as the basis for a monument but magnified and inscribed onto its very surface, the ephemera Halsey gathers gain new meaning as they are recontextualized within Halsey's iconography. By mobilizing these disparate signifiers within the bounds of her own personal pantheon, Halsey resituates what might otherwise be overlooked in a monumental context, lending it the credibility of that form to create a monumental vocabulary for what Kevin Quashie calls an "aesthetics of aliveness," or the "animating capacities evident in the art object."[29] In a form that too often indexes anti-Blackness, Halsey builds on the funk and Black classical traditions to establish a fundament from which to understand the persistence of Black life in monumental form and at monumental scale. Halsey also works the seam that at once separates and connects individual life with collective persistence. Whereas laying images out in precisely the same way with little visible ordering logic other than the aesthetics of the surface and the constraints of the form often risks flattening the distinction among each signifier, the heterogeneous arrangement of signifiers that stem from various distinct signifying systems in *the eastside of south central* resist such collapse. Most viewers who encounter the work—indeed, possibly all viewers save for Halsey—will encounter moments of opacity at multiple sites across the surface, a textual strategy that would seem to run counter to the multiplicity of processional axes throughout the work were it not for the fact that these too are slightly offset, harbingers and echoes of the degree to which signification and legibility are rarely as simple as a single entrance into or way through anything.

Part of what makes *the eastside of south central* both monumental and a monument is that it relies on the traditional conventions of the genre. Its multivalent collapse of distinctions is a response to the reliance of historical monuments on the maintenance of distinctions and naturalization of dominance, something perhaps most in evidence in Halsey's decentering of the avenue of

approach. *the eastside of south central* is neither the only nor the first monumental precedent for what amounts to a democratization of physical approach; the AIDS Quilt was laid out in a grid that enabled visitors to walk in any of the four cardinal directions. But in *the eastside of south central* the processional axis runs north-south, while the facades reach from northeast to southwest along the orientation of the island of Manhattan. The monument's alignment, then, has resonances with the route north to freedom during enslavement but is not reducible to them. In its offset axes and oscillating opacity, *the eastside of south central* rebuts the easy legibility of traditional monuments, surfacing a range of distinctions—dominant and minoritized, ancient and contemporary, individual and broader cultural—to describe a relationship between the conventionally monumental and that which has traditionally been unrepresented in or by such monuments.

In its status as a prototype of monumental architecture that draws on and reinscribes monumentality, *the eastside of south central* also gestures toward fugitivity, refusing the transition of the chattel body into a transactable object, and toward fungibility, which describes the condition of Black being as in a perpetual state of becoming, in the activity of escaping that never reaches a terminus of achievement.[30] This understanding of being as always in process also creates a queer temporality that, in refusing to ever arrive (or perhaps never being able to arrive), places the queer/Black subject out of chrononormative time. If one is always in the process of becoming, one is also partaking simultaneously of a past and present, while sampling the possibilities of the future. As a condition of being a prototype, then, *the eastside of south central* filters African and African American signifying regimes through a queer temporality to create a slippage between fugitivity and fungibility, "conjoined matters of imagination and theft" whose confluence, as the literary scholar C. Riley Snorton argues, produces a situation "wherein sex and gender [become] inexhaustibly revisable according to the racial logic of consumption as they [pass] in and out of carceral states."[31] Snorton locates antebellum precedents for the modern condition of transness at this juncture; Halsey imagines what comes after that arc by staging the progressive logics of racism and capitalism as infinitely revisable according to queer/Black logics of temporality as they map onto or diverge from heteronormative temporal logics of productivity. This resonates with the AIDS Quilt in allegorizing the subject's transit not only laterally

but also upward in an Afrofuturist gesture toward the sky, where the processional axis also transects life and death. In this way, *the eastside of south central* both moves off of and inverts the monumental precedent of the AIDS Quilt, gathering together a range of heterogeneous objects and filtering them through a single life to create a monument that remains open. But whereas the Quilt is radically open, *the eastside of south central* only provisionally is, a prototype for a monument to not only the potentiality of queer/ Black futures but also the Black classical tradition that Halsey proposes underwrites it.

—

*the eastside of south central* and *Tomorrow Is Another Day* share a wide array of formal qualities. Both are monumental interventions into monumental buildings that gesture toward a future that is not wholly circumscribed by the nuanced complexity of the past, but which also do not lose sight of it. Both Bradford and Halsey also propose the adumbration of the contours of the present impossibility of a queer/Black future as a method for calling that possibility into being. As they imagine what might be cast off to bring that future about, they also imagine what might be called up in or on the way to that future. Both artists also propose that the histories of minoritized subjects, and minoritized strategies of survivance, are central to the work of future-making that departs the conditions of the present.

Crucial to both artists' engagement with the monumental tradition is a methodologically queer/Black intervention into the chrononormativity of conventional monumentality. To step out of the chrononormative—whether by force or by choice— enables one to think beyond other regulatory conditions. Most applicable in these monuments is a critique of the causal periodization that chrononormative time—and, by association, traditional monuments—enforce. Traditional monuments separate out the past, present, and future to suggest that the conditions, stories, and possibilities of each of these periods have already been decided. In *Tomorrow Is Another Day* and *the eastside of south central*, by contrast, the past is up for contestation and can be revised not just from a position of power but from any subject position—even those whose very existence the present architectures of power repeatedly call into question or attempt to extinguish.

At the same time, Bradford and Halsey propose radically different routes to, and visions for, a future. *Tomorrow Is Another Day* offers a heroic narrative not just among ruins but indeed through them, taking the visitor on a journey from the nightmare of the Middle Passage to a present in which the past is not yet past, the future is not yet here, and the concomitant representation of each through the material terms of destruction suggests the possibility of a future that is wholly contingent on rupture. This comes through in Bradford's titling; to say that tomorrow is *another* day implies a continuity between today and tomorrow, while also containing the possibility that, through rupture, it can become an *other*—which is to say, a different—day. For Bradford, then, the present contains potentiality out of which a different future may grow, but one that can only come into focus if the structures that have long dominated—and the narratives that have upheld them—are destroyed.

*the eastside of south central*, by sharp contrast, proposes that the ability to realize a future turns on the revisitation of a past that is called on, among other things, to restore a monumental authority on certain conditions of life that might not be valued in the present. As the preparatory object for something in the future that is legible in part as a condition of its similarity to an ancient form, *the eastside of south central* also recenters the monumental form. What sets Halsey's monument apart from more conventional examples of the form is not simply that *the eastside of south central* is constituted through an aesthetics of queer/Black aliveness—though in the monumental context that itself is remarkable—but also because it collapses the experience of past and future into the spatiotemporal present. This collapse is, in turn, echoed in the work's bidirectional processional axis, which destabilizes the binary of entrance and exit; indeed, it is entirely possible that the only exit proper to the work is the massive, square opening in the ceiling, an exit up that not only allegorizes the future but also reifies the connection between this monument and more conventional expressions of the form, which are routinely also oriented upward. *the eastside of south central*, then, is deeply—if queerly—invested in a monumental future in which the promise of what might be possible turns on a revitalization of past glory through the reclamation of the most traditional of monumental terms.

*Tomorrow Is Another Day* and *the eastside of south central* describe two distinct approaches to the relationship between minoritized

subjectivity and the future of monuments. Bradford proposes a future contingent on the destruction of monuments—if perhaps on the way to new monumentalities beyond the monumental form—while Halsey imagines a new monumental landscape filled with forms that describe the relationship between previously elided pasts and a vast array of presents beyond dominant subject positions. Though they differ, these two approaches are not irreconcilable; rather, they represent complementary projects that reflect a larger debate taking both material and conceptual shape in this monument boom around what should come after an ostensible end to the building of conventional monuments. Both monuments studied in this chapter, despite other points at which they diverge, seem to suggest that material permanence is an important convention to eschew in favor of the temporary, which offers a condition that sits between a monumental present and a monumental future in the case of Bradford, or as a condition of baking provisionality into the form in the case of Halsey.

Despite their articulately distinct investments in the future, *the eastside of south central* and *Tomorrow Is Another Day* both also culminate in ambivalent ends. In the case of the former the visitor cannot actually levitate up through the oculus, while in the latter the visitor may leave, but the work never truly ends because of the looped condition of the final video and architectural space. That the endings of these works are themselves only provisional gestures back toward this recent monumental generation as a whole, in which the very fact of a future, in dramatic contradistinction to the monumental tradition, is anything but certain. As two examples of the ways in which contemporary monuments relay the potentialities of queer/Black temporalities, *the eastside of south central* and *Tomorrow Is Another Day* both demonstrate that not even monuments are beholden to a single temporal regime. They, like so many other forms of domination with which they have been associated, are already in the process of being taken down, and reformulated to bring about a different future.

Epilogue

From Kara Walker's *A Subtlety* to Lauren Halsey's *the eastside of south central los angeles hieroglyph prototype architecture (I)*, a new generation of monuments that interrogate the terms of monumentality has, for the last decade, prevailed over more traditional expressions of the form. Befitting the way that monuments have long been defined, this new generation has routinely intervened into monumental conventions in both formal and narrative terms to represent histories that have been left out, expose the utility of the monument to projects of domination and interrogate whether a different future is realizable while monuments—interventionist or not—still stand.

This generation may be defined by a recent surge in interventionist projects, but monumental interventions that go beyond simple toppling to tell a more nuanced and complex story about the role of monuments are not themselves new. Such practices have a long history that reaches, like the genealogies of these contemporary interventions, back through time and across continents. One example involves Nelson's Column, a 145-foot-high

Corinthian column topped by a statue of Admiral Horatio Nelson and flanked at the base by bronze panels to four major battles in which Nelson led the British Royal Navy to victory between 1797 and 1805. Since its completion in 1843, Nelson's Column has stood at the center of Trafalgar Square in London and is one of the best examples of how monuments and monumental space can telegraph the core values of a nation's self-image. That image, in this case, is inextricable from the twin imperial legacies of military and cultural domination: the north border of Trafalgar Square is marked out by the facade of the National Gallery—a repository for the visual culture that composes the national self—while the rest of its perimeter is dotted with colonial missions, or "High Commissions," of nations including Canada and South Africa that became part of the Commonwealth as a condition of British imperial expansion through settler and extractive colonial activity.

Trafalgar Square is situated between what, at the end of the nineteenth century, were two radically different neighborhoods—the working-class East End of the city, and the upper-class West End—and its location at that classed frontier made it a popular site for protests in which people demonstrated simultaneously against the class and imperial systems. These protests were regularly met with deadly force, as in the example of a November 13, 1887, event in which the Social Democratic Federation, an early British socialist organization, joined the Irish National League to protest coercive and extractive practices by the British government in Ireland. The ensuing crackdown, which killed numerous protesters and has come to be known as the first of three Bloody Sundays in British history, was captured in a dramatic image published in the *Illustrated London News* depicting a crowd of protestors held back by a line of baton-wielding police as more officers on horseback look on.[1] Prominently rendered behind the line of police is the base of Nelson's Column, flanked by statues of lions and ringed by another dense phalanx of police, as though the security of the polis were coterminous with that of the monument itself, and the protestors, by association, a threat to both.

The Social Democratic Federation was one of several socialist organizations in the late nineteenth century that offered a space for left-radically inclined citizens to envision and strategize toward alternatives to the capital-driven imperial conditions under which they lived. Another such organization, the Socialist League, counted among its founding members the ardent socialist

THE RIOTS IN LONDON ON SUNDAY, NOV. 13: DEFENCE OF TRAFALGAR-SQUARE.

THE LIFE GUARDS KEEPING THE SQUARE.

Figure 5.1 "Bloody Sunday, 1887." Police combating rioters in Trafalgar Square, London, November 13, 1887. Engraving in the *Illustrated London News*, November 19, 1887. British Library/Granger. All Rights Reserved.

and famed textile designer William Morris, who would go on to be one of the most widely heard political speakers of his time.[2] Morris's politics are substantially reconcilable with those motivating the reconsideration of the US monumental landscape today. As the Victorianist and Morris scholar Florence Boos has argued, Morris was "unable to conceive of the existence of socialism in any meaningful sense without true equality between persons of all abilities and personal qualities."[3] Morris was also, Boos notes, averse "to unjust wars, as well as to those attracted to war in general,"[4] a description that constitutes something of an echo ricocheting between Kehinde Wiley and the biblical verse he cites, which warns not just of war itself, but of the dangers of discourse that can bring war about.

As a model for both uprising and community structure, Morris looked to the 1871 Paris Commune, taking inspiration from the Communards to establish the *Commonweal*, a newspaper and activist organ for the Socialist League. Among the serialized stories that were a central feature of the *Commonweal*, whose banner Morris also designed, was Morris's own "The Pilgrims of Hope," in which the narrator travels back in time to participate in the Paris Commune. One of the most striking photographs of the historical Commune captures the aftermath of the toppling of the Vendôme Column, which, like Nelson's Column, is 145 feet high and crowned by a statue of Nelson's opposite, Napoleon I. But the felling of the Vendôme Column is strikingly absent from Morris's 1885 story. Five years later, Morris published another serialized novel, *News from Nowhere*, and in this one, written in the wake of Bloody Sunday, a kind of toppling does appear. In *News from Nowhere*, the narrator is transported from a Trafalgar Square peopled by rows of military men that recall the aforementioned illustration to a deindustrialized London fifty years hence, to find lines of apricot trees in lieu of those of soldiers, and a small refreshment stand "painted and gilded" where Nelson's Column once stood.[5] There is resonance here with the AIDS Quilt, which is arrayed in regimented rows, but where the AIDS Quilt takes up those aesthetics to gain credibility and assert belonging as part of the national self-image, Morris's apricot trees that replace soldiers take up an aesthetics of militarization in order to challenge it.

Morris's reimagining of monumental space that replaces key nationalist and military indicators with sweet sustenance is a monumental intervention based on a rhetorical device that the

# NEWS FROM NOWHERE:

OR,

## AN EPOCH OF REST.

BEING SOME CHAPTERS FROM A UTOPIAN ROMANCE.

CHAP. VII.—TRAFALGAR SQUARE.

AND now again I was busy looking about me, for we were quite clear of Piccadilly Market, and were in a region of elegantly-built much ornamented houses, which I should have called villas if they had been ugly and pretentious, which was very far from being the case. Each house stood in a garden carefully cultivated, and running over with flowers. The blackbirds were singing their best amidst the garden-trees, which, except for a bay here and there, and occasional groups of limes, seemed to be all fruit-trees : there were a great many cherry-trees, now all laden with fruit ; and several times as we passed by a garden we were offered baskets of fine fruit by children and young girls. Amidst all these gardens and houses it was of course impossible to trace the sites of the old streets : but it seemed to me that the main roadways were the same as of old.

We came presently into a large open space, sloping somewhat toward the south, the sunny site of which had been taken advantage of for planting an orchard, mainly, as I could see, of apricot-trees, in the midst of which was a pretty gay little structure of wood, painted and gilded, that looked like a refreshment-stall. From the southern side of the said orchard ran a long road, chequered over with the shadow of tall old pear-trees, at the end of which showed the tall tower of the Parliament House, or Dung Market.

A strange sensation came over me ; I shut my eyes to keep out the sight of the sun glittering on this fair abode of gardens, and for a moment there passed before them a phantasmagoria of another day. A great space surrounded by tall ugly houses, with an ugly church at the corner and a nondescript ugly cupolaed building at my back ; the roadway thronged with a sweltering and excited crowd, dominated by omnibuses, crowded with spectators. In the midst a paved be-fountained square, populated only by a few men dressed in blue, and a good many singularly ugly bronze images (one on the top of a tall column). The said square guarded up to the edge of the roadway by a four-fold line of big men clad in blue, and across the southern roadway the helmets of a band of horse-soldiers, dead white in the greyness of the chilly November afternoon——

I opened my eyes to the sunlight again and looked round me, and cried out amongst the whispering trees and odorous blossoms, "Trafalgar Square!"

"Yes," said Dick, who had drawn rein again, "so it is. I don't wonder at your finding the name ridiculous : but after all, it was nobody's business to alter it, since the name of a dead folly doesn't bite. Yet sometimes I think we might have given it a name which would have commemorated the great battle which was fought on the spot itself in 1952,—*that* was important enough, if the historians don't lie."

"Which they generally do, or at least did," said the old man. "For instance, what can you make of this, neighbours ? I have read a muddled account in a book—O a stupid book !—called James' Social Democratic History, of a fight which took place here in or about the year 1887 (I am bad at dates). Some people, says this story, were going to hold a ward-mote here, or some such thing, and the Government of London, or the Council, or the Commission, or what not other barbarous half-hatched body of fools, fell upon these citizens (as they were then called) with the armed hand. That seems too ridiculous to be true ; but according to this version of the story, nothing much came of it, which certainly *is* too ridiculous to be true."

"Well," quoth I, "but after all your Mr. James is right so far, and it *is* true; except that there was no fighting, merely unarmed and peaceable people attacked by ruffians armed with bludgeons."

"And they put up with that ?" said Dick, with the first unpleasant expression I had seen on his good-tempered face.

Said I, reddening : "We *had* to put up with it ; we couldn't help it." The old man looked at me keenly, and said : "You seem to know a great deal about it, neighbour ! And is it really true that nothing came of it ?"

"This came of it," said I, "that a good many people were sent to prison because of it."

"What, of the bludgeoners ?" said the old man. "Poor devils !"

"No, no," said I, "of the bludgeoned."

Said the old man rather severely : "Friend, I expect that you have been reading some rotten collection of lies, and have been taken in by it too easily."

"I assure you," said I, "what I have been saying is true."

"Well, well, I am sure you think so, neighbour," said the old man, "but I don't see why you should be so cocksure."

As I couldn't explain why, I held my tongue. Meanwhile Dick, who had been sitting with knit brows, cogitating, spoke at last, and said gently and rather sadly :

"How strange to think that there have been men like ourselves, and living in this beautiful and happy country, who I suppose had feelings and affections like ourselves, who could yet do such dreadful things."

"Yes," said I, in a didactic tone; "yet after all, even those days were a great improvement on the days that had gone before them. Have you not read of the Mediæval period and the ferocity of its criminal laws; and how in those days men fairly seem to have enjoyed tormenting their fellow men !—nay, for the matter of that, they made their God a tormentor and a jailer rather than anything else."

"Yes," said Dick, "there are good books on that period also, some of which I have read. But as to the great improvement of the nineteenth century, I don't see it. After all, the Mediæval folk acted after their conscience, as your remark about their God (which is true) shows, and they were ready to bear what they inflicted upon others ; whereas the nineteenth century ones were hypocrites, and pretended to be humane, and yet went on tormenting those whom they dared to treat so by shutting them up in prison, for no reason at all, except that they were what they themselves, the prison-masters, had forced them to be. O, it's horrible to think of !"

"But perhaps," said I, "they did not know what the prisons were like."

Dick seemed roused and even angry. "More shame for them," said he, "when you and I know it all these years afterwards. Look you, neighbour, they couldn't fail to know what a disgrace a prison is to the Commonwealth at the best, and that their prisons were a good step on towards being at the worst."

Quoth I : "But have you no prisons at all now ?"

As soon as the words were out of my mouth I felt that I had made a mistake, for Dick flushed red and frowned, and the old man looked surprised and pained ; and presently Dick said angrily, yet as if restraining himself somewhat—

"Man alive ! how can you ask such a question ? Have I not told you that we know what a prison means by the undoubted evidence of really trustworthy books, helped out by our own imaginations ? And haven't you specially called me to notice that the people about the roads and streets look happy ; and how could they look happy if they knew that their neighbours were shut up in prison, while they bore such things quietly ? And if there were people in prison, you couldn't hide it from folk, like you may an occasional man-slaying ; because that isn't done of set purpose, with a lot of people backing up the slayer in cold blood, as this prison business is. Prisons, indeed ! O no, no, no !"

He stopped, and began to cool down, and said in a kind voice : "But forgive me ! I needn't be so hot about it, since there are *not* any prisons : I'm afraid you will think the worse of me for losing my temper. Of course, you coming from the outlands cannot be expected to know about these things. And now I'm afraid I have made you feel uncomfortable."

In a way he had ; but he was so generous in his heat, that I liked him the better for it, and I said : "No, really 'tis all my fault for being so stupid. Let me change the subject, and ask you what the stately building is on our left just showing at the end of that grove of plane-trees ?"

"Ah," he said, "that is an old building built quite in the beginning of the twentieth century, and as you see, in a queer fantastic style not over beautiful ; but there are some fine things inside it, too, mostly pictures, some very old. It is called the National Gallery ; I have sometimes puzzled as to what the name means : anyhow, nowadays wherever there is a place where pictures are kept as curiosities permanently it is called a National Gallery, perhaps after this one. Of course there are a good many of them up and down the country."

I didn't try to enlighten him, feeling the task too heavy ; but I pulled out my magnificent pipe and fell a-smoking, and the old horse jogged on again. As we went, I said—

"This pipe is a very elaborate toy, and you seem so reasonable in this country, and your architecture is so good, that I rather wonder at your turning out such trivialities."

It struck me as I spoke that this was rather ungrateful of me, after having received such a fine present ; but Dick didn't seem to notice my bad manners, but said :

"Well, I don't know ; it *is* a pretty thing, and since nobody need make such things unless they like, I don't see why they shouldn't make them, *if* they like. Of course, if carvers were scarce they would all be busy on the architecture, as you call it, and then these 'toys' (a good word) would not be made ; but since there are plenty of people who can carve—in fact, almost everybody, and as work is somewhat scarce, or we are afraid it may be, folk do not discourage this kind of petty work."

He mused a little, and seemed somewhat perturbed ; but presently his face cleared, and he said : "After all, you must admit that the pipe is a very pretty thing, with the little people under the trees all cut so clean and sweet ;—too elaborate for a pipe, perhaps, but—well, it is very pretty."

"Too valuable for its use, perhaps," said I.

"What's that ?" said he ; "I don't understand."

I was just going in a helpless way to try to make him understand, when we came by the gates of a big rambling building, in which work of some sort seemed going on. "What building is that ?" said I, eagerly, for it was a pleasure amidst all these strange things to see something a little like what I was used to : "it seems to be a factory."

"Yes," he said, "I think I know what you mean, and that's what it is ; but we don't call them factories now, but Banded-workshops : that is, places where people collect who want to work together."

"I suppose," said I, "power of some sort is used there ?"

"No, no," said he. "Why should people collect together to use power, when they can have it at the places where they live, or hard by, any two or three of them ; or any one, for the matter of that ? No ; folk collect in these Banded-workshops to do hand-work in which working together is necessary or convenient ; such work is often very

Figure 5.3  Statue of Napoleon I after the fall of the Vendôme Column, 1870. Photo Credit: Bruno Braquehais.

Morris scholar Owen Holland calls a "narrative transplantation," a reversal that takes place in the narrative but which is not overtly narrativized in text. Like other monumental spaces constructed through the terms of a national self-image, Trafalgar Square is an important site of discernment in part because of the way that it is both constituted through and telegraphs the kinds of hierarchies that result from distinguishing among and ordering bodies. Traditional monuments have been so effective at conveying belonging, domination, and exclusion precisely because they keep tight focus on a monocultural narrative, and exclude everything that would draw focus from it. It is both the work of the monument, and of the monumental space that it anchors, that Morris in *News from Nowhere* seeks to undo. The narrative transplantation occurs not just in the replacement of Nelson's Column with a fruit stand but in the implied toppling of the column that stands between the two visions of the space, inviting the reader to hold in mind simultaneously both the present condition of citizenship—as envisaged through public space, ringed by evidence of colonial and imperial conquest, peopled with statues to kings and generals, and anchored by a monument to national identity—and a fantastical

alternative framed by a radically different set of values.[6] Morris's decision not to mention the well-known column that only benefits the few and replace it with a fruit stand that provides something beneficial for and available to all gestures toward the representational regimes of traditional monuments but is not wholly delimited by them, and sharpens the distinction between the imperial present and potentially utopic future, however illusory or distant it may be. The political payoff of Morris's narrative transplantation is what the literary theorist Ross Chambers calls the "seduction" of appropriation in literary work, a rhetorical device that draws on but is not precisely of the present,[7] and which poses a challenge to power "without challenging the system, since it consists of making use of dominant structures for 'other' purposes and in 'other' interests, those of the people . . . whom power alienates or oppresses."[8] *News from Nowhere*, therefore, is not just a toppling in absentia, but rather a literary example of the kind of monumental intervention that has been studied in this book.

What distinguishes twenty-first-century efforts to intervene in the monumental landscape from those that have come before is not simply that they are material rather than literary. As mentioned in the introduction, the tradition of toppling monuments in the United States dates at least back to 1776, but if one broadens the definition of toppling to include removal or destruction in the process of domination, and the definition of monuments to the more broadly monumental (which is to say, objects or spaces or processes that are vitally central to a culture's self-conception), the practice can be understood to have a much longer-standing history in the United States than that which attends the properly monumental as defined through the terms of Western aesthetics. As the speed and scale of topplings have increased, what was long an extrajudicial practice has been at least partially absorbed into the state or cultural apparatus act of dismantling what Achille Mbembe calls "the economy of symbols whose function, all along, has been to induce and normalize particular states of humiliation based on white supremacist presuppositions"[9] that may have been or at times may still be a decolonial act but which also works in the service of the state. Put another way, to remove symbols of the machinations of racial capital—the rationale behind the vast majority of topplings that have transpired concurrent with this recent monument boom—indicates the presence of a germinal seed of representational change, but toppling may remain most

significant in demonstrating the power that monuments, and the systems that erected them in the first place, still hold, their selective assimilation into the project of reconfiguring a national identity an indicator of the limits of their impact.

This book and the projects studied within it are not only about Black or queer subjectivity and strategy, but rather are examples of how minoritized strategies can intervene in the monumental landscape. Of the various projects that emerged in the opening decade of this monument boom, this book focuses on a small set of interventions that take up the histories and afterlives of Atlantic slavery. I chose these monuments not only because they are especially dense examples of contemporary monuments, but also because they intervene in scopic and representational regimes that have long underwritten and evidenced the binary logic of racial capital that persists in structuring US culture today. That the majority of forms that do this work of reinscription also resonate with or make use of queer strategies may in part be a response to the ways in which the strategically queer poses a challenge to that logic. These monuments offer a path through which to conceive of multiple and concurring ways of being in the world that are irreducible to the monocultural, as exemplified in the juncture of the Black and the queer explored by multiple artists in this book. Both the promise and the limits of that site are perhaps most productively explicated in the narrative arc of *Tomorrow Is Another Day*, where the nightmare of slavery and the threats of the AIDS crisis crystallize an understanding that though it is yoked to domination only through habit, the monumental form is nevertheless so closely tied to such projects that it may not have a place in a future that makes a substantial break with anti-Blackness.

This book also only deals with a small fraction—if a particularly visible and well-known one—of the interventionist projects in this new monument boom. Readers may have expected to find a number of other projects that are formally or thematically related, but are not included herein. In the introduction, I made a distinction between monuments and memorials, and have focused in this book on monuments, even if, as in the AIDS Quilt, the official title includes the word "memorial." The memorial looks backward, describing something that happened in the past as crucially important to how we understand ourselves in the present. The memorial may also call, whether explicitly or implicitly, to those who encounter it to prevent the conditions that paved

the way for or caused that loss from ever happening again. The National Memorial for Peace and Justice, the Freedom Monument and Sculpture Park, and the African Burial Ground National Monument are all examples of such efforts, and though some of these have the word "monument" in their official title and are undeniably monumental, they do not fit into the narrowly defined terms of this book.

Readers may also have expected to find monumentally scaled sculptures made in the last decade that deal narratively with varying themes related to Black life and the African diaspora, such as Simone Leigh's 2019 *Brick House*, Hank Willis Thomas's 2023 *The Embrace*, or Sanford Biggers's 2023 *Oracle*. While each of these is monumental in scale, they have a distinct relationship to that formal conceit—and make part of their meaning by being smaller objects magnified to monumental size and cast in conventionally monumental materials—that sets them apart from the small group defined in this book. Also not included but perhaps expected are traditional historical sculptures that use the monumental template to recognize otherwise elided or marginalized subjects or histories, like Thomas Ball's Freedmen's Memorial—which, as noted in the introduction to this book, was an important object and event in earlier African American memorializing work—or Augusta Savage's 1939 *All Wars Memorial to Colored Soldiers* in Philadelphia. Also excluded from this project are museums that do educational work of monumental importance, such as the Legacy Museum of African American History, the International African American Museum, and the Whitney Plantation museum. These are just a few among the critically important projects that contribute to the important labor of telling a more complete story of the history of Black life in the United States, but which could not be included in the scope of this project.

The projects between 2014 and 2023 that have interrogated the monumental form have not been limited to those about the past and present of anti-Black racism in the United States. A number of Indigenous artists have also turned to the monumental form as a key site for intervention into the colonial landscape, which includes but is not limited to the monumental one. Projects such as Rose B. Simpson's *Counterculture* (2022), a row of twelve monumentally scaled figures of different shades whose surfaces evoke clay, and Jeffrey Gibson's *the space in which to place me* (2024), the artist's 2024 installation for the Venice Biennale that opens with

Figure 5.4  Rose B. Simpson, *Counterculture*, 2022. Dyed-concrete and steel sculptures with clay and cable adornments. Dimensions variable. © Rose B. Simpson. Courtesy the artist, Jessica Silverman, San Francisco, and Jack Shainman Gallery, New York. Photo: Stephanie Zollshan.

a collection of matte red, monumentally scaled plinths in front of the American Pavilion, are just two recent instances in which Indigenous artists have explored the role that monumental interventions can play in decolonial projects. A long-form study of those and other thematically related projects is long overdue, and these are just some of the stories being told in new monumental terms that merit extended closer examination.

A decade into this new monument boom we remain at the beginning, rather than the end, of a process of monumental transformation—something nowhere more evident perhaps than in the Andrew W. Mellon Foundation's Monuments Project, a $500 million initiative "aimed at transforming the nation's commemorative landscape to ensure our collective histories are more completely and accurately represented."[10] That none of the projects in this book came about as a result of the Monuments Project is a testament to the extensive interest in this labor. Along a similar timescale to this present monument boom, support for long-standing (and long ignored) calls to take down monuments to slaveholders and Confederates in the United States was catalyzed by the May 25, 2020, murder of George Floyd. Yet many traditional monuments, both Confederate and not, still remain, and

Figure 5.5  Jeffrey Gibson, *the space in which to place me* (2024), forecourt sculpture, exterior view. Exhibition for the United States Pavilion, 60th International Art Exhibition–La Biennale di Venezia), April 20–November 24, 2024. Photograph by Timothy Schenck. Courtesy of Jeffrey Gibson Studio, Portland Art Museum, SITE SANTA FE, and Timothy Schenck.

so new monuments in a rapidly expanding range of forms will be installed, whether temporarily or permanently, alongside myriad very traditional monuments to figures who have been deemed sufficiently important to the national self-image, and insufficiently unpalatable for transgressions sanctioned at the time, to remain in place for the time being.

Just as monuments gain and maintain potent meaning through their role in culture across the *longue durée* of the monumental, their meaning can also be lost to time. Whether in traditional or more interventionist forms, monuments cannot count on eternal legibility beyond the life of the culture that erected them, a flaw that has already manifested in monumental form. The Great Sphinx of Giza is a large and famous example of how not even scale—a formal quality that both telegraphs and routinely tracks power—can guard against the loss of cultural knowledge. Nevertheless, monuments persist in being proposed as a way of telegraphing what is important in the present into a hypothetically infinite future.

Though it is often difficult to understand the implications of loss after the fact, it is possible to understand the implications

of loss when it can be anticipated. Take, for example, the dangers of nuclear waste, a uniquely complex problem because of the timescale of the risk to all living things. Nuclear waste will still pose a danger long after humans themselves have either become extinct—a scenario that seems especially likely in the current climate crisis—or evolved in a way that loses that knowledge, whether through a process so gradual it goes unnoticed or through some more sudden catastrophic event. In either case, the semantic systems humanity currently relies on to signal that danger would, in all likelihood, be lost alongside the knowledge of the danger itself.

Following the Three Mile Island nuclear accident in 1979, the field of nuclear semiotics emerged to explore ways to communicate, as broadly as possible, the presence and the danger of nuclear waste. Groups like the technocratically named Human Interference Task Force and the more spiritually suggestive Atomic Priesthood went to work in conversation with government agencies, and in 1993 the government-run Sandia National Laboratories issued a report based that proposed the creation of a set of written, pictoriographic, and physical markers that could communicate the danger of nuclear waste on a 10,000-year time horizon. To guide the creation of those materials, they included a series of statements to direct the makers of such markers: "Sending this message was important to us. We considered ourselves to be a powerful culture. . . . What is here was dangerous and repulsive to us. This message is a warning about danger. . . . The danger is to the body, and it can kill."[11] The majority of the forms suggested in the report were grounded in the principles of hostile architecture (fields of massive spikes or thorns, or enormous slabs of black rock large enough to cover that area and thick enough to prevent their easy rupture) that would mark out the exterior of an area above where nuclear waste is buried.[12] As the art historian Julia Bryan-Wilson has observed, many of the proposals answer to the terms of the traditionally monumental in both form and narrative.[13] Also like other monuments, the same problem stalks each proposal: there is no way to represent something in a way that can persist beyond the semantic terms of a culture, no preontologically comprehensible language that can implicitly be understood beyond the terms that give rise to it.

A loss of meaning that spells danger in one context, however, can spell possibility in another, for example when it comes to the

Figure 5.6 "Spikes Bursting through Grid, view 2," concept by Michael Brill and art by Safdar Abidi, 1993. Source: Kathleen M. Trauth, Stephen C. Hora, and Robert V. Guzowski, "Expert Judgment on Markers to Deter Inadvertent Human Intrusion into the Waste Isolation Pilot Plant," Sandia National Laboratories report, November 1, 1993.

logic of racial capital and the other armatures of ordering that follow on and support it. Loss is present throughout this book as an inescapable reality of the histories and afterlives of Atlantic slavery, but it is also present from the very beginning as a productive possibility, from Piper's exploration in *Food for the Spirit* of how xenophobia might be lost to Bradford's proposal in *Tomorrow Is Another Day* that the monumental should be lost. Loss in the contexts of the ordering systems that conventional monuments uphold, this new generation suggests, can even spell promise. In 2003, Piper began *Everything*, a series in which the words "Everything will be taken away" were written onto various surfaces. Early terms in the series consist of photographs, often of people, photocopied in black and white onto graph paper. The faces of the people pictured have been erased, and the phrase is printed in burgundy ink on the obliterated center.[14] In 2004, the phrase began to appear on other objects, among them an oval mirror, titled *Everything #4*, framed in a warm brown wood, with the work engraved and gold-leafed on the surface of the glass.

Though the phrase "Everything will be taken away" involves no deictics, it nevertheless has the tone and tenor of an address that is applicable to a universal viewer. *Everything #4* places each viewer

who steps in front of it in relationship both with themselves and with whomever else might be in the field of their reflected vision, this message of loss the only thing standing between them and their reflection. As such, *Everything #4* can be understood as a coda to *Food for the Spirit*: where the earlier work presages many of the representational strategies that materialize at monumental scale in this new generation of monuments, the more recent spells out the thrust of a new monumental gesture toward the operations of power that invite such interventions in the first place. In the earlier work, Piper uses a mirror and a camera—a device comprised of mirrors—as a way of marking out not just difference, but the specific ways in which difference becomes freighted with social meaning, while in *Everything #4* a similar set of material terms reaches instead for a universal. This universal may appear to some as a counterproductive loss, the work a *memento mori* not only for the viewing subject, but to some greater swath of humanity that transcends the individual, the identitarian, and the other ways in which subjects are sorted, separated, selected, or deselected. And yet loss is not inherently negative; it may also be understood from the works examined in this book that an insufficient degree of loss of cultural or xenophobic habit has precluded us from reaching new possibilities not just for the monument as object but for the kind of cultural labor monuments have done or could do. *Everything #4* thus might be understood to propose that there will be an end to these universalized systems, but also that the experience of that end will not itself be universal; whether one reads the words "Everything will be taken away" as a promise or as a threat, just as whether one reads the loss of conventional monumentalism as productive or a problem, depends to a great degree on one's relationship to power.

Despite a growing consensus in the United States that Confederate monuments should be taken away, there is far less discussion of whether and to what degree other monuments to persons or ideologies that benefited from or engaged in practices no longer part of the dominant national self-image—including but not limited to enslavement—should persist. One striking feature of debates over the last decade is that while the removal of Confederate monuments has been hotly debated and broadly supported, far less energy has been put to inflecting or removing monuments to, or the institutional monumentalization of, other figures who enslaved people or who architected or participated in efforts to

expel or extirpate Indigenous peoples. This rather myopic focus on the Confederacy suggests that much of the toppling sentiment, while entirely valid, also trades in the same rhetoric of nationalism that underwrites many traditional monuments. The more difficult, delicate, and longer-term monumental labor is the expansion of this discourse to move beyond the confines of nationalism by, for example, inflecting monuments to George Washington to reflect his own complicated relationship to the institution of slavery, or reconsidering the location and allocation of a monument to Thomas Jefferson given his violent hypocrisy on the subject. Understanding that removing or inflecting monuments is not an inherent threat to veracity in history, or to the ongoing viability of the nation, is of vital import to crafting or sustaining a national identity that truly upholds the values that recent monuments and topplings suggest are becoming, however incrementally, ever more part of the national self-image.

One of the most significant formal conceits among the forms gathered in this book as a sample of approaches to monumentality that have appeared in the last decade is that they are temporary—whether in terms of their materials or in terms of their installation. In these works, as I discussed at the conclusion of the previous chapter, the temporary offers a powerful rejoinder to permanence not simply because it is the obverse term, but because it contravenes foundational claims that traditional monuments make about their relationship to time. The conventional monument takes a vision of the past that is crafted in the present and describes an arc between those two temporalities that also opens onto a future in which those who have the power to build monuments and tell stories through them persist in thriving. The temporary (or, in Halsey's case, prototypical) monument, by contrast, allows for the possibility that there is always more to learn from the past, that pursuing lines of inquiry that might complicate what was previously the settled narrative of that past can enrich the present, and that the future can be different. The temporary also, crucially, suggests that in the future, other stories or people might have need for the monumental form, and that their sense of self, their efforts toward survivance, and their claims to subjecthood might benefit from the authority conferred by that form. Temporariness also, on a fundamental level, points up the absurdity of the claims to which permanent structures gesture, and acknowledges that everything will be taken away.

Though temporariness tends to be counterposed to permanence, the temporary monument does not wholly redress the rhetorical issues raised by permanent ones. To move into a condition in which the temporary monument is effective unto itself would require that there are no permanent monuments that need counterbalancing. The alternative—a world in which monuments remain central to the cultural landscape, but are more broadly representational of the cultural makeup of the nation in more permanent materials—risks perpetuating, if not affording even more power to, the role of the monumental form in the elaboration of dominant ideology, meeting certain terms related to representation—itself not an unimportant project—while distracting from the systemic silences and violences that both monuments and the politics of representation tend to obscure. Kehinde Wiley's *Rumors of War*—permanent despite its first brief installation in Times Square—gains a substantial degree of its credibility precisely as a condition of its permanence, but makes its important intervention into the exclusion of a particularly identitarian category through the exclusion of another. Nevertheless, in addition to the ways in which the materially conventional nature of its structure acts, as I argued in chapter 3, as a wish for its obsolescence, the permanent nature of Wiley's monument is also a tacit acknowledgment that there remains an urgent need in the present for the monumental representation of the persistence of anti-Black violence, and calling for its end. That it is also one of several examples in this generation of a permanent outdoor monument is itself a testament that a conceptual rather than material temporariness is an important formal element in this new monumental boom.

In the introduction, I offered a narrow definition of the term "monument" that supported the tight focus of this book. That definition holds up both for traditional expressions of the form and for many of the projects today. The ongoing utility of a heterogeneous set of formal expressions that answer to those narrative terms suggests the impossibility of credibly defining this or any other category without performing an act of foreclosure that is inherently motivated by some concern external to the project. These new forms complicate rather than resolve questions about the qualities through which the monument is defined, a muddying of the already opaque definitional waters that constitutes a very queer process of destabilization that draws from and contributes to antiracist and feminist projects, and demonstrates

that categorization almost always serves projects that sort and hierarchize bodies according to observable traits. This book also intervenes in processes of categorization—of monuments and disciplines, of bodies and behaviors—by demonstrating that objects and representational strategies whose material status might preclude them from answering to the terms of the monument are of formal and narrative significance to interventions in the monumental tradition. The inclusion of nonmonumental objects in this consideration of the monumental genre is yet another a queer abrogation of the distinctions that withhold conferral of monumentality beyond its traditional terms.

This book emerged from a desire to understand the formal and narrative mechanics at work in recent monuments and their relationship to, among other historical precedents, the art of social address that emerged out of the social unrest of the 1960s and early 1970s. Distinct from their precursors, however, the more recent works studied in this book look to the future, interrogating the longer-term relationship between the form of the monument and its cultural utility, exploring whether the monumental landscape to come will be constituted through a greater diversity of monuments telling a greater diversity of stories, or whether instead the long-standing imbrication of the monumental form with histories of domination means that the form itself may need to be retired in order to move on. It may be that in addition to the forms it can take, the monument is also a gesture, one that comes from the present, and from the body, and moves in the direction of something else exterior to itself in both space and time. The gesture claims no authority; it can be straight or camp, made with such assertive force that it is nearly impossible to avoid or so faint one can barely notice it. A gesture can mean anything but cannot be anything; it is there to be read by those who wish to read or misread it. To frame the monument as a gesture is to refuse, on some fundamental level, to give it the kind of power—domineering or reparative—with which it has long been freighted, and instead to see it as a form full of possibility that can as readily tell of wars and rumors of war as it can tell of a throwing down of the stones from which they are built. This generation of artists works with monumentality to describe, with as much precision as is formally and materially available, the historical investments and present limits of the monumental gesture. This representational path of creating recognizably monumental forms to histories and figures that have

been devalued or erased is born of the politics of representation, of showing up where one is not welcome, of making one's presence known, of asserting one's personhood through quotidian acts in spite of the fact that one faces almost certain violence and, often, the possibility of death. Structures that answer to the terms of monuments enough that they are recognizable as such but also subvert and ironize the conventions of the form ultimately have the capacity to address both the violent histories that attend monuments and the architectures of domination that have long led to them. In intervening in those histories, these recent monuments suggest that what Walker calls monumental misremembering can cut both ways: that what has been lost need not stay lost and that the present contains within it the potential for bringing about a more just future.

*Acknowledgments*

I learned to think at Smith College, have had the incredible privilege of returning there to teach, and continue to grow through what Sylvia Plath called the agony of learning. It is the greatest serendipity to finish my first book where the journey that led to it began.

Though it bears little resemblance to my dissertation, *Monumental* is a continuation of the inquiry begun therein and is the result of many years of curiosity and examination. I am profoundly grateful to the many people and institutions who have made it possible for me to pursue this line of inquiry.

This project was supported by generous fellowships from the Institute for Holocaust, Genocide, and Memory Studies (IHGMS) at the University of Massachusetts Amherst; the Center for Research in Feminist, Queer, and Trans Studies at the University of Pennsylvania; the Andrew W. Mellon Foundation Sawyer Seminar on Race and Representation at the University of Massachusetts Amherst; and the MIT Press Fund for Diverse Voices. The Smith College Departments of Art History and the Study of Women, Gender, and Sexuality, as well as the University of Pennsylvania Department of the History of Art, graciously extended research affiliations that were vital to my ability to complete this book.

This project could not have found its way into the world without my brilliant editor Victoria Hindley, associate editor Gabriela Bueno Gibbs, and the rest of the superlative team at the MIT Press, including Matthew Abbate and Stephanie Sakson. I am grateful for your organization, professionalism, and patience. Thanks also to Frances Key Phillips for editorial support on the first full draft.

I received critical assistance from generous librarians and other staff members in collections and institutions, including Roddy Williams and Gert McMullin at the National AIDS Memorial, Scott Briscoe at Sikkema Jenkins & Co., Emma Yau at Souls Grown Deep, Camila Nichols at David Kordansky, and David Carozza at Kehinde Wiley Studio.

I received invaluable feedback from colleagues who took the time to review the manuscript at various stages. I learned much from presenting an early version of some of these ideas to colleagues in the 2020–2021 Five College Working Group on Race and Representation at IHGMS. André Dombrowski, Andrea Moore, Beans Velocci, Frazer Ward, Ian Fleischman, Jessica Delgado, Maria Murphy, and Tiana Webb Evans gave generous and impactful notes. Special thanks to Britt Russert, who read this in its entirety at a critical moment, gave vital feedback, and has taught me so much about writing and collegiality. I am also grateful to the colleagues

who peer-reviewed this work; their careful attention and detailed feedback were transformative.

An extensive network of colleagues, mentors, and friends sent along citations, talked through ideas, offered words of encouragement, or otherwise helped me develop the capacity to bring this project to fruition, including Alex Keller, Banu Subramaniam, Barbara Kellum, Brigitte Buettner, Carrie Baker, Charlotte Ickes, Colin Hoag, Cornelia Pearsall, Daniel Rivers, Erin Peters, Florence Boos, Gülru Çakmak, Gwendolyn DuBois Shaw, Isolde Brielmeyer, Katrina Karkazis, Kelly Anderson, Libby Otto, Lisa Armstrong, Loretta Ross, Melissa Parrish, Melissa Sanchez, Paul Farber, Remi Onabanjo, Rujeko Hockley, Sarah Hamill, Svati Shah, Stephen Clingman, Stephanie Sparling Williams, Willa Hammitt Brown, Whitney Battle-Baptiste, and Yancey Richardson.

I learn a tremendous amount from my students, but among the many exceptional groups I am especially grateful to those in my Spring 2024 Monuments and Memory course at Sarah Lawrence College.

I am fortunate to be part of multiple and extensive networks of terrific people beyond my academic community: Amanda Díaz, Anja Manuel, Anna Thompson, Ashley Artis, Bradley Pearson, Ben Baur, Bryan Garman, Charlie McCormick, Cerrie Bamford, Christine Vachon, David Antonio Cruz, David Hinojosa, Greg Manuel, Hilary Harp and Butch Roberts, Jack Snyder, Jacob Esocoff, Jasmine Wahi, Joseph Ligotti, Laura Handman, Lee Snyder, Liza Coviello, Marlene McCarty, Patrick Güldenberg, Peter Leventi, Rebecca Jampol, Res, Robert Fenton, Sascha Feldman, Susan Sachs Goldman, Will Dawson, various Braunohlers, Hardings, and Jaffes, the Project for Empty Space family, the Sidwell Friends community, and an ever-expanding cast of Skowhegans. Finally, my profound gratitude to my parents, who have made so much possible; to my partner, long-time editor, and colleague Victoria Camblin, who helped me develop my voice as a writer, and from whom I continue to learn new things every day; and to Jonathan David Katz, for taking me on as a student and never letting go.

# Notes

## Introduction

1. Robert Epstein, "Eating Their Words: Food and Text in the Coronation Banquet of Henry VI," *Journal of Medieval and Early Modern Studies* 36, no. 2 (2006): 359.

2. Hilton Als called it "triumphant, rising from another kind of half world—the shadowy half world of slavery and degradation as she gives us a version of 'the finger.'" Als, "Culture Desk: The Sugar Sphinx," *New Yorker*, May 8, 2014.

3. There were three different styles of attendants: one carrying a basket on their back, one carrying a basket in front, and one holding a bunch of bananas. Some of the baskets were filled with cast sugar from failed attempts to cast the attendants, per a March 20, 2024, communication between the author and Scott Briscoe, gallery manager at Sikkema Malloy Jenkins.

4. "The Sugar Market: A Temporary Advance in Prices on Account of the Havemeyer Fire," *New York Times*, January 11, 1882, accessed April 2024, https://timesmachine
.nytimes.com/timesmachine
/1882/01/11/98578894.html
?pageNumber=8. See also Sidney W. Mintz, *Sweetness and Power: The Place of Sugar in Modern History* (New York: Penguin, 1985); Khalil Gibran Muhammed, "The Sugar That Saturates the American Diet Has a Barbaric History as the 'White Gold' That Fueled Slavery," *New York Times*, August 4, 2019.

5. Walker has noted that part of her inspiration for this work was finding chocolates formed into racist caricatures of Black children. "Kara Walker and James Hanaham: On Sex and Sacred Cows," *Frieze*, February 19, 2021.

6. For example, Kirk Savage moves off a definition of monuments as inherently public and made of stone, though one infers that stone is a synecdoche for other impermeable and enduring materials. Savage, *Monument Wars: Washington, D.C., the National Mall, and the Transformation of the Memorial Landscape* (Berkeley: University of California Press, 2001), 1. Elsewhere Savage uses the term "monument" interchangeably with "memorial" and "public sculpture": Savage, *Standing Soldiers, Kneeling Slaves: Race, War, and Monument in Nineteenth-Century America* (Princeton: Princeton University Press, 1999), 165–166. Mechtild Widrich is one of a number of scholars who understand temporary, ephemeral, invisible objects and even acts of speech as part of the category. Widrich, *Performative Monuments: The Rematerialization of Public Art* (Manchester: Manchester University Press, 2014), 3. Another contribution to this categorical incoherence is that some scholars, one perhaps among them Arthur Danto, distinguish between the monument and memorial in narrative if perhaps less so in form. Danto, "The Vietnam Veterans Memorial," *Nation*, August 31, 1985, 152. Others use the terms interchangeably; see, for example, Kirstin Ann Hass, *Blunt Instruments: Recognizing Racist Cultural Infrastructure in Memorials, Museums, and Patriotic Practices* (Boston: Beacon Press, 2022), 29.

7. Among the myriad texts devoted to this subject: James E. Young, *The Texture of Memory: Holocaust Memorials and Meaning* (New Haven: Yale University Press, 1993), 2–7; Robert S. Nelson and Margaret Olin, "Introduction," in *Monuments and Memory, Made and Unmade*, ed. Nelson and Olin (Chicago: University of Chicago Press, 2003), 2–4; Widrich, *Performative Monuments*, 1–2.

8. Southern Poverty Law Center, accessed March 2024, https://www.splcenter.org
/20220201/whose-heritage
-public-symbols-confederacy
-third-edition/.

9. Jay Winter, "The Memory Boom in Contemporary Historical Studies," *Raritan* 21, no. 1 (Summer 2001): 53.

10. Saidiya Hartman, *Lose Your Mother: A Journey along the Atlantic Slave Route* (New York: Farrar, Straus and Giroux, 2008), 6.

11. Thanks to Britt Russert to calling my attention to this. "The Rush Monument," *Elevator*, September 6, 1873; "The *Christian Recorder* Mentions the Formation of an Association of Colored Men for the Purpose of Erecting a Monument to John Brown," *Weekly Louisianan*, October 8, 1872; "Freedmen's Meeting in Washington," *New Orleans Tribune*, July 25, 1865.

12. Joan Marie Johnson, "'Ye Gave Them a Stone': African American Women's Clubs, the Frederick Douglass Home, and the Black Mammy Monument," *Journal of Women's History* 17, no. 1 (2005): 63.

13. US Congress, Senate, Committee of the Library,

"Authorizing the erection in the city of Washington of a monument in memory of the faithful colored mammies of the South" (Bill S. 4119), 67th Cong., 4th Session, 1922, pp. 2–3. National Archives Identifier 4685889; Record Group 66; General Files, 1910–1954.

14. Johnson, "'Ye Gave Them a Stone,'" 64–65. Johnson also notes that Cedar Hill was the first monumental project, but that it followed other initiatives of substantial import including education, social welfare, and journalism oriented toward projects of racial uplift in the style of W. E. B. Du Bois and Carter G. Woodson.

15. "Freedmen's Aid Association," *New Orleans Tribune*, August 10, 1865; "Declaration of Sentiment and Resolutions of the First Convention of Colored Men of Kentucky, Held in Lexington, March 22, 23, 24, and 26, 1866," *Tennessean*, July 18, 1866; David W. Blight, *Frederick Douglass: Prophet of Freedom* (New York: Simon and Schuster, 2018), 2.

16. Alexandria Russell, "'In Them She Built Monuments': Celia Dial Saxon and American Memory," *Journal of African American History* 106, no. 2 (Summer 2021): 385. Russell's recent book *Black Women Legacies: Public History Sites Seen and Unseen* (Champaign: University of Illinois Press, 2024) tells another segment of important and previously unarticulated monumental history, but came out too close to my own deadline to be included here.

17. Kevin Quashie, *Black Aliveness, or A Poetics of Being* (Durham: Duke University Press, 2021), 59.

18. A recent book by Rebecca Peabody, *Consuming Stories: Kara Walker and the Imaging of American Race* (Oakland: University of California Press, 2021), has much to contribute to the discourse on and around this work as well.

19. Christina Sharpe, *Monstrous Intimacies: Making Post-Slavery Subjects* (Durham: Duke University Press, 2010), 31; José Esteban Muñoz, *Cruising Utopia: The Then and There of Queer Futurity* (New York: New York University Press, 2009), 12.

20. Mechtild Widrich, *Monumental Cares: Sites of History and Contemporary Art* (Manchester: Manchester University Press, 2023), 1.

21. According to Savage, "yield resolution and consensus, not to prolong conflict." Savage, *Monument Wars*, 1.

22. Fred Moten, *Stolen Life* (Durham: Duke University Press, 2018), 202.

23. Savage calls monuments "the most conservative of commemorative forms precisely because they are meant to last, unchanged, forever"; the memorial studies scholar James E. Young has called them "fixed and static"; Mechtild Widrich calls them, more simply, "outdated authoritarian machines." Savage, *Standing Soldiers, Kneeling Slaves*, 4; Young, *The Texture of Memory*, 6; Widrich, *Performative Monuments*, 2.

24. See, for example, Andreas Huyssen, "Monument and Memory in a Postmodern Age," *Yale Journal of Criticism* 6, no. 2 (1993): 249–261, and Nelson and Olin, *Monuments and Memory, Made and Unmade.*

25. Laurie Allen, Paul Farber, and Sue Mobley, *National Monument Audit* (Philadelphia: Monument Lab and the Andrew W. Mellon Foundation, 2021), 17.

26. Quentin Stevens, Karen A. Franck, and Ruth Fazakerley, "Counter-monuments: The Anti-monumental and the Dialogic," *Journal of Architecture* 17 (2012): 722. For the Latinate root, see *Oxford English Dictionary*, s.v. "monument (*n.*), sense 2.a," March 2024.

27. US military incursions have also been accompanied by officially sanctioned topplings. As Erika Doss notes, US invasions of Nazi Germany and Iraq were both accompanied by directives to remove or destroy monuments, memorials, and museums to the regimes being challenged. Doss, *Memorial Mania: Public Feeling in America* (Chicago: University of Chicago Press, 2010), 9.

28. A history of these practices in a Southern context can be found in Dell Upton, *What Can and Can't Be Said: Race, Uplift, and Monument Building in the Contemporary South* (New Haven: Yale University Press, 2015).

29. Allen, Farber, and Mobley, *National Monument Audit*, n.p. Monument Lab, which also explicates some of the difficulties in securing hard and fast data on the prevalence of the form, goes into some detail on how they have gone about distinguishing among traditional monuments and other markers such as plaques and place names. Their "Methodology and Technical Documentation" provides a fuller picture

of some of the nuances and complexities in their study of monuments in particular, and the study of monuments in general: https://monument lab.github.io/national-mon ument-audit/app/docs. html#what-is-a-monument.

30. Monument Lab and the Southern Poverty Law Center (SPLC), which hosts the database and study "Whose Heritage? Public Symbols of the Confederacy (Third Edition)," move off somewhat divergent definitions of monuments, and offer different tallies of the Confederate monuments in the United States. The SPLC also uses the term "monument" interchangeably with the word "statue." Both Monument Lab and the SPLC further note that there is little data related to the prevalence of, or contemporaneous reduction in, Confederate or slaveholding place-names. Southern Poverty Law Center, accessed March 2024, https:// www.splcenter.org/20220201 /whose-heritage-public -symbols-confederacy-third -edition/.

31. Stevens, Franck, and Fazakerley, "Counter-monuments," 955.

32. Widrich, *Performative Monuments*, 172.

33. Stevens, Franck, and Fazakerley, "Counter-monuments," 951.

34. James E. Young, "The Counter-Monument: Memory against Itself in Germany Today," *Critical Inquiry* 18, no. 2 (Winter 1992): 272.

35. For example, Christo and Jeanne-Claude's practice of wrapping monuments in Europe dates to the 1970 *Wrapped Monument to Vittorio Emmanuele II*, Piazza del Duomo, Milan, Italy.

36. Clara Kim, "An Allegory of the Black Atlantic," in *Kara Walker: Fons Americanus*, ed. Clara Kim (London: Tate Publishing, 2019), 108.

37. There are minor nomenclatural variations across the official descriptions of this work; throughout this book, the name *Victoria Memorial* is used.

38. Kara Walker, "Fons Americanus," in Kim, *Kara Walker: Fons Americanus*, 58.

39. Cathy J. Cohen, "Punks, Bulldaggers, and Welfare Queens: The Radical Potential of Queer Politics?," *GLQ: A Journal of Lesbian and Gay Studies* 3, no. 4 (1997).

40. Cohen, "Punks, Bulldaggers, and Welfare Queens," 481.

41. Brian Stephens, "Prissy's Quittin' Time: The Black Camp Aesthetics of Kara Walker," *Open Cultural Studies* 1 (2017): 646, 653.

42. Thanks to Sascha Feldman for vital conversations around this work.

43. Fred Moten, *The Universal Machine* (Durham: Duke University Press, 2018), 81. Moten derives this phrase from Édouard Glissant ("One World in Relation: Édouard Glissant in Conversation with Manthia Diawara," trans. Christopher Winks, *Journal of Contemporary African Art* 28 [2011], 5), and offers several different descriptions for it throughout this text. I have chosen this particular instance because it is offered in a section on an early work by Adrian Piper.

44. Saidiya Hartman, *Scenes of Subjection: Terror, Slavery, and Self-Making in Nineteenth-Century America*, 2nd ed. (New York: W. W. Norton, 2022), xxx–xxxi.

45. Kara Keeling, *Queer Times, Black Futures* (New York: New York University Press, 2019), 103.

46. Paul B. Preciado, "When Statues Fall," *Artforum* 59, no. 3 (December 2020).

47. Hartman, *Scenes of Subjection*, 127–129.

Chapter 1

1. Adrian Piper, *Out of Order, Out of Sight*, vol. 1: *Selected Writings in Meta-Art 1968–1992* (Cambridge. MA: MIT Press, 1996), 55.

2. Thanks to Res for confirming the machine.

3. John P. Bowles, *Adrian Piper: Race, Gender, and Embodiment* (Durham: Duke University Press, 2011), 209.

4. Kirk Savage, *Standing Soldiers, Kneeling Slaves: Race, War, and Monument in Nineteenth-Century America*, new ed. (Princeton: Princeton University Press, 2018), 162.

5. Piper, *Out of Order, Out of Sight*, 1:55.

6. Laurie Allen, Paul Farber, and Sue Mobley, "National Monument Audit," Monument Lab, 2021, accessed April 2024, https://monu mentlab.com/audit#data; Southern Poverty Law Center, "Whose Heritage? Public Symbols of the Confederacy," accessed April 2024, https:// www.splcenter.org/20190201 /whose-heritage-public -symbols-confederacy.

7. Henry Louis Gates Jr. puts a fine point on this: "Reconstruction revealed a fact that had been true but not always acknowledged before the Civil War: that it was entirely possible for

many in the country, even some abolitionists, to detest slavery to the extent that they were willing to die for its abolition, yet at the same time to detest the enslaved and formerly enslaved with an equal passion." *Stony the Road: Reconstruction, White Supremacy, and the Rise of Jim Crow* (New York: Penguin, 2019), 11.

8. "Constitution of the United Daughters of the Confederacy," United Daughters of the Confederacy, 1895, accessed April 2024, https://archive.org/details /constitutionofdaughters /mode/2up?view=theater.

9. Adam H. Domby, *The False Cause: Fraud, Fabrication, and White Supremacy in Confederate Memory* (Charlottesville: University of Virginia Press, 2020), 3.

10. Harriet F. Senie and Sally Webster, "Politics, Patronage, and Public Art," in *Critical Issues in Public Art: Content, Context, and Controversy*, ed. Senie and Webster (Washington, DC: Smithsonian Books, 1992), 101.

11. Domby, *The False Cause*, 10.

12. Domby, *The False Cause*, 20–21.

13. Karen Cox, *No Common Ground: Confederate Monuments and the Ongoing Fight for Racial Justice* (Chapel Hill: University of North Carolina Press, 2021), 15.

14. Domby, *The False Cause*, 19 n. 18, the full citation for which is Brian K. Fennsey, "Silent Sam and Other Civil War Monuments Rose on Race," *News and Observer* (Raleigh, NC), November 23, 2017.

15. Cox, *No Common Ground*, 15.

16. See, for example, Cynthia J. Mills and Pamela H. Simpson, eds., *Monuments to the Lost Cause: Women, Art, and the Landscapes of Southern Memory* (Knoxville: University of Tennessee Press, 2017); Kristin Ann Hass, *Blunt Instruments: Recognizing Racist Cultural Infrastructure in Memorials, Museums, and Patriotic Practices* (Boston: Beacon Press, 2022).

17. Savage, *Standing Soldiers, Kneeling Slaves*, 210.

18. Sarah Beetham, "'An Army of Bronze Simulacra': The Copied Soldier Monument and the American Civil War," *Nierka: Revista de Estudios de Arte* 4, no. 7 (January-June 2015): 36–37.

19. According to SPLC data, the earliest of these is a 1891 monument of indeterminate form in Hinds, Mississippi; at the time of this book's publication, 348 of these remain "live," a number that can only partially be attributed to the UDC's practice of suing anyone who tries to remove monuments they raised money to build. Southern Poverty Law Center, "Whose Heritage?"

20. Domby, *The False Cause*, 23.

21. According to the SPLC, 190 of the 446 UDC monuments were placed on courthouse grounds; it is more difficult to determine how many were Common Soldiers. At least half are categorized as such in the data, but because the data often typologizes each monument according to its title, it is likely that, given the popularity and inexpensive nature of this form, a higher proportion of

Common Soldier monuments makes up the Confederate courthouse lawn landscape. Southern Poverty Law Center, "Whose Heritage?"

22. Cox, *No Common Ground*, 21; Fred Evans, *Public Art and the Fragility of Democracy: An Essay in Political Aesthetics* (New York: Columbia University Press, 2019), 2. Evans mentions that many of these took the form of Common Soldier statues on tall columns.

23. Jacqueline Goldsby, *A Spectacular Secret: Lynching in American Life and Literature* (Chicago: University of Chicago Press, 2006), 17–18.

24. Sherrilyn Ifill, *On the Courthouse Lawn: Confronting the Legacy of Lynching in the 21st Century* (Boston: Beacon Press, 2007), 16.

25. Ifill, *On the Courthouse Lawn*, 16.

26. Saidiya Hartman, *Scenes of Subjection: Terror, Slavery, and Self-Making in Nineteenth-Century America*, 2nd ed. (New York: W. W. Norton, 2022), xxx.

27. Ersula Ore, *Lynching: Violence, Rhetoric, and American Identity* (Jackson: University of Mississippi Press, 2019), 55.

28. Ore, *Lynching*, 60.

29. Ore, *Lynching*, 59n20.

30. Goldsby, *A Spectacular Secret*, 248.

31. Goldsby, *A Spectacular Secret*, 248–249.

32. Ore, *Lynching*, 58.

33. Ore, *Lynching*, 51, 58–59.

34. Ifill, *On the Courthouse Lawn*, 16.

35. Ifill, *On the Courthouse Lawn*, 8; Evans, *Public Art and the Fragility of Democracy*, 2.

36. "Louisiana Negro Lynched," *New York Times*, May 13, 1914. This is one of at least

eight articles in Louisiana alone with variations on the same headline published in the paper of record between February 1901 and January 1935.

37. Cecelia Trenticosta and William C. Collins, "Death and Dixie: How the Courthouse Confederate Flag Influences Cases in Louisiana," *Harvard Journal on Racial and Ethnic Justice* 27 (2011), 127.

38. Though the Caddo Parish Commission voted in 2017 to remove the monument, the Parish held off removing it until 2022, when they were able to secure the permission of the UDC. In 2020, as a stopgap, a wall was erected around the monument, blocking all but the Common Soldier statue atop it. Lex Talamo, "Split Caddo Commission Votes to Remove Confederate Monument," *Shreveport Times*, October 19, 2017.

39. Trenticosta and Collins, "Death and Dixie," 126.

40. Trenticosta and Collins, "Death and Dixie," 133.

41. Ifill, *On the Courthouse Lawn*, 5, 7.

42. Shaun Assael, "The Secret Fight to Save Confederate Monuments," *Glamour*, August 16, 2018.

43. See, for an early and defining example among the myriad available, T. J. Clark, "Clement Greenberg's Theory of Art," *Critical Inquiry* 9, no. 1 (September 1982): 139–156.

44. Clement Greenberg, "Avant-Garde and Kitsch," *Partisan Review* 6 (Fall 1939): 34–49.

45. Kantian thought in general and his framework for judgment in particular—articulated in the *First Critique* and expanded on in his third—was, as the performance studies scholar Amelia Jones has noted, crucial to the development of Western theories of aesthetics and interpretation. Amelia Jones, *Body Art: Performing the Subject* (Minneapolis: University of Minnesota Press, 1998), 3; see also Mark Cheetham, *Kant, Art, and Art History: Moments of Discipline* (Cambridge: Cambridge University Press, 2001), 98–99.

46. Cheetham, who has written a historiography of Greenberg on Kant—a roster on which non-cis-male names, Piper among them, are not included—indexes Greenberg's formalism directly to Kantian objectivity, and both formalism and objectivity, in turn, to the role of politics, which he further understands to be distinct from the role of art. Cheetham, *Kant, Art, and Art History*, 98–99.

47. See, for example, the periodization by Darby English in *1971: A Year in the Life of Color* (Chicago: University of Chicago Press, 2016), 2.

48. Louis Menand, "Thirteen Crucial Years for Art in Downtown New York," *New Yorker*, March 28, 2017.

49. See, for example, Gene Swenson, *The Other Tradition* (Philadelphia: Institute for Contemporary Art, University of Pennsylvania, 1966); Scott Burton, "Tony Smith and Minimalist Sculpture," lecture at Walker Art Center, October 10, 1967; and Lucy Lippard, *Six Years: The Dematerialization of the Art Object* (Berkeley: University of California Press, 1997).

50. English, *1971*, 7.

51. Stephanie Sparling Williams defines direct address—a way of describing social address that is historically specific to think moment—as "a strategy deployed by visual artists . . . by which an art work 'speaks to' or engages its viewers, with the manner of address being central to how the work's meaning is derived." Sparling Williams, *Speaking out of Turn: Lorraine O'Grady and the Art of Language* (Oakland: University of California Press, 2021), 2.

52. Jones, *Body Art*, 1.

53. For example, the very first image of Piper that appears in the catalog of her 2018 retrospective at the Museum of Modern Art is a 1965 self-portrait in charcoal and colored pencil of Piper in a mirror, the first of many times that the mirror—an object that often stands in for more conceptual queries into reflection and spectation—would appear in Piper's art. Christophe Cherix, Cornelia H. Butler, and David Platzker, eds., *Adrian Piper: A Synthesis of Intuitions, 1965–2016* (New York: Museum of Modern Art, 2018), 95, 178–179. A few years later, in the late summer of 1970, Piper began work on *Catalysis*, which would become a series of performances that also answer to the terms of body art. Adrian Piper, *Out of Order, Out of Sight*, 1:32–34.

54. The MoMA catalog states that there are fifty-six pages, but the installation

photo has fifty-eight framed pages; I have chosen to use the visible count. Cherix, Butler, and Platzker, *Adrian Piper: A Synthesis of Intuitions*, 183.

55. See, for example, Bowles, *Adrian Piper*, 29; and Jörg Heiser, "Adventures in Reasonland," in Cherix, Butler, and Platzker, *Adrian Piper: A Synthesis of Intuitions*, 32.

56. Maurice Berger, "Black Skin, White Masks: Adrian Piper and the Politics of Viewing," in *How Art Becomes History: Essays on Art, Society, and Culture in Post–New Deal America* (New York: Harper-Collins, 1992), 95–96.

57. Thanks to Rujeko Hockley for this observation.

58. Piper, *Out of Order, Out of Sight*, 1:55.

59. Hilton Als, "Profile: Shadow Act: Kara Walker's Vision," *New Yorker*, October 1, 2007, n.p.

60. Édouard Glissant, *Poetics of Relation*, trans. Betsy Wing (Ann Arbor: University of Michigan Press, 1997), 190–193.

61. The relationship between image cultures and systems evolved from Enlightenment-era thought to order bodies into taxonomies of race and sex in the service of elaborating logics for the elevation of certain groups of subjects over others has been documented extensively. See, for example, Londa Schiebinger, "Skeletons in the Closet: The First Representations of the Female Skeleton in Eighteenth Century Anatomy," *Representations* 14 (1986): 42–82.

62. The foundational feminist critique of this phenomenon is Laura Mulvey, "Visual Pleasure and Narrative

Cinema," *Screen* 16, no. 3 (Autumn 1975): 6–18. One excellent account that both explicates and intervenes in this history is Denise Murrell, *Posing Modernity: The Black Model from Manet and Matisse to Today* (New Haven: Yale University Press, 2018).

63. Examples of detailed accounts of these dynamics include Jones, *Body Art*, and Julia Bryan-Wilson, *Art Workers: Radical Practice in the Vietnam War Era* (Berkeley: University of California Press, 2009).

64. Bowles, *Adrian Piper*, 207.

65. The curator Rujeko Hockley has suggested Barbara McCullough's 1979 *Water Ritual #1: An Urban Rite of Purification* as perhaps the closest contemporaneous correlate to *Food for the Spirit*; Hockley in conversation with the author, April 24, 2024. Lorraine O'Grady, "Olympia's Maid: Reclaiming Black Female Subjectivity," in *The Feminism and Visual Culture Reader*, ed. Amelia Jones (New York: Routledge, 2003), 177.

66. English, *1971*, 1.

67. Hilton Als, "Brightening the History of Harlem," *New Yorker*, March 11, 2024, n.p.

68. Grace Glueck, "15 of 75 Black Artists Leave as Whitney Exhibition Opens," *New York Times*, April 6, 1971, 50.

69. Examples of this include the Twentieth Century Creators (formed in 1964, subsequently disbanded and reconstituted as the Weusi Artist Collective in 1965) and Nyumba Ya Sanaa Gallery (founded in 1967 and merged with Weusi in 1968).

70. While shows curated by white women like

*Womanhouse* (curated by Judy Chicago and Miriam Schapiro in 1972) and *c.7,500* (curated by Lucy Lippard in 1973) are often attributed as the earliest examples of feminist art shows, shows like *Where We At: Black Women Artists*—first mounted in Dinga McCannon's living room before moving to the Acts of Art Gallery—or *Sapphire Show: You've Come a Long Way, Baby* at Suzanne Jackson's Gallery 32 in Los Angeles in 1970 are earlier. An extensive and exemplary text on this period is *We Wanted a Revolution: Black Radical Women 1965–1986: A Sourcebook*, ed. Catherine Morris and Rujeko Hockley (Durham: Duke University Press, 2017).

71. Bowles, *Adrian Piper*, 207; Kobena Mercer, "Contrapositional Becomings: Adrian Piper Performs Questions of Identity," in *Adrian Piper: A Reader*, ed. Cornelia Butler and Nizan Shaked (New York: Museum of Modern Art, 2018), 120.

72. Piper, *Out of Order, Out of Sight*, 1:55.

73. Adrian Piper, "Biography," accessed April 2024, http://www.adrianpiper.com /biography.shtml/.

74. Adrian Piper, "Xenophobia and Kantian Rationalism," *Philosophical Forum* 24, no. 103 (Fall-Spring 1992–1993): 188.

75. Piper, "Xenophobia and Kantian Rationalism," 188.

76. This includes Mark Cheetham's analysis of Greenberg, which lauds the critic for his "close reading and subtle employment" of the *Third Critique*. Cheetham, *Kant, Art, and Art History*, 89.

77. Piper, "Xenophobia and Kantian Rationalism," 188.

78. Piper, "Xenophobia and Kantian Rationalism," 190.

79. Piper, "Xenophobia and Kantian Rationalism," 189–190.

80. Piper, "Xenophobia and Kantian Rationalism," 188–189.

81. Piper, "Xenophobia and Kantian Rationalism," 189.

82. Piper, "Xenophobia and Kantian Rationalism," 190–191.

83. Piper, "Xenophobia and Kantian Rationalism," 189, 191.

84. Piper, "Xenophobia and Kantian Rationalism," 190. This essay was eventually included in a volume dedicated to examining whether and to what degree Kant's work could actually bear the weight of the some of the more exclusionary projects to which it had been put, and to resurface Kant's "theories of autonomy, subjectivity, and rationality in a way that can further feminist projects." In addition to reprinting Piper's essay, it also published one by Piper's contemporary Marcia Moen, who found a basis for a similar interpretation of the *Third Critique* that is not unlike what Piper locates in the *First*. Marcia Moen, "Feminist Themes in Unlikely Places," in *Feminist Interpretations of Immanuel Kant*, ed. Robin May Schott (State College: Penn State University Press, 1997), 213–256.

85. Piper "Xenophobia and Kantian Rationalism," 189.

86. Huey Copeland, "Specters of History," in *Carrie Mae Weems*, ed. Sarah Elizabeth Lewis with Christine Garnier (Cambridge, MA: MIT Press, 2021), 12.

Chapter 2

1. Thanks to Roddy Williams for bringing Miller's panels to my attention.

2. Thanks to Jonathan D. Katz for bringing this panel to my attention.

3. Lawrence K. Altman, "Rare Cancer Seen in 41 Homosexuals," *New York Times*, July 3, 1981.

4. Cathy J. Cohen, *The Boundaries of Blackness: AIDS and the Breakdown of Black Politics* (Chicago: University of Chicago Press, 1999), 148.

5. Dan Royles, *To Make the Wounded Whole: The African American Struggle against HIV/AIDS* (Chapel Hill: University of North Carolina Press, 2020), 4.

6. Vivane Namsate, "AIDS Histories Otherwise: The Case of Haitians in Montreal," in *AIDS and the Distribution of Crises*, ed. Jih-Fei Cheng, Alexandra, Juhasz, and Nishant Shahani (Durham: Duke University Press, 2020), 131–147.

7. Sarah Schulman, *Let the Record Show: A Political History of ACT UP New York, 1987–1993* (New York: Farrar, Straus and Giroux, 2021), 18.

8. Susan Sontag, *AIDS and Its Metaphors* (New York: Farrar, Straus and Giroux, 1989); Paula Treichler, "AIDS, Homophobia, and Biomedical Discourse: An Epidemic of Signification," *October* 43 (Winter 1987): 31–70.

9. Centers for Disease Control, "HIV and AIDS—United States, 1981–2000," June 1, 2001, accessed March 2024, https://www.cdc.gov/mmwr/preview/mmwrhtml/mm5021a2.htm.

10. Cohen, *The Boundaries of Blackness*, 8.

11. "14 San Francisco Sex Clubs to Close to Curb AIDS," *New York Times*, October 10, 1984.

12. Mervyn Silverman, "AIDS Care: The San Francisco Model," *Journal of Ambulatory Care Management* (May 1988), 15.

13. For example, the Korean War Memorial was erected over four decades after the military engagement that it referenced had officially concluded; the World War II Memorial opened nearly six decades after Germany surrendered.

14. Commissioned from Maya Lin in 1982, a mere seven years after the conclusion of the Vietnam War, the Vietnam Veterans Memorial in crucial ways presages the departures from the monumental tradition that would manifest in the AIDS Quilt: it sits below grade, lists the names the dead according to date of death rather than according to traditional military hierarchies, and is nonpictorial.

15. Michel Foucault, *History of Sexuality*, vol. 1: *An Introduction* (New York: Vintage, 1990), 140–141.

16. Achille Mbembe, *Necropolitics* (Durham: Duke University Press, 2019), 38.

17. This tradition might also be traced both to the ancient and to the poetic; for an explication at the confluence of the two, see Cornelia D. J. Pearsall, *Tennyson's Rapture: Transformation in the Victorian Monologue* (Oxford: Oxford University Press, 2008), 80–87.

18. Kirk Savage, *Monument Wars: Washington, D.C., the National Mall, and the*

*Transformation of the Memorial Landscape* (Berkeley: University of California Press, 2001), 141.

19. Savage, *Monument Wars*, 99.

20. Savage, *Monument Wars*, 147.

21. Judith Butler, *Frames of War: When Is Life Grievable?* (New York: Verso, 2009), 14.

22. Robert Pear, "A.M.A. Rules That Doctors Are Obligated to Treat AIDS," *New York Times*, November 13, 1987.

23. See, for example, Gayle Rubin, "Thinking Sex: Notes toward a Radical Theory of Sexuality," in *Pleasure and Danger: Exploring Female Sexuality*, ed. Carole Vance (Boston: Routledge, 1984), 157–210; Jonathan D. Katz, "How AIDS Changed American Art," in *Art AIDS America: Art and Mourning in America* (Seattle: University of Washington Press; Tacoma: Tacoma Art Museum, 2015), 24–45.

24. Thanks to Ian Thomas Fleischman for emphasizing this connection.

25. As relayed by Jonathan D. Katz in conversation with the author, October 12, 2021.

26. Cleve Jones, *When We Rise: My Life in the Movement* (New York: Hachette, 2016), 216; see also Peter S. Hawkins, "Naming Names: The Art of Memory and the NAMES Project AIDS Quilt," *Critical Inquiry* 19, no. 4 (Summer 1993): 757.

27. Amanda Sikarskie, "Erica Wilson and the Quilt Revival," *Uncoverings* 36 (2015), 93–114.

28. Erica Wilson, *Erica Wilson's Quilts of America* (Birmingham, AL: Oxmoor House, 1979), 2.

29. Wilson, *Erica Wilson's Quilts of America*, 6.

30. Wilson, *Erica Wilson's Quilts of America*, 192.

31. John Beardsley, "River Island," in *The Quilts of Gee's Bend* (Atlanta: Tinwood Books, 2002), 21–22.

32. Beardsley, "River Island," 22. Thanks to Emma Yau, curatorial assistant at Souls Grown Deep, for confirming the centrality of this source.

33. Beardsley, "River Island," 24.

34. Beardsley, "River Island."

35. James T. Wooten, "A Negro Community in Alabama Cherishes Memory of Dr. King," *New York Times*, April 4, 1970, 29.

36. Wooten, "A Negro Community in Alabama Cherishes Memory of Dr. King."

37. "Alabama Judge Denies Bid to Name Town for Dr. King," *New York Times*, May 15, 1968, 34.

38. Nancy Callahan, *The Freedom Quilting Bee: Folk Art and the Civil Rights Movement* (Tuscaloosa: University of Alabama Press, 1987), 13.

39. Callahan, *The Freedom Quilting Bee*, 18.

40. Callahan, *The Freedom Quilting Bee*, 64–65. Emma Yau notes that "in the May 1968 issue, the red and white cotton seat was pieced by the FQB (Freedom Quilting Bee). While the August 1968 issue does not mention the FQB directly, they had a contract with Parish-Hadley. The June 1969 issue names the FQB."

41. Wilson, *Erica Wilson's Quilts of America*, 14.

42. Jones, *When We Rise*.

43. Callahan, *The Freedom Quilting Bee*, 13.

44. As relayed by activist and art historian Jonathan D.

Katz in conversation with the author, October 12, 2021.

45. Gladys-Marie Fry, *Stitched from the Soul: Slave Quilts from the Antebellum South* (Chapel Hill: University of North Carolina Press, 2002), 45–46.

46. Jacquelyn L. Tobin and Raymond G. Dobard, *Hidden in Plain View: A Secret History of Quilts and the Underground Railroad* (New York: Anchor, 2000), 70.

47. John Hope Franklin Humanities Institute, Duke University, "Fred Moten & Saidiya Hartman at Duke University | The Black Outdoors," YouTube, October 5, 2016, accessed April 2024, https://www.youtube.com/watch?v=t_tuz6dybrc.

48. Katz, "How AIDS Changed American Art," 36–37.

49. D. W. Winnicott, *Playing and Reality* (New York: Routledge, 1989), 12.

50. Douglas Crimp, "Mourning and Militancy," *October* 51 (Winter 1989), 7.

51. Cohen, *The Boundaries of Blackness*, 220–249; Jih-Fei Cheng, "AIDS, Women of Color Feminisms, Queer and Trans of Color Critiques, and the Crises of Knowledge Production," in *AIDS and the Distribution of Crises*, ed. Jih-Fei Cheng, Alexandra, Juhasz, and Nishant Shahani (Durham: Duke University Press, 2020), 78–80; Schulman, *Let the Record Show*, 19–21.

52. Crimp, "Mourning and Militancy," 5.

53. Eve Kosofsky Sedgwick, "White Glasses," in Sedgwick, *Tendencies* (Durham: Duke University Press, 1993), 265.

54. Silverman, "AIDS Care," 607.

55. Sedgwick, "White Glasses," 265.

56. Sedgwick, "White Glasses," 265.

57. The author in email correspondence with Roddy Williams, Quilt Operations Manager, National AIDS Memorial, January 13, 2024.

58. Sedgwick, "White Glasses," 264.

59. Sedgwick, "White Glasses," 264.

60. That this collapse resonates with both possibilities and problems of conventional postmodernism has been observed and is well explicated by Jonathan D. Katz in "How AIDS Changed American Art," 32–37.

61. *Oxford English Dictionary*, s.v. "sepulchre (*n.*), sense 1.a."

62. Katz, "How AIDS Changed American Art," 26.

63. Katz, "How AIDS Changed American Art," 43.

64. Katz, "How AIDS Changed American Art," 37.

65. Sedgwick, "White Glasses," 257.

66. Lauren Berlant, *Cruel Optimism* (Durham: Duke University Press, 2011), 58.

67. This photograph was taken in 1989. Nino Testa, "'If You Are Reading It, I Am Dead': Activism, Local History, and the AIDS Quilt," *Public Historian* 44, no. 3 (August 2022): 48. Special thanks to Lyndsay Knecht, Licensing and Loans Coordinator, Special Collections, UNT Libraries, for illuminating the timeline of this image relative to the panel.

68. Thomas Richards situates the archival impulse firmly in the expansion of British imperial culture over the course of the nineteenth century. Thomas Richards,

*The Imperial Archive: Knowledge and the Fantasy of Empire* (New York: Verso, 1993), 4–7. Enwezor notes that the British empire was "founded on the production of paper, assorted documents, and images, all of which spawned other documents, along with the systems organizing them and the rules for distributing their content." Okwui Enwezor, *Archive Fever: Uses of the Document in Contemporary Art* (New York: Steidl/International Center for Photography, 2008), 20.

69. Jacques Derrida, *Archive Fever*, trans. Eric Prenowitz (Chicago: University of Chicago Press, 1995), 1.

70. Derrida, *Archive Fever*, 84.

71. Enwezor, *Archive Fever*, 28. As archival scholar Dorothy Berry notes, traditional archives are often, on a very procedural level, inequitable in access, "stacked in secure shelving, unbeknownst and inaccessible to implicated communities." Dorothy Berry, "The House Archives Built," *up//root: a we here publication*, June 22, 2021, 1–12, accessed March 2024, https://www.uproot.space/features/the-house-archives-built.

72. Anjali Arondekar, *For the Record: On Sexuality and the Colonial Archive in India* (Durham: Duke University Press, 2009), 1.

73. Saidiya Hartman, "Venus in Two Acts," *Small Axe* 12, no. 2 (2008): 2.

74. Hartman, "Venus in Two Acts," 11.

75. Arondekar, *For the Record*, 4.

76. The Lesbian Herstory archives was founded in 1974

as "a center for all women who want to get a sense of their Lesbian Herstory," according to the Archive's first newsletter in 1975, which also contained a call for "lesbian materials." Implicit in the letter was a self-identification with the archive akin to that which would be used over a decade later in the AIDS Quilt. Sahli Cavallaro, Deborah Edel, Joan Nestle, Pamela Oline, and Julia Stanley, "Lesbian Herstory Archives Newsletter," June 1975, accessed April 2024, https://lesbianherstoryarchives.org/content/uploads/2020/06/News01.pdf.

77. This argument is also made to great effect by Adam H. Domby in *The False Cause: Fraud, Fabrication, and White Supremacy in Confederate Memory* (Charlottesville: University of Virginia Press, 2020).

78. Derrida, *Archive Fever*, 91.

79. Sedgwick, "White Glasses," 265.

80. World Health Organization, "Number of People Dying from AIDS-Related Causes," accessed April 2024, https://www.who.int/data/gho/data/indicators/indicator-details/GHO/number-of-deaths-due-to-hiv-aids#:~:text=The%20estimated%20650%20000%20%5B510,in%20many%20high%20burden%20countries.

81. Butler, *Frames of War*, 3.

82. Mbembe, *Necropolitics*, 38.

Chapter 3

1. Saidiya Hartman, *Scenes of Subjection: Terror, Slavery, and Self-Making in Nineteenth-Century America*, 2nd ed. (New York: W. W. Norton, 2022), 129.

2. Saidiya Hartman, "Venus in Two Acts," *Small Axe* 12, no. 2 (2008): 11.

3. Walker's piece is titled "Black/White (Grey) Notes on Adrian Piper"; Hilton Als, "Profile: Shadow Act: Kara Walker's Vision," *New Yorker*, October 1, 2007.

4. Thomas Chatterton Williams, "Adrian Piper's Show at MoMA Is the Largest Ever for a Living Artist. Why Hasn't She Seen It?," *New York Times*, June 27, 2018.

5. See, for example, Williams, "Adrian Piper's Show at MoMA," n.p.; Maurice Berger, "Black Skin, White Masks: Adrian Piper and the Politics of Viewing," in *How Art Becomes History: Essays on Art, Society, and Culture in Post–New Deal America* (New York: HarperCollins, 1992), 95–96; John P. Bowles, *Adrian Piper: Race, Gender, and Embodiment* (Durham: Duke University Press, 2011), 1–2.

6. June O. Patton, J. Strickland, and E. J. Crawford, "Moonlight and Magnolias in Southern Education," *Journal of Negro History* 65, no. 2 (Spring 1980): 153–154.

7. Tony Horwitz, "The Mammy Washington Almost Had," *Atlantic*, May 31, 2013.

8. Harriet F. Senie and Sally Webster, "Politics, Patronage, and Public Art," in *Critical Issues in Public Art: Content, Context, and Controversy*, ed. Harriet F. Senie and Sally Webster (Washington, DC: Smithsonian Books, 1992), 101.

9. Carolina A. Miranda, "Q&A: Kara Walker on the Bit of Sugar Sphinx She Saved, Video She's Making," *Los Angeles Times*, October 13, 2014.

10. Their geographic proximity was short lived; the Stuart statue was removed from the pedestal on which it stood for over a century in June 2020. In 2022 the pedestal, which remained defaced, was itself removed.

11. Harry Kollatz Jr., "'Rumors of War' Revealed," *Richmond Magazine*, December 11, 2019. Notably, the temporally first term in this genealogy is left out of later reviews of the work, such as the one that appeared in the *New Yorker*, which focused on the local: Kriston Capps, "Kehinde Wiley's Anti-Confederate Memorial," *New Yorker*, December 24, 2019.

12. According to contemporaneous remarks made by Wiley, the face of the rider is comprised of a composite of the faces of six men. Colleen Curran, "There's Something Changing in These Winds: Kehinde Wiley's Rumors of War Unveiled in Richmond," *Richmond Times-Dispatch*, December 10, 2019. According to David Carozza, archivist at Kehinde Wiley's studio, there is no list of persons whose faces comprise the composite. David Carozza in conversation with the author, March 5, 2024.

13. Richmond City Council Ordinance 2020-154, adopted August 3, 2020, accessed February 2024, https://richmondva.legistar.com/LegislationDetail.aspx?ID=4582895&GUID=7AF4B6D7-0EF9-4F52-8E9E-07FF9AD D4487&Options=ID|Text|&Search=2020-154.

14. Kirk Savage, *Standing Soldiers, Kneeling Slaves: Race, War, and Monument in Nineteenth Century America* (Princeton: Princeton University Press, 2018), 209.

15. Wiley could have chosen another referent in Richmond, for example, to memorialize a member of the 5th United States Colored Cavalry to address historical exclusions of Black subjects from this particular memorial form, or the more famous Robert E. Lee monument in Richmond. Instead he chose a contemporary figure without an individualized subjectivity for this very historical form.

16. Nicola Frith, *The French Colonial Imagination: Writing the Indian Uprisings, 1857–1858, from the Second Empire to the Third Republic* (New York: Lexington Books, 2014), 27.

17. Shashi Tharoor, *Inglorious Empire: What the British Did to India* (London: C. Hurst, 2017), 81.

18. Frith, *The French Colonial Imagination*, 28.

19. Fintan Cullen, "Migrating Objects: John Henry Foley and Empire," in *Artists and Migration: 1400–1850: Britain, Europe and Beyond*, ed. Kathrin Wagner, Jessica David, and Matej Clemenčič (Newcastle upon Tyne: Cambridge Scholars, 2017), 185–187.

20. Tharoor, *Inglorious Empire*, 2.

21. As Tharoor notes, at the beginning of the Raj, there were better processes for the production of steel on the Indian subcontinent than there were in Britain; the British took note of these, implemented them at home, and then changed the specifications required in a way that rendered Indian steel unsaleable.

22. Cornelia D. J. Pearsall, "Assume the Globe: Tennyson's Jubilee Ode and the Institutions of Imperialism,"

*Victorian Poetry* 59, no. 2 (Summer 2021): 181, 184.

23. Sylvia Wynter, "Unsettling the Coloniality of Being/Power/Truth/Freedom: Towards the Human, After Man, Its Overrepresentation—An Argument," *CR: The New Centennial Review* 3, no. 3 (Fall 2003): 267.

24. Hannah Arendt, *The Origins of Totalitarianism* (New York: Harcourt, Brace, Jovanovich, 1973), 153.

25. Maurie D. McInnis, "'To Strike Terror': Equestrian Monuments and Southern Power," in *The Civil War in Art and Memory*, ed. Kirk Savage (New Haven: Yale University Press, 2016), 131.

26. Fred Moten, *Stolen Life* (Durham: Duke University Press, 2018), 17.

27. This trajectory is also in evidence in Wiley's 2022 installation at the Musée d'Orsay, which featured new interventions into his well-known painting *Femme piquée par un serpent* (2008), a painting and a sculpture both titled *Femme piquée par un serpent (Mamdou Gueye)*, after the French soccer player—and a new equestrian statue titled *An Archaeology of Silence*. Though the 2008 painting is legible as queer, in these more recent instances any trace of queerness is gone, and the idea of silence may actually further recover these works to a more sepulchral, if not overtly memorial, trajectory than *Rumors of War* has.

28. Martina Droth, Jason Edwards, and Michael Hatt note that the Queen purchased and then lent out for the Great Exhibition a replica of Christian Daniel Rausch's *Victory* (the original remained

in Walhalla, the German pantheon designed to celebrate Germany's defeat of Napoleon). While the authors suggest that its location in the royal collections, next to a portrait of that very same queen, is the source of this relationship, given the low circulation of the populace through those spaces I might venture that people need not see the two together to make the connection. *Sculpture Victorious: Art in an Age of Invention, 1837–1901* (New Haven: Yale University Press, 2015), 15.

29. Tharoor, *Inglorious Empire*, 32–35.

30. Anna Arabindan-Kesson, *Black Bodies, White Gold: Art, Cotton, and Commerce in the Atlantic World* (Durham: Duke University Press, 2021), 8–9.

31. Cornelia D. J. Pearsall, "Blank Verse and the Expansion of England: The Meter of Tennyson's Demeter," in *Meter Matters: Verse Cultures of the Long Nineteenth Century*, ed. Jason David Hall (Athens: Ohio University Press, 2011), 221.

32. Paul Gilroy, *Small Acts: Thoughts on the Politics of Black Culture* (New York: Serpent's Tail, 1993), 157.

33. While Walker would appear to be using the word "Albion" in the general sense of the lands from which whiteness hails, Hartman makes separate reference to a history written by James Barbot, captain of the frigate *Albion*, a ship that, according to the Trans-Atlantic Slave Trade Database (https://www.slavevoyages.org/voyage/database), made several voyages as a slave

ship and "attested to the coincidence of the pleasures afforded in the space of death. It was difficult to exercise sexual restraint on the slave ship, Barbot confessed, because the 'young sprightly maidens, full of jollity and good humor, afforded an abundance of recreation.'" Hartman, "Venus in Two Acts," 19.

34. Thanks to Kathleen Pierce for suggesting this connection.

35. Kara Walker, "Fons Americanus," in *Kara Walker: Fons Americanus*, ed. Clara Kim (London: Tate Publishing, 2019), 58.

36. Hartman, "Venus in Two Acts," 1.

37. I am grateful to Whitney Battle-Baptiste for suggesting this connection in an early talk on this material at the Five College Working Group on Race and Representation, Institute for Holocaust, Genocide, and Memory Studies, University of Massachusetts, Amherst, February 18, 2021.

38. Kimberly Juanita Brown, *The Repeating Body: Slavery's Visual Resonance in the Contemporary* (Durham: Duke University Press, 2015), 142.

39. Audre Lorde, "A Litany for Survival," in *The Collected Poems of Audre Lorde* (New York: W. W. Norton, 1997), 255.

40. Brown, *The Repeating Body*, 12.

41. Walker, "Fons Americanus," 58.

42. Renato Rosaldo, "Imperialist Nostalgia," *Representations* 26 (Spring 1989): 108.

43. "Look Closer: Kara Walker's *Fons Americanus*," Tate Modern, accessed April 2024, https://www.tate.org.uk/art/artists/kara

-walker-2674/kara-walkers
-fons-americanus.

44. "Look Closer."

45. Elizabeth Alexander, "'Can You Be Black and Look at This?' Reading the Rodney King Video(s)," *Public Culture* 7, no. 1 (January 1994): 78.

46. Jacqueline Goldsby, *A Spectacular Secret: Lynching in American Life and Literature* (Chicago: University of Chicago Press, 2006), 4.

47. There is at least one organization, the National Association of Black Scuba Divers, which places plaques on the sea floor where slave ships are discovered. Marcus Wood, *Blind Memory: Visual Representations of Slavery in England and America, 1780–1865* (Manchester: Manchester University Press, 2000), 300.

48. Hartman, *Scenes of Subjection*, 128.

49. Édouard Glissant, *Poetics of Relation*, trans. Betsy Wing (Ann Arbor: University of Michigan Press, 1997), 193.

50. See, for example, Micki McElya, *Clinging to Mammy: The Faithful Slave in Twentieth Century America* (Cambridge, MA: Harvard University Press, 2007); Patricia A. Turner, *Ceramic Uncles and Celluloid Mammies: Black Images and Their Influence on Culture* (Charlottesville: University of Virginia Press, 1994).

51. McElya, *Clinging to Mammy*, 3.

52. Wynter, "Unsettling the Coloniality of Being/Power/Truth/Freedom," 306.

53. For a detailed explication of this tradition and its deep imbrication with gender and race in the US context, see Charmaine A. Nelson,

*The Color of Stone: Sculpting the Black Female Subject in Nineteenth-Century America* (Minneapolis: University of Minnesota Press, 2007), 57–72.

54. Christina Sharpe, *In the Wake: On Blackness and Being* (Durham: Duke University Press, 2016), 8.

*Chapter 4*

1. Elizabeth Freeman, *Time Binds: Queer Temporalities, Queer Histories* (Durham: Duke University Press, 2010), 3.

2. Ernesto Laclau and Chantal Mouffe, *Hegemony and Socialist Strategy: Towards a Radical Democratic Politics*, 2nd ed. (New York: Verso, 2001), 7.

3. José Esteban Muñoz, *Cruising Utopia: The Then and There of Queer Futurity* (New York: New York University Press, 2009), 49.

4. Kara Keeling, *Queer Times, Black Futures* (New York: New York University Press, 2019), 103.

5. Keeling, *Queer Times, Black Futures*, 95.

6. Saidiya Hartman, "Venus in Two Acts," *Small Axe* 12, no. 2 (2008): 11.

7. Among myriad available examples, see Ann Stanford, "Medusa," in *In Mediterranean Air* (New York: Viking Press, 1977), 42; Susan R. Bowers, "Medusa and the Female Gaze," *NWSA Journal* 2, no. 2 (Spring 1990): 217–235.

8. Some images of this work depict it in its preparatory state in a Los Angeles warehouse where the dome was covered in ads akin to those that appear in the vicinity of prisons;

Bradford ultimately does not include those in the Venice installation.

9. Zadie Smith, "Niagara," in *Mark Bradford: Tomorrow Is Another Day*, ed. Katy Siegel and Christopher Bedford (New York: George Miller & Co. and Hatje Cantz, 2017), 85–86.

10. Fred Moten, "Black Op," *PMLA* 123, no. 5 (October 2008): 1745.

11. Fred Moten, *Stolen Life* (Durham: Duke University Press, 2018), 113; Fred Moten, *Black and Blur* (Durham: Duke University Press, 2017), 84.

12. Rizvana Bradley's *Anteaesthetics: Black Aesthetics and the Critique of Form* (Stanford: Stanford University Press, 2023) deepens this discussion; unfortunately the book came out too close to my own deadline to include substantive discussion of it here.

13. Smith, "Niagara," 88.

14. Robin Bernstein, *Racial Innocence: Performing American Childhood from Slavery to Civil Rights* (New York: New York University Press, 2011), 4.

15. Michelle Alexander, *The New Jim Crow: Mass Incarceration in the Age of Colorblindness* (New York: New Press, 2012), 16.

16. Muñoz, *Cruising Utopia*, 25.

17. Muñoz, *Cruising Utopia*, 49.

18. Michael Slenske, "Lauren Halsey's Monumental Moment," *W Magazine*, March 30, 2023.

19. Erin A. Peters, "Coloring the Temple of Dendur," *Metropolitan Museum Journal* 53 (2018), 9.

20. Robert Schork, "The Dendur Temple in New York: The Gallus Connection," *Arion: A Journal of Humanities and the Classics* 18, no. 3 (Winter 2011): 98.

21. Erin Peters, "Vaguely Dendur: A Theoretical Unbinding of Egyptology," 13th International Congress of Egyptologists, August 6–11, 2023.

22. Peters, "Coloring the Temple of Dendur," 16.

23. Keeling, *Queer Times, Black Futures*, 4.

24. Gilroy also notes that "the musicians who created the music did not always control its packaging, but they were sometimes able to use cover art to collude with their preferred audience in telling ways which the multinational companies who circulated these products either did not care about or were unable to foresee." Paul Gilroy, *Small Acts: Thoughts on the Politics of Black Culture* (New York: Serpent's Tail, 1993), 241.

25. Abraham Thomas, "South Central Dream Worlds," in *The Roof Garden Commission: Lauren Halsey*, ed. Abraham Thomas and Douglas Kearney (New Haven: Yale University Press, 2023), 12.

26. In addition to Piper's well-known *Funk Lessons* (1982–1984), one of only two events Piper records in her personal chronology from the year 1984 was watching P-Funk music videos. Christophe Cherix, Cornelia H. Butler, and David Platzker, eds., *Adrian Piper: A Synthesis of Intuitions, 1965–2016* (New York: Museum of Modern Art, 2018), 317. See also Elvan Zabunyan, *Funk Lessons* (Cambridge, MA: MIT Press, 2024).

27. Keeling, *Queer Times, Black Futures*, 49.

28. Keeling, *Queer Times, Black Futures*, 49.

29. Kevin Quahshie, *Black Aliveness, or A Poetics of Being* (Durham: Duke University Press, 2021), 58.

30. As Moten asserts, "the whole point about escape is that it's like an activity. It's not an achievement. You know, you don't ever get escaped." John Hope Franklin Humanities Institute, Duke University, "Fred Moten & Saidiya Hartman at Duke University | The Black Outdoors," YouTube, October 5, 2016, accessed April 2024, https://www.youtube.com/watch?v=t_tuz6dybrc.

31. C. Riley Snorton, *Black on Both Sides: A Racial History of Trans Identity* (Minneapolis: University of Minnesota Press, 2017), 63–64.

*Epilogue*

1. Heartfelt thanks to André Dombrowski for calling my attention to the Morris connection, and to Florence Boos for calling my attention to the Bloody Sunday illustration.

2. Florence Boos, "Introduction: William Morris's Uncollected Political Essays: Equality, Nonviolence, and 'One Socialist Party,'" in *William Morris on Socialism: Uncollected Essays*, ed. Florence Boos (Edinburgh: Edinburgh University Press, 2023), 1.

3. Boos, "Introduction," 11.

4. Boos, "Introduction," 6.

5. William Morris, *News from Nowhere*, in *News from Nowhere and Other Writings* (New York: Penguin, 1993), 77.

6. Owen Holland, "From the Place Vendôme to Trafalgar Square: Imperialism and Counter-Hegemony in the 1880s Romance Revival," *Key Words: A Journal of Cultural Materialism* 14 (2016): 99–100.

7. Ross Chambers, *Room for Maneuver: Reading (the) Oppositional (in) Narrative* (Chicago: University of Chicago Press, 1991), 11–13.

8. Chambers, *Room for Maneuver*, xiii.

9. Achille Mbembe, "Decolonizing Knowledge and the Question of the Archive," lecture at the Wits Institute for Social and Economic Research (WISER), University of the Witwatersrand (Johannesburg), 2015, accessed April 2024, https://wiser.wits.ac.za/system/files/Achille%20Mbembe%20-%20Decolonizing%20Knowledge%20and%20the%20Question%20of%20the%20Archive.pdf.

10. "Presidential Initiatives: The Monuments Project," Andrew W. Mellon Foundation, https://www.mellon.org/article/the-monuments-project-initiative, accessed October 2024.

11. Kathleen M. Trauth, Stephen C. Hora, and Robert V. Guzowski, "Expert Judgment on Markers to Deter Inadvertent Human Intrusion into the Waste Isolation Pilot Plant," Sandia National Laboratories report, November 1993.

12. Responses to the proposal from beyond Sandia included evolving a breed of "ray cat" to glow green

in the presence of nuclear waste to warn humans when nuclear danger was nearby. Françoise Bastide and Paolo Fabbri, "Lebende Detektoren und komplimentäre Zeichen: Katzen, Augen und Sirenen," *Zeitschrift für Semiotik* 6, no. 3 (1984).

13. Julia Bryan-Wilson, "Building a Marker of Nuclear Warning," in *Monuments and Memory, Made and Unmade*, ed. Robert S. Nelson and Margaret Olin (Chicago: University of Chicago Press, 2003), 183–208.

14. In the Museum of Modern Art catalog, nine of the first ten items involve works on paper that fit the in-text description; the ninth of those ten, however, is printed on vellum rather than graph paper. Christophe Cherix, Cornelia H. Butler, and David Platzker, *Adrian Piper: A Synthesis of Intuitions, 1965–2016* (New York: Museum of Modern Art, 2018), 284.

"Alabama Judge Denies Bid to Name Town for Dr. King." *New York Times*, May 15, 1968, 34.

Alexander, Elizabeth. "'Can You Be Black and Look at This?' Reading the Rodney King Video(s)." *Public Culture* 7, no. 1 (January 1994): 77–94.

Alexander, Michelle. *The New Jim Crow: Mass Incarceration in the Age of Colorblindness*. New York: New Press, 2012.

Allen, Laurie, Paul Farber, and Sue Mobley. *National Monument Audit*. Philadelphia: Monument Lab and the Andrew W. Mellon Foundation, 2021.

Als, Hilton. "Brightening the History of Harlem." *New Yorker*, March 11, 2024.

Als, Hilton. "Culture Desk: The Sugar Sphinx." *New Yorker*, May 8, 2014.

Als, Hilton. "Profile: Shadow Act: Kara Walker's Vision." *New Yorker*, October 1, 2007.

Altman, Lawrence K. "Rare Cancer Seen in 41 Homosexuals." *New York Times*, July 3, 1981.

Arabindan-Kesson, Anna. *Black Bodies, White Gold: Art, Cotton, and Commerce in the Atlantic World*. Durham: Duke University Press, 2021.

Arendt, Hannah. *The Origins of Totalitarianism*. New York: Harcourt, Brace, Jovanovich, 1973.

Arondekar, Anjali. *For the Record: On Sexuality and the Colonial Archive in India*. Durham: Duke University Press, 2009.

Assail, Shaun. "The Secret Fight to Save Confederate Monuments." *Glamour*, August 16, 2018.

Bastide, Françoise, and Paolo Fabbri. "Lebende Detektoren und komplimentäre Zeichen: Katzen, Augen und Sirenen." *Zeitschrift für Semiotik* 6, no. 3 (1984).

Beardsley, John. "River Island." In *The Quilts of Gee's Bend*, ed. William Arnett, 2–33. Atlanta: Tinwood Books, 2002.

Beetham, Sarah. "'An Army of Bronze Simulacra': The Copied Soldier Monument and the American Civil War." *Nierka: Revista de Estudios de Arte* 4, no. 7 (January–June 2015): 34–45.

Berger, Maurice. "Black Skin, White Masks: Adrian Piper and the Politics of Viewing." In *How Art Becomes History: Essays on Art, Society, and Culture in Post–New Deal America*, 93–113. New York: HarperCollins, 1992.

Berlant, Lauren. *Cruel Optimism*. Durham: Duke University Press, 2011.

Bernstein, Robin. *Racial Innocence: Performing American Childhood from Slavery to Civil Rights*. New York: New York University Press, 2011.

Berry, Dorothy. "The House Archives Built." *up//root: a we here publication*, June 22, 2021, 1–12. https://www.uproot.space /features/the-house-archives-built.

Blight, David W. *Frederick Douglass: Prophet of Freedom*. New York: Simon and Schuster, 2018.

Boos, Florence. "Introduction: William Morris's Uncollected Political Essays: Equality, Nonviolence, and 'One Socialist Party.'" In *William Morris on Socialism: Uncollected Essays*, ed. Florence Boos, 1–30. Edinburgh: Edinburgh University Press, 2023.

Bowers, Susan R. "Medusa and the Female Gaze." *NWSA Journal* 2, no. 2 (Spring 1990): 217–235.

Bowles, John P. *Adrian Piper: Race, Gender, and Embodiment*. Durham: Duke University Press, 2011.

Brown, Kimberly Juanita. *The Repeating Body: Slavery's Visual Resonance in the Contemporary*. Durham: Duke University Press, 2015.

Bryan-Wilson, Julia. "Building a Marker of Nuclear Warning." In *Monuments and Memory, Made and Unmade*, ed. Robert S. Nelson and Margaret Olin, 183–208. Chicago: University of Chicago Press, 2003.

Burton, Scott. "Tony Smith and Minimalist Sculpture." Lecture at Walker Art Center, October 10, 1967.

Butler, Judith. *Frames of War: When Is Life Grievable?* New York: Verso, 2009.

Callahan, Nancy. *The Freedom Quilting Bee: Folk Art and the Civil Rights Movement*. Tuscaloosa: University of Alabama Press, 1987.

Capps, Kriston. "Kehinde Wiley's Anti-Confederate Memorial." *New Yorker*, December 24, 2019.

Cavallaro, Sahli, Deborah Edel, Joan Nestle, Pamela Oline, and Julia Stanley. "Lesbian Herstory Archives Newsletter." June 1975. https://lesbianherstoryarchives.org/content/uploads/2020/06 /News01.pdf.

Centers for Disease Control. "HIV and AIDS—United States, 1981– 2000." June 1, 2001. https://www.cdc.gov/mmwr/preview /mmwrhtml/mm5021a2.htm.

Chambers, Ross. *Room for Maneuver: Reading (the) Oppositional (in) Narrative*. Chicago: University of Chicago Press, 1991.

Cheetham, Mark. *Kant, Art, and Art History: Moments of Discipline*. Cambridge: Cambridge University Press, 2001.

Cheng, Jih-Fei. "AIDS, Women of Color Feminisms, Queer and Trans of Color Critiques, and the Crises of Knowledge Production." In *AIDS and the Distribution of Crises*, ed. Jih-Fei Cheng, Alexandra, Juhasz, and Nishant Shahani, 76–92. Durham: Duke University Press, 2020.

Cherix, Christophe, Cornelia H. Butler, and David Platzker, eds. *Adrian Piper: A Synthesis of Intuitions, 1965–2016*. New York: Museum of Modern Art, 2018.

"The *Christian Recorder* Mentions the Formation of an Association of Colored Men for the Purpose of Erecting a Monument to John Brown." *Weekly Louisianan*, October 8, 1872.

Clark, T. J. "Clement Greenberg's Theory of Art." *Critical Inquiry* 9, no. 1 (September 1982): 139–156.

Cohen, Cathy J. *The Boundaries of Blackness: AIDS and the Breakdown of Black Politics*. Chicago: University of Chicago Press, 1999.

Cohen, Cathy J. "Punks, Bulldaggers, and Welfare Queens: The Radical Potential of Queer Politics?" *GLQ: A Journal of Lesbian and Gay Studies* 3, no. 4 (1997): 437–465.

Copeland, Huey. "Specters of History." In *Carrie Mae Weems*, ed. Sarah Elizabeth Lewis with Christine Garnier, 7–14. Cambridge, MA: MIT Press, 2021.

Cox, Karen. *No Common Ground: Confederate Monuments and the Ongoing Fight for Racial Justice*. Chapel Hill: University of North Carolina Press, 2021.

Crimp, Douglas. "Mourning and Militancy." *October* 51 (Winter 1989): 3–18.

Cullen, Fintan. "Migrating Objects: John Henry Foley and Empire." In *Artists and Migration: 1400–1850: Britain, Europe and Beyond*, ed. Kathrin Wagner, Jessica David, and Matej Clemenčič, 183–195. Newcastle upon Tyne: Cambridge Scholars, 2017.

Curran, Colleen. "There's Something Changing in These Winds: Kehinde Wiley's Rumors of War Unveiled in Richmond." *Richmond Times-Dispatch*, December 10, 2019.

Danto, Arthur. "The Vietnam Veterans Memorial." *Nation*, August 31, 1985.

"Declaration of Sentiment and Resolutions of the First Convention of Colored Men of Kentucky, Held in Lexington, March 22, 23, 24, and 26, 1866." *Tennessean*, July 18, 1866.

Derrida, Jacques. *Archive Fever*. Trans. Eric Prenowitz. Chicago: University of Chicago Press, 1995.

Diawara, Manthia. "One World in Relation: Édouard Glissant in Conversation with Manthia Diawara." Trans. Christopher Winks. *Nka: Journal of Contemporary African Art* 28 (2011): 4–19.

Domby, Adam H. *The False Cause: Fraud, Fabrication, and White Supremacy in Confederate Memory*. Charlottesville: University of Virginia Press, 2020.

Doss, Erika. *Memorial Mania: Public Feeling in America*. Chicago: University of Chicago Press, 2010.

Droth, Martina, Jason Edwards, and Michael Hatt. *Sculpture Victorious: Art in an Age of Invention, 1837–1901*. New Haven: Yale University Press, 2015.

English, Darby. *1971: A Year in the Life of Color*. Chicago: University of Chicago Press, 2016.

Enwezor, Okwui. *Archive Fever: Uses of the Document in Contemporary Art*. New York: Steidl/International Center for Photography, 2008.

Evans, Fred. *Public Art and the Fragility of Democracy: An Essay in Political Aesthetics*. New York: Columbia University Press, 2019.

Foucault, Michel. *History of Sexuality*. Vol. 1: *An Introduction*. New York: Vintage, 1990.

"14 San Francisco Sex Clubs to Close to Curb AIDS." *New York Times*, October 10, 1984.

"Freedmen's Aid Association." *New Orleans Tribune*, August 10, 1865.

"Freedmen's Meeting in Washington." *New Orleans Tribune*, July 25, 1865.

Freeman, Elizabeth. *Time Binds: Queer Temporalities, Queer Histories*. Durham: Duke University Press, 2010.

Frith, Nicola. *The French Colonial Imagination: Writing the Indian Uprisings, 1857–1858, from the Second Empire to the Third Republic*. New York: Lexington Books, 2014.

Fry, Gladys-Marie. *Stitched from the Soul: Slave Quilts from the Antebellum South*. Chapel Hill: University of Carolina Press, 2002.

Gates, Henry Louis, Jr. *Stony the Road: Reconstruction, White Supremacy, and the Rise of Jim Crow*. New York: Penguin, 2019.

Gilroy, Paul. *Small Acts: Thoughts on the Politics of Black Culture*. New York: Serpent's Tail, 1993.

Glissant, Édouard. *Poetics of Relation*. Trans. Betsy Wing. Ann Arbor: University of Michigan Press, 1997.

Glueck, Grace. "15 of 75 Black Artists Leave as Whitney Exhibition Opens." *New York Times*, April 6, 1971, 50.

Goldsby, Jacqueline. *A Spectacular Secret: Lynching in American Life and Literature*. Chicago: University of Chicago Press, 2006.

Greenberg, Clement. "Avant-Garde and Kitsch." *Partisan Review* 6 (Fall 1939): 34–49.

Hartman, Saidiya. *Lose Your Mother: A Journey along the Atlantic Slave Route*. New York: Farrar, Straus and Giroux, 2008.

Hartman, Saidiya. *Scenes of Subjection: Terror, Slavery, and Self-Making in Nineteenth-Century America*. 2nd ed. New York: W. W. Norton, 2022.

Hartman, Saidiya. "Venus in Two Acts." *Small Axe* 12, no. 2 (2008): 1–14.

Hass, Kristin Ann. *Blunt Instruments: Recognizing Racist Cultural Infrastructure in Memorials, Museums, and Patriotic Practices*. Boston: Beacon Press, 2022.

Hawkins, Peter S. "Naming Names: The Art of Memory and the NAMES Project AIDS Quilt." *Critical Inquiry* 19, no. 4 (Summer 1993): 752–779.

Holland, Owen. "From the Place Vendôme to Trafalgar Square: Imperialism and Counter-Hegemony in the 1880s Romance

Revival." *Key Words: A Journal of Cultural Materialism* 14 (2016): 98–115.

Horowitz, Tony. "The Mammy Washington Almost Had." *Atlantic*, May 31, 2013.

Huyssen, Andreas. "Monument and Memory in a Postmodern Age." *Yale Journal of Criticism* 6, no. 2 (1993): 249–262.

Ifill, Sherrilyn. *On the Courthouse Lawn: Confronting the Legacy of Lynching in the 21st Century*. Boston: Beacon Press, 2007.

John Hope Franklin Humanities Institute, Duke University. "Fred Moten & Saidiya Hartman at Duke University | The Black Outdoors," YouTube, October 5, 2016, https://www.youtube.com /watch?v=t_tuz6dybrc.

Johnson, Joan Marie. "'Ye Gave Them a Stone': African American Women's Clubs, the Frederick Douglass Home, and the Black Mammy Monument." *Journal of Women's History* 17, no. 1 (2005): 62–86.

Jones, Amelia. *Body Art: Performing the Subject*. Minneapolis: University of Minnesota Press, 1998.

Jones, Cleve. *When We Rise: My Life in the Movement*. New York: Hachette, 2016.

"Kara Walker and James Hanaham: On Sex and Sacred Cows." *Frieze*, February 19, 2021.

Katz, Jonathan D. "How AIDS Changed American Art." In *Art AIDS America*, 24–45. Seattle: University of Washington Press; Tacoma: Tacoma Art Museum, 2015.

Keeling, Kara. *Queer Times, Black Futures*. New York: New York University Press, 2019.

Kim, Clara, ed. *Kara Walker: Fons Americanus*. London: Tate Publishing, 2019.

Kollatz, Harry, Jr. "'Rumors of War' Revealed." *Richmond Magazine*, December 11, 2019.

Laclau, Ernesto, and Chantal Mouffe. *Hegemony and Socialist Strategy: Towards a Radical Democratic Politics*. 2nd ed. New York: Verso, 2001.

Lippard, Lucy. *Six Years: The Dematerialization of the Art Object*. Berkeley: University of California Press, 1997.

"Look Closer: Kara Walker's *Fons Americanus*." Tate Modern. https:// www.tate.org.uk/art/artists/kara-walker-2674/kara-walkers-fons -americanus.

Lorde, Audre. "A Litany for Survival." In *The Collected Poems of Audre Lorde*. New York: W. W. Norton, 1997.

"Louisiana Negro Lynched." *New York Times*, May 13, 1914.

Mbembe, Achille. "Decolonizing Knowledge and the Question of the Archive." Lecture at the Wits Institute for Social and Economic Research (WISER), University of the Witwatersrand

(Johannesburg), 2015. https://wiser.wits.ac.za/system/files
/Achille%20Mbembe%20-%20Decolonizing%20Knowledge%20
and%20the%20Question%20of%20the%20Archive.pdf.

Mbembe, Achille. *Necropolitics*. Durham: Duke University Press, 2019.

McElya, Micki. *Clinging to Mammy: The Faithful Slave in Twentieth Century America*. Cambridge, MA: Harvard University Press, 2007.

McInnis, Maurie D. "'To Strike Terror': Equestrian Monuments and Southern Power." In *The Civil War in Art and Memory*, ed. Kirk Savage, 125–146. New Haven: Yale University Press, 2016.

Menand, Louis. "Thirteen Crucial Years for Art in Downtown New York." *New Yorker*, March 28, 2017.

Mercer, Kobena. "Contrapositional Becomings: Adrian Piper Performs Questions of Identity." In *Adrian Piper: A Reader*, ed. Cornelia Butler and Nizan Shaked, 102–131. New York: Museum of Modern Art, 2018.

Mills, Cynthia J., and Pamela H. Simpson, eds. *Monuments to the Lost Cause: Women, Art, and the Landscapes of Southern Memory*. Knoxville: University of Tennessee Press, 2017.

Mintz, Sidney W. *Sweetness and Power: The Place of Sugar in Modern History*. New York: Penguin, 1985.

Miranda, Carolina A. "Q&A: Kara Walker on the Bit of Sugar Sphinx She Saved, Video She's Making." *Los Angeles Times*, October 13, 2014.

Moen, Marcia. "Feminist Themes in Unlikely Places." In *Feminist Interpretations of Immanuel Kant*, ed. Robin May Schott, 213–256. State College: Penn State University Press, 1997.

Morris, Catherine, and Rujeko Hockley, eds. *We Wanted a Revolution: Black Radical Women 1965–1986: A Sourcebook*. Durham: Duke University Press, 2017.

Morris, William. *News from Nowhere*. In *News from Nowhere and Other Writings*, 44–231. New York: Penguin, 1993.

Moten, Fred. *Black and Blur*. Durham: Duke University Press, 2017.

Moten, Fred. "Black Op." *PMLA* 123, no. 5 (October 2008): 1743–1747.

Moten, Fred. *Stolen Life*. Durham: Duke University Press, 2018.

Moten, Fred. *The Universal Machine*. Durham: Duke University Press, 2018.

Muhammed, Khalil Gibran. "The Sugar That Saturates the American Diet Has a Barbaric History as the 'White Gold' That Fueled Slavery." *New York Times*, August 4, 2019.

Mulvey, Laura. "Visual Pleasure and Narrative Cinema." *Screen* 16, no. 3 (Autumn 1975): 6–18.

Muñoz, José Esteban. *Cruising Utopia: The Then and There of Queer Futurity*. New York: New York University Press, 2009.

Murell, Denise. *Posing Modernity: The Black Model from Manet and Matisse to Today*. New Haven: Yale University Press, 2018.

Namaste, Vivane. "AIDS Histories Otherwise: The Case of Haitians in Montreal." In *AIDS and the Distribution of Crises*, ed. Jih-Fei Cheng, Alexandra, Juhasz, and Nishant Shahani, 131–147. Durham: Duke University Press, 2020.

Nelson, Charmaine A. *The Color of Stone: Sculpting the Black Female Subject in Nineteenth-Century America*. Minneapolis: University of Minnesota Press, 2007.

Nelson, Robert S., and Margaret Olin. "Introduction." In *Monuments and Memory, Made and Unmade*, ed. Nelson and Olin, 1–11. Chicago: University of Chicago Press, 2003.

O'Grady, Lorraine. "Olympia's Maid: Reclaiming Black Female Subjectivity." In *The Feminism and Visual Culture Reader*, ed. Amelia Jones, 174–186. New York: Routledge, 2003.

Ore, Ersula J. *Lynching, Violence Rhetoric, and American Identity*. Jackson: University of Mississippi Press, 2019.

Patton, June O., J. Strickland, and E. J. Crawford. "Moonlight and Magnolias in Southern Education." *Journal of Negro History* 65, no. 2 (Spring 1980): 149–155.

Pear, Robert. "A.M.A. Rules That Doctors Are Obligated to Treat AIDS." *New York Times*, November 13, 1987, A14.

Pearsall, Cornelia D. J. "Assume the Globe: Tennyson's Jubilee Ode and the Institutions of Imperialism." *Victorian Poetry* 59, no. 2 (Summer 2021): 177–199.

Pearsall, Cornelia D. J. "Blank Verse and the Expansion of England: The Meter of Tennyson's Demeter." In *Meter Matters: Verse Cultures of the Long Nineteenth Century*, ed. Jason David Hall, 217–236. Athens: Ohio University Press, 2011.

Pearsall, Cornelia D. J. *Tennyson's Rapture: Transformation in the Victorian Monologue*. Oxford: Oxford University Press, 2008.

Peters, Erin A. "Coloring the Temple of Dendur." *Metropolitan Museum Journal* 53 (2018): 8–23.

Peters, Erin A. "Vaguely Dendur: A Theoretical Unbinding of Egyptology." Lecture at the 13th International Congress of Egyptologists, August 6–11, 2023.

Piper, Adrian. "Biography." APRAF Berlin: The Adrian Piper Research Archive. http://www.adrianpiper.com/biography.shtml/.

Piper, Adrian. *Out of Order, Out of Sight*. Vol. 1: *Selected Writings in Meta-Art 1968–1992*. Cambridge, MA: MIT Press, 1996.

Piper, Adrian. "Xenophobia and Kantian Rationalism." *Philosophical Forum* 24 (Fall-Spring 1992–1993): 188–232.

Preciado, Paul B. "When Statues Fall." *Artforum* 59, no. 3 (December 2020).

Quashie, Kevin. *Black Aliveness, or A Poetics of Being*. Durham: Duke University Press, 2021.

Richards, Thomas. *The Imperial Archive: Knowledge and the Fantasy of Empire*. New York: Verso, 1993.

Richmond City Council Ordinance 2020-154. Adopted August 3, 2020. https://richmondva.legistar.com/LegislationDetail.aspx?ID=4582895&GUID=7AF4B6D7-0EF9-4F52-8E9E-07FF9ADD4487&Options=ID|Text|&Search=2020-154.

Rosaldo, Renato. "Imperialist Nostalgia." *Representations* 26 (Spring 1989): 107–122.

Royles, Dan. *To Make the Wounded Whole: The African American Struggle against HIV/AIDS*. Chapel Hill: University of North Carolina Press, 2020.

Rubin, Gayle. "Thinking Sex: Notes toward a Radical Theory of Sexuality." In *Pleasure and Danger: Exploring Female Sexuality*, ed. Carole Vance, 157–210. Boston: Routledge, 1984.

"The Rush Monument." *Elevator*, September 6, 1873.

Russell, Alexandria. "'In Them She Built Monuments': Celia Dial Saxon and American Memory." *Journal of African American History* 106, no. 2 (Summer 2021): 383–410.

Savage, Kirk. *Monument Wars: Washington, D.C., the National Mall, and the Transformation of the Memorial Landscape*. Berkeley: University of California Press, 2001.

Savage, Kirk. *Standing Soldiers, Kneeling Slaves: Race, War, and Monument in Nineteenth-Century America*. Princeton: Princeton University Press, 1999.

Schiebinger, Londa. "Skeletons in the Closet: The First Representations of the Female Skeleton in Eighteenth Century Anatomy." *Representations* 14 (1986): 42–82.

Schork, Robert. "The Dendur Temple in New York: The Gallus Connection." *Arion: A Journal of Humanities and the Classics* 18, no. 3 (Winter 2011): 93–105.

Schulman, Sarah. *Let the Record Show: A Political History of ACT UP New York, 1987–1993*. New York: Farrar, Straus and Giroux, 2021.

Sedgwick, Eve Kosofsky. "White Glasses." In *Tendencies*, 252–266. Durham: Duke University Press, 1993.

Senie, Harriet F., and Sally Webster. "Politics, Patronage, and Public Art." In *Critical Issues in Public Art: Content, Context, and Controversy*, ed. Harriet F. Senie and Sally Webster, 101–104. Washington, DC: Smithsonian Books, 1992.

Sharpe, Christina. *In the Wake: On Blackness and Being*. Durham: Duke University Press, 2016.

Sharpe, Christina. *Monstrous Intimacies: Making Post-Slavery Subjects*. Durham: Duke University Press, 2010.

Sikarskie, Amanda. "Erica Wilson and the Quilt Revival." *Uncoverings* 36 (2015): 93–114.

Silverman, Mervyn. "AIDS Care: The San Francisco Model." *Journal of Ambulatory Care Management* (May 1988): 14–18.

Slenske, Michael. "Lauren Halsey's Monumental Moment." *W Magazine*, March 30, 2023.

Smith, Zadie. "Niagara." In *Mark Bradford: Tomorrow Is Another Day*, ed. Katy Siegel and Christopher Bedford, 82–93. New York: George Miller & Co. and Hatje Cantz, 2017.

Snorton. C. Riley. *Black on Both Sides: A Racial History of Trans Identity*. Minneapolis: University of Minnesota Press, 2017.

Sontag, Susan. *AIDS and Its Metaphors*. New York: Farrar, Straus and Giroux, 1989.

Southern Poverty Law Center. "Whose Heritage? Public Symbols of the Confederacy (Third Edition)." https://www.splcenter.org /20220201/whose-heritage-public-symbols-confederacy-third -edition/.

Sparling Williams, Stephanie. *Speaking out of Turn: Lorraine O'Grady and the Art of Language*. Oakland: University of California Press, 2021.

Stanford, Ann. "Medusa." In *In Mediterranean Air*. New York: Viking Press, 1977.

Stephens, Brian Stephens. "Prissy's Quittin' Time: The Black Camp Aesthetics of Kara Walker." *Open Cultural Studies* 1 (2017): 646–659.

Stevens, Quentin, Karen A. Franck, and Ruth Fazakerley. "Counter-monuments: The Anti-monumental and the Dialogic." *Journal of Architecture* 17 (2012): 951–972.

"The Sugar Market: A Temporary Advance in Prices on Account of the Havemeyer Fire." *New York Times*, January 11, 1882. https:// timesmachine.nytimes.com/timesmachine/1882/01/11/98578894 .html?pageNumber=8.

Swenson, Gene. *The Other Tradition*. Philadelphia: Institute for Contemporary Art, University of Pennsylvania, 1966.

Talamo, Lex. "Split Caddo Commission Votes to Remove Confederate Monument." *Shreveport Times*, October 19, 2017.

Testa, Nino. "'If You Are Reading It, I Am Dead': Activism, Local History, and the AIDS Quilt." *Public Historian* 44, no. 3 (August 2022): 24–57.

Tharoor, Shashi. *Inglorious Empire: What the British Did to India*. London: C. Hurst & Co., 2017.

Thomas, Abraham. "South Central Dream Worlds." In *The Roof Garden Commission: Lauren Halsey*, ed. Abraham Thomas and Douglas Kearney, 10–39. New Haven: Yale University Press, 2023.

Tobin, Jacquelyn L., and Raymond G. Dobard. *Hidden in Plain View: A Secret History of Quilts and the Underground Railroad*. New York: Anchor, 2000.

Trauth, Kathleen M., Stephen C. Hora, and Robert V. Guzowski. "Expert Judgment on Markers to Deter Inadvertent Human Intrusion into the Waste Isolation Pilot Plant." Sandia National Laboratories report, November 1, 1993.

Treichler, Paula. "AIDS, Homophobia, and Biomedical Discourse: An Epidemic of Signification." *October* 43 (Winter 1987): 31–70.

Trenticosta, Cecelia, and William C. Collins. "Death and Dixie: How the Courthouse Confederate Flag Influences Cases in Louisiana." *Harvard Journal on Racial and Ethnic Justice* 27 (2011): 125–164.

Turner, Patricia Ann. *Ceramic Uncles and Celluloid Mammies: Black Images and Their Influence on Culture*. Charlottesville: University of Virginia Press, 1994.

United Daughters of the Confederacy. "Constitution of the United Daughters of the Confederacy." 1895. https://archive.org/details /constitutionofdaughters/mode/2up?view=theater.

Upton, Dell. *What Can and Can't Be Said: Race, Uplift, and Monument Building in the Contemporary South*. New Haven: Yale University Press, 2015.

Widrich, Mechtild. *Monumental Cares: Sites of History and Contemporary Art*. Manchester: Manchester University Press, 2023.

Widrich, Mechtild. *Performative Monuments: The Rematerialization of Public Art*. Manchester: Manchester University Press, 2014.

Williams, Thomas Chatterton. "Adrian Piper's Show at MoMA Is the Largest Ever for a Living Artist. Why Hasn't She Seen It?" *New York Times*, June 27, 2018.

Wilson, Erica. *Erica Wilson's Quilts of America*. Birmingham, AL: Oxmoor House, 1979.

Winnicott, D. W. *Playing and Reality*. New York: Routledge, 1989.

Winter, Jay. "The Memory Boom in Contemporary Historical Studies." *Raritan* 21, no. 1 (Summer 2001): 52–66.

Wood, Marcus. *Blind Memory: Visual Representations of Slavery in England and America, 1780–1865*. Manchester: Manchester University Press, 2000.

Wooten, James T. "A Negro Community in Alabama Cherishes Memory of Dr. King." *New York Times*, April 4, 1970, 29.

World Health Organization. "Number of People Dying from AIDS-Related Causes." https://www.who.int/data/gho/data/indicators /indicator-details/GHO/number-of-deaths-due-to-hiv-aids #:~:text=The%20estimated%20650%20000%20%5B510,in%20 many%20high%20burden%20countries.

Young, James E. "The Counter-Monument: Memory against Itself in Germany Today." *Critical Inquiry* 18, no. 2 (Winter 1992): 267–296.

Young, James E. *The Stages of Memory: Reflections on Memorial Art, Loss, and the Spaces Between.* Amherst: University of Massachusetts Press, 2018.

Young, James E. *The Texture of Memory: Holocaust Memorials and Meaning.* New Haven: Yale University Press, 1993.

# Index

Page numbers in *italics* refer to illustrations.

abolitionism, 12, 26, 228n7
abstraction, 96, 116, 182
  painterly, 53, 55
Acconci, Vito
  *Conversions*, 61
accumulation, 174, 195, 197
Acts of Art Gallery, 230n70
Africa. *See also* Egypt
  classical tradition, 6, 34,
    196–198, 200
  Yemọja, 156–158
African Burial Ground
  National Monument, 213
African diaspora, 156, 158, 174,
  186, 195, 213
African Methodist Episcopal
  Church, 12
Afrofuturism, 195–196, 200
AIDS Coalition to Unleash
  Power (ACT UP), 108–110,
  120
AIDS crisis
  activism, 109
  antiretrovirals/AZT, access
    to, 73, 78, 91, 108, 123
  Bradford's *Tomorrow Is
    Another Day* and, 182–183,
    185–186, 212
  contamination, fear of, 79,
    90, 92
  cure, 91, 92, 122
  early nomenclature for, 78
  emergence of, 33, 88, 92, 101
  as epidemic, 74, 80, 88, 91,
    102–104, 122
  first reporting on, 74
  as global pandemic, 82, 86,
    91, 104, 113
  Haiti hit by, 77, 79
  hemophilia connected to,
    74, 78, 86
  homosexuality connected
    to, 74–79, 82, 91
  IV drug use and, 74–79
  Kaposi sarcoma and, 77,
    109, 183
  as necropolitical control,
    88, 121–122
  prevention and, 79, 123
  public service
    announcements, 91
  stigmas connected to, 78–
    80, 86, 88, 104–105
  testing, 77, 80
  treatment, 79, 80, 105, 108
AIDS Memorial Quilt, 32–33,
  *34*, 67, 71–123, 129, 145, 212,
  231n14
  African American quilting
    tradition and, 22, 32, 82,
    101, 103, 171
  allegory in, 86, 88, 119, 122,
    199–200
  as archive, 33, 82, 86–88,
    112, 115–120, 122–123,
    233n76
  cathexis, 106
  as "comfort object" or
    "transitional object," 106
  deictics and, 91, 111, 113–115
  expansion and
    expansiveness, 33, 82,
    105, 108, 119, 122
  first flyer advertising, 80, *84*
  flatness, 33, 92
  gridded rows, 199, 208
  Halsey's *east side of south
    central* compared with,
    198–200
  horizontality, 85, 88–89, 122
  material heterogeneity of,
    33, 85–87, 102, 105, 108,
    200
  materiality of, 82, 108, 112,
    115, 123
  National Mall, installed on,
    *34*, 79–82, 85–86, 88–89,
    105, 106, 122
  necropolitical control,
    redress of, 88, 115,
    121–123
  opacity, 104
  panels, numbers of, 71,
    80–82
  panels for, 71–83, *72*, *73*,
    *74*, *75*, *76*, *77*, *83*, 102,
    *103*, 110–111, *110*, 115, *116*,
    *117*, 120
  polyvocality, 102, 111, 115
  quilting bees, 80, 102–103,
    106, 109
  scale, 71, 82, 86, 89, 120
  Sedgwick on, 109–112, 114,
    120
  as sepulchral relation, 112–
    115, 121, 122
  spectatorial relation of, 91,
    106, 112, 114, 120
  as synecdoche, 123
  Walker's *A Subtlety*
    compared with, 127–129
Albers, Josef, 96
Alexander, Elizabeth, 159
Alexander, Michelle, 188
aliveness, 198, 201
allegory
  AIDS Memorial Quilt and,
    86, 88, 119, 122, 199–200
  in Bradford's *Tomorrow Is
    Another Day*, 186
  in Halsey's *eastside of south
    central*, 201
  in *Victoria Memorial*, 24, 26,
    149, 151
  in Walker's *Fons Americanus*,
    24, 26–28, 156, 158–159
Als, Hilton, 57, 62, 131–132,
  225n2
American Medical
  Association, 90
Andrew W. Mellon
  Foundation, 214
antimonuments, 18–22
antiracism, 28, 220
anti-Semitism, 65
antiwar movement, 33, 55
appropriation, 171–172, 194,
  211
Arabindan-Kesson, Anna, 151
architectures of domination,
  11, 222
archive, 30, 154
  AIDS Quilt as, 33, 82, 86–
    88, 112, 115–120, 122–123,
    233n76
  archival impulse, 119–120,
    122, 123, 233n68
  Derrida on, 116, 119
  Enwezor on, 116–117
  Halsey's *eastside of south
    central* and, 191, 196–198
  imperialism's ties to, 116,
    118, 233n68
  Lesbian Herstory, 233n76

archive (cont.)
  queer approach to, 30, 82,
    119
  traditional, 116–118, 233n71
  traditional monuments
    as based on, 86–87, 116,
    119, 120
Arendt, Hannah, 142
Aristide, Jean-Bertrand, 79
Arondekar, Anjali, 118
Art Workers' Coalition, 62,
  63
art world, 43, 53–54, 62, 64–
  65, 96
*Aschrottbrunnen* (Hoheisel),
  19–20, 19
assemblage, 96
Athens, Georgia, 132
Atlantic slavery
  abolitionism, 12, 26, 228n7
  afterlives of, 11, 13, 14, 127,
    144, 186, 212, 217
  ending of, 42, 94
  Jefferson's hypocrisy on,
    175, 219
  "libidinal economy" of,
    154–156
  living in the wake of, 167,
    186
  sugar's relationship to, 6
  Underground Railroad,
    103–104
  Washington's complicated
    relationship to, 219
Atlantic slave trade, 148, 156,
  158
  Middle Passage, 158, 161,
    201
  slave ships, 235n33, 236n47
  sugar as key driver of, 6
Atlantic world, 34, 154–156,
  164
Atomic Priesthood, 216
Augustus Caesar, 191, 193

Balagoon, Kuwasi, 74, 77
Ball, Thomas
  Freedmen's Memorial, 12,
    213
Banzhaf, Maron, 73–74, 77
Barbot, James, 235n33
bas-relief, 150
Bauhaus, 96

BDSM, 71, 102
Beardsley, John, 94
Berlant, Lauren, 115
Berlin
  *Denkmal für die Ermordeten
    Juden Europas*, 20–21, 20
Bernstein, Robin, 187–188
Biggers, Sanford
  *Oracle*, 213
biopower, 87
Black artists, 62–64
Black Atlantic, 29, 118, 156,
  164
Black Belt, 93
Black bodies, 6, 33, 48–50,
  145, 159
Black diaspora. *See* African
  diaspora
Black Emergency Cultural
  Coalition (BECC), 62–64
Black Liberation Army, 74
Black Lives Matter, 13, 31
Blackness, 14, 148, 184, 188
  anti-, 198, 212
Black Panthers, 74, 120
body art, 55–56, 60–62, 131,
  229n53
Boos, Florence, 208
Bose, Subhas Chandra, 142
Botticelli, Sandro
  *Birth of Venus*, 24, 26, 154, 158
Bradford, Mark. See *Tomorrow
  Is Another Day*
Britain
  Bloody Sunday, 206–208,
    207
  colonial rule in India, 138–
    143, 234n21
  imperial expansion, 139,
    141, 150–152, 164, 206,
    233n68
  Order of the British
    Empire, 161
  socialist organizations,
    206–208
British East India Company,
  141
broadsides, 154
Brock, Thomas. See *Victoria
  Memorial*
bronze, 16, 26, 102, 206
  Common Soldier
    monuments, 42, 46

*Victoria Memorial*, 149, 150,
  163
  Wiley's *Rumors of War*, 136,
    143–144
Brown, John, 12
Brown, Kimberly Juanita,
  156, 158
Bryant, Anita, 78
Bryan-Wilson, Julia, 216,
  230n63
Butler, Judith, 90, 121

Caddo Parish, Louisiana, 50–
  52, 229n38
camp, 28–29, 163, 185, 187, 221
Canada, 206
capitalism
  abstraction as innovation
    of, 53
  racial, 6, 30, 159, 166, 187,
    199, 211, 212, 217
  valuation of labor under,
    107
caricature, racist, 49, 162–163
  Walker and, 6, 24, 28, 158,
    162–164, 171, 225n5
Cartesian subject, 55, 58
cathexis, 106
Centers for Disease Control,
  79, 91
Chambers, Ross, 211
Cheetham, Mark, 229n46,
  230n76
Cheng, Jih-Fei, 107
Chicago, 77
Chicago, Judy, 230n70
Christo and Jeanne-Claude
  *Wrapped Monument to
    Vittorio Emmanuele II*,
    227n35
chrononormative time, 172–
  174, 189, 197, 199, 200
Civil Rights movement, 9, 10,
  15, 33, 51, 54, 55, 89
  Bloody Sunday, 95
  Louverture's importance
    to, 26
Civil War, 44, 138, 143. *See
  also* Common Soldier
  monuments; Confederacy;
  Reconstruction; United
  Daughters of the
  Confederacy

Clésinger, Auguste
   *Femme piquée par un serpent*,
     147–148, *147*
Cohen, Cathy J., 27, 74, 78, 107
Cold War, 54
Collins, William C., 51–52
colonialism
   archive and, 116
   British colonial rule in
     India, 138–143, 234n21
   extractive, 138–141, 206
   settler, 17, 93, 141, 165, 206
commemoration, 6–9, 12, 18,
   21, 118, 141, 214, 226n23
Common Soldier monuments,
   15, 42–44, 46–47, 50–52
   Caddo Parish, Louisiana,
     50–52, 229n38
   courthouse lawns, siting
     on, 32, 42, 43, 47, 50–52,
     228nn21–22
   Grayson County, Texas, 47
   lynching and, 32–33, 42–44,
     47, 50–61
   Piper's *Food for the Spirit*
     as inversion of, 43, 59–
     60, 67
   Talbot, Maryland, 52
   United Daughters of the
     Confederacy and, 47, 50,
     228n21, 229n38
conceptual art, 66
Confederacy. *See also* Common
   Soldier monuments;
   United Daughters of the
   Confederacy
   flag, 51–52, 143
   Lost Cause, 9, 12, 45, 50–
     53, 139
   monuments to, 18, 32, 52,
     133, 138, 227n30
   removal of monuments,
     13, 18, 31, 51–52, 138, 214,
     218–219
*Contemporary Black Artists in
   America* (1971), 62–64
Copeland, Huey, 67
countermonuments, 18
Cox, Karen, 46
Crimp, Douglas, 106, 109–111
critical fabulation, 118–119
Cullen, Fintan, 139
Cullors, Patrisse, 31

cultural domination, 206
cultural others, 13, 15, 85

Dade County, Florida, 78
Danto, Arthur, 225n6
decoloniality, 211, 214
deictics, 91, 111, 113–115, 217
*Denkmal für die Ermordeten
   Juden Europas* (Eisenman),
   20–21, *20*
Derrida, Jacques, 116, 119
direct address, 132, 229n51
disenfranchisement, 45, 73
Dobard, Raymond G., 104
Domby, Adam, 45–46, 233n77
Douglass, Frederick, 52
   Cedar Hill, 12, 226n14
Du Bois, W. E. B., 226n14

*eastside of south central los
   angeles hieroglyph prototype
   architecture (I), the* (Halsey),
   11, *36*, 174, 190–202, *190*,
   *193*, 205
   as accumulation, 195, 197
   Afrofuturism and, 195, 200
   Bradford's *Tomorrow Is
     Another Day* compared
     with, 34–36, 174, 200–
     202
   column capitals, 190, 191,
     194, 195
   ephemera, 191, 198
   Metropolitan Museum of
     Art, commission for, 34,
     174, *190*, 191–194, *192*, 197
   oculus, *193*, 194, 202
   opacity, 198, 199
   processional axis, 194,
     198–201
   as "prototype," 174, 194–
     195, 197, 199, 200, 219
   queer/Black temporalities
     and, 174, 197, 199–202
   sphinxes, 190–191, 194, 195
Edmonds, John
   *Untitled (Hood)*, 144–145
Egypt
   Great Sphinx, 3, 6, 15, 215
   hieroglyphs, 191
   sphinxes, 190, 191, 194, 195
   Temple of Dendur, 174, 191–
     195, *192*, 197

Eisenman, Peter
   *Denkmal für die Ermordeten
     Juden Europas*, 20–21, *20*
Emancipation Proclamation,
   42
English, Darby, 54–55
Enwezor, Okwui, 116–118,
   233n68
ephemerality and
   impermanence, 14
   materials, 9, 27, 34, 128,
     165–167, 189
   monuments, 16, 18, 34, 36,
     225n6
epitaphs, 111, 154, 175–176
equestrian monuments, 15, 21,
   142, 235n27. *See also* George
   III; Outram, James; *Rumors
   of War*; Stuart, James Ewell
   Brown
escape, 104, 185, 187–189,
   237n30
Europe, 59, 139, 156, 186,
   227n35
   antimonumental gestures
     in, 21
   gendered racism in, 6
   heraldic tradition, 163
   quilting tradition, 93
   rotunda, 179
Evers, Medgar, 15
Evers, Merlie, 15
Ewing, Leslie, 110
extractive colonialism, 138–
   141, 206

Feldman, Marvin, 80, *83*
femininity, 148, 154, 158, 178
   white, 183, 184
feminism, 33, 55, 118, 173, 220,
   231n84
   Black, 179, 186
   gaze, 59, 230n62
feminist art, 12, 64, 92, 230n70
fiber arts, 93
figuration, 15, 53, 144, 145, 166,
   188, 189
Floyd, George, 214
Foley, John Henry
   James Outram monument,
     138–142, *140*, 145
   Stonewall Jackson
     monument, 142

*Fons Americanus* (Walker), 23, 24–31, *25*, 34, 129, 131, 149–167, *150*, *153*, *155*, *157*, *160*, 172–173, 176, 235n33
  allegory in, 24, 26–28, 156, 158–159
  Captain/Louverture, 26, 159, 163
  caricature, 24, 28, 158, 162–164, 171
  Daughter of the Waters/Venus, 24, 26–27, 154–158, *157*
  enslaver, 26, 28
  Kneeling Man, 163
  materiality of, 26, 163, 166, 189
  Melancholy, 159
  opacity, 29, 161
  *Physical Impossibility of Blackness in the Mind of Someone White, The*, 159–161
  Piper's *Food for the Spirit* compared with, 161–162
  Queen Vicky, 26, 28, 158–159, 163
  shell grotto, 24, 152–154, *153*, 158
  Tate Modern, installed at, 24, 149, 152, 165
  title, 24, 154, *155*, 158
  tree, 24, 26, 28, 159, *160*
  *Victoria Memorial*, modeled on, 24–28, 149–152, 158–159, 163–164
  Walker's *Subtlety* compared with, 24, 129, 131, 154, 166
  Wiley's *Rumors of War* compared with, 34, 130–131, 149, 164–167, 171–172
*Food for the Spirit* (Piper), 33, 41–44, 53–67, 132, 174, 188, 196, 230n65
  body art and, 55–56, 60–62, 131
  camera, 41, 58–60, 218
  Common Soldier monuments, inversion of, 43, 59–60, 67
  gendered racism, intervention into, 33, 56, 60–61, 66

Kant's *Critique of Pure Reason* and, 42–43, 56–57, 64, 66
  Menil Collection, made for, 62
  mirror, 41, 58, 59, 218
  opacity, 58
  performance art and, 61
  Piper's *Everything #4* as coda to, 218
  Piper's New York loft, setting for, 41, 61
  Piper's nudity in, 41, 59–62, 67
  spectatorial condition of, 57–59, 62
  Walker's *Fons Americanus* compared with, 161–162
  Walker's *Subtlety* compared with, 67, 132
  formalist modernism, 53–55, 64–65
  objectivity, claims to, 43, 55, 57–60
Foucault, Michel, 87
fountains. *See Aschrottbrunnen*; *Fons Americanus*; *Victoria Memorial*
Freedmen's Memorial, 12, 213
Freedom Monument and Sculpture Park, 213
Freedom Quilting Bee, 32, 95–101, 232n40
Freeman, Elizabeth, 172
Frith, Nicola, 139
Fry, Gladys-Marie, 103
fugitivity, 104, 199
fungibility, 199
funk, 196, 198, 237n24, 237n26

Garvey, Marcus, 159
Garza, Alicia, 31
Gates, Henry Louis, Jr., 44, 227–228n7
gay community, 74, 77, 79, 82, 91, 104
  "It Gets Better," 187
gay liberation movement, 55, 77
Gay Men's Chorus, 102
Gay Men's Health Crisis (GMHC), 79–80, *81*

Gee's Bend, Alabama, 32, 93–102
gendered racism
  Piper's *Food for the Spirit* and, 33, 56, 60–61, 66
  Walker's *Subtlety* and, 6, 13, 128–129, 132–133, 166
George, Rachel Carey
  *My Way*, 96, *99*
George III (king of England) monument to, 16–17, *17*
Gibson, Jeffrey
  *the space in which to place me*, 213–214, *215*
gilding, 26, 149, 163, 208
*Giles v. Harris* (1903), 44
Gilroy, Paul, 152, 196, 237n24
Glissant, Édouard, 58, 161, 227n43
global economy, 141, 150–151
Goldsby, Jacqueline, 47–49, 159
Gonzalez-Torres, Felix
  "*Untitled*" (*Portrait of Ross in L.A.*), 113–114
granite, 21, 102
Grayson County, Texas, 47
Great Migration, 94
Greenberg, Clement, 53–55, 65, 229n46, 232n76
  "Avant-Garde and Kitsch," 53
grid, 20, 178, 199, 217
Guantanamo Bay, 79

Haiti, 77–79
Haitian Revolution, 26, 159
Halifax County, North Carolina, 94
Halsey, Lauren. *See eastside of south central los angeles hieroglyph prototype architecture (I), the*
Hamilton, Ed, 50
Hammons, David
  *In the Hood*, 144–145
*Harlem on My Mind* (1969), 62
Hartman, Saidiya, 29, 118, 130, 154–156, 161, 235n33
  "afterlife of slavery," 11
  "critical fabulation," 118

"inadequacy of the
  redressive action," 37
"spectacular violence," 48
Helms, Jesse, 79
Hendricks, Barkley, 172
Hinds, Mississippi, 228n19
Hirst, Damien
  *The Physical Impossibility
    of Death in the Mind of
    Someone Living*, 159–161
HIV/AIDS. *See* AIDS crisis
Hoheisel, Horst
  *Aschrottbrunnen*, 19–20, *19*
Holland, Owen, 210
hollowness, 28, 163, 166, 190
Holocaust, 18
  *Denkmal für die Ermordeten
    Juden Europas*, 20–21, *20*
homophobia, 27, 30, 65, 74,
  77–79
homosexuality, 74, 77–79, 114
hoodies, 136, 144–145, 147
hostile architecture, 216
Human Interference Task
  Force, 216

identity politics, 54, 131
Ifill, Sherrilyn, 48, 49, 52
*Illustrated London News*, 206,
  *207*
imperialism, 27, 130, 158
  archive's ties to, 116, 118,
    233n68
  British, 138–141, 149–152,
    161, 164, 206, 210–211,
    233n68
  "imperialist nostalgia," 159
  others, 85, 152
impermanence. *See*
  ephemerality and
  impermanence
India, British colonial rule in,
  138–143, 234n21
Indigenous artists, 213–214
Indigenous peoples, 17, 18,
  85, 219
  Monacan Nation, 165
  Powhatan Chiefdom, 165
  Yoruba, 156
International African
  American Museum, 213
Iraq, 226n27
Irish National League, 206

Jackson, Stonewall, 142
Jackson, Suzanne, 230n70
James, Ashley, 145
Jefferson, Thomas, 219
  Monticello, 175
Jim Crow, 45
Johnson, Joan Marie, 12,
  226n14
Jones, Amelia, 55, 229n45,
  230n63
Jones, Cleve, 80, 101

Kant, Immanuel, 229n45
  *Critique of Pure Reason* (first
    *Critique*), 42–43, 56–57,
    64–66, 231n84
  *Critique of the Power of
    Judgment* (third *Critique*),
    53–54, 65, 229n46,
    230n76, 231n84
Kaposi sarcoma, 77, 109, 183
Kassel, Germany
  *Aschrottbrunnen*, 19–20, *19*
Katz, Jonathan David, 91, 106,
  114, 233n60
Keeling, Kara, 30, 174, 195,
  197–198
Kim, Clara, 24
King, Martin Luther, Jr.,
  94–95
King, Rodney, 159
kinning and kinship
  networks, 92, 105, 107
Kolkata, India
  James Outram monument,
    138–142, *140*, 145
Korean War Memorial, 231n13
Kramer, Larry, 108–109
Ku Klux Klan, 46

labor movement, 33, 55
Laclau, Ernesto, 172
Lavender Scare, 54
Lawrence, Jacob, 62
Laycock, Ross, 113
Lee, Robert E., 234n15
Legacy Museum of African
  American History, 213
Leigh, Simone
  *Brick House*, 213
L'Enfant, Pierre Charles, 89
Lesbian Herstory archives,
  233n76

Lin, Maya
  Vietnam Veterans
    Memorial, 21–22, 86, 116,
    231n14
Lincoln, Abraham
  Freedmen's Memorial, 12,
    213
  Lincoln Memorial, 15
Lippard, Lucy, 230n70
London. *See also* Tate Modern;
  *Victoria Memorial*
  Admiralty Arch, 152
  Nelson's Column, 205–206,
    208, 210
  Trafalgar Square, 150, 152,
    206–208, *207*, 210
Lorde, Audre, 158
Los Angeles, 77, 182, 236n8
  Gallery 32, 230n70
  South Central, 191, 195
Lost Cause, 9, 12, 45, 50–53,
  139
Louverture, Toussaint, 26,
  159, 163
Lowry, Bates, 62, *63*
Lynch, Michael, 110–111
lynching, 32–33, 42–43, 47–52,
  159, 229n36
  Common Soldier
    monuments and, 32–33,
    42–44, 47, 50–61
  courthouse lawns,
    preferred locations for,
    32, 42, 47, 50
  lynch law, 47–48, 50, 51
  photographs, 48–49
  public nature of, 48
  tree, synecdoche for, 26, 28

Mammy, 12, 132–133, *134–135*,
  162
marble, 26, 102, 147, 150,
  163–165
marginalization, 44, 58, 189,
  213
  AIDS crisis and, 74, 78–79,
    88, 91, 104–105, 121
masculinity, 148, 178–179
  Black, 183, 184, 187
  militarized, 142
  naturalization of, 32
  signifiers of, 61
  white, 59, 60, 108

materiality, 26, 60, 82, 96, 112, 146, 184
  of difference, 115, 123
  of impermanence, 163, 189
  masculinized, 108
  nonmonumental, 166
Mbembe, Achille, 88, 121–122, 211
McCannon, Dindga, 230n70
McCullough, Barbara
  *Water Ritual #1*, 230n65
McDaniel, Ora, 95
McElya, Micki, 162
McMullin, Gert, 110
memorials, 12, 15, 21, 32, 141, 226n27. *See also* AIDS Memorial Quilt; *Denkmal für die Ermordeten Juden Europas*; Lincoln, Abraham; *Victoria Memorial*; Vietnam War
  epitaphs, 111, 154, 175–176
  Holocaust, 18
  monuments compared with, 16, 212–213
  war and, 87, 231n13
memorial studies, 11, 226n23
memory, 12, 18, 21, 42, 162
memory studies, 9, 31
Menil Collection, 62
Mercury, Freddie, 73, *74*
Metropolitan Museum of Art
  *Harlem on My Mind*, 62
  Roof Garden commission, 34, *36*, *190*, 191, *193*
  Temple of Dendur, 174, 191–195, *192*, 197
militarism, 32, 142
Miller, David, *72*, 73, *73*, 102
minimalism, 96, 178, 182
minoritization, 73, 127, 130, 152, 186
  strategies derived from, 13, 14, 27, 30, 188–189, 200, 212
minstrel, 6, 49
mirror, 183
  Piper and, 41, 56–59, 217, 218, 229n53
misogyny, 30, 64
Moen, Marcia, 231n84
Monacan Nation, 165
Monroe, Marilyn, 183

Montgomery, Alabama, 95
  Freedom Monument and Sculpture Park, 213
  National Memorial for Peace and Justice, 213
monument boom
  early twentieth-century, 138
  present-day, 10–13, 17, 32, 37, 53, 67, 202, 211–212, 214
Monument Lab, 16, 226–227n29, 227n30
monuments
  Confederate, removal of, 13, 18, 31, 51–52, 138, 214, 218–219
  definitions of, 6–11, 16, 205, 220–221, 225n6, 227n30
  and domination, 11, 14, 22, 30, 138, 142, 202, 205, 206, 210, 221, 222
  memorials compared with, 16, 212–213
  publicness, 34, 37, 45, 165
  scale, 13, 127, 129, 148, 175, 198, 218
  toppling of, 16–17, 22, 205, 208, 210, 211–212, 219, 226n27
  as the will of the public, 45
  wrapping, 227n35
monuments, traditional
  archival basis of, 86–87, 116, 118–120
  centrality and urban siting of, 13, 89, 165
  chronormative time, 172–174, 200
  exclusions from, 29, 30, 143–145, 164–165, 210, 234n15
  finish, 166, 174, 197
  genealogy of, 21–22, 42, 137, 144, 234n11
  history as presented in, 129, 172
  impermeability, 6, 13, 28, 142, 166, 225n6
  legibility of, 199
  material homogeneity, 85–86

  monocultural fictions of, 10, 13
  nationalism, in service of, 120, 133, 142, 208, 219
  permanence telegraphed in, 9, 15, 45, 128, 166–167, 174
  scale, 13, 29, 127
  solidity, 11, 166, 174
  verticality, 85, 88
Monuments Project, 214
Morris, William, 208–211
  *Commonweal*, 208, *209*
  *News from Nowhere*, 208–211
Moten, Fred, 15, 29, 104, 145, 185, 227n43, 237n30
Mouffe, Chantal, 172
Moynihan, Frederick
  J. E. B. Stuart monument, 137–138, 141–144, *143*, 234n10
Muñoz, José Esteban, 14, 173, 174, 188, 189
Museum of Modern Art (MoMA)
  Piper retrospective (2018), 229n53, 229–230n54, 238n14
  13 demands submitted to director of, 62, *63*
mythology
  Clio, 50
  Hephaestus, 175–179, 184, 189
  Isis, 191
  Medusa, 178–179, 182, 186
  Venus, 24, 26–27, 154–158
  Yemoja, 156–158

NAMES Project. *See* AIDS Memorial Quilt
Napoleon I, 208, *210*, 235n28
National Association of Colored Women (NACW), 12
National Gallery, London, 206
national identity, 9, 36, 152, 212, 215, 219
  exclusions from, 86, 92, 208
  racism and, 49, 133, 138, 218
  UK, 142, 206, 210
  US, 85, 121, 219
  war dead and, 21, 33, 89

nationalism, 193
    traditional monuments in
        service of, 120, 133, 142,
        208, 219
    white, 42, 44, 45, 59, 149
National Memorial for Peace
    and Justice, 213
National Socialism. *See* Nazi
    Germany
nation-state, 13, 16, 21, 85,
    89, 186
    Black bodies as threat
        to, 48
    oculus as synecdoche for,
        179
Nazi Germany, 18–21, 226n27
necropolitics, 88, 115–118,
    121–123
Nelson's Column, 205–206,
    208, 210
New York City. *See also*
    Metropolitan Museum of
        Art; Museum of Modern
        Art; Whitney Museum of
        American Art
    African Burial Ground
        National Monument, 213
    art world, 53, 54, 96
    Domino Sugar Refinery, 3
    Gee's Bend and Freedom
        Quilting Bee quilts in,
        96, 101
    Harlem, 62
    layout, changes to, 54
    Manhattan, orientation
        of, 199
    New York Harbor, 16
    Piper's loft in, 41, 61
    Stonewall Riots and pride
        parades, 77
    Times Square, Wiley's
        *Rumors of War* installed
        in, 35, 136, 137, 220
*New York Times*, 50, 74, 229n36
Nigeria, 156
nuclear waste, 216, 237–238n12
nudity, 3, 41, 59–62, 67, 147,
    148
Nyumba Ya Sanaa Gallery,
    230n69

obelisks, 16, 21, 47, 85
obituary relation, 111–112, 114

objectivity, 53, 173
    formalist/Greenbergian
        modernism's claims to,
        43, 53–55, 57, 59, 229n46
    Kantian, 43, 54, 56, 229n46
    Piper's *Food for Spirit*'s
        intervention into, 43, 53,
        56–60, 66
obsolescence, 146, 220
oculus, 179, *193*, 194, 202
Oerteil, Johannes Adam
    Simon
    *Pulling Down the Statue of
        King George III*, 16–17, *17*
O'Grady, Lorraine, 62
Olmsted, Frederick Law, 89
opacity, 29, 58, 104, 133, 161,
    198, 199
Ore, Ersula J., 48–49
others, othering, and
    otherness, 186
    cultural, 13, 15, 85
    imperial, 85, 152
    of queers, 78
    racialized, 152, 154, 161,
        162, 164
    valences of, 90
    xenophobia as response
        to, 65
Outram, James
    monument to, 138–142,
        *140*, 145

painterly abstraction, 53, 55
Palladio, Andrea, 175
Paris
    Vendôme Column, 208, *210*
Paris Commune, 208
Parliament-Funkadelic
    (P-Funk), 196, 237n26
    *Mothership Connection*, 196
Pearsall, Cornelia D. J., 141, 151
performance art, 16, 61
permanence, 9, 11, 45, 128, 130,
    166–167, 174, 182
    ideological, 28, 166
    material or materiality
        of, 15, 165, 167, 182, 189,
        195, 202
    temporariness as rejoinder
        to, 219–220
Peters, Erin, 193
Pettway, Ethel Mae, 95

Pettway, Lorraine
    *Medallion Work Clothes
        Quilt, 98*
    *Strip Quilt*, 96
Pettway, Lucy T., 96
    *Housetop*, 96, 97
photographs, 62, 208. *See also*
    Piper, Adrian
    of the AIDS Quilt, 115, 122,
        233n67
    lynching, 48–49
Piper, Adrian, 32. See also
    *Food for the Spirit*
    *Calling Cards*, 131–132
    *Catalysis*, 229n53
    *Concrete Infinity
        Documentation Piece*,
        55–56
    *Everything* series, 217–218,
        238n14
    *Funk Lessons*, 237n26
*Plessy v. Ferguson* (1896), 44
polis, security or well-being
    of, 54, 175, 206
polystyrene, 3, 9, 128
polyvocality, 102, 111, 115
Possum Bend, Alabama, 95
postmodernism, 16, 233n60
    "poetic postmodern," 114
Powhatan Chiefdom, 165
Preciado, Paul B., 36–37
processional axis, 149, 175,
    191, 194, 198–201
publicness, 34, 37, 45, 165
Puryear, Duane Kearns, 115,
    *116*, 117

Quashie, Kevin, 13, 198
queerness and queer
    strategies, 14, 114
    archival practices, 30, 82,
        119
    Bradford's *Tomorrow Is
        Another Day* and, 183–184,
        188, 189
    kinship networks, 105, 107
    othering of, 78
    regulation of, 87
    subjectivity, 87, 148, 212
    temporality, 173, 197, 199,
        202
    Wiley's *Rumors of War* and,
        148–149, 235n27

quilts and quilting. *See also*
AIDS Memorial Quilt
African American tradition,
22, 32, 33, 82, 93–94, 96,
101, 171
bees, 80, 92, 102–103, 106,
109
*Erica Wilson's Quilts of
America*, 93, 101
Freedom Quilting Bee, 32,
95–101, 232n40
Gee's Bend, 32, 93–102
*Housetop*, 96, 97
H-style, 96
*Medallion Work Clothes
Quilt*, 98
*Milky Way*, 96, 100
*My Way*, 96, 99
network TV, quilting's role
in the expansion of,
92–93
patchwork, 93, 104
piecing, 96, 101–102,
232n40
*Strip Quilt*, 96
Underground Railroad and,
103–104
white-dominant tradition,
92, 101

race and racism. *See also*
Blackness; caricature,
racist; gendered racism;
white-dominant culture;
white nationalism;
whiteness; white
supremacy
ordering systems of, 57–58,
67, 154, 163, 164, 230n61
racial discrimination and
disenfranchisement, 45
racial equality, 18, 51
racialized others, 85, 152,
164
racialized terror and
violence, 28, 44, 47–48,
60, 145, 220
racial solidarity, 48, 142–
143
scientific, 162
segregation, 44, 45
stereotypes, 48, 67, 127, 132,
133, 162, 184

structural, 28, 58, 74, 77,
95, 145
systemic, 27, 49, 148
Rausch, Christian Daniel
*Victory*, 235n28
Reconstruction, 12, 44–47,
227–228n7
anti-Black terror during,
44, 47
defeat of, 9, 42, 44–46, 89
Red Cross, 94
Red Scare, 54
regulatory architectures, 173
renaming, 52, 95
restitution, 29–30, 156, 164
Revolutionary War, 89
Rhodes, Cecil, 31
Richmond, Virginia
Confederate monuments,
137–138, 141–144, *143*,
234n10, 234n15
United Daughters of the
Confederacy based in,
44, 137
Virginia Museum of Fine
Arts, 137
Ringgold, Faith, 62
Rome, 6, 191, 193
Rosaldo, Renato, 159
Roth, William
*Portrait of Lieutenant General
Sir James Outram, G.C.B.*,
*140*
Royles, Dan, 74–77
*Rumors of War* (Wiley), 11, 34,
*35*, 129–131, 136–149, *137*,
220
anonymous Black
everyman, 138, 234n12
biblical verse on plinth,
136–137, 145, 190, 208
bronze, 143–144
equestrian statues,
modeled on, 137–144,
146, 234n11, 234n15
hoodie, 136, 144–145
Nike Air Force 1s in, 136,
144
obsolescence, 146, 220
queerness and, 34, 146–149,
235n27
Times Square, installed at,
*35*, 136, 137, 220

Virginia Museum of Fine
Arts, relocated to, 137
Walker's *Fons Americanus*
compared with, 34, 130–
131, 149, 164–167, 171–172
Wiley's *Femme piquée par un
serpent* and, 147–148, *147*,
235n27
Rush, Christopher, 12
Russell, Alexandria, 12,
226n16

Sandia National Laboratories,
216, *217*, 237n12
San Francisco, 77, 79–80, 101
*Sapphire Show* (1970), 230n70
Savage, Augusta
*All Wars Memorial to Colored
Soldiers*, 213
Savage, Kirk, 42, 46, 89, 225n6,
226n21, 226n23
Schapiro, Miriam, 230n70
Schneemann, Carolee
*Interior Scroll*, 61
Schork, Robert, 193
Schulman, Sarah, 107, 109
scientific racism, 162
Scott, Charlotte, 12
Sedgwick, Eve Kosofsky, 109–
112, 114, 120
segregation, 44–45, 87
Selma, Alabama, 94–95
Senie, Harriet F., 45
sepulchral relation, 112–115,
121, 122
settler colonialism, 17, 93, 141,
165, 206
sexuality, 78, 112, 148, 154, 156,
183, 189
Sharpe, Christina, 14, 167
Silverman, Mervyn, 79–80
Simpson, Rose B.
*Counterculture*, 213, *214*
Sisters of Perpetual
Indulgence, 73, *76*
slavery. *See* Atlantic slavery
slave trade. *See* Atlantic slave
trade
Smith, Zadie, 185, 186
Smithsonian Institution, 93
Snorton, C. Riley, 199
social address, 55, 131, 221,
229n51

Social Democratic Federation, 206

Socialist League, 206–208

social justice, 10, 54, 64

Sontag, Susan, 78

South Africa, 31, 206

Southern Poverty Law Center (SPLC), 227n30, 228n19, 228n21

Sparling Williams, Stephanie, 229n51

speculative practices, 29, 118, 161, 174

sphinxes, 190, 191, 194, 195
  Great Sphinx, 3, 6, 15, 215

Springfield, Illinois, 12

Stella, Frank, 96

Stephens, Brian, 28–29

stereotypes, 121, 162
  homophobic, 77, 90
  racialized, 48, 67, 127, 132, 133, 162, 184

stone, 17, 21, 46, 89, 154, 225n6

Stonewall Riots, 77

structural racism, 28, 58, 74, 77, 95, 145

Stuart, James Ewell Brown (J. E. B.)
  monument to, 137–138, 141–144, 143, 234n10

subjecthood, 30, 58, 66, 158, 219

subjectivity
  Black, 6, 29, 43, 148, 212
  Black women's, 12, 43, 132, 156, 158, 164
  conditions and construction of, 33, 55, 66, 132, 162, 185
  Kant's ideas on, 57, 231n84
  of perception, 56, 59
  queer, 87, 148, 212

Subtlety, A (Walker), 3–9, 4–5, 7, 8, 16, 23, 31, 34, 128, 205, 225n5, 226n18
  AIDS Quilt compared with, 127–129
  Attendants, 6, 7, 8, 24, 154, 225n3
  gendered racism, gesture toward tropes of, 6, 13, 48, 128, 133, 166

Great Sphinx, modeled on, 3, 6

Piper's Food for the Spirit compared with, 67, 132

polystyrene, 3, 9, 128

racial capitalism, 6, 166

slavery thematized in, 6, 11, 225n2

spectatorial experience of, 133–136

sugar, 3, 6, 9, 128, 225n3

sugar refinery building, installed at, 3, 6

as turning point, 9, 127, 129, 171

Walker's Fons Americanus compared with, 24, 129, 131, 154, 166

sugar, 3, 6, 9, 128, 225n3

survivance, 200, 219

Sutton, Terry, 110–111, 110

synecdoche, 56, 142, 149
  AIDS Quilt as, 123
  Common Soldier monuments as, 46
  monuments as, 142
  oculus as, 179
  stone as, 225n6
  tree as, 26

systemic racism, 27, 49, 148

Talbot, Maryland, 52

Tate Modern, London, 24, 149, 152, 165

temporality, 86, 130, 185–186, 196, 219
  chrononormative, 172–174, 189, 197, 199, 200
  "dynamic" approach to, 13
  of lynching, 50
  queer/Black, 173, 197, 199, 202
  temporal collapse, 120, 173–174, 188, 196–197, 199

Tharoor, Shashi, 139–141, 234n21

Thomas, Abraham, 196

Thomas, Hank Willis
  The Embrace, 213

Three Mile Island, 216

Tobin, Jacqueline L., 104

Tometi, Opal, 31

Tomorrow Is Another Day (Bradford), 11, 34–36, 35, 173, 175–190, 176–183, 212, 217, 236n8
  abstract canvases, 182–183, 182
  Black and queer strategies in, 34, 173, 183–190
  escape, 185, 187–189
  Halsey's eastside of south central compared with, 34–36, 174, 200–202
  "Hephaestus," 175–178, 177, 184–185, 189
  Medusa, 178–179, 179, 182, 186
  Niagara, 183, 183–187, 189
  oculus, 179, 202
  The Odyssey, 178, 182
  Oracle, 179–182, 180, 181
  Spoiled Foot, 176, 178, 183, 185, 187
  Venice Biennale, installed at, 34, 173, 175, 236n8

Treichler, Paula, 78

Trenticosta, Cecelia, 51–52

Turner, Patricia A., 162

Twentieth Century Creators, 230n69

Underground Railroad, 103–104

United Daughters of the Confederacy (UDC), 44–47, 50, 149, 228n21
  Common Soldier monuments, 47, 50, 228n21, 229n38
  headquarters, 44, 137–138
  lawsuits mounted by, 52–53, 228n19
  Mammy Monument, 12, 132–133, 134–135

universality, 43, 59, 109, 128, 136, 161

University of Chicago, 73, 75

US Congress, 12, 132–133, 134–135

US Supreme Court, 47
  Giles v. Harris (1903), 44
  Plessy v. Ferguson (1896), 44
  Williams v. Mississippi (1898), 44

utopia, 161, 211

Vanderbilt University, 52
Van Der Zee, James, 62
Vendôme Column, 208, *210*
Venice Biennale, 34, *35*, 173,
175, *176–183*, 213–214,
236n8
Venus, 24, 26–27, 154–158
veracity, 87, 174, 219
verticality, 85, 88
Victoria (queen of England),
141, 149, 151–152, 164
*Victoria Memorial* (Brock), 24,
26–28, 32, 149–152, *151*, 158,
163–164
allegories, 24, 26, 28, 149,
235n38
Buckingham Palace, 24, 149
imperial project, 152, 174
marble and bronze, 163
title, 227n37
water as leitmotif, 24, 27,
150–152
Vietnam Veterans Memorial
(Lin), 21–22, 86, 116, 231n14
Vietnam War
antiwar movement, 33, 55
memorial in Talbot,
Maryland, 52
Vietnam Veterans
Memorial, 21–22, 86, 116,
231n14
Virginia Museum of Fine Arts
(VMFA), 137

Walker, Kara, 11, 30, 131–
132, 222. See also *Fons
Americanus*; *Subtlety, A*
"Black/White (Grey) Notes
on Adrian Piper," 131,
234n3
Walter, Francis X., 95
Washington, DC. *See also*
AIDS Memorial Quilt;
Washington Monument
Cedar Hill, 12, 226n14
Freedmen's Memorial, 12,
213
Korean War Memorial,
231n13
Lincoln Memorial, 15
National Mall, *34*, 79–82,
85–86, 88, 105, 106, 122,
132

Vietnam Veterans
Memorial, 21–22, 86, 116,
231n14
World War II Memorial,
231n13
Washington, George, 144, 221
Mount Vernon, 12
Washington Monument, 32,
82, 116
AIDS Memorial Quilt and,
88–89, 122
National Mall anchored
by, 85
verticality, 15, 88
Webster, Sally, 45
Weems, Carrie Mae, 67
Weusi Artist Collective, 230n69
*Where We At* (1970), 230n70
white-dominant culture, 11,
30, 52, 62, 64, 132, 156, 186
white nationalism, 42, 44, 45,
59, 149
whiteness, 6, 60, 164, 188,
235n33
institutionalization of, 141
naturalization of, 32, 42,
164–165
US national identity as
founded or elaborated
in, 48, 51
white supremacy, 45–46, 49,
51, 89, 211. *See also* Common
Soldier monuments;
Confederacy
monuments to, 13, 133
Whitney Museum of
American Art, 62–64
Whitney Plantation museum,
213
Widrich, Mechtild, 15, 142,
225n6, 226n23
Wilcox County, Alabama, 93–
94, 102
Wiley, Kehinde. See *Rumors
of War*
Williams, John Sharpe, 132
Williams, Thomas
Chatterton, 131
*Williams v. Mississippi* (1898), 44
Wilson, Erica, 93
*Erica*, 93, 101
*Erica Wilson's Quilts of
America*, 93, 101

Winnicott, D. W., 106
*Womanhouse* (1972), 230n70
Woodson, Carter G., 226n14
World Health Organization,
120–121
World War II, 54
World War II Memorial,
231n13
Wynter, Sylvia, 164

xenophobia, 28, 65–66, 162–
163, 217, 218

Yoruba, 156
Young, James E., 226n23
Young, Nettie
*Milky Way*, 96, *100*

The MIT Press
Massachusetts Institute of Technology
77 Massachusetts Avenue, Cambridge, MA 02139
mitpress.mit.edu

This publication has been supported by the MIT Press Fund for Diverse Voices.

The MIT Press would like to thank the anonymous peer reviewers who provided comments on drafts of this book. The generous work of academic experts is essential for establishing the authority and quality of our publications. We acknowledge with gratitude the contributions of these otherwise uncredited readers.

This book was set in Haultin Normal by New Best-set Typesetters Ltd. Printed and bound in the United States of America.

Library of Congress Cataloging-in-Publication Data

Names: Dawson, Cat, author.
Title: Monumental : how a new generation of artists is shaping the memorial landscape / Cat Dawson.
Description: Cambridge, Massachusetts : The MIT Press, [2025] | Includes bibliographical references and index.
Identifiers: LCCN 2024059884 | ISBN 9780262049757 (hardcover)
Subjects: LCSH: Monuments—Philosophy. | Memorials—Philosophy. | Monuments—Social aspects—United States. | Memorials— Social aspects—United States. | Minority artists—United States.
Classification: LCC NA9345 .D39 2025 | DDC 731/.760973—dc23/ eng/20250122
LC record available at https://lccn.loc.gov/2024059884

10   9   8   7   6   5   4   3   2   1

EU Authorised Representative: Easy Access System Europe, Mustamäe tee 50, 10621 Tallinn, Estonia | Email: gpsr.requests @easproject.com